GEORGE RICKEY
A LIFE IN BALANCE

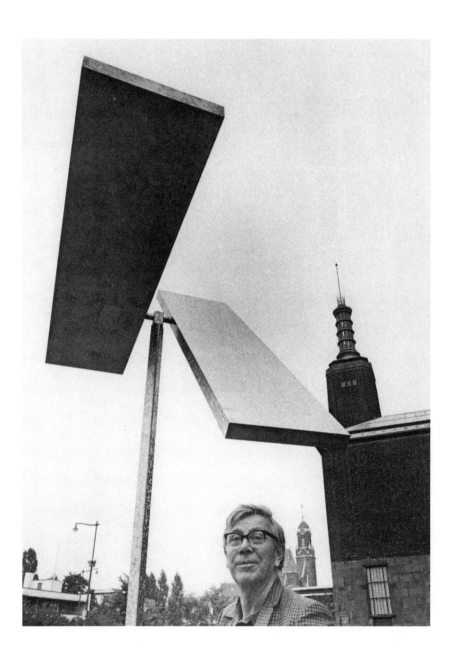

GEORGE RICKEY

A LIFE IN BALANCE

BELINDA RATHBONE

GODINE • BOSTON • 2021

Published in 2021 by
Godine, Publisher
Boston, Massachusetts

FRONTISPIECE: George Rickey with Two Rectangles, Rotterdam,
Netherlands, circa 1973. *Photograph by Ary Groeneveld. George Rickey
Estate, LLC / licensed by Artist Rights Society, New York.*

LIBRARY OF CONGRESS CATALOGING-IN-PUBLICATION DATA

Names: Rathbone, Belinda, author.
Title: George Rickey : a life in balance / Belinda Rathbone.
Description: Boston : Godine, 2021. | Includes index.
Identifiers: LCCN 2021011696 (print) | LCCN 2021011697 (ebook) |
ISBN 9781567927078 (hardback) | ISBN 9781567927085 (ebook)
Subjects: LCSH: Rickey, George. | Sculptors—United States—Biography.
Classification: LCC NB237.R5 R525 2021 (print) | LCC NB237R5 (ebook) |
DDC 730.92 [B]—dc23
LC record available at https://lccn.loc.gov/2021011696
LC ebook record available at https://lccn.loc.gov/2021011697

First Printing, 2021
PRINTED IN THE UNITED STATES OF AMERICA

To Elliot

CONTENTS

PART **ONE**

1

Eclipse

BEHIND EVERY public sculpture is a story the public never hears. In December 2017—literally overnight—such a work appeared in New York at the busy corner of West 48th Street and the Avenue of the Americas. It was George Rickey's *Annular Eclipse*, a giant pair of wind-powered stainless-steel circles, sixteen feet in diameter, held aloft by a post, thirty-five feet off the ground. Defying the steel-girded Midtown skyscrapers and holiday decorations bristling with colored lights up and down the avenue, the sculpture silently moved to its own timeless rhythms.

Installing a large sculpture in a dense urban setting is no simple matter; George Rickey knew that well, as did everyone who ever worked for him. The preliminaries can go on for months, but the actual installation, once the date is confirmed, must be meticulously timed and coordinated. With permits from the city at last in hand, the date was set—Wednesday, December 6—with a tight window. Work was to begin after 9 P.M., when the traffic died down, and be

completed by 6 A.M. the following day. Installation would take twelve workers, nine hours, and approximately a hundred thousand dollars.

At the appointed hour, three parties convened on the site. Leading the effort was the team from the artist's workshop, among them the artist's younger son, Philip Rickey, along with a crew of veteran studio assistants. Machinery movers parked a seventy-five-foot tractor-trailer carrying the sculpture in pieces, with twenty sheets of plywood to protect the stone paving of the plaza, half a dozen sawhorses, three dozen packing blankets, and piles and piles of rope and rigging equipment, on the corner of 48th Street. Soon afterward arrived a four-wheel-drive forklift with extending boom, a scissor lift, and a motorized light stand with their operators. Meanwhile, half a dozen men hired by the office building stood by to oversee the safety of both the workers and the sculpture. A custom-designed plinth, awaiting the installation, was already embedded in the pavement of the small plaza.

After unloading the van, the workshop crew rested the pieces of the first circle on sawhorses and assembled it on the spot, using some five hundred screws and nuts in the process. "Space them out, start loose," instructed Steve Day, who had almost fifty years of experience constructing and installing Rickey's sculptures. Six handlers assembled the first circle in a little more than an hour. With the steady hand of the forklift driver and direction from the crew on the ground, they hoisted the post onto the plinth and bolted it down. Then came the most challenging and hazardous part of the job: lifting the circle into position, aligning it with the rotating arm, and sliding it into place. By the time they had completed this task, it was 3:30 A.M., and the second circle was yet to be assembled.

Working straight through the freezing cold December night, the team completed the job, with all the equipment removed, just under the wire—6:01 A.M. A city employee, known as the bolt checker, gave it the official green light. As the workday began and employees swarmed toward the building's revolving doors, the circles danced silently above

them, in gentle opposition to the vertical rise of the skyscraper behind them and the din of the morning traffic.

"He's a sculptor who stands up to any urban situation," said Philip Rickey, with the relief and exhilaration of a job well done, "and that's rare."[1]

Until the installation, the sculpture had been very much at home in the country, rocking with the breezes in a hilly meadow just a few hundred yards from the workshop where it was made.

On a bright October afternoon a little more than a year earlier, media mogul Rupert Murdoch and his new bride, former supermodel Jerry Hall, ventured into the woods of Columbia County, New York. For Murdoch it was a nostalgia trip. He once had a weekend home in Old Chatham, and among its local pleasures for him was to drive over to East Chatham to visit George Rickey in his studio. At the time Murdoch, then married to Anna Maria Torv, was just one of Rickey's many high-profile art patrons, such as Joseph Hirshhorn, S. I. Newhouse Jr., Carl Djerassi, Sir Peter Palumbo, and Nelson Rockefeller, and museum directors including Alfred Barr, of the Museum of Modern Art, Carter Brown, of the National Gallery, and Thomas Messer, of the Guggenheim Museum, to visit East Chatham in view of adding a Rickey sculpture to their collections.

A hundred and thirty-five miles north of New York City, where the Berkshire Hills meet the Hudson River Valley, an area long ago settled by farmers cultivating fields of rye for horses and now almost completely forested, land in 1957 was cheap, and so was the dilapidated farmhouse that George Rickey and his wife, Edie, bought that year. George adapted the tumbledown chicken barn as his studio, laying wooden boards over the dirt floor and installing electricity and a woodstove for heat. The house was so cold in winter that they took the cats to bed with them to keep warm.

Over the years they modernized the house and, as they were able to, acquired adjacent land and buildings along County Route

34. They cleared trees and dug ponds all over the property, creating the setting for a constant and ever evolving exhibition of Rickey's outdoor sculptures throughout the seasons. They engaged staff to support every aspect of the operation, from outdoor maintenance to skilled and unskilled studio assistance and from business accounting to sales.

In its heyday, the Rickey workshop was its own little empire in the woods. In that quiet corner of Columbia County, it was a scene of constant motion—of staff coming and going and of multiple sculptures under construction and arrayed around the property, rocking and playing to the wind.

After Rickey died, in 2002, the house remained furnished but uninhabited. Much of the land was sold off, while a skeleton staff continued to work on the grounds and in the workshop. By the time Murdoch and Hall came by in 2016, there were just a few sculptures scattered around what was left of the estate.

The couple's intention had been to add to their private art collection in Los Angeles, but Murdoch abruptly changed course when he caught sight of Rickey's last major work, the spectacular *Annular Eclipse*. In a high field with a view of the Taconic Range in the distance, a pair of stainless-steel circles focused the view of the distant hills like an enormous lens. Murdoch was now envisioning his Midtown office building in the heart of corporate America: "It's going to stop traffic," he predicted gleefully.[2] Officially handling estate sales since 2009, Marlborough Gallery brokered the deal, and the sculpture was Murdoch's in time for Christmas.

While permits for its installation were under review at New York's City Hall, another process was in the works upstate. Studio assistants dismounted the sculpture from its post in the field, took it apart, changed all the hardware and the ball bearings of the rotating arms, and cleaned away the moss that had gathered over eighteen years in its natural setting.

❉ ❉ ❉

IN A major historical survey of American sculpture at the Whitney Museum of American Art in 1976, Rickey was hailed as "the major spokesman of kinetic art."[3] His work was by that time well known. His duets and trios and quartets of moving blades, planes, and circles were prominently displayed in museums and public parks and at college campuses and corporate headquarters around the world. When he died, the *New York Times* called Rickey "one of two major twentieth-century artists to make movement a central interest in sculpture. Alexander Calder, whose mobiles Mr. Rickey encountered in the 1930s, was the other."[4]

Although Rickey's work would forever be associated with Calder's, it was unmistakably his own. Calder opened the door, he would say, but he soon wondered "if Calder had said it all."[5] Through the door that Calder opened Rickey ventured on, adding sophisticated engineering and a multitude of forms to the basic idea of moving sculpture while reducing the concept to a study of movement itself. While Calder's colorful mobiles bobbed and turned, Rickey's kinetic sculptures achieved complete rotation, multiple variations of the pendulum, and the disturbing, joyride effects of conical movement. He produced more than three thousand works, from small indoor pieces for the private collector to hundreds of major outdoor installations.

Rickey was ultimately an artist for the public. His work was intellectually refined, but it was also eminently accessible. It called attention to itself, but even more than that to the atmosphere around it. It sculpted the air with its movements; it defined the invisible wind. Nature, Rickey would say, was not his subject; it was "a partner or collaborator."[6] His mature work, constructed of cool geometric forms in monochrome stainless steel, is deliberately lacking in imagery of any kind. It was the shape of its movement that mattered, he said, and that was all. As Hayden Herrera wrote in 1985, Rickey "explores a counterpoint of visible and invisible geometry in constructions that are as simple and straightforward as Shaker tools, but as mysterious in their implications as God's compass in medieval images of Genesis."[7]

Despite Calder's example, Rickey discovered at an early stage of his journey that he was "working in a rather lonely idiom," but for a period in the 1960s he found company in that lonely field in great variety, joining a younger generation of mostly European artists in a quest to break away from the dominance of postwar painting.[8] At that point he became a defining figure in what the artist Hans Richter coined the "movement movement." He was center stage in a wild ride, a pillar of reason and rationality amid a mad decade. Perhaps more succinctly than any other artist of his time, Rickey articulated a late-Modernist convergence of equal parts art and science. Yet while his work enjoyed many years in the limelight, his unique contribution to the vocabulary of modern abstract sculpture has dwelled in the shadier groves of modern art history. He was highly informed and actively engaged in the art world of his time, but in the long run, he was a lone star in a galaxy of overlapping and conflicting trends.

Though much has been written about Rickey's work in sculpture, little has been studied of his life and career in the wider context of the twentieth-century art world and the leading figures and movements through which he navigated—from his student days at the Ruskin School at Oxford to Paris in the 1920s, from Depression-era America to the disruptions of World War II, from the rise of New York as the world's art capital at mid-century to the tumultuous 1960s, when he first emerged as an international figure. His sculpture, always an expression of balance and tension, uneven structures and counterweights at play with one another, also expressed, though he never said so, the dual forces of his personality and personal relationships in abstract form.

He was fond of citing the mythological figures of his classical education by way of explaining the twists and turns of his life. "Chance, quite possibly, outweighs inspiration in an artist's life," Rickey admitted in the heyday of his success. "The Greeks invoked the Muse, but there was also Fortuna."[9] He considered himself at least as fortunate as he was inspired. As deliberate as Rickey was by nature, he also actively

embraced the role in his life of chance. Chance was integral to his wind-powered sculpture, but so was Fate in its limitations. Another ancient myth he was fond of citing was that of the three Fates of Roman mythology: three old women weavers—one who spins, one who measures, and one who cuts.

At the measuring stage of Rickey's career, in the late 1940s, when he turned from painting to sculpture, his second marriage, to his much younger wife, the vivacious Edith Leighton, made for a power couple soon to be well known in the art circles of New York, New Orleans, Berlin, and Los Angeles. In the full-time management of her husband's career and reputation, Edie was the exemplary woman-behind-the-man of her era. Many would say that he would not have achieved his success and fame without her devotion as his tireless executive secretary and unforgettable hostess. She towered over him physically at her full six feet and overshadowed him socially as the artist's wife.

Successful as it was, their collaboration was not without conflict. As Rickey's popularity accelerated in the 1970s and a growing number of assistants joined him in his upstate New York workshop, the innocence and adventure of earlier days was lost in the headlong race to meet the demand for his work, and the strain on his marriage and family emerged in the background of his well-managed public profile.

Fortunately for us, both George and Edie Rickey were masters of the dying art of personal letter writing. From the time he learned to write to his final halting days, George penned his thoughts, impressions, opinions, worries, and emotions to his friends and lovers and his wife and family. We can read, therefore, in real time rather than in retrospect what he witnessed and experienced in clear, complete sentences, with a richness and immediacy nonexistent in any other form. Edie, also a voluminous correspondent, created a flowing, action-packed newsreel down to the last detail, with generous helpings of humor and emotion. When George and Edie were separated by oceans and continents, they volleyed air letters back and forth like

two private diaries in conversation, with their differences of character along with their mutual devotion to the cause in high relief.

THIS IS the story of an American artist who was never entirely American, a sculptor who was for many years a painter, an artist who was at least as much a teacher, a critic as well as an historian, a man who in all his ninety-five years never really settled down. Rickey was ambidextrous, literally, and metaphorically. The grandson of a judge on one side and a clockmaker on the other, it was his two sides—one that creates while the other observes, one that stands by while the other takes off—that made his sculptures a riveting study in balance. This is a story of a life style as much as a life, of a marriage as well as a man.

What are the origins of an artist's inspiration? What encourages the artist to strike out on his own, to reject the safer worlds of the more traditional vocations? It is only in retrospect that the artist, or we, can say. In Rickey's early years, it was the tinkle of glass wind chimes over a neighbor's door, the anvil of the blacksmith shoeing a horse, the crank of a casement window, the pedal of a sewing machine, and the stiffening of a sail in the wind. "Childhood," he wrote at the other end of his life, "is a time of discovery. The 'second childhood' of the elderly is, in art, *still* a time of discovery—something new every day, not only between the front door and the garden gate, as Emerson saw it in Concord, but at the point of the burin, at the contact of the brush with the canvas, or the blade of the chisel with wood or stone, or *now*, the torch cutting steel, the wheel grinding away metal. These combat areas are not for children; they are where the battle's lost or won, and where all the resources of a lifetime are thrown into the fray."[10]

2

A Scottish Childhood

"WHAT CAN one really recall from childhood?" George Rickey asked himself in later life.[1] In his case, most of those recollections would be based in Scotland, where his family moved from South Bend, Indiana, when he was five years old, in 1913. Certain early memories made their indelible impression. He remembered arriving in Glasgow on the T.S.S. *Caledonia* on a stormy March day, the deck awash with water right up to the cabin windows, and his delight as piles of crockery crashed to the floor of the trembling ship. It was cold and rainy when they disembarked onto the dock, and he wondered, a few days later, if the sun they had left behind in America would ever come out in Scotland.

His father, Walter Josiah Rickey, had been hired to manage the Singer Sewing Machine Factory in the industrial waterfront town of Clydebank, eight miles west of Glasgow, on the Firth of Clyde. At that time Singer was the world leader in the manufacture of sewing machines, and the Scottish outpost of the American company was the largest in Europe. As a busy port city with iron foundries and a skilled,

low-cost labor force, Glasgow made an ideal location for Singer's European expansion in 1867. Those were boom years for the industry, and also for Glasgow as a major industrial port known for shipbuilding. As demand for its product grew, in 1882 Singer broke ground for a gigantic modern brick factory on forty-six acres in Clydebank, soon to be the biggest in the world and yet not big enough. By 1913, when the Rickeys arrived, the Clydebank plant had expanded to more than a hundred acres and doubled its production, reaching its all-time peak. That year the factory shipped 1.3 million machines and still could not keep pace with the demand.

Nor could it stay abreast of the growing unrest among its fourteen thousand employees, whose workload had grown without a comparable rise in their wages. A change of leadership was urgently needed. The previous manager, an American named Franklin Park, was a shrewd administrator but he appeared aloof and indifferent to the day-to-day life of his workers. Walter Rickey, who had successfully managed the Singer branch in South Bend for the past eight years, seemed just the man to deal with the present crisis. A buoyant and sociable character then in his early forties, with management experience and engineering expertise, Rickey promised to usher in a new era.

Pulling up stakes in South Bend for an unknown number of years in Scotland was not a simple matter for a family of seven. Walter and Grace Rickey had five children, and a sixth would be born in Scotland. Elizabeth and Emily were the eldest two, George was their third child and the only boy, with Jane, Kate, and finally Alison, who was soon to follow. George later said that he "suffered from a surfeit of sisters," though as individuals he was quite fond of them all.[2] Furthermore, as the only boy sandwiched between both older and younger female siblings, he developed a natural respect for women from an early age.

In the midst of preparations for their move and with another baby on the way, the Rickeys sent George to spend the winter with his paternal grandparents in Athol, Massachusetts. George's grandfather

George Warren Rickey was the town watch- and clockmaker. George remembered observing him at his workbench by the window overlooking the main street, cleaning and repairing the watches of Athol. Every Sunday he wound the clock in the steeple of the Congregational church, a towering white edifice in the heart of the village across from the town green, and George was allowed to follow him up the narrow stairs into the bell tower to watch him wind up the weights.[3] Though George was too young to attend school, he got an early education of another kind, one that never left him. His grandfather invited him to take apart a Swiss clock with wooden gears and then put it back together again. Although this was an insurmountable task for a five-year-old, George was not spoiled by the challenge. It imbued in him an appreciation for mechanical structures and the intricate handwork that went into their making as well as a fascination with that ancient clockwork device—the pendulum—that he would employ years later in his modern kinetic sculpture.

Before departing for Scotland, in March, the family also visited George's maternal grandparents in Schenectady, New York, where his mother, Grace Landon, grew up. Her father, Judson Landon, was a judge on the State Supreme Court, and they were a prominent family in the city. Their big Victorian house was in the heart of town, across from Union College, where Judson Landon was a trustee and at one time acting president. Grace's mother, Emily Landon, was a school-teacher. She also held drawing classes and seems to have passed along a genetic strain of artistic talent that became evident in all the Rickey children and several of their cousins on the Landon side as well. Grace had traveled to Europe as a teenager, and had visited the Louvre and the Sistine Chapel, but she was ultimately more interested in literature than in art. An avid reader, she was among the early graduates of Smith College. Although her education was firmly in the humanities, she was politically progressive and, as the judge's daughter, inculcated early on with a sense of civic responsibility.

Walter Rickey, the son of an artisan, came from a modest

background, by comparison. But as a bright, ambitious, and practical young man he was determined to rise above his small-town background and had earned a degree from the best technical school in America, the Massachusetts Institute of Technology. Working at his first job as a mechanical engineer for General Electric in Schenectady, Walter met Grace Landon and in 1901, after a brief courtship, the two married.

In 1904 Walter was hired away from General Electric to be assistant plant manager of the Singer factory in South Bend. Three years later he was promoted to plant superintendent. On that strength, Walter and Grace bought an attractive 1882 Italianate house on shady West Washington Street and renovated it to the latest modern conveniences in 1907, the year George was born. His memories of South Bend were scant, as were those of his parents' respective hometowns, Athol and Schenectady. But these familial scenes would remain key places on the map of his early childhood, even though he would not be visiting them again for many years.

SOON AFTER arriving in Glasgow, the Rickeys found their home in a house called Rockfort in the attractive seaside suburb of Helensburgh, a comfortable twenty miles west of the Singer factory in industrial Clydebank. Tucked away from the Clyde Road down a tree-lined driveway, the house was a small, gabled Victorian made of stone, with high ceilings, a wide stone staircase, and ample windows. Rockfort was aptly named—it perched right on the edge of the rocks above the water, a fortress of safety from the elements that lapped at its door.

The principle of "ladies first" prevailed in the Rickey household and meant that George was in line for the smallest piece of cake; however, his status as the only boy also awarded him a room of his own. On the second floor, it overlooked the wide tidal River Clyde, with a view to the shipyards on the far side with its glade of cranes to the seaweed-covered rocks right below his window. To the west he could

see a few miles up the wide Gare Loch, where expensive steam yachts dropped anchor and the ferry made the half-mile crossing from Rhu Point to Rosneath. To the east he could see farther down the Clyde to the busy Craigendoran Pier. He learned to interpret the calls of nature as they whipped around the house, as well as the various sounds of the steamships that brought workers up the river to meet the trains for Dumbarton and Glasgow, and could tell which one was passing by without leaving his bed. "I believe I could tell by the sounds whether it was the *Lucy Ashton* from Gardochhead or the *Waverly* or the *Dandy Dinmont* from Dunoor," he recalled.[4]

Every workday morning Walter Rickey was up early to catch the "strivers" train, which left at eight o'clock from the Craigendoran station. The service was created for the thousands of employees who commuted to the Singer factory in Clydebank. Meanwhile, the Rickey children would be off to school. The girls went to Saint Bride's, a private day and boarding school for girls in Helensburgh, which George later appraised as a "really very good school," and George went by himself to Miss Johnston's primary school for the local gentry's sons and later to Larchfield, a "fairly good" prep school for boys.[5]

At Miss Johnston's he was discovered to be left-handed and had his knuckles rapped until this trait was drummed out of him. At Larchfield, he was given a solid grounding in arithmetic, algebra, physics, and chemistry, as well as Latin and French. The students wrote their lessons with scratchy pen and ink. Each desk had an inkwell, which often dried out and sometimes froze.

A Miss Baxter taught a drawing class, where the emphasis was on the faithful reproduction of inanimate objects and correct proportion and perspective, and George won prizes for his precise renderings in pencil of daffodils in jars. More academic than inspiring, George remembered his early drawing classes at Larchfield as "a kind of obedience exercise."[6]

It was a long walk from home to school, and especially so during a Scottish winter when the trip in both directions had to be undertaken

in the dark. Occasionally George rode a bicycle to school, lighting his way with a little oil lamp attached to the handlebars. On some winter afternoons he would encounter the lamplighter on his rounds, follow him as far as he could, and delight at the sight of him sticking his pole into the streetlamp and giving it a bit of a poke until "the gas flared and the mantle glowed." Another fascination was the blacksmith's shop on Clyde Street, where he witnessed the making of a horseshoe out of a bar of iron, watched the blacksmith pump air into his fire until the iron was hot enough to bend it into shape, and marveled at how adeptly he handled the pointed tool in his left hand and a hammer in his right to make the holes for the nails. The blacksmith would then lift the horse's leg and fit the shoe, still hot, to its foot. It "sizzled and smoked as he pressed it on the hoof and I wondered that the horse did not feel it."[7]

The horse and carriage was still a familiar sight on the streets of Helensburgh in those days, and the motorcar was a luxury few could afford even in that well-to-do community. The Rickeys did not own a car for the first ten or so years, until Walter Rickey bought a secondhand Packard straight eight with two fold-down seats, making it an ample carriage for the whole family. It was often reluctant to start without a good deal of cranking the motor and fiddling with spark plugs, especially on a damp morning, but "once running it was a wonderful car," recalled George,[8] and made for exciting excursions into the highlands. One Christmas Walter Rickey bought a phonograph, still a great rarity at the time, which also took winding up to operate. George remembered the exciting novelty of listening to Italian opera singers like Caruso right in their own living room and, later, ragtime.

IT WAS taken for granted by all concerned that the only son of Walter Rickey would follow in his footsteps and grow up to be an engineer. George himself had no doubt about it. His training began at home. When he was seven or eight years old, his father gave him a little

steam engine, disassembled, for Christmas. He then watched, fascinated, as his father put the pieces together and made it run. From this demonstration he became familiar with the principles of steam power. Once he was old enough, whenever he was aboard a steamship he would boldly ask to visit the engine room in order to watch "the huge version of what my father had assembled for me go through its gyrations."[9]

Visiting the Singer factory with his father, George was exposed to another kind of machinery along with the craftsmanship of the workers there, each with his own particular skill. He watched the forming of sand molds and the casting of molten iron, the machining of steel parts on a lathe, and also "the quite complicated process of making a sewing machine needle out of a piece of wire cut from an ordinary coil."[10] George learned the basics of running the sewing machine—threading the machine, adjusting the tension, and joining two pieces of cloth. He was capable of sewing on a button, and rather enjoyed the challenge of dead reckoning with the needle that it entailed. His sisters, on the other hand, learned the more advanced technical skills such as hemming, tucking, and quilting, and were familiar with all the special attachments that these involved. It was part of Singer's highly successful sales strategy to offer lessons to women of all ages in the use of their machines that helped to make owning and operating a Singer sewing machine as popular and intuitive as riding a bicycle.

While learning to sew, George was beginning to draw and paint, and so were his sisters. They all showed a native talent for art, no doubt inherited from their maternal grandmother. Grace took her children into Glasgow to visit the museum and art gallery in Kelvingrove Park, but at that stage George was more interested in the model ships and machinery on the ground floor of the museum than in the pictures upstairs. Talented as he was at drawing, the idea of becoming a professional artist was utterly foreign, "not for practical people the likes of us," as George later described the family attitude, which had much in common with that of the average Scot. As Rickey later reflected of

those days, "Britain simply had a slower pulse for all but the literary arts."[11]

There was in their midst, however, one of the leading art schools of that time: the Glasgow School of Art. A recently completed building designed by Charles Rennie Mackintosh and completed in 1909, further advanced its reputation as an important school of art and design. Generally regarded as Mackintosh's masterwork, the building was both highly functional and uniquely aesthetic, boldly integrating architectural details from the turreted baronial castle style to a factory building and juxtaposing the austerity of local stone and iron with the warmth and refinement of the woodwork inside.

By the time he was designing the Glasgow School of Art, Mackintosh had already distinguished himself with an important private commission. In 1902 Walter Blackie, of Blackie and Son, a successful Glasgow publisher of quality books, commissioned Mackintosh to design a large suburban house in Helensburgh. His uncle Robert Blackie had set a precedent for engaging the best of contemporary architects and designers for the publishing company buildings as well as for its book designs. For the Walter Blackies, Mackintosh designed Hill House, set high on the steep slope of Helensburgh overlooking the Clyde. With its white-stucco rendering of the exterior walls, slate roof, small windows, and round towers, it resembled a traditional sixteenth-century Scottish tower house.

But inside, the world of Mackintosh prevailed to the smallest detail in lighting fixtures, skirting board, textiles, stenciled wall decoration, built-in furniture, tableware, and tilework. In its strict conformity to its unique aesthetic and in the absolute absence of clutter, the house had a certain austerity. Still, the Blackie children grew up with a feeling of informality and comfort inside their work of art.

As families of prominent businessmen in the neighborhood, the Rickeys and the Blackies were on friendly terms, and Grace Rickey became a regular at Anna Blackie's bridge parties. Though the Blackie daughters were a bit older, George remembered accompanying his

mother to the unforgettable Hill House and playing in the garden while his mother was at her ladies card game in the drawing room. Another early exposure to Mackintosh was the special treat of going to the Willow Tea Rooms, on Sauchiehall Street in Glasgow. This was the third establishment of the entrepreneurial Catherine Cranston, the daughter of a tea merchant, a staunch supporter of the temperance movement, and a well-known figure around town. The Willow Tea Rooms were also designed down to the last detail by Mackintosh, with its signature ladder-back chairs, which commanded an upright posture and from which young George gazed with admiration at the paintings of flowers by Mackintosh's wife, Margaret Macdonald, that decorated the walls.

WHILE GEORGE and his sisters were growing up in Scotland, their father was the energetic manager of that country's branch of the Singer company, boldly leading it in new directions and involving himself with every aspect of the company's life and activities, including the design of the machines themselves. Among his first tasks was to address the hazardous conditions of the workplace, which he remedied with exhaust ventilation in the dusty cabinetmaking division of the building, mechanized dippers and spraying machines in the paint shop where before the workers had used their bare hands, and improved safety guards in the dangerous power press department.

In addition, Rickey created all kinds of recreational programs to enhance the lives of the workers and their families beyond the factory walls, and commissioned a communal hall and sporting grounds for that purpose. The influence of Grace Rickey in these efforts was undoubtedly strong. Grace, said George, was "as near to being a socialist as the wife of a rather prominent industrialist could be."[12] Grace was Walter's conscience. She was concerned about the well-being of the workers in every respect, including the value of community spirit. For Singer workers of the Rickey era, there was something for

everyone, from badminton to bowling and golf, from a chess club to a ladies sewing club, a literary society, a horticultural society, an orchestral society, and a pipe band. The Rickeys presided over the annual gala and the crowning of the Queen of the Fair, and never failed to show up at Singer's festival week, ending with the ceremonial awarding of prizes.

Walter Rickey also introduced paid leave for pregnant women. Apparently it was not for nothing that Grace corralled him into joining her at suffragette meetings in Glasgow.

Just two years into his tenure, Walter Rickey was dealing with another crisis altogether. The Great War, beginning in 1914, created the urgent need for munitions, and factories all over Britain suspended their normal production and converted their machinery to make them. The Singer factory was no exception. Nor was it immune to the loss of its men in the war. Almost three thousand Clydebank employees served with the armed forces, of which four hundred and eleven died, each one commemorated on a copper tablet at the factory's main entrance.

As a boy in wartime, George watched the searchlights sweeping across the Clyde at night while the windows of Rockfort were blacked out to hide from German warplanes. The Clyde estuary was closed to thwart enemy submarines with a huge metal net hanging from a boom. The familiar boats of all sizes that George had come to recognize were pressed into service, and he recalled the shock of seeing the RMS *Aquitania*, the luxury ocean liner built in Clydebank, requisitioned during the war, in camouflage. He also experienced the dismal reality of wartime food rationing. Children were required to bring their meat coupons to school lunch, and if you were lucky enough to have one, the headmaster of Larchfield knew how to carve a piece of meat "so thin you could see through it."[13]

<p style="text-align:center">✻ ✻ ✻</p>

WALTER RICKEY was a busy man and, as a result, an often absent father. But there was one family activity for which he was always and vitally present and that formed the strongest bonds of familial love, and that was sailing. With the Clyde at their doorstep and the western isles beyond, there was a perfect opportunity to indulge his passion and instill the same in his wife and children. After the war, he kept a thirty-eight-foot cutter, the *Thora*, at the dock at Rhu Point, and George recalled the family's first long cruise on their new yacht up the west coast of Scotland when he was about nine years old. Through a canal at the Mull of Kintyre, the *Thora* passed into the open water and away from the looming ships on the Firth of Clyde. It was, "for us children," George remembered, "like going abroad."[14]

With these sailing expeditions, George became intimate with the water and the wind and the movements of the boat—pitch, roll, and yaw—that would inform his art in years to come. In addition to trimming the sail and navigating the locks, George and his sisters learned to clean and light the little paraffin stove to cook breakfast: first the porridge, then the herring or mackerel they had netted themselves. Life aboard the *Thora* for a family of eight was crowded, but it was also cozy. At dusk, Grace Rickey would read aloud to her children by the light of an oil lamp set on a gimbal, swinging with the movement of the boat but weighted with lead so that it was always upright. Some days the wind was brisk and all young hands were on deck to stay the sails and come about. Other days a light breeze fell to calm in the late afternoon, and they would lower the dinghy and tow the boat to its mooring. "Perhaps it was on those long tiring tows that I learned that a little progress is still progress," reflected George years later, "that often there is no choice but to be patient and persistent, and that much can still be done by hand."[15]

3

Glenalmond

As GEORGE entered his teenage years, two important changes—of home and of school—reshaped his world. The first was the family's move from Rockfort to a much larger house in Helensburgh called Clarendon. The Singer Company had acquired the house as a residence for the Clydebank manager, and with the long-awaited departure to New York of former manager Franklin Park to become vice president of the Singer Company, in 1921 Clarendon was made available to Walter Rickey and his family.

This Victorian mansion was in the smartest part of town, with a two-acre garden on the slope of a hill overlooking the Clyde. "I think we were never as suited to it as the rambling but more intimate scale of Rockfort," George said.[1] Whereas at Rockfort he enjoyed climbing trees and gamboling on the lawn and his sister Elizabeth spent many happy hours reading in the crook of a pear tree, the fashionably planted grounds of Clarendon, with clipped yews and giant sequoias, did not lend itself to lounging or playing outdoors. Whereas at Rockfort the Rickeys kept chickens and harvested much of their fresh fruit

and vegetables from their kitchen garden, once they moved to Clarendon Grace Rickey sat at her desk in the "morning room" and ordered groceries over the telephone from the grocer, the fishmonger, and the baker, to be delivered by a boy to their door. A small staff of servants—table-maid, housemaid, and cook—kept the house and kitchen in order, and recreation moved indoors.

At Clarendon there was a billiard room with leaded-glass windows, a music room on the second floor, and a huge drawing room with brocaded walls and a polished wood floor grand enough to host a small dance of Scottish jigs and reels as the elder Rickey girls entered their coming-out years.

Among the advantages of the family's move to Clarendon was its position practically next door to Saint Bride's School, where all five Rickey girls were enrolled. But George's preparatory school, Larchfield, came to an end for boys at the age of fourteen, so further education had to be sought elsewhere. Although there were other private day schools for boys in Glasgow, his parents decided that the best option at that juncture was to send their only son to boarding school.

While for the sons of British nobility and wealth, the public schools of choice were Eton and Harrow in southern England, an acceptable alternative for the Scottish well to do, and much closer by, was Trinity College, Glenalmond. About fifty miles northeast of Glasgow, in the barren hills and moors of Perthshire, Glenalmond was small, with just one hundred forty students, but growing. Boys from Helensburgh of the Rickeys' acquaintance had gone there, and it was deemed as good and suitable as any other school for miles around. And so George was enrolled in September 1921.

The former prime minister William Gladstone, who was of Scottish descent though raised and educated at Eton and Oxford, had established Glenalmond, in 1854, as an Episcopal school modeled on the English public schools. The campus buildings, a subdued but convincing Victorian display of Gothic revival, set a tone unusual in Presbyterian Scotland. At the center of the campus stood the chapel,

an impressively large building with a vaulted timbered ceiling, stained-glass windows, carved wooden doors, and linen-fold paneling. Here the school community assembled every weekday for the ritual morning prayer—a psalm, a lesson, and a hymn—and every night for evensong. Among the first shocks of George's entry into student life at Glenalmond was to discover how much singing he was expected to do on a daily basis, beginning with the school hymn in Latin.

There were other more painful shocks in store. The school morning began with a brutally refreshing exercise known as "the wallows." George remembered standing in a line of naked, shivering boys on the stone staircase for his turn at a ten-second dunk in a cold bath— held by his underarms, submerged in the water with the tap running full force, and then released to hurriedly dry and dress before roll call. Bodily warmth was a luxury at Glenalmond that George was soon to appreciate as never before. Hot baths were rationed to once a week, and the warm foot soak in the changing rooms after games were "an intoxication."[2] As a defense against the cold stone buildings of the school, each boy was issued a blanket, known as a "rug," to be used as a cushion on a hard chair or to tuck around his lower half, like a kilt. Still, many students at Glenalmond, as at many other British boarding schools at the time, came to accept that chilblains, a painful swelling of the toes and fingers, were part of life.

Breakfast was a bowl of porridge; lunch and dinner were hardly more exciting. "The worst day's dinner of the week is Sunday!" George wrote home to his sister Kate. "[W]e get soup—the only hot item—cold potatoes, aged cold meat, and cold pudding."[3] It was more or less taken for granted that care packages would be sent from home to make up for the limitations of the Glenalmond diet, and George was grateful for regular shipments of salted peanuts, tinned sardines, and his sister Emily's homemade toffee.

Though at most hours of the day they were not evident, rats were everywhere at Glenalmond, that oasis of shelter and food in the middle of nowhere. They lived underground and behind the walls, and

crept out at night to forage for biscuit crumbs inside the pockets of the schoolboys' tweed jackets, leaving the telltale line of nibbled holes. Amid the dead quiet of an evening study hall, a rat might venture out from behind the steam pipes. Then the boys would watch with rapt attention as the presiding prefect reached for one of his selection of heavy objects he kept on his desk for the purpose, set aim, and hurled it at the tawny creature, which always got away.

Modern memoirs such as George Orwell's *Such, Such Were the Joys* and Roald Dahl's *Boy* provide testament to life at British boarding schools as Rickey knew his, and ample proof of the bullying that was endemic to all of them. "The worst feature, and the most indelible, of Glenalmond," George recalled, "was the sanctioned brutality of the slightly older boys against the new arrivals."[4] At his dormitory, called Goodacre's, his home for the next five years, just after the evening study hall each new boy was made to stand on a table and sing something—anything—to the older boys. Terrified as his turn approached, George managed to come up with a little verse from his childhood, after which he was allowed down from the table to a chorus of jeers and a hail of books and other projectiles. Later came regular poking, pushing, and beatings on the rear end with a ruler and on the head with a dictionary. Another favorite exercise was to push the new arrivals, bare-bottomed, against the hot steam pipes. And as a "fag" assigned to an older boy, George endured the humbling role of lowly servant to his master along with the rest of the newcomers.

Even with this dark and primitive aspect of schoolboy behavior, there was the flip side: In speech, politeness, and formal respect for their elders (every fifth word, in talking to a master, was *sir*), the boys' manners were impeccable. There was also a certain code of behavior that George would never forget. This was "the strength of the code that kept us from whimpering or protesting or retaliating, and from telling." Likewise, there was a strict standard of confessing the truth of their misdemeanors to their masters, whatever the cost. The evasion of this showed a weakness of character, more difficult to bear than

the most painful session with the master and his strap or cane. Here a hapless boy was stripped to his undershirt and instructed to bend over a chair and grasp its back legs to receive the requisite number of strokes to his thinly covered back. "Victims were examined afterward by their fellows, and appraisals given," remembered George; "in the showers, after Games, the incidence of punishment was evident to all."[5] The more pronounced the scar, the more respect it elicited for the chap who was brave enough to do the wrong, and all the braver to confess it.

George came in for at least one beating. His survival instinct turned this into a study of the offending weapon with the cool detachment of an engineer. The "canes," he learned, "were not bamboo but supple Malacca, sold in bundles by educational suppliers. They were about four feet long and a little thicker than a pencil, bent to a hook at one end so that they wouldn't slip out of the beater's hand."[6]

Glenalmond also reinforced notions George would have already been well acquainted with at Larchfield School—namely, that the sun never set on the British Empire, that Britain ruled the waves and perforce the world, and there was a reason for it: The British were superior people. "Fortified by this unshakeable certainty," George later reflected on the British national character, "it was possible to indulge convincingly in understatement, muddling through, stiff-upper-lip fortitude in the face of disaster, and 'losing every battle but the last one.'"[7] As an American, George might have remained circumspect about this assumption, but he was trained to the part. As a teenager, he would have easily passed for a middle-to-upper-class Scot, with his Anglo-Saxon features, his British inflection, and his use of public school slang such as "toff" and "ripping." Like his sisters and unlike his parents, he was British-raised. Yet he was not by birth or upbringing one of them and knew that he never would be, and therefore carried inside himself a kernel of doubt about their birthright, an American regard for this attitude that was bred in his very genes.

George survived his first year at Glenalmond with the help of letters

and packages from home and the friendship of classmates, especially his roommate, John Snodgrass, who was also from Helensburgh. The academic work was well within his grasp, and sports were a welcome break from the classroom. He discovered his strength in athletics: First he boxed, to his amazement outwitting a bigger and older boy, and then, lacking sufficient competition, took up team sports for the duration. By his senior year he was captain of the cricket team, and for two years he played with the top fifteen at rugby. Further physical activity was the officer training corps that every boy at Glenalmond was required to join for a season. Aside from a good deal of calisthenics, the boys learned how to care for and use a Lee-Enfield rifle and how to read a map, and they marched, sometimes in full dress: tartan kilt (Murray of Athol), tartan stockings, and "pity the boy who had mislaid his Glengarry Cap."[8]

Like most boys schools in those days, Glenalmond did not value the visual arts as an important part of the curriculum, but there was the token art class conducted by Henry W. Daniel, whose formal portraits of the school wardens lined the walls of the dining hall. Once a week Daniel came all the way from Dundee to teach a class in drawing. These took place in the gym—there was no dedicated studio space—and in fair weather they moved out of doors. Here the boys took full advantage of their freedom from the classroom, spread out into the bushes, and made a lark out of dropping their stools into the rushing River Almond and then having to run and fetch them downstream, so that Mr. Daniel would have to spend much of the brief session tracking them down. Cultivating his innate gifts at draftsmanship was a pleasure for George, and he enjoyed drawing classes, but he was among the very few, if not the only boy in his class to take them seriously. He asked for and was granted "extra drawing," though it was hardly enough to satisfy. "The lessons are only supposed to be an hour long," he wrote home to his mother, whose approval he could have counted on, "but I go early and get about two hours and a quarter. I have done a picture in pastel of the Mill."[9]

<center>* * *</center>

ANOTHER TEACHER at Glenalmond was to make the deepest impression on George's outlook at boarding school and indeed for the rest of his life. This was George Lyward, a passionate educator in his late twenties when in 1923 he arrived at Glenalmond, and it was Rickey's good fortune to have been there during the young teacher's four-and-a-half-year tenure, and furthermore in his prime. It was Lyward who nurtured his interest in history, inspired him to teach, and ultimately endowed him with the sense of adventure to become an artist.

George Lyward's arrival at Glenalmond was part of a general expansion of the school's student body and program. When Rickey entered, in 1921, the school's warden, or headmaster, was the reverend Sydney Ernest Longland, who had sought to raise the academic standard of the school with selective enrollment and an entrance examination, but otherwise did not strive for much change or improvement. In 1923, when George was in his third year, Canon Frederick Matheson, an alumnus of Glenalmond, succeeded Longland and began a period of significant growth and modernization.

Under Matheson, the student body grew from one hundred forty to two hundred, and buildings and playing fields were enlarged accordingly (and so were the systems—as George reported to his father, there was a new water turbine at the mill, a new oil engine, "and they have doubled the voltage").[10] It was Matheson's belief that the boys should be constantly occupied with sports and other extracurricular activities outside of the classroom. George Lyward, a graduate of Saint John's College, Cambridge, had much to offer in this regard. A man of multiple talents and enthusiasms, he taught English and history, directed plays, and coached rugby. As a tutor he was in charge of the "Modern Sixth," a curriculum for those aspiring to university that substituted modern languages for Greek and Latin and modern history for science. As a housemaster of the new era, Lyward embodied the values

that Matheson espoused, and provided emotional support in measure equal to the academic.

This newcomer was an object of immediate curiosity, both for his youth and his striking appearance. He was tall and thin—almost skeletal—with an angular face and big brown eyes, and his every movement quivered with urgent intensity. He was musical and also theatrical, talents he inherited from his father, a minor opera singer who abandoned the family early on. Lyward's passion for teaching can be easily traced to his mother, who, in addition to raising three children by herself, taught at the local primary school. Physically frail from an early age, the result of polio, Lyward strove to overcome his handicap and had pushed himself to play rugby.

The trials of his childhood made Lyward an unusually progressive and sensitive master. Instead of teaching by rote, typical of Rickey's previous school experience, Lyward turned every reading assignment—whether in English or in history—into a subject for debate and also self-discovery. He urged his students to question assumptions, to be more interested in the journey than in the destination, in feelings than in facts. Indeed, Lyward seemed to cast every subject in a new and interesting light, breathing life into dead poets and playwrights, and he made the study of history as dynamic as the moving parts of an engine that had fascinated George at a younger age. He taught his students to look at every side of a situation, to compare opposites and hold them side by side, and only after rigorous study of their differences to reach a conclusion. *La vérité consiste dans les nuances* was one of his many oft-quoted aphorisms. In the words of Rickey's friend Snodgrass, Lyward constantly pushed his students "to question the obvious."[11]

In every sense, Lyward was a demanding teacher. Give all you can and then give some more, he would say, turn the screw a little more. He invented an acronym for this effort—"Mobeb—"My Own Bloody Extra Bit." Although strict, he was never reproachful, and while he pressed his pupils hard for results, he also forgave. He advocated

teamwork, whether on the stage or the playing field, and encouraged the boys to fearlessly criticize one another as part and parcel of being an effective team. He tolerated no evasion or bluff, and he set an example in himself that could not be denied. As coach and teacher, he never let up. He ran play rehearsals with a whistle, insisting on voice projection and clear pronunciation, that no precious word of the playwright, whether Shakespeare or a lesser mortal, might be lost.

With Lyward as director of school plays, George found himself willing and even capable of important roles he would not have thought possible before. He was MacDuff in the school's *Macbeth* and a convincing Snout in *A Midsummer Night's Dream*. In Oliver Goldsmith's *She Stoops to Conquer*, he had the important role of Tony Lumpkin, an awkward but sympathetic character who rebels against his domineering mother, which by all accounts he performed courageously.

Early in his career as a teacher and before coming to Glenalmond, Lyward discovered his ability to reach the minds of troubled and difficult boys. At sixteen, George Rickey would not have appeared outwardly to be a troubled adolescent, but Lyward apparently perceived in him an intellectual and artistic urge, latent talents that merited bidding forth, and a structure at home that had repressed them. In 1923, the year when Lyward arrived at Glenalmond, George was beginning to think about what he would do after graduating. Until then he had felt no need to question the idea that he would go on to a technical school to study engineering, hewing to the example his father had so clearly set before him. As George wrote to his father in his third form year, he planned, after leaving Glenalmond, to work for one or two years "in a machine shop, or something like that" as a way of deciding which branch of engineering he should follow.[12] But Lyward had taught him to question assumptions. As the two enjoyed long rambles in the countryside or talked over a hot cup of tea, Lyward also sensed in George Rickey a real interest in the humanities, and a talent for them as well. Psychologically astute, Lyward was careful not to directly advise him about his future course of study; rather, as he did

in teaching, he laid out the options, leaving his young friend to grapple with the questions for himself.

By the early spring of his fifth-form year, George had changed his mind about his future. Lyward had opened a door to a bigger world that led him to question the inevitability of a career in engineering he had for so long taken for granted. The only problem was, as George confided in his master, he was "more and more shy of speaking out at home."[13] Did the estranging years at boarding school make expressing himself at home more difficult than ever before? But with Lyward on his side, he was now armed with the moral strength necessary to stand up to his father for the first time in his life.

In late March 1925, George wrote to his father unequivocally that he was no longer interested in a future in math and science. He assured him that the decision was not sudden, but it was final. He was convinced that "the arts side of me is much stronger than the cold calculating scientific side." In fact, he said, he was certain that the study of math and science "would freeze me to death." As George went on to explain, he would need to spend a sixth year at Glenalmond studying history, almost exclusively with Lyward, to prepare for the entrance exam to a top university. "He knows my work, my strong points, and my shortcomings better than anyone else," he wrote. At the end of this brave epistle, George was careful to acknowledge the paternal arm of authority, but only in the financial sense. "Of course everything rests with you, the keeper of the Exchequer."[14]

In June, George went home to Helensburgh to face his father in person. While he was there, Lyward stepped in as his counselor on a weekend visit with the family. Afterward, he wrote to Walter Rickey, summarizing his thoughts. Instead of advocating George's study of history, Lyward spoke of something more personal—the urgency of encouraging him to express his deepest feelings, for the sake of "a true, lasting and intelligent relationship with those to whom he is dear, and who are dear to him."[15]

George and a few other boys would spend the extra year at

Glenalmond, preparing for the entrance examinations to Oxford and Cambridge. Lyward drilled into them a solid grounding in the facts and honed their critical-writing skills to tackle any question they might face in the exams.

Also that year, George found religion. Lyward was a deeply spiritual man who, in addition to earning his degree from Cambridge, had studied theology at Bishop's College Cheshunt, and he had the ability to inspire in the bored or cynical young student a real interest in the Christian faith. Glenalmond boys were required to take Bible studies in their fourth year; however, there was little substance to be drawn from them, as George blandly recalled, "no commentary, no religion, no theory, no discussion, no hint either of doubt or belief." Nor had the Rickey family given more than cursory attention to their children's religious upbringing, and George had never been baptized. But in the sensitizing company of Lyward, the Christian faith took on new meaning for George. Thus at eighteen, in the vaulted and stained-glass splendor of Glenalmond's chapel, along with several of his classmates, he took the necessary steps first to be baptized and then to be confirmed an Episcopalian. George Lyward was his godfather.

4

Oxford

ON MAY 3, 1926, a general strike throughout Great Britain brought industry and transportation systems to a standstill. Some two million workers united in support of a miners strike over longer hours and lower wages due to the precipitous fall in the price of coal. In Glasgow, twenty-five thousand demonstrators marched through the city to rally on the Glasgow Green. Fights broke out between police and strikers. Machine guns were mounted all around George's Square, soldiers and tanks at the ready. Prime Minister Stanley Baldwin declared a state of emergency across Britain. There was widespread fear of a communist revolution. In the end, the government prevailed and the strikers went back to work, but the nine-day strike had made for a new solidarity among Britain's labor class, with whom George would soon be rubbing shoulders.

At the time of the strike, George was about to graduate from Glenalmond. In June he turned eighteen. He had always worked odd jobs around the house and garden during the summer holidays, but

now, his father told him, it was time for him to get some work experience in the real world. Nothing could have been more obvious than a job at the Singer factory in Clydebank. Whether this was Walter Rickey's last attempt to direct his son toward an engineering career or simply par for the course, the experience was one that George did not regret in the long run. Indeed, one can easily imagine how the technical skills he learned assembling parts of sewing machines would ultimately inform his knowledge of mechanical movement, just as time spent with his grandfather taking apart a clock had done when he was a boy of five. Among the lessons he might have also absorbed from his factory work was the complex organization of tasks and tools in each step of the construction process, which would one day play out in his own small factory in East Chatham, New York.

George, the boss's son, was awarded no privileged treatment. Like the other common laborers, he took the train at seven thirty every weekday morning, disembarked at the Singer station, and joined the stream of workers as they filed into the massive brick building, anchored by its two-hundred-foot clock tower—with the largest clock face in the world—that could be seen and heard for miles around.

Employees typically worked on one component of the sewing machine, assembly-line style. George was assigned to putting together sewing machine stands: tables made of wrought iron and wooden parts, which included the foot pedals that drove the movement and varied the speed of the machine in concert with the hand-crank, each part designed and crafted with the care of finely made furniture. He found the work awkward at first, but with practice, he mastered the set of operations and was racing against the clock on the wall, striving to increase the number of stands he could assemble per hour.

As chief engineer, Walter Rickey ran a tight ship. Employees regarded him as a driven and highly energetic man who constantly toured the plant with his erect posture, bouncing gait, and intense, popping blue eyes, ever alert to signs of weakness in the chain of production. But there was one thing Singer workers could count on to

their relief—that the boss took off every Wednesday afternoon for a game of golf at Troon or, in the case of foul weather, a bibulous lunch with friends at the New Club in Glasgow.

With his muscular build and his quiet dedication to the task at hand, the boss's son did not appear to be either a slacker or a toff. And along with the rest of the workers, he was proud and happy at the end of the week to pick up his wages, an envelope containing a couple of bank notes and a few shillings.

THE CHALLENGE of admission to university was of a different nature. George had at one point set his sights on Cambridge University, where Lyward had earned his degree and his sister Emily was then studying. But Cambridge in those days was also known for a greater emphasis on the sciences, and because this was no longer the direction he leaned toward, he went instead to Balliol College, one of the oldest and largest of the Oxford colleges and where Scotsmen were traditionally favored, to take the scholarship exam. Somewhat intimidated by the students around him, many from the ranks of Eton or Harrow, "the biggest challenge was the essay," he recalled.[1] Candidates were given three or four topics to choose from. One was "Cynicism." While the Etonian (or Harrovian) beside him immediately plunged into the task, the nervous George snuck a peak at his neighbor's first sentence, an aphorism from Oscar Wilde that he would never forget: "The cynic knows the price of everything and the value of nothing." It made him feel quite out of his depth. Nevertheless, he managed to produce an acceptable three or four pages on a blander topic—references to clothing in the Bible. Although he was not granted a scholarship, he was accepted at Balliol College for the fall of 1926. His first reward for this triumph was a holiday from Singer, and his first trip to the Continent.

In early August, George embarked from Glasgow on a cargo steamer as one of a handful of passengers with a small crew and a flock of chickens. They traveled south along the coast of Spain and

passed into the Mediterranean, delivering and picking up shipments of onions and beans along the way. Landing in Genoa, George disembarked with ten days to see the sights of Italy before he was to meet his boat in Naples to head home. As a typical Brit on his first trip to Italy with limited time, George went for the reliable "Cook's tour," picking up his tickets at the local Thomas Cook & Son office in each city for transportation and guided excursions to the famous sights of Milan, Venice, Pisa, Florence, Rome, and Pompeii.

He dutifully recorded his impressions in a journal and took photos with his Kodak Brownie camera. He practiced his French as the lingua franca, and found the foreigners' attempts at English difficult to understand. He tasted food unlike any he had ever known before, was entranced by the pastel layers of ice cream of a *cassata*, and was fascinated by the dexterity of a waiter removing the backbone of a sole and taking apart a roast chicken with a few strokes of a very sharp knife. For the first time in his life, George experienced the buzz and the bite of a mosquito. He was violently ill in Pompeii. In Naples, a city he found "vilely dirty,"[2] he dug his best shirt out of the bottom of his bag to visit Captain David Bone, the father of a Larchfield School classmate from Glasgow, aboard his ship, the *Tuscania*. And then it was time to head back to Scotland and his job at Singer before the academic year began.

ENTERING BALLIOL College in October, George found his room on the top floor of the south side of the quadrangle next to that of a trim and dapper fellow named Leonard Snow, affectionately known as "Snogs," who was to become a lifelong friend. Snow introduced George to the pleasures of music (especially the lighthearted operettas of Gilbert and Sullivan) and to the finer points of French wine. He spoke with an upper-class inflection, perfect grammar, and frequent use of the relative clause. Snogs would add to George's assessment of university life with the kind of world-weary English humor that was

rare north of the border. Snogs had "a great capacity for gentle enjoyment," recalled George of his Oxford classmate.[3]

George read modern history, a subject he had learned to love at Glenalmond and for which Balliol was well known. But Oxford in other ways was something of a shock to his system. Following his highly structured life at boarding school, university life was remarkably permissive, and after the intensity of close relationships in that small community in the Scottish moors, it felt quite impersonal. There were lectures he could go to or not, books to be read or not read; all that was required was to pass the exams at the end of the year. George's assigned tutors—Humphrey Sumner, a gaunt Russianist who wrote with an old-fashioned quill pen and was easily identified around the quad by his broad-rimmed black hat; Kenneth Bell, a historian of the British empire; and "a very deaf, shy don called Stone"[4]—did not at first impression seem to ensure his academic success in any way. The years he had spent writing essays at Glenalmond helped to prepare him for independent study, but he did not share the confidence of some of his Balliol classmates, a student body traditionally comprising the sons of statesmen, nobility, and wealthy eccentrics. He would hardly have shared Balliol alumnus and former prime minister Herbert Henry Asquith's impressions of the Oxford experience as the "tranquil consciousness of effortless superiority."[5] The arrogance of the Oxford attitude was amply demonstrated by one of the famous Balliol dons of Rickey's day, Benjamin Jowett, whose little rhyme was forever etched in his memory:

> *My name is Benjamin Jowett,*
> *I'm master of Balliol College,*
> *If a thing is worth knowing I know it,*
> *And what I don't know isn't knowledge.*

Under the circumstances, it is not surprising that within his first few months at Oxford George found himself developing an inferiority

complex. But for the ongoing guidance of George Lyward by letter, he might have felt quite lost. "Get going with work right from the very start," Lyward advised early on, "learn to allot your time, and *do not keep late hours*, for you do want above all else . . . to keep fresh and keep poised."[6] He urged George to send him regular accounts of his progress and to seek his tutorial help wherever needed.

But in this new atmosphere of liberation and with modern history his only subject, George found himself bored and restless. European history turned out to be mostly English history, and he found it rather plodding compared with the stimulating exhortations of Lyward's lectures. Whether the cause was boredom or a crisis of confidence, by the end of his first year George's academic performance was disappointing. Lyward felt compelled to remind him that there were "thousands of people of your age who would give anything to be in your shoes." He also gently admonished him for his pride. And not for the first time, he played the intermediary between George and his doubtful father. "He cares," Lyward reminded him; "keep that always in mind." He urged George to aim for a "first": "You owe it to yourself to get as good a degree as you can."[7]

Lyward had by that time left Glenalmond and was living in London. A woman he was engaged to had changed her mind and left him heartbroken and unable to function properly in his multiple roles at the school. Out of work and low on money, Lyward was grateful for the loyalty of friends. "I hope you won't desert me now that I have nothing to do with [Glenalmond]," he wrote to George at Oxford.[8] It was George's turn to offer comfort to his mentor. Powerful as he had been as a model, Lyward was an emotionally fragile and vulnerable man, as George now reflected on their friendship at Glenalmond, adding to "a certain naivete I saw in him, even then," he said many years later.[9]

During his second year at Oxford, George's spirits lifted when he discovered another kind of learning experience simply by crossing the road from the Balliol quadrangle and entering the university's art

museum, the Ashmolean, a Neoclassical edifice he had studied for some time from his dormitory window. One day, following a lecture on Botticelli at the Ashmolean, he came upon a large door at the end of a corridor on the ground floor, where a sign announced drawing classes: SPECIAL COURSES FOR UNDERGRADUATES, it read. Here was the Ruskin School of Drawing, named for the legendary artist and critic John Ruskin, virtually at his doorstep. He learned that classes were very cheap and that one could start at any time and go every weekday afternoon from two to five. The ease of signing up made it hard to resist. George paid his couple of pounds, bought the necessary supplies of paper and pencils, and opened the door.

He entered a large room with high ceilings in which meticulously detailed drawings of Gothic windows, drawn to scale, covered the walls—the work of John Ruskin himself. On the tables were small plaster casts of classical sculptures that George was instructed to draw as his first exercise. In the next room was a life drawing class, to which he would graduate when the master deemed he was ready.

John Ruskin established the Ruskin School of Drawing at Oxford in 1871, with the intention of developing a curriculum that would lead to a degree in art. Classical training in the studio was at the core of the program, but with Ruskin's extensive collection of drawings and water-colors for students to study firsthand, they also received a grounding in art history and theory. From its inception, the Ruskin School drew its instructors from London, and favored artists who had attended the Slade School of Art, where Ruskin himself had studied and honed his ideals and methodology.

At the time George was taking classes, the drawing master was Sydney Carline, a big, ruggedly handsome man with a swath of wavy brown hair. Carline commuted from London, where he was an active member of the art scene. He grew up in a household fertile to the artistic temperament. Both of his parents—George Francis Carline and Anne Smith—were artists, as was his younger brother, Richard, and his sister, Hilda, who married the artist Stanley Spencer in 1925.

All three Carline children learned to paint at home in Hampstead, often traveling to the countryside for painting retreats. They also studied in Paris with Percyval Tudor-Hart, a Canadian Post-Impressionist, who brought them up to date with sophisticated Modernist ideas, especially in the nonliteral use of color. Following their education in Paris, they all attended the Slade, where they received a rigorous training in the techniques of the old masters in drawing and painting. Henry Tonks, a former surgeon, was their hard-driving drawing master. A towering figure at well over six feet, Tonks taught drawing like a religious act, preached the value of verisimilitude, and sermonized that making a bad drawing was like living a lie. His criticism was as sharp as his pencil points, and so withering that a sensitive student could be made to feel almost suicidal.

Despite Tonks's strong influence on the school, the students at the Slade were not immune to the waves of modernism that Roger Fry imported from the Continent in 1912 with his exhibitions of Post-Impressionist art at the Grafton Galleries in London. Even though much of the work was ten or twenty years old by that time, it came as a shock to most viewers in England. Henry Tonks warned his students against the "contamination" of this artistic influence, and spoke bitterly about Post-Impressionism as "an evil thing" that threatened to lure away his most talented students. But other Slade masters feared being left behind if the school did not adopt a more tolerant attitude toward modernism. The result of these opposing forces was a remarkable diversity of talents and backgrounds.

Stanley Spencer, a Neo-Realist and history painter; Dora Carrington, a Bloomsbury Modernist; David Bomberg, among the first British Expressionists; and Ben Nicholson, who developed his own distinct and precise form of abstraction—all were students at the Slade during what Tonks called "the last crisis of brilliance."[10]

Thanks to Sydney Carline, Modernism had a presence at the Ruskin School, with occasional visits from the London avant-garde artists who came to critique and to fraternize. But Slade rigor and

the tradition of strong draftsmanship also prevailed at the Ruskin School in the 1920s, and George Rickey took to them naturally. Sydney Carline, making the rounds in the studio, paused to comment, and "drawing on the margin of my sheet of paper," recalled George, "made me look further."[11] Some weeks later Carline deemed him ready to pass through the door from plaster to flesh. It was his first experience drawing from the model. A thrilling sensation came over him. He was drawing, in an art school!

STUDENTS AT Balliol were instructed to spend their summers gaining real-world experience. To that end George, along with a friend from Helensburgh, Stephen Murray, signed up as a purser's clerk for Captain David Bone on the Anchor Line passenger ship *Transylvania*, sailing from Glasgow to New York. Arriving in New York for the first time since he was a small child heading for Scotland, the layover presented him with an opportunity to visit his recently widowed grandmother Emily Landon, Uncle Robert, Aunt Mary, and Aunt Minnie, and various Landon cousins in Schenectady, and soon family expeditions to the Adirondacks were also in the offing. Such were the distractions and attractions of being in his native land that he and Stephen conspired not to return to New York in time to board the *Aquitania* for Glasgow.

Traveling on a later vessel in steerage, George arrived back in Glasgow with plenty of summer left for travel. He took off for a few weeks in Heidelberg, thanks to Oxford classmate Reinald Hoops, whose father was a professor at the university. In Heidelberg he exchanged a few English lessons for German lessons with a local college student. He saw *Hamlet* performed in German on the Schlossgarten. He witnessed the celebration of the departure of the Allied arm of the occupation, a *Befreiung*, with bonfires on every promontory.

Living in student housing, he met a bold and voluptuous Jewish girl from South Africa who made fun of his religious beliefs. That she

bothered to challenge him for being stodgy and old-fashioned only added to her allure, and on the shores of the appropriately named Neckar River they kissed. Though they never met again, her sting remained and George would later admit that the South African was a kind of catalyst of change or liberation from the traditions and attitudes that bound him. The passion he briefly felt at Glenalmond for joining the church had withered in the absence of his godfather, George Lyward. He no longer believed in God.

Returning to Oxford in the autumn for his final year, George found that he was more excited about drawing at the Ruskin School than anything else. With drawing classes every afternoon he would have to give up his place on the rugby team, for which his teammates forgave him and while his parents remained uninformed.

Just as he was becoming ever more committed to his art studies, in February 1929 Sydney Carline caught the flu, developed pneumonia, and died. As he was the only full-time instructor at the Ruskin School, it closed until a substitute could be found. Following his burial service in a country churchyard not far from Oxford, George spoke to Sydney's brother, Richard Carline, about what could be done, whereupon Richard suggested that he come down to London once a week to show him his progress. The younger Carline proved to be at least as good a teacher as his brother, and perhaps even more encouraging. He urged George to progress from drawing to oil painting and, with that, his first lesson in Modernism. Carline instructed him to set up a still life of white eggs on a white dish on a white cloth, and then to paint the still life in color. "Stymied at first by my Scottish caution," recalled George, "plus New England sobriety, and a mechanic's conditioning to logic, I began to realize that logic did not apply, that I had to imagine and invent a world beyond what I saw."[12]

When the Ruskin School reopened under a new drawing master, Albert Rutherston, George resumed his regular classes there. Other artists of the English avant-garde, such as Stanley Spencer, Gilbert Spencer, and John and Paul Nash, came to visit and teach, adding their

modernist views, espousing the genius of Cézanne and van Gogh. Being around these older artists made a deep impression on George. Nothing of the kind had ever touched him in his youth in Scotland. Most important, Richard Carline continued to tutor George privately, coming up to Oxford or inviting him down to London, and nurtured his progress. "I wonder now why he did it," George later reflected, "my efforts must have seemed appallingly ignorant, inept, and talentless."[13]

George was planning to get a teaching job after graduating. His history tutor, Humphrey Sumner, had taken a real interest in his future and had been scouting for positions. But as he approached graduation with no immediate prospects, George was warming to an idea that Richard Carline had first put in his head: "what had seemed, with my background and circumstances, unthinkable," he recalled, "namely, a year in Paris."[14]

5

Paris

IN THE 1920s, Paris was the prime destination for aspiring young artists everywhere. They flocked there from all over Europe, and Americans arrived in droves. They stayed in little hotels in Montparnasse, in the 14th arrondissement, which had succeeded Montmartre as the bohemian heart of the city. They frequented the famous café Les Deux Magots and the café Le Dôme, absorbing the last traces of the Belle Époque and discussing the meaning of their lives and their art. Among the Americans who had made Paris their permanent outpost was Sylvia Beach, with her legendary bookstore Shakespeare and Company, at 12 rue de l'Odéon, a favorite haunt of James Joyce, Ernest Hemingway, and Leo Stein and his sister Gertrude. Josephine Baker performed her erotic dances at the Folies Bergère. Her notorious "Danse Sauvage," with a suggestive string of bananas draped around her bare waist, became an iconic image of the Jazz Age, while Henry Miller broke ground on his first novel, *Tropic of Cancer*, a sexually explicit surrealist stream of consciousness with no literary precedent. At the same time, Alexander Calder was making a reputation for

himself as ringmaster of a miniature traveling circus—complete with his tent and trapeze, acrobats and animals packed in five suitcases—wherever he was invited to perform.

This intense concentration of artistic creativity was due to the liberating force of life in Paris, far from the conventions of a post-Victorian America. Paris was the hub and the hotbed of all the latest in art and literary life, the requisitioned home of the so-called Lost Generation. It was the place to shed one's puritan hang-ups, and for young Americans the constrictions of Prohibition as well. It was the place to indulge the senses—to learn how to drink, to eat, and to make love. George Rickey, fresh out of Oxford at twenty-two, was yearning for a taste of it.

From Richard Carline, George was given the basic guidelines for his Paris sojourn. He should live in Montparnasse, where rents were cheap, café life abundant, and the neighborhood full of aspiring young intellectuals and artists just like him. Montparnasse was also the home of the Académie Lhote, where he would study art. There he would learn the language of Cubism, at the time the reigning modern style. "I knew what cubism was, I'd heard about it," George recalled, "and I thought it was a little odd. But it was talked about."[1] However odd it seemed, he knew that to call himself a serious artist, he would have to master its basics.

After calculating his finances—a little left over from his Singer factory job, another small sum from his steamship stewardship, and a nest egg in the Schenectady Savings Bank, adding up to about sixty pounds—George figured he had enough to live on for three months in Paris without asking his parents for help. Once there, he could hope to earn some money on the side. In September 1929, with this sense of financial independence and knowing that his parents would not be happy with his decision, he simply confronted them with his plans, packed his bags, and took off, feeling quite liberated by the sensation. He was in search of experience, without boundaries. As if giving up engineering for the humanities wasn't enough of a shock for

his father, he boldly drove his point home: "For me experience is not confined to that which helps me to fill a better paid or more responsible or more powerful position, or provide me with good references," he wrote to him, "or even that which makes my judgment sounder."[2]

Part Scot, part American, and part hopeful bohemian, George wore his shirtsleeves rolled up past his elbows, baggy flannel trousers, and sandals. Parisians were just returning to the city from their summer holidays when he checked into a modest hotel on the rue de la Grande Chaumière. The weather was warm and the pace of life relaxed, but he had little time to take in his new surroundings before beginning his art classes at the Académie Lhote.

Upon entering the building at 18 rue d'Odessa and climbing the shabby stairs to the main floor, he encountered a life drawing class already in session in a lofty studio, the walls covered with brightly colored cubist paintings by Lhote himself. Directed to visit the office of the *mossier*, who collected the monthly fees and generally kept an eye on things, George produced his first month's tuition before setting up his easel and getting down to work.

André Lhote, initially trained in the decorative arts at L'École des Beaux-Arts in Bordeaux, after moving to Paris began to paint in the colorful Fauve style and later became enamored with Cubism. As a critic and teacher, he emerged as one of the movement's most ardent and influential followers. In a manner based on the old atelier system, Lhote would come in on Monday morning and pose the model, and then return at the end of the week for the critique. Although Lhote was not generally considered a great painter, he was an outstanding instructor. A handsome man, clear and convincing, and rather witty too, he would also lecture to the students about the old masters and the structure of their paintings. He taught them to look with the eyes of a modernist, with a command of the color wheel and an eye for composition—to see a Rubens as pure geometry.

Lhote would constantly pressure his students to *cherchez un style*, but he also hammered home an overriding structural formula—what

George called "a kind of academic cubism"—that would ensure their credibility in the circles of modern art. "His lucid, rational, systematic analysis was so convincing that it took me, afterward, four or five years to wash it out of my brain," remembered George.[3]

ALTHOUGH HE had had nine years of French in school, when George was required to speak with the natives he found himself quite out of his depth. With as much money as he could spare, he took private lessons in conversational French with a woman in the neighborhood. At the end of October, he quit the lessons for lack of cash, but a middle-aged woman who lived next door invited him to come up occasionally and "*bavarder un peu.*"[4] Without speaking a word of English herself, his new tutor talked knowledgeably about art and seemed to know personally all the great painters of the last thirty years, and was on intimate terms with Matisse's wife. Years later George learned that his companion, Fernande Olivier, was Picasso's former lover and muse.

Piecing together a living in Paris without seeking financial help from his parents meant that George needed to earn some money on the side. Dropping into the Gardner School of Languages, on the Grand Boulevard, he landed a job teaching in the Berlitz method every evening for about three hours, earning twenty-five cents an hour. This led to more lucrative private lessons with a housekeeper at a big hotel nearby, for which he earned triple the amount he made at the Gardner School.

He also found seasonal work as a messenger for an American fashion consultant.

In the days when every well-dressed woman looked to Paris for the latest in fashion, Marie Leonard provided sketches from the Paris runway to the dress houses of Seventh Avenue in New York, where the French original was loosely redesigned for the American mass market. Something of a pirating operation, the so-called "copy houses" in Paris provided many a young artist with a small income as

an illustrator. For Leonard's operation, George ran the mimeograph machine and shuttled packages to and from the post office. On the whole, he found the people in the fashion business bad mannered and unscrupulous, a world of "awful looking women in the most expensive clothes."5 Yet it was at this job that he made his closest friend—Eve Vogt, a stylish young Swiss divorcée with an intriguing gap between her front teeth—who was employed to transfer the drawings into mimeograph sheets. A little older than George, Eve was fluent in German and French and spoke English perfectly. She was a warm and exuberant companion with a sense of style and a passion for art, and it was not long before she and George formed a close bond.

AFTER A few weeks of study at the Académie Lhote, George could already see the limits of Lhote's teaching methods. He could give a student a great deal in a very short time, but then it started to feel redundant. George began to seek alternatives. At the time, Paris was at the crossroads of artistic styles and philosophies, with Surrealism emerging on the one hand, evoking the private and erotic side of human nature, and on the other, a cool, cerebral form of abstraction offered an alternative to the painterly style of Picasso and Braque. By the end of November, George had his eye on the Académie Moderne, where Fernand Léger and Amédée Ozenfant offered courses in painting that represented a departure from the kind of formulaic Cubism that Lhote espoused.

Although George was initially attracted to the school by Léger's painting, he found him a brusque and disappointing teacher—rather discouraging in fact. The diminutive Ozenfant was more sympathetic. Ozenfant had collaborated with the architect Le Corbusier in their rejection of Cubism with their book *Après le Cubisme,* in which they advocated a more architectural approach to painting they called Purism. This was a style that called for a neutral palette and evenly applied paint, producing a rigorous, machinelike aesthetic and clarity of form that instinctively won George's respect, for even though he

knew that some form of abstraction was what he had come to Paris to learn, George struggled with the concept.

One of his first encounters in Paris was at the studio of the English painter Stanley William Hayter, whom he found "stooping over an enormous canvas flat on the floor slopping some paint onto what seemed to be a meaningless abstraction. It was quite a shock after the Ruskin School."[6] Verisimilitude was a quality he still valued highly, even as he learned to break down his images into abstract planes and cubes. Ozenfant "presented abstraction with human values."[7]

Straight out of Oxford, George felt more of a kinship with the British youth than with Americans abroad, and sought to distance himself from his conspicuous compatriots in every way. (His feelings toward his fellow Americans were probably reinforced by his friendship with Eve Vogt.) Leonard Snow was amused by George's "impassioned invective against Americans in Paris." A touch of envy, perhaps, went along with the teasing, as Snogs was meanwhile beginning his financial career in London, with a heavy sense of obligation and not much excitement as he donned his banker's uniform and marched off to the City every morning. "The dreaded hour has come and gone," he wrote to George, "I am a City Man . . . clad in a neat blue suit and black shoes . . . the *Times* under one arm, umbrella over the other, a bowler hat etc."[8]

Like many a young man of British upbringing, the Continent was the door to sensual discovery of every kind. If George arrived in Paris a virgin, he certainly did not leave as one. Charmed by George's Anglo-Saxon manners and also determined to break them down, Eve made the perfect teacher—patient, candid, and kind. She was sensitive to his inexperience, but willing to instruct. She taught him how to ask a woman what she wanted, and how to bring her to climax with his hand. In exchange for these lessons in love, George taught Eve how to read poetry. They shared a passion for literature as well as for art. Trading books back and forth, they discussed Dostoyevsky, and the poetry of Swinburne, Byron, and the *Rubáiyát*. They bought prints from the

little booksellers along the Seine. They drank at Les Deux Magots in the rain. George's youthful enthusiasm was the lightness Eve needed to recover from her failed marriage, and friends remarked that he had changed her mood from melancholy to gay.

AFTER A few months in Paris, George's visit home to Helensburgh, in February 1930, was a trial. The town was all gray—gray stone, gray weather—and Clarendon seemed hopelessly Victorian in its architectural excess and stuffy Scottish furnishings. His parents asked too many questions and scolded him for slouching. His eldest sister, Elizabeth, was suffering a mental breakdown and was the subject of a great deal of hushed and urgent conversation behind closed doors. Emily, the next eldest, had by then graduated from Cambridge and was studying chemistry at their father's alma mater, MIT. His younger sister Jane, a promising artist herself, was keen to visit George in Paris. As much as he was willing to help her settle in, he feared a loss of his own freedom in the bargain, and warned his parents, "[Jane] will have to fend to a considerable extent for herself . . . she must not depend on her brother for her good time."[9] George could hardly wait to return to Paris. Yet as stifling as its mood suddenly appeared to be in contrast, Scotland had its own sensual delights, perhaps all the more keen to his senses, which he was eager to share with Eve. From Helensburgh, he sent her shortbread, heather, and branches of bay myrtle.

As their love affair evolved into a close friendship, George and Eve openly tolerated each other's sexual wanderings, and judging from her letters to him, which he saved, each seemed to get an erotic charge out of the other's infidelities in the true spirit of free love. George pressed Eve for details of her lovemaking with other men, and she obliged him with vivid descriptions. George, meanwhile, sought her romantic advice, such as whether to take the virginity of a Scottish girl named Kitty, even if she begged him to. "Handling a virgin is a very difficult thing," the experienced Eve advised. "[It] takes time and

conscientiousness . . . to do it well and not leave sorrow and bitterness in your wake."[10]

IN MAY 1930, George's work was included in a group show of André Lhote's students at the Salon de l'Art francais independents. Toward the end of his year in Paris, his father visited him there, and George had the satisfaction of impressing him with his command of French and familiarity with the city. It seems that Walter was by then somewhat more receptive to the creative pursuits of his prodigal son. His change of attitude might have been mainly the result of George's prospects at that point, which to the concerned parent of an aspiring artist were looking a lot more realistic.

In the middle of his year in Paris, George was approached for a teaching job at the Groton School, a prestigious boarding school for boys in Groton, Massachusetts, which he had never heard of. With the stock market crash of 1929 only a few months old, securing a job of any kind would be fortunate for a young man of twenty-three, and a more venerable position for a high school history teacher could hardly be imagined. George's tutor at Balliol, Humphrey Sumner, had arranged a meeting between George and Roger Merriman of the Groton faculty, who thought him "an excellent chap," adding "he might prove a real ten-strike."[11] That George Rickey was an American with a British education was certainly in his favor. The Reverend Endicott Peabody, founder of the school in 1884, came from a similar academic background; he attended an English boarding school at Cheltenham followed by Trinity College, Cambridge. In March, William Cushing, a member of Groton's faculty, met Rickey in Oxford, where George cemented the positive impression he had already made.

George wrote to Peabody to express his interest in the position, to which Peabody responded that if he proved to be the right fit, he could consider staying on at Groton permanently, as many schoolmasters did. Flattering and reassuring as this was, George was not willing to

commit himself for more than two years. "I am still very young," he wrote candidly to Peabody, "and I don't know what point I shall have reached in two years' time." Although teaching had been an abiding ambition since he was sixteen, he added that he had had "the misfortune to discover a certain amount of artistic talent at the age of 20. I should prefer letting that talent die a natural death, to killing it with too long a contract."[12] Peabody officially offered him the job in April 1930, at a very respectable starting salary of two thousand dollars a year, slightly more than the average entering master, along with room and board.

Soon thereafter came word from Peabody that he and his family would be visiting Paris in July, and he invited Rickey to join them for lunch. At a fashionable restaurant on the Champs-Élysée, George's future employer displayed a fluency in French and knowledge of food and wine that immediately won the young man's admiration. Just one point of possible concern was left in the air: the question of George's religious faith. He admitted to Peabody that despite having been confirmed a Christian and having attended an Episcopal school, he did not believe in God. Peabody's only question was whether he would feel obliged to tell his students. When Rickey answered no, Peabody was satisfied.

Grateful as he was for this new prospect, George was reluctant to give up his freedom as a young artist in Paris. Eve Vogt was his confidante. "But perhaps an interruption is good for you," she wrote to him. "[I]n those 2 years your inclination will get stronger, so that you will know by then in which way to turn." She would be sorry to see him go, but had high hopes for their friendship to survive, "very probably no more as lovers," she wrote, "but as the best of friends."[13] Both of Eve's predictions proved to be correct: In two years he would know which way to turn, and they would remain the best of friends.

6

Groton

"I EXPECT it was with mixed feelings that you arrived in America," wrote George Lyward to George Rickey in the fall of 1930.[1] If Rickey's feelings were mixed when he landed in New York, in September of that year, the ten days he spent exploring the city were a promising start to his new American life. As soon as he arrived, his Oxford tutor, Humphrey Sumner, swept him up for lunch and suggested they visit the Museum of Modern Art, which had opened less than a year earlier. In its fledgling state, the museum at that time was just forty-six hundred square feet of rental space on the twelfth floor of the Heckscher Building, at the southwest corner of Fifth Avenue and 57th Street. There they would have seen the *Summer Show*, a summing up of the museum's exhibition season, with an impressive variety of loans from collectors it was actively courting—painting and sculpture by European Modernists such as Picasso, Cézanne, Léger, Miró, and Paul Klee, as well as the Americans Edward Hopper and Georgia O'Keeffe. George was impressed by the exhibition and humbled to

realize that Humphrey Sumner "knew so much more about modern art than I, the would-be artist."[2]

Upon arriving by train in Boston, George headed forty miles north-west to the historic town of Groton. He stopped on his way in nearby Athol, where he had spent a winter with his grandfather the clock-maker so many years before. Less than three miles down the road was his new home, the Groton campus, with brick buildings arranged in a ring on a high plateau overlooking the hills and farmland all the way to the White Mountains of New Hampshire. It felt remote, but also familiar. Like Glenalmond and Peabody's alma mater, Cheltenham, Groton was an Episcopal school with an impressive Gothic chapel at the heart of the campus. This one was designed by Henry Vaughan, a leading neo-Gothic architect of the day, with stained-glass windows custom made in England. "The whole place is rather English," wrote George to his mother of his first impressions, not the least of which was his welcome at the headmaster's residence with a proper cup of China tea.[3]

As Frank Ashburn, a member of the Groton faculty, described him in the school history, Endicott Peabody was "hewn from the Puri-tan rock and molded in the English public school."[4] To that English model, Peabody was determined to bring a distinctly American spirit and mission at Groton. With the rise of the entrepreneurial upper class in America, to which he was born, he sought to educate young men to a life of service and a strong sense of community. To ensure that same community spirit, he kept the school small; in 1930 there were one hundred eighty students, most of them the sons of power and privilege. Peabody's wife, Frances, known to the boys as "Madame," was a beloved presence at the school, adding the feminine touch to the all-male preserve, and, as George suspected right away, "the real ruler of the roost."[5]

By the time George arrived at Groton, Peabody was more than seventy years old and had been running the school since its founding, for nearly fifty years. New pedagogical trends had emerged and spread

widely in the meantime. John Dewey's progressive theories were very much in the air, as were those of Maria Montessori and Rudolf Steiner, influencing curricula at all levels of education. But Peabody was not easily swayed by these modern methods and ideas. Let others experiment with passing fads; he would stick to the sound traditional policies he knew so well. All the same, by the time Rickey arrived, Peabody had allowed for some modifications to the Groton curriculum. Academic offerings had expanded to the arts and sciences, Greek was no longer required, and the study of history had crept up to the twentieth century. There was a new recognition of different kinds of aptitude among the students, and within each subject the school had formed three divisions to better match the pace of a student's learning.

Following years of tradition, Peabody presided personally over every turning point of the school day. His attire alternated between a dark blue suit with starched white collar and the priest's robes he donned for the blessing at morning chapel and later for evening prayers, after which he shook hands with every student in turn and said "Goodnight, my boy" as each filed by to his dormitory and to bed. His pace never wavered, the blessing never changed. As Frank Ashburn surmised, "Peabody's 'system' endured all those years because it was so simple. He believed in character, hard work, discipline, and good manners, and in the simplicity that he found in Christ."[6]

Oxford and Glenalmond had prepared George to teach history at Groton, with its emphasis on the ancient world, and where British and European history predominated. But to his great relief, Groton was a gentler place than the British boarding school he had known. It was strict and regimented, but the cane was spared and fagging was not part of its tradition.

From a distance, George Lyward remained Rickey's loyal mentor. "It must amuse you to teach the stuff I taught you, and more beside," he wrote to George, while gently probing the questions of his future. "I hope it's fulfilling its purpose, this new job of yours. I wonder if you have patience to let it do that."[7] For as Lyward well knew, in the back

of Rickey's mind were nagging questions: Was he a teacher or an artist? Was it possible to be both? For now, he would dive headlong into prep school life as the young history master, and do his best to paint and draw in his limited spare time.

"Spring is late here compared to England," George wrote home to his mother, "and rather abrupt."[8] As a single and adventurous young man, he would have languished at any season without opportunities to escape the campus on weekends and holidays. He bought a car, a secondhand 1929 Model A Ford—his lifeline to social and cultural expeditions off campus. His younger sister Jane, who had followed him to Paris, was now attending Smith College (their mother's alma mater), which made for a crop of bright young women for him to meet about a two hour drive away, and before long he was a regular visitor to Northampton.

A young woman at Smith named Mary interested him for a spell. She found George intellectually challenging in a way that she enjoyed, and he found her challenging in another way: He wanted to take her virginity, and offered a philosophical argument for her sexual emancipation; she was not easily won. "I hope yesterday wasn't too bad for you," she wrote to him coyly. "I've heard it is, to go so far without going to the limit."[9] As Mary waffled between sexual temptation and the virgin's natural caution, George became a sounding board for the musings of a young woman on the risks of love. When one night under the stars she finally gave in to him, she was a changed woman, a part of the universe, she told him. She was not in love with him, but she was grateful to him for leading her gently into the hazardous world of adult relationships.

Janet, a girlfriend from Wellesley College, was puzzled by George's many "selves." At first he had seemed "a gay, young beau seeking the favor of a maiden" and the next time he seemed much older.[10] She felt a degree of condescension in George, as if the teacher with his pupil, which she did not enjoy as much.

The bright young women from Smith and Wellesley were an

entertaining intellectual match for George. He could challenge their opinions about art, history, and literature, jousting with words, and with the slight age difference in his favor and a greater depth of experience. He was the schoolteacher and they were still students. With his Oxford degree, he had explored Europe by ship, train, and motorcar, and had lived among the bohemian circles of Paris. He spoke French, both proper and colloquial, and English with an interesting accent that was difficult to place. He had grown up in Scotland, that romantic land of the kilt and the clan, of castles and heather-covered moors. Sandy-haired and handsome, with his penetrating blue eyes and square jaw, he had a pugilist's physique and an artist's mind. He was a rugby player who loved poetry, an intellectual with the engineer's instinct for how things worked. He knew how to dress properly, but with an air of nonchalance. Not the least of his attractions, he was a young man with a job and a car.

George's sexual experience, when it did not inspire fear, inspired confidence. He was ardent in his pursuit of young women, but he eluded capture, a mesmerizing and vexing combination. Tough and unsentimental, he demanded clarity and candor, but he also valued the inchoate searching of a creative spirit, a lost soul he might help through her struggle to find herself.

Perhaps this was the quality he discerned in a young woman from Quincy, Illinois, named Susan Luhrs. They had met two summers before on a boat crossing the English Channel, while Susan was traveling with her family on her first tour of Europe. A trim blonde with porcelain skin, Susan was a doll-faced beauty, sensuous and innocent. Just a year younger than George, her simple, unpretentious background, far from the Eastern establishment and the prestigious women's campuses of Smith and Wellesley, touched a chord.

After attending a small Christian college in Missouri, Susan had studied at the University of Illinois and Northwestern University, added two years of training as a nurse in a hospital in Evanston, Illinois, and had later worked in a nursery school. She took a lively

interest in theater, puppetry, costumes, and music, and for two years managed a marionette theater. She yearned to somehow turn these creative pursuits into a career. For the time being, she lived like a caged bird at home with her parents while she stayed in touch with George by letter.

With spring in the air, George planned a cross-country motor trip over the summer vacation of 1931 with his first stop Quincy, Illinois. The Luhrs family welcomed him there in mid-July. "I have stopped and rested a bit with a family I met in Europe two years ago," Rickey wrote to his mother. Feeling his way, he stayed a few days and then stayed a few more, "as the welcome seems still warm." He found the small Midwestern town slow-paced and refreshingly friendly, where "nobody is a stickler for form."[11] With a growing respect for his own Midwestern roots, George expressed an appreciation for the American heartland to his mother back in Scotland: "a civilization that is still very, very young and very raw, but which is developing character of its own more genuine than the European imitations on the Atlantic seaboard."[12] For their part, the Luhrses considered George a very eligible and attractive young beau for their daughter.

By the time George was ready to travel farther west, Susan was eager to go with him. Her parents, though, insisted on a chaperone. Thus it was that George, Susan, and her school friend Janet Adams set out in mid-July. Road travel in the American West in the early 1930s was something of an adventure. Conditions were unpredictable, with paved roads giving way to dirt in remote areas and gas stations few and far between. George was glad that his car was a Ford, as even the smallest towns had a Ford agency he could rely on in case he needed a repair or a replacement part. He was determined to reach California, so they had little time for mishaps with just two weeks to travel. At top speed the Model A reached sixty-five miles an hour.

George was fascinated by the Kansas landscape, "covered with a patchwork of almost white wheat fields and dark green corn," and the air was so clear they could see the distant horizon "sharp and clear . . .

like mid-ocean." They drove through the steep mountains and valleys of Colorado, with their winding rivers and canyons and "miraculous rock architecture" rising straight out of the Colorado River. George was mesmerized by the "geometrical forms, usually rough pyramids, but with infinite variations."[13] Exhilarated by his discovery of the Western landscape, his deepening affection for Susan Luhrs added to his sense of adventure. She was a small-town girl with dreams that touched his heart. By the time they returned to Quincy, meeting their August 3 deadline, their bond was strong.

IN SEPTEMBER 1931, back at Groton, George felt the effects of the economic depression as it deepened all around them. "One feels rather lucky to be a schoolmaster now," he wrote to his mother, and especially at a financially stable school such as Groton. At public schools across the country, teachers worked without pay for months on end, and many private schools closed under the weight of prohibitive tuition costs. Many Groton families of bankers and stockbrokers took a beating in the crash and some students left the school as a result, but the school itself was able to withstand the crisis, as, George reported to his mother, "the income from its endowment (over $6,000,000) is little diminished."[14]

The youngest master on campus, George could easily relate to the boys he taught, and they to him. He commanded the respect of both the athletes and the intellectuals, and in the sympathetic spirit of George Lyward at Glenalmond, he was demanding without being stern or forbidding. Helen Resor probably spoke for many when she told Walter Rickey that her son Stanley had found George "a most stimulating teacher as well as a sweet friend."[15]

Peabody invited Rickey to deliver the Thanksgiving address that year. It was his first public speech: He took the honor seriously, and in that bastion of conservatism seized the opportunity to voice his burgeoning progressive views of education. From the carved wooden

pulpit of Groton's lofty St. John's Chapel, he did not shy away from sweeping topics and gave a bold critique of contemporary society. "Who is not relieved that he lives now and not in the last century?" he asked the assembled. Yet for all their comforts, he warned of the dangers of mediocrity and mass production and the mass influence of the movies and the press—"chains of newspapers printing chained opinions."

He encouraged the Groton boys to develop their judgment, refine their sensibilities and perception as individuals, and act on standards based on their own experience rather than "aimless tradition." He told these sons of the rich that there was another kind of poverty—the poverty of the imagination—and he urged them to fight it. He reminded them to be grateful for living in a time "when free criticism is the mode," and he praised the schools of the day for "a deeper intellectual approach," which came with "a greater appreciation, not only for nature and art and music, but for the world we live in."[16]

Whether this was the kind of sermon Peabody was looking for, we have no way of knowing, but his note to George tactfully avoided commenting on its overriding message. "Many thanks," he wrote to George a few days later. "[T]he address was admirable in style and extremely well delivered."[17] Style and delivery were certainly qualities that George strove for, and he quoted the rector's words to his parents with pride.

WHENEVER POSSIBLE, on weekends and holidays George took off for New York City to visit galleries and museums and keep up with the latest in modern art. He discovered that he could drop in at the Art Students League on West 57th Street, where for a small fee he could draw or paint from the model and occasionally attract the attention of a passing instructor. The League had a highly flexible and informal program for students and teachers alike; artist instructors were encouraged to assert their individual style and students at any level

were invited to sample the various studios as if from a menu, and at the convenience of their own schedule. George would also have been attracted to the broad spectrum of artists who taught there, from the Social Realist painter Kenneth Hayes Miller to the Modernist Jan Matulka.

With the academic year at Groton behind him, George was determined to devote the summer of 1932 to his painting; however, he had other goals as well. One was to spend as much time as possible with Susan Luhrs, another was to make some money on the side. Returning to Quincy, Illinois, he found a little apartment in town and created a job for himself teaching at the Quincy Art Club. Going door to door like a traveling salesman, he managed to round up perhaps ten pupils—locals of all ages and every level of talent, experience, and income level. If a student could not afford to pay, George took them on for free. In addition to teaching and critiques, he offered illustrated lectures on the principles of modern art, as if rehearsing for his future as a professor of art history.

Heading east at the end of the summer with more than twenty new paintings, George spent a week in New York searching for a gallery to show his work. Frederick P. Keppel, the father of one of George's students at Groton, offered an introduction to Carl Zigrosser, one of the more sophisticated young dealers in town. "He is one of the few people I know who can be provocative without being offensive," Keppel told George.[18] Before George arrived for his appointment at the Weyhe Gallery, on Lexington Avenue, with a half dozen recent portraits and landscapes under his arm, Zigrosser had already warned him that it was a terrible time to exhibit and an almost impossible time to sell, but he agreed to have a look. Zigrosser thought the work was "competent"; however, he criticized its lack of real content. He told Rickey frankly that his paintings were no more than "five finger exercises," that he needed a theme to interpret, a key to his time, a *Weltanschauung*, or worldview. Diego Rivera, the great Mexican muralist, was the prime example of this, according to Zigrosser, and he went on to say that

the only place where "healthy" art was happening today was Mexico. George was not sure Zigrosser was right about this, and he described the conversation with his mother in some detail.[19] In due course, as we shall see, George would heed Zigrosser's words.

At another important meeting, arranged by the Russian American sculptor Milton Horn at his studio, George met the sculptor Frank de Luna and a picture dealer, D. Caz-Delbo, who had a gallery at 561 Madison Avenue. George considered the reception of his work at this key meeting "fairly enthusiastic." Milton Horn, who had seen the work before, reservedly commented that he had "made strides"; Frank de Luna thought the work "professional" but advised George not to show while his style was still so much in flux, that showing "would prejudice my reception in future rather than help it," George wrote to his mother.[20] The warmest praise came from the dealer, Caz-Delbo.

With the help of his cousin Katherine Landon, with whom the dealer was on friendly terms, George secured a date for an exhibition of his work at the Caz-Delbo Gallery in December of that year. Katherine had suggested that George offer the dealer some financial assistance for the show, for like everyone else in 1933, Caz-Delbo needed the money. Heeding her advice, George forked over a hundred and fifty dollars to cover the printing and mailing of invitations and press announcements, which was "pretty stiff, but I feel it is worth it," he told his mother. The date set for his exhibition at Caz-Delbo— December 28 to January 10—was excellent as far as George was concerned because during the Christmas holiday, "I have the best chance of getting the wealthier Groton parents to come around."[21] Without a doubt, one of the great benefits of teaching at Groton was the variety of connections a young master could make among the power elite of the Northeast establishment.

By the end of the school term, George was exhausted. The strain of turning out a number of paintings along with the workload of full-time teaching was more than he could realistically handle. As he had told Endicott Peabody when he accepted the job, he had not known

whether his artistic aspirations would overtake his interest in teaching. Now, it was clear that they had.

GEORGE RICKEY'S first one-man show in New York was a mix of landscapes, still lifes, and portraits—twenty-nine oil paintings and three watercolors in all. Even though he was determined to banish the Cubist influence, or what he called "the Lhote infection,"[22] he may have also been hedging his bets that a more traditional figurative style would more likely lead to sales or commissions. With several paintings depicting the landscape around Groton, including a large screen painting in an "oriental manner," he hoped to attract the interest of a Groton parent for four or five hundred dollars. Meanwhile, he was using a variety of connections to spread the word to people of influence in the press and museum world. During the Christmas break, he was on hand in the gallery to respond to any interest in his paintings that might come through the door.

The press reception of the show was for the most part positive. A critic for *The World* wrote that Rickey's pen-and-ink drawings showed "a spontaneity and subtlety of execution which just escape being sketchy"[23]; one writing for *The Herald Sun* thought the influence of Cézanne in his still life with guitar "too evident for complete enjoyment," but, he wrote, Rickey's "skill with his brush" shone through.[24] On the whole, Rickey's work struck a note of Paris sophistication within an acceptable figurative tradition for most American art viewers of the day.

With the Caz-Delbo Gallery letterhead in hand, legitimizing his status as a professional artist, George mustered the strength to write his letter of resignation to Endicott Peabody. He explained that he remained deeply interested in teaching, but he did not feel he could do justice to the job while pursuing a career in art. "My interest in both teaching and art has been growing steadily," he wrote, "and now they have begun to crowd each other like seedlings which have been

planted too close together for both to become mature plants." Art was winning out as the greater passion, and there was no turning back. He would be leaving Groton in June. "I shall hate to go. I have loved the work . . . Groton has been a home to which I have been glad to return."[25]

While the feelings he expressed to Peabody were certainly sincere, there was another that George kept to himself: He felt remote from the world on that idyllic rural campus, that circle of classical brick buildings in the middle of nowhere. "It was a kind of haven," he later remarked,[26] and he was uncomfortable with its insularity and privileged sense of security in an insecure world.

That same year, Franklin Delano Roosevelt, a Groton graduate, was elected president. Always deeply loyal to his Groton education, FDR had in 1905 asked Peabody to officiate at his wedding to his distant cousin Eleanor. In return he gave the commencement address at Groton when he was governor of New York, in 1932, the same year that Rickey taught history to the two youngest of FDR's four sons, Franklin Jr. and John. The conservative parent body of the school for the most part adamantly opposed Roosevelt "beyond the realm of argument" in the election,[27] and Peabody, fond as he was of Franklin (whom he remembered as a quiet, satisfactory student at Groton, with too slight a build for athletics), cast his vote for Hoover, believing him to be "the abler man" given the economic crisis at hand. Nevertheless, Peabody invited FDR during his campaign year to speak to the students about the importance of taking an interest in politics, and assured him that if he were elected, the school would "back him to the limit in loyalty and love." FDR asked Peabody to conduct the formal blessing at his inauguration when he took office in March 1933 and throughout his presidency the rector was happy to "claim a bit of honor for Groton to have one of its own in the White House" and was a regular visitor there throughout his presidency.[28]

As the Depression deepened, it was Roosevelt's monumental task to revive the economy and rescue millions of Americans from

unemployment and poverty. Most of all, he needed to restore confidence in the American dream to a panic-stricken public. "First of all," he famously said in his inaugural address in 1933, "let me assert my firm belief that the only thing we have to fear is fear itself." A young man now looking at his future with some trepidation, Rickey took these words to heart. And though it may have seemed that the world was falling apart all around him, and that his place within it was no more secure than that of any other hopeful young artist, he had more than did many others to count on—two thousand dollars in the bank and a one-man show under his belt.

7

Susan

QUITTING HIS job was not the only leap of faith that George would be taking in the spring of 1933. He was impatient to embark on his new life, and his mind was made up: He wanted to marry Susan Luhrs. Both decisions were daunting in themselves, but taken together they were perhaps less so. As he boldly ventured into the unknowns of the artist's life, he felt braver with the prospect of having a loving companion by his side. Furthermore, he had reason to speculate that he would be in a better position to ask for his father's financial support—should the need arise—as a married man. On March 27, fully confident that Susan would accept his proposal, he sent his father a telegram: "If I marry next week could you give any financial assistance in the next five years if needed," adding "purely hypothetical."[1]

Though no one in his family had yet met Susan, Walter promptly answered, with some reserve, "income much reduced last two years but can assist in a limited way."[2] With that, George called Susan long distance in Illinois, and proposed. When she immediately said yes, he pressed her to come to New York so they could be married right away.

Susan had her own reasons for acting quickly. She was dying to get out of Quincy, and from under her parents' watchful gaze. Conversations at home about her future had become unbearably strained. In those financially stressed times, they hesitated to pay for Susan's piano lessons without a clear career path in sight. Susan herself was not at all sure that she was worth the expense. "I have a certain amount of feeling, but a lot of me is bluff," she had confessed to George. "What if there isn't any talent?" But of one thing she was sure. Whatever talent she had would never emerge under the stifling conditions of home. Perhaps as much, if not more, she felt the prospect of her self-worth in being George's wife and partner, and she was not willing to risk losing her chance with him. Marriage would engage her in his artistic development, and would make her whole. "What women give men, I have a lot of faith in it," she wrote to him, adding hopefully, "you have confessed yourself that a lot of your painting is part me."[3] So, against her parents' pleas to postpone the wedding until June, Susan hurriedly packed her bags and caught the next train east.

George's parents were no less concerned about the precipitous manner of their wedding plans. He assured them that even though the final decision was quite sudden, marriage "had been in the offing" for some time. "Once we had made up our minds we didn't see any point in dallying," he argued, "nor did we think of the wedding as a great event in itself." Eager to get on with their married life, he explained, "the less to do about it, the sooner one could get started on a new phase of life. Let the celebrations come after we have achieved something . . . the future is yet to be conquered and we shall conquer it together instead of singly."[4]

And then he did his best to describe his new bride in the form of a list of some "particulars" and a sketch of her background, a report that was frankly reserved in its praise. Susan was "very musical," and a "fairly good actress," and "very appreciative of literature." He admitted that her scholastic background lacked the solid foundation of the Eastern establishment he had come to know at Groton, and that she held

no degrees. He felt the need to mention that her grammar was "bad."[5] But she was from a good family of German American stock, certain aspects of which would speak to his father's engineering interests and Yankee spirit—her maternal grandfather was the inventor of the safety break in elevators, and her father's father was a German wagonmaker.

George and Susan were married in New York in the interdenominational Riverside Church, in Morningside Heights, on April 3, 1933, a Monday afternoon, with just three witnesses: his cousin Katherine Landon and two friends of the Luhrs family from Quincy. Their modest honeymoon consisted of a brief stay with George's former student Frank Keppel and his family at their country house in Montrose, on the Hudson River, followed by an overnight visit to Schenectady with George's aunt Minnie and uncle Rob. In mid-April they returned to the Groton campus, so that George could complete his final months of teaching.

True to form, the Peabodys welcomed the newlyweds warmly, with a small dinner party with other faculty "complete with a miniature wedding cake." The couple moved into a spacious apartment at the far end of the infirmary on the ground floor, where Mrs. Peabody, with typical thoughtfulness, had placed flowers all around. As George proudly reported to his parents, the apartment had "a huge sitting room, about thirty feet square, with four large windows and a fireplace, a kitchenette with electric range, a little dining room, spacious bathroom, bedroom and dressing room, besides a vast basement to put junk in."[6] The school provided linen as well as a laundry service and midday dinners. As a wedding gift, Walter sent a check that made "the future look considerably more secure," George said in thanking him.[7] And so their married life began.

News of the young history teacher's marriage to the blonde beauty spread quickly across the all-male campus. George's student Louis Auchincloss remembered Susan as a gorgeous creature. A glimpse of her in passing or, better yet, to encounter her at close quarters in the dining hall was enough to make a young man's day. With the

newlyweds' bedroom window on the ground floor, George was careful to keep the curtains drawn at night. To some, Susan made an impression as a "radical girl from Greenwich Village,"[8] and at least one student detected a hint of contempt for the smug faculty wives and the spoiled prep school boys who now surrounded her. But George's reports home to his family describe a contented bride, all in all. Susan was practicing the piano for the school concert, making marmalade, and learning lithography so that she could make prints of his drawings.

IN JUNE, after packing up the Groton apartment, they sold George's 1929 Ford for twenty-five dollars and headed to coastal Rumsen, New Jersey, to visit Louis Auchincloss and his family, "just lazing for the few days before we sail," he wrote to his father.[9] George intended ultimately to make New York his "headquarters," but he and Susan planned to spend at least a year in Europe, based in Paris. Eve Vogt did her best to prepare him for a different Europe from the one he had known just three years before. The economic and political climate had changed radically, especially in Germany. "You can't imagine what Germany is like now, and München especially," she told him; "everything is so sad and depressing, and what Paris will be a year from now, nobody can guess."[10]

On June 30 they sailed from New York with the American Merchant Lines, arriving ten days later in London, and headed straight for Scotland to spend the month of July. Anticipating meeting the Rickeys for the first time, Susan wrote to Grace and Walter of her excitement at the prospect: "to acquire such a large new family in one leap is quite wonderful—and if you are any like your George, I shall love you at once."[11]

Arriving at Clarendon, George found the scene all very much as he had left it, though he was struck by how much his younger sisters had grown up in the intervening three years. The Scottish scenery seemed more beautiful than ever, and he was eager to show Susan the

sights. Fortunately for them, the weather was kind. Susan was favorably impressed with the Rickey family in every way, and she and Walter took a special shine to each other.

In mid-August they set off for Paris to find a place to live and work for the next few months. They bought a tandem bicycle and toured the city and beyond, eventually finding a studio apartment to rent in Montrouge, in the southern outskirts of Paris, which was becoming a popular alternative—cheaper and quieter—to Montparnasse. At their little house at 18 rue Périer, George organized his studio on the ground floor and set to work. No longer as anti-American as he was on his first visit to Paris, George was included in a group show of American artists and actively acquainted himself with others.

While George painted, Susan was left to puzzle over her own creative pursuits. These were not as easily come by. She had her passions—music, tapestry, gardening—but without a piano, or a loom, or a garden, it was difficult to know where to begin. While George was content to paint for hours in the privacy of his studio, Susan felt excluded.

She threw herself into the tasks of homemaking and hosting friends. Much of their social life revolved around studio visits with other artists. Every Friday afternoon they held an open house or a tea, welcoming friends and acquaintances for an informal hour or two. Susan was delighted that the young men brought a *"petit bouquet"* of mimosas, which brightened up their little house. When George's sister Jane arrived from Scotland, they threw a small dance in the studio, with dinner upstairs.

"We have met a number of American painters," George wrote to Endicott Peabody, "although only 10% of 1929's Americans are still here."[12] As Eve Vogt had warned him, there was a noticeable change in the air since his earlier sojourn in Paris. The flamboyant 1920s generation of American expats lived more quietly or had returned home. Under the economic pressures of the time, a migration had begun in the other direction. Back home, Prohibition had been lifted and rents

were cheap whereas Europe was in the throes of turbulent political times. The Roaring Twenties had tempered into the anxious and creatively cautious 1930s.

Hitler was appointed chancellor of Germany in January 1933, and a subject of heated debate throughout Europe. This strangely charismatic figure, promising to rescue Germany from its economic woes and its diminished political power since the Great War, riveted the attention of Europeans everywhere, while Americans both at home and abroad watched at a tentative distance, not quite sure what to make of him. Susan had learned that her distant relatives in Germany were "all raving about the wonders of Hitler."[13] George reported to the Peabodys that he had run into three recent Groton graduates at the American Express office in Paris who, having just cycled through Germany and Austria, had become "ardent Hitlerites, on the grounds that he was giving Germany something to live for, even at the expense of her culture."[14] George's Oxford classmate Reinald Hoops had returned home to Heidelberg and was observing Hitler at closer range and with some reservations. Hoops had, in fact, joined the National Socialist Party in 1927, while still at Oxford, even though "in general I don't like any party and more or less hate politics," he told George.[15]

The newlyweds found themselves in a kind of diminishing capsule of an earlier era in Paris, as they sought out some of the luminaries who had helped to fashion its previous glow. Most of all they were determined to meet the legendary Gertrude Stein and see her collection of modern paintings. With a letter of introduction from a friend in Boston, they awaited an invitation. A few days later a little note arrived from Alice B. Toklas telling them when they could come. At the appointed hour they arrived at 27 rue de Fleurus, where the diminutive figure of Toklas appeared to show them the pictures, while Gertrude, they learned, was still in bed. Few but close friends had visited in recent years, but Toklas was the perfect guide. Amid the comfortably worn old-fashioned furniture and avant-garde art, she explained the history of every picture, densely stacked one above the

other from halfway up the wall, and faithfully quoted what Miss Stein would say about each one. Following the visit, George wrote to his mother of his enthusiasm for Stein and Toklas: "[I]f you get a chance beg, borrow, buy, or steal *The Autobiography of Alice B. Toklas* by Gertrude Stein."[16]

This historic visit led to another, to Gertrude's brother Michael Stein at his modern house Les Terrasses, designed by Corbusier in 1927, in Garches. Their aim in visiting the Villa Stein-de-Monzie was ostensibly to see the Steins' collection of paintings, but George was struck by something more important to him in the long run— the experience of the building itself, of moving through its windowed interior spaces and up and down its ramps. "I realized that the form didn't need to be a closed mass but could be a series of points or lines around which the mind makes an envelope," he later reflected.[17]

As fall turned to winter, the newlyweds considered a trip to Spain to see the sun again, but worried about the political climate there too, with the rise of the right-wing Nationalists against the Republican Party then in power. A civil war was brewing. "We think that America is the safest and calmest and most hopeful nation to go to," wrote George to Endicott Peabody, "but we are having an awfully good time in Europe and don't want to leave quite yet."[18] Susan reported to her mother-in-law that "George and I are thinking of staying here another year—we love it so."[19]

As a young art student in Paris, *la vie bohème* had been very much a part of George's emerging identity. His three years of teaching history at an American boys boarding school had perhaps tempered but not completely diminished its effect on him. A significant aspect of his Paris enlightenment meant that a woman must be emancipated, in the way of his former Swiss lover Eve Vogt, and a man free to roam. He firmly believed this to be the essence of a modern relationship.

Apparently agreeable to George's wish for sexual freedom from the start of their marriage, Susan sensed an attraction between him and an American friend of hers and did not discourage him from acting on it. But when the three of them made a trip to Salzburg, Susan realized that she had overestimated her tolerance for sexual freedom. When he acted on her permission, she became hysterical, and her cries could be heard all over the little inn where they were staying. At five in the morning, she headed for the train station to return to Paris. After a protracted struggle, George managed to dissuade her from leaving, while the other woman more calmly offered to leave instead.

As if a test of her emotional strength in the face of George's brutal honesty, once they had all returned to Paris, Susan took the further risk of suggesting that the three of them indulge in a ménage à trois. Whatever prompted the idea, George, for his part, did not warm to it. But when Susan insisted, he finally agreed to what he could only call an "attempt," which he found unbearable. Soon afterward the other woman took off for Spain, leaving the couple to grapple alone with their personal issues. George felt that the problem was not the third party as much as their own relationship and the deep differences that were ever more evident between them.

It was hard to talk. "I could never know in advance if you were going to snatch a discussion off the rational plane into the emotional, thereby leaving me powerless to continue," George later summarized their relationship in a letter to Susan. "Your talent for misunderstanding what I was trying to say further narrowed the field I had in common with you."[20] This narrowing of the common field had much to do with the differences in their education, but equally in their character. Susan's struggle to articulate her point of view and to recognize in George's the difference between a plain statement and a metaphor made arguments between them all the more painful. In Susan's response to his efforts to explain himself, George found his words twisted and his meaning distorted because she didn't understand, or

didn't want to. In Susan's attempts to reach his core, she was continually thwarted by his rationality and emotional distance. At the height of her frustration, she responded by screaming and hurling things at him.

On a bicycle trip in Spain and southern France they hoped to heal the wounds of Salzburg and its tortured aftermath. The beach at San Sebastian was warm and soothing, but too much rain fell for them to enjoy Biarritz or Bordeaux, and they canceled their plans for Poitiers and Chartres.

Back in Paris, George suggested that they separate, with the prospect of splitting up altogether. "The fear of another outburst was ever present and made life miserable," George later confided to his mother.[21] He stayed in Paris and worked in his studio while Susan took off for Trouville for a break. They agreed to book passage to New York separately, and from there Susan would head to Chicago to spend the fall, and they would meet again in New York in January to try again. But first, Susan wanted to visit the Rickey family in Scotland to say good-bye.

In May, George and Susan flew from Paris to Croyden on a brand-new airplane designed by the Short Brothers for Imperial Airways— the Scylla land plane—a larger and faster version of their earlier Kent Flying Boat, with space for thirty-nine passengers and the luxury of a dining room. With a set of four propellers on a horizontal bar above the fuselage, the Scylla was a modern curiosity with a striking resemblance to some of George's kinetic sculptures, still several years in his future.[22] Its sophisticated engineering would have been of great interest to his father, as well. Walter Rickey was at the airport to greet them on the other side of their historic flight.

The photographs of their meeting on the tarmac tell more than words can say about the triangle that was about to unfold among Susan, George, and his father. Walter Rickey poses with his daughter-in-law, her arm tucked snugly in his, beaming at him like a bride on her honeymoon, while he gazes right into her eyes. By contrast, in

a photo of the newlyweds, George looks straight ahead, windswept and preoccupied, while Susan meets the photographer's eye, all innocence and charm in her chic little hat. From there, the couple went their separate ways: George to visit Oxford classmates in the South and Susan to the home comforts of Clarendon and his family.

From Susan's nervousness, Grace Rickey immediately suspected that the marriage was under strain. After a couple of days at Clarendon, Walter took Susan aside for a confidential chat. At first she denied that anything was wrong, but eventually she weakened under the pressure of his bulging blue eyes and obvious sympathy for her side and confessed the truth. To preserve the intimacy of their talks from Grace, Walter then invited Susan on a little fishing trip, just the two of them. Walter suspected George's infidelity and told Susan about his own temptations to stray in the past. But he was determined to preserve their relationship. He related a story about a friend whose wife had faked a pregnancy in order to save her marriage, and it had worked, and he suggested that Susan do the same. Susan was at first shocked at the idea, and said she could never go through with such a plot. Furthermore, she had been advised since an operation some years before that she could never bear children, as George was apparently aware of. A few days later she left Helensburgh to catch her passage home. But after missing her boat, perhaps intentionally stalling for time, and returning again to Scotland, she eventually came around to Walter's idea, and his assertion that her apparent inability to have children would make the ruse all the more convincing and effective.

Meanwhile, George was making the rounds in the South, visiting Leonard Snow and his family in Croydon and George Lyward in Kent and in general catching up with old friends. He also attempted to connect with his father when he passed through London on a business trip, to explain his marital situation in his own way, but Walter dodged his aim. George suspected that Walter and Susan were conspiring somehow, and he was sure that Susan wasn't telling Walter the whole truth. In his own defense, he wrote a five-page letter to his

mother, detailing the demise of the relationship from his perspective, and placing the onus of infidelity squarely on Susan's shoulders. It was she, after all, who proposed the ménage à trois; it was she, he said, who encouraged his liaison with the other woman.

Soon afterward, Susan delivered to George the surprising announcement of her pregnancy, forcing a conditional reconciliation of sorts. Further reinforcement came from Walter, who promised to double George's allowance if he remained married to Susan. At the end of a muddled summer, Susan and George booked separate cabins on the same ship back to New York and saw little of each other on board. Arriving in early October, George stayed in New York while Susan left for Illinois, ostensibly with the intention of staying there to have her baby closer to home. Three months later, she summoned George to Evanston, where she had once worked as a nurse in a hospital. There she had visited a certain Dr. Smith, who apparently owed her a favor and was willing to issue a false statement, in writing and in person, that her pregnancy had ended in a miscarriage. George believed them, peace was restored, and in January 1935 they returned to New York to live together again.

8

New York

GEORGE AND Susan spent the winter of 1935 in a small apartment on East 72nd Street. While George pursued his painting, Susan found work at the J. Walter Thompson advertising agency, thanks to her husband being on friendly terms with the boss, Stanley Resor, whose son he had taught at Groton. She started at the bottom of the ladder, as a secretary at twenty dollars a week. Her relationship with George seemed to be mending, and Susan, in retrospect, would say that it was the happiest period of their marriage. All the while, however, she kept her secret, afraid to confess the truth that might destroy their tentative peace.

In April they moved to 138 East 39th Street, to a basement flat with a garden. Susan was delighted with the location—just four blocks from the J. Walter Thompson offices, in the Graybar building—as well as the domestic prospect of gardening to unite them at home. Together they plowed up piles of weeds, fertilized the earth, and planted a few seeds. In May they were beginning to see the fruits of their labor, as blades of grass shot up along with the first signs of radishes and

nasturtiums, and the tangled wisteria vine began to bloom. Morning and evening they walked around their little garden feeling proud of their progress.

George exhibited some of his paintings in a group show at the cooperative Uptown Gallery—a townhouse at 249 West End Avenue that drew the emerging talents of Philip Evergood, Paul Cadmus, Alfred Maurer, Theodore Roszak, Mark Rothko, and Adolph Gottlieb. Run by a Russian émigrée named Rosa Persin, this was one of the few galleries in New York where young and little-known American artists could show their work, and despite the diversity in style and approach, they gathered there in their mutual need for community, recognition, and survival. George's work was included in one of the gallery's group shows in 1935. His painting of water lilies was singled out by one critic for its "fine resolution of forms in decorative design," and a nude portrait titled *Dolores* was described as "soundly and sensitively modeled."[1]

The Uptown Gallery show added a note of optimism to George and Susan's new life in New York, and the two looked forward to showing off their new digs to Walter, who would be coming over to New York on Singer business that spring. "We are awfully glad to hear that you are coming over, and so soon," George wrote to his father on May 4, and promised that they would be down to meet him at the boat.[2]

Just a few days later, they received a telegram from the head of the Singer headquarters in New York with alarming news: Walter Rickey had been in a car accident outside of Paris and was seriously injured. The head-on collision involved a heavy Voisin, a French luxury car in which he was riding with two other passengers, a French engineer and "another friend." Apparently, Walter was on his way to visit the new Singer plant at Bonnières before sailing for New York. Rushed to a hospital in Mantes, he had had a good night's sleep and his progress report was favorable. Grace Rickey was on her way to Paris to be by his side. Over the next few days, Walter's condition was reported to be stable or improving, and he was moved to a hospital in Neuilly.

On Monday, doctors there considered him "out of danger."[3] But relief in this news was brief: Two days later they learned that his brain had swollen and he had died in a coma. He was sixty-four.

Deeply shocked, George immediately sent a telegram to his mother to ask if he should go to France. He also wired his sister Emily in Grand Rapids, where she had married an American bacteriologist, Percy Phelps, and where they were both working for the Michigan Department of Health. George urged her to come to New York at once and be ready to sail on the *Majestic* later that week if they needed to or simply to be there to greet their mother in New York. Grace advised them to stay put. She would be coming over in two or three weeks, when Walter's embalmed body, then in the care of a Paris undertaker, would be shipped to New York for funeral arrangements. A small memorial service was held in the American Church on the Quai d'Orsay on May 24. In early June, Grace arrived in New York with Walter's body and, with George's help, made arrangements for a funeral in Schenectady, where they would find the greatest number of family friends and relatives to share their grief.

WITH NO warning, George, not quite twenty-eight, was thrust into a position of responsibility for his entire family in the wake of his father's sudden death. As the only son, and furthermore, as the only one besides Emily to have moved back to America, his instinct to advise, direct, and protect his mother and sisters in every way possible came quickly to the fore.

To begin with, he would be the one to inform his sisters about what to expect from their father's estate. Walter Rickey had been well paid as a Singer director, but his premature death caught the family financially off guard. Also, without him, they would no longer be able to call the grand house of Clarendon their home, and without Walter's employment at Singer, there was no reason to remain in Scotland. What this meant was an unexpected homecoming to a place they

hardly knew. It also involved packing up more than twenty years of domestic life in Scotland.

Grace would be living on four thousand dollars per year, considerably less than she was accustomed in the way of supporting her family; however, she established an irrevocable trust for her children so that each would be given an allowance enough to get by, and if they chose to work, they would be that much better off.

"I think you would all do well to forget about jobs for the moment and concern yourselves with feeling your feet over here," George wrote to his sister Jane in June. New York City was not the ideal place to make a start, he told her: "It is impossible to become acquainted with people here." From his own experience, New York was manageable thanks in large part to the personal connections he had forged at Groton, and which his sisters lacked. He also warned of the overwhelming size of the city, its high unemployment rate, and how exhausting it was to get around, "quite different from London or Paris," which were easier to navigate and much friendlier, too. He recommended they all begin on the familiar soil of Schenectady, where they would find "a large group of people eager to meet you."4

He further advised the family on the question of what to bring over and what to leave behind, to consider the relative value of everything they transported, and to remember that they would be moving into a house much smaller than Clarendon. Wardrobes were unnecessary, he told them, because in America, houses have closets. Leave all his old clothes behind; sell the workbench but bring all the tools. He also ordered them emphatically to "bring *all* of Papa's personal effects—preserve all papers, both at home and what he had in his safe at the factory, meticulously."5

The regular allowance that George would be receiving from his father's estate gave him a level of comfort and stability few artists were lucky enough to count on. But George was conservative with money, Susan's income from her various jobs was both modest and unpredictable, and making ends meet was a constant concern. An opportunity

presented itself when George encountered a former Groton student who was working at *Newsweek*. George had entertained him by taking a blue pencil to an article published in the magazine, as if he were correcting a school paper. When the student took it to his boss, he promptly hired Rickey as a copy editor. He was grateful for a job, but three months later, Vincent Astor bought the magazine and soon reshuffled the staff—George was laid off.

FOR AN artist, these were difficult times to sell, but there was a positive side to the Depression as well. In many ways the 1930s were a boon to artists, for along with FDR's New Deal came a surge in government funding for the arts. Under the Works Progress Administration (WPA), the Federal Art Project (FAP), which began in 1935, provided gainful employment for artists and craftsmen, at the same time fostering national and regional pride. Amid the economic adversity that left no one untouched came an egalitarian spirit, shining a light on the common experience of Americans, and even though America represented the apotheosis of modernity, its preindustrial past was suddenly of value.

Van Wyck Brooks's influential 1918 essay in *The Dial*, "On Creating a Usable Past," encouraged Americans to plumb their cultural past not for the masterpieces, but instead for the more homespun tendencies that united them, to search for meaning not only in the big cities but in the small towns, too. There was a Brooksian "usable past" in the multitude of material evidence of America's vanishing culture and traditions, and a new urge to document it as a permanent record. To that end, the Federal Arts Project sponsored the *Index of American Design*, a project that employed several hundred artists across the country to illustrate examples of American decorative arts, tools, and artifacts that defined an earlier way of life.

The Federal Writers' Project (FWP) assigned thousands of writers and illustrators in the creation of guidebooks for each of the forty-eight

states in the union, directing travelers to every last monument and historic site, while at the same time government projects improved the highways and encouraged domestic travel to visit them. The Farm Security Administration (FSA) dispersed photographers into the field to document the plight of sharecroppers and migrant farmers, from the hills of Appalachia, to the Deep South, to the West Coast. A massive program for public art projects employed artists to paint murals in municipal buildings, schools, public libraries, post offices, and hospitals across the country. Some artists continued to work in their studios, and received relief checks in exchange for donating their work to public buildings. Under FDR's New Deal, artists were considered a part of the national workforce, as worthy of government funding as were the builders of roads and bridges.

Like many of his contemporaries, George was encouraged by these developments, not only in practical terms but in the ideological sense as well. "For two centuries art has become more and more a luxury," he wrote to Endicott Peabody, "more expensive, and more an opportunity for speculators. Artists have either become very rich or very poor, and art has lost touch with the people as a whole." Government patronage was a step in the right direction, he believed, as "it tends to take the artist off a pedestal."[6] The ideas George expressed in his letter to Peabody were formulating a guiding philosophy as he entered his first serious phase as a professional artist.

In New York, George visited galleries uptown and down, keeping up with his contemporaries and ever alert to opportunities to show his work. Despite hard times and slow sales, the number of galleries specializing in modern art was on the increase. In the 1930s, New York was rapidly gaining credibility as a leading international art scene and the gateway between Europe and the rest of America. The majority of the thirty or so galleries surviving the Crash of 1929 showed old masters, but there was a growing interest in American modernists. The art-going public had matured since the shock of the Armory Show in 1913, when the idea of avant-garde made its first appearance in the

form of Marcel Duchamp's *Nude Descending a Staircase*, Matisse's *Blue Nude*, and other challenges to nineteenth-century tradition and to the very idea of what art could be.

By the 1930s, cultural cross-pollination had taken its effect with the return of many American artists from Paris. Meanwhile, European artists, dealers, and scholars fleeing Nazi Germany and other fascist states were changing the scene and invigorating the modernist spirit in New York. At the same time, they imported their fascination with American culture and gave it a new vigor.

Alfred Stieglitz, an early champion of European modernism and photography as an art form, was the grand old man of dealers in modern art. In 1929 he had opened his third and last gallery, An American Place, on the seventeenth floor of the Shelton Hotel, at the corner of 53rd Street and Madison Avenue. His lofty perch seemed to signify his Olympian achievements, and he was famously unapproachable to all but a circle of American painters, such as John Marin, Marsden Hartley, Arthur Dove, and Georgia O'Keeffe.

The Downtown Gallery, at 113 West 13th Street, established by Edith Halpert in 1926, was a favorite stop of Abby Aldrich Rockefeller, one of the founders of the Museum of Modern Art. It also served others interested in contemporary American art as well as the new passion for American folk art, for which the astute Halpert had carved her niche. Also part of the burgeoning downtown scene was a museum on East 8th Street, opened in 1931 by the artist and collector Gertrude Vanderbilt Whitney after the Metropolitan Museum rejected her offer of her modern art collection. Herman Baron in 1932 established the American Contemporary Artists Galleries—the ACA—on Madison Avenue with founding artists Stuart Davis, Yasuo Kuniyoshi, and Adolf Dehn, adding strength to the melting pot of American artists with new arrivals from abroad.

Perhaps no artist represented this cross-pollination taking place in New York at that time better than Alexander Calder. He had recently returned from Paris, with strong connections on both sides

of the Atlantic. At the time, Calder was evolving from the one-man miniature-circus performer to an abstract sculptor of moving parts. These highly original moving sculptures would evolve into the classic mobiles for which he became famous, with their floating, bobbing forms in space. Although Rickey may have been intrigued by Calder's work, it would be some time before he would derive any inspiration from his playful experiments with form and color. For now, he was actively shedding his European influences, developing his technique as a realist painter, and searching for that meaningful theme and purpose for his art in America that Carl Zigrosser had advised him to find. Social Realism was emphatically on the ascendant, along with the egalitarian spirit of the day, and Rickey was ready to embrace it.

9

Olivet

By the spring of 1937, Rickey was growing restless as an independent artist in New York and eager for an opportunity to be a part of the public art projects that were proliferating across the country. He was not quite poor enough to qualify for a Federal Arts Project grant, but there were options. Through a former student from Groton, Francis "Frank" Keppel, he had come to know the boy's father, Frederick P. Keppel (also called Frank), who was president of the Carnegie Corporation. Since 1923, Keppel had directed Carnegie's program of awarding grants to stimulate the arts nationwide in a variety of ways—endowing professorships, funding museum-building expansions, supporting loan exhibitions and educational programs, and awarding individual grants to artists. Where government patronage for the visual arts fell short, the Carnegie Corporation stepped up.

For George Rickey, the name "Carnegie" had a special ring to it, with associations that dated back to his school days, when he had visited the Carnegie Library in Glasgow. The Scottish-born Andrew Carnegie became a titan of the American steel industry and also a

prominent philanthropist, funding the spread of public libraries across the country. How fortunate for George that he now found himself with access to the top of Carnegie's philanthropic organization. The challenge was where to find, or if necessary create, a position for himself worthy of a Carnegie grant.

An important aspect of the Carnegie program for which Rickey's experience as a teacher made him especially qualified was art education. Collaborating with the Carnegie Corporation, Eric Clarke, of the American Association of Colleges, conceived of an artist-in-residence program, for which Rickey made a suitable test-case candidate. Despite the fact that he had never taught art in a school, he had been a teacher, and with his skills as an artist he could parlay the two into a credible profile that might take him almost anywhere.

In April 1937, Rickey followed up on a lead at Olivet College, in Olivet, Michigan. A small liberal arts Congregational college founded in 1844 in a prairie town consisting of about thirty houses, a grocery store, a garage, and a café, Olivet was an unlikely place to host an innovative arts program. But in the 1930s, due to its visionary president at that time, Joseph Brewer, it became an oasis of avant-garde culture and progressive education in the conservative Midwest. Brewer was seeking an artist to add to the cultural life of the college and had expressed this need to Eric Clarke, who promptly recommended George Rickey. A few meetings ensued among Clarke, Brewer, and Rickey, and in July the funds came through to support Rickey as an artist in residence at Olivet.

Joseph Brewer was the son of a wealthy banker in Grand Rapids. After graduating from Dartmouth College, he went on to earn a master's degree in English literature from Magdalen College, Oxford. Following that, he worked as personal secretary to John Strachey, legendary editor of The Spectator, and came to know many leading writers in London. Forever after he spoke with a slight English accent that matched his sartorial style—bespoke three-piece suits, a gold watch chain across his trim midriff, and small round silver-rimmed

glasses blending seamlessly with his carefully brushed silver hair. He had lived in Paris in the 1920s, consorted with many of the ex-patriot artists and writers there, and developed an expansive taste in the arts in general. Returning to America, he established the publishing house Brewer, Warren, and Putnam, and while living in New York, he shared a dilapidated townhouse at 312 East 53rd Street with the writer and social activist Muriel Draper and her son Paul, a modern dancer. The Drapers enjoyed a broad acquaintance with the art, musical, and literary sets in New York and abroad, and at Muriel's weekly salons, Brewer hobnobbed with the dance impresario Lincoln Kirstein and the photographers Walker Evans, Carl Van Vechten, and Man Ray.

An unlikely fit to lead a small Midwestern college, in 1934 Brewer felt the pull of his Midwestern roots and the opportunity to spread his influence into the realm of education when he became Olivet's president. During the summer of 1937, Brewer held a writers conference—one of the first in the country—with Katherine Anne Porter, Allen Tate, and Caroline Gordon. At the same time, he was able to persuade several prominent writers to take up residence at the college for a few months. Ford Maddox Ford, in 1937, was Olivet's first writer in residence. Sherwood Anderson and Carl Sandburg arrived the following year; and on her lecture tour through the states in 1934–35, Gertrude Stein, with Alice B. Toklas, stopped at Olivet for several days for an informal visit with their good friend Joe. "We all sat around Gertrude Stein's feet and heard her pontificate," remembered former Olivet student Robie MacCauley of their historic visit, "At that time Olivet was very much into semiotics, it was the intellectual rage at the time . . . considered the wave of the future . . . it was kind of a wacky school with a lot of artists and writers around and a lot of fun."[1] Except for Ford, who was English, the literary trend at Olivet was all American in its spirit and imagery, from Anderson's *Winesberg, Ohio* to Sandburg's *Chicago*, with the Midwestern prairie as quintessential regionalist backdrop.

* * *

As GEORGE prepared for his move to Olivet in the fall of 1937, Susan was fully expecting to join him, but after visiting the college together, George made it clear that he did not want her there. For George's part, the Olivet residency was exactly the kind of opportunity he sought to make a break from his troubled marriage. There were times, he felt, when Susan's behavior in social circumstances had been detrimental to his career. She was unpredictable, and sometimes acted inappropriately at parties with important supporters, such as the Keppels and the Resors. At home, she resented his need for privacy and was jealous of his long hours of work with his models. He had come to dread her knocks on his studio door, and he suspected her of prying into his letters and personal writings. As George withdrew emotionally, Susan had screaming tantrums that sometimes erupted into physical violence; in her rage, she threw dishes and furniture at him.

In fact, George and Susan had already spent several months of that year living apart, and it was becoming a habit. Susan's job at J. Walter Thompson had lasted but a year, and was followed by an undiagnosed illness that led her to spend the winter of 1937 with her sister and brother-in-law in West Palm Beach, quietly working at sewing projects and hosting George's sisters for brief holidays in the sun. Back in New York in better health that spring, she took a part-time job at the ACA Galleries for Herman Baron. This made for the excuse George needed for her absence at Olivet.

JOE BREWER had ambitious plans for his little college. He boldly restructured the curriculum, fusing the Oxford tutorial system of his own traditional background with the progressive movement of the time and the similar experiments of other small liberal arts colleges, such as Antioch, Reed, Bennington, and Sarah Lawrence, where higher education was above all a process of self-discovery. Progressive

education was given a lift in that period between the wars. The Depression had leveled society and questioned the moneyed establishment, responsible for the present crisis. In addition, the threat of Fascism then spreading in Europe made a liberal education an urgent priority, and gave the ideas of John Dewey—that is, to fight totalitarianism at its core, to nourish independent young minds, and to create a conducive atmosphere for differences of opinion—a new relevance.

In modern America, change was so inevitable that an older generation could not possibly prepare the younger for a life in the unknown future by the old one-way method, by which knowledge was handed down from the absolute authority at the top into the empty vessel of the student below. Education was to be a collaborative venture between student and teacher.

At Olivet, Brewer silenced the bells, broke down the classroom, and dispensed with textbooks, examinations, and grades. Students were assigned to tutors in their fields of study to work at their own pace. Conversation was the essence of learning, Brewer believed, and with a student population of less than three hundred, and a student–teacher ratio of ten to one, he was able to encourage his students to experience it at its best. In this spirit he brought a sense of occasion to every ritual of the day. Everyone dressed for dinner, and tea was served in every building at four o'clock, so students could interact informally with faculty, wrestle with ideas, and encounter points of view that might challenge their own.

With his own traditional Oxford background, combined with the liberal outlook of an artist, Rickey found himself much on the same wavelength as Brewer. He also enjoyed the company of the very interesting faculty Brewer had gathered to his cause, beginning with writer-in-residence Ford Maddox Ford, with whom he shared a delicious home-cooked meal, with refreshingly international flavors, soon after his arrival. Janice Biala, a young artist who was living with Ford, sautéed fresh tomatoes à la Provençal while Ford produced a chutney, and George was impressed that this worldly couple happily drank the

local sherry. That Janice was a painter also greatly boosted his spirits, and they talked for hours about their favorite artists and the paintings and painters they "would die for."[2]

Rickey also had the sympathy of Harry Prior, Olivet's art history professor. They made for compatible colleagues working through the unknowns of their respective roles in art education—where they might collaborate and how to divide the tasks—and managed to work out an agreeable compromise between history and practice.

Rickey had very specific plans for fulfilling his role as an artist in residence. Rather than working alone in his studio with the door open to visitors, he wanted to directly engage students in a major project, to join in the spirit of collaboration that was the heart of the Olivet plan. What he had in mind was a mural, a team project of the artist and a group of apprentices. In Paris, during the first year of his marriage, he had learned the rudiments of fresco painting from an Austrian artist, and here was his chance to try it. Brewer agreed to his choice of a large mural at the entrance to the college's dining hall—a space of about three hundred fifty square feet—to conduct his experiment.

Full of anticipation, Rickey began recruiting students for the mural project soon after arriving at Olivet. Not surprisingly, the twelve or fifteen students who signed up expected Rickey to teach them the basic techniques of drawing or painting. "The first prospects of my mural project came in today," he wrote in his diary. "[T]hey are not very promising." One student aspired to become a commercial artist, another a kindergarten teacher, and a third an interior decorator. Plainly career minded, they seemed to have missed the mission of self-discovery and exchange of ideas that were at the core of the new program. For all Brewer's vision of a lively dialogue between faculty and students, they were shy and reluctant to speak up. Now on the spot with his students, his project, and his limited time frame, Rickey's challenge was, as he put it, "how to cure this mental inertia,"[3] to somehow demonstrate the purpose of art, to draw out of the students

whatever raw talent he might nurture, and to get them to see and feel for themselves.

With Brewer at the helm, Olivet was a bold experiment, one that did not always run smoothly or according to his lofty ideals. At the first convocation of the year, Brewer rambled on about Aristotle, Hobbes, Rousseau, and Hegel, quantum theory, and semiotics in what Rickey called "one of the most extraordinary attempts I have ever witnessed to talk deliberately over the heads of his audience."[4] For Rickey was above all a teacher, while Joe Brewer was not. Rickey was an intellectual, not an academic. His mission was to communicate, not obfuscate. Furthermore, as an administrator, Joe Brewer proved very difficult to pin down. George worried how prepared the college would be for the more practical needs of his mural project—the scaffolds, the plasterers, and the disruption of a public space for unknown lengths of time.

RICKEY'S FIRST task was to engage his students in the selection of a theme for the mural. One evening in mid-October, they gathered to discuss it over cider and doughnuts. They agreed that the subject matter should be something familiar and close to them, something they all understood. For some this meant football and dancing, but George persuaded them to embrace a wider field. He showed them examples of great murals of the past and gently guided them toward mural themes of the time—democratic visions of the common worker and of the local community. Eventually, they settled on the idea of agriculture and industry in the region; each theme would command its own stretch of wall to the left and right of the entrance to the dining hall. A third section, following the cut of the doors, would somehow depict the acquisition of knowledge: the essence of the college experience.

With their subject determined, Rickey dispersed the students into the field with their sketchbooks. A few traveled to the Oldsmobile factory in Lansing, some thirty miles away, for a whirlwind tour of the

plant, through crankshafts and fenders and the enormous steel presses that made them, which must have reminded George of the Singer factory he knew so well in his youth. To further inspire them, he took a few students on a field trip to the Detroit Institute of Arts to see the celebrated 1932 murals by Diego Rivera depicting the inner workings of the Ford factory—a monumental epic of tremendous spatial depth and dynamic activity. Other students explored the farm country surrounding Olivet, observing apple picking, plowing, planting, and grazing livestock. Rickey was glad to find that he could draw on their own intimate knowledge of farming and rural life in the area, and they were surprised at the value of their special knowledge and the interesting problem of giving it pictorial form.

Images in hand, the task was to assemble the various pictorial elements into a coherent composition. They scaled up the images by projecting them on the wall—one inch to one foot—and traced them onto paper, then shaded the composition in black and white to give them a sense of volume and overall composition. After squaring off the sections, they pounced the walls through the paper to show the outlines of the composition and where the sections would line up. By mid-February, Rickey started to feel that the project was working as he had first imagined it: a true apprenticeship.

The actual painting began in March, and the delicate process of true fresco technique. Professional plasterers came to prepare the wall for paint and Rickey also enlisted the help of any students who seemed eager to wield a trowel. It would require three layers of lime and sand plaster, the last coat applied to a small area each day, then quickly painting with pigment (powdered color) and water before the plaster dried—a physically and mentally taxing exercise. The process was full of risks that made him anxious. But once the painting was under way, the project became a spectacle of interest to the entire college community in just the way he had hoped it would. Up on the scaffold every day, students and faculty stopped to watch him at work, asked questions, and offered their opinions. He was certain that for some,

this event would mark the beginning of their awareness of art and its place in their world, with at least as great an impact on the college population as a whole as on those directly involved with it.

In time, a few of his students stood out. One was Bill Dole, a senior majoring in art. George noticed him right away as a serious young man with talent, "adept at rapid sketching and took down very good notes of postures, facial expressions, clothes, as well as the details of machinery and structure."[5] Though shy to voice his opinion in a group, Dole quickly had George's ear and proved to be a person with ideas and a sophistication that belied his background as the postmaster's son from small-town Angola, Indiana. His grasp of the project might easily have stemmed from a mural recently completed for the Angola post office, "Hoosier Farm," by Charles Campbell. Though George was technically his teacher, "I immediately began to learn from Bill," he fondly recalled years later. In his quiet way, Dole added a point of view; he "shed a revealing side-light, which brought the highs and lows of the subject into sharper relief."[6] He also focused thoughtfully and tirelessly on the work at hand like no other student.

OVER THE ensuing months, word spread through Michigan college circles of the mural project at Olivet. Visitors came from Detroit, Grand Rapids, Ann Arbor, and Kalamazoo. During that year at Olivet, Rickey was invited to Kalamazoo College, about an hour's drive west, to teach a course in portrait painting once a week.

That same year, in March, he received a commission from the Federal Arts Project to create a mural for a post office in the small town of Selinsgrove, Pennsylvania, with a scant six weeks to complete it. Having applied to the FAP for such a project some months before, he was in no position to turn it down, even if he wanted to. Here was another opportunity to hone his skills as a muralist. The mural was designated for a twelve-foot-high wall in the lobby surrounding the door to the postmaster's office. Due to the limitations of time and

budget, he would not work directly on the wall but instead on canvas that would then be adhered to the surface, which relieved him of some of the technical challenges he was facing at Olivet. For this project, he decided to try his hand at egg tempera paint, another technique he had learned something about during his post-Groton year in Paris. He also managed to find an ideal temporary studio nearby—a shuttered bank with a twenty-foot ceiling and plenty of daylight.

The postmaster suggested a historical theme that would include the town's founder, but after touring the area, Rickey proposed a sweeping vista of the Susquehanna River Valley farmland, with the local farmers at work in their fields, scattered houses, and church spires. In a style he sized up as "a mixture of Renaissance and Rivera," he depicted the lush valley of the Susquehanna, with its seasonal regeneration in a timeless cycle.[7] In its final stages, with the post office serving as his open studio, there was a steady flow of curiosity-seekers to his worksite.

Back at Olivet, Rickey was coping with the less predictable qualities of real fresco. He was pleased overall with the progress of the work, but unexpected setbacks kept cropping up. For example, a mysterious mottled bloom appeared in a portion of the sky; he scraped it off and repainted, only to have it appear again. "To be uncertain of what is going to happen over night to the day's work is too harrowing," he wrote in his notebook.[8] He wondered whether the sand-wash needed to be cleaner and finer grained, and if the plaster should be kept damp throughout the process. He debated these technical points with the plasterers, who were as new to the technique as he was. He consulted artists he knew in New York with fresco experience, such as Rico LeBrun and Reginald Marsh, to find out if there was any harm in letting the plaster dry. Marsh said no, but advised him to vigorously apply a steel brush to the area he would paint the next day and then wet it. "The steel brushing breaks the lime skin and the wetting restores some of the suction," Marsh told Rickey. He admitted, though, that his experience was not extensive, "so I hope I am not

leading you astray—good luck."⁹ Uncertainty was at the heart of Rickey's ambitious project, and he would work through every technical problem as it arose, wiping away a day's work, repainting, replastering, and soldiering through with an iron resolve to meet each head on.

Rickey's residency was intended for one year, but as winter turned to spring, he realized he would never be finished with his mural on time. The work interested him and he felt no desire to return to New York. He was refreshed by the sight of the rolling prairie and the big sky, but perhaps most of all by his unmitigated sense of purpose. With this distance, he observed that his artist friends in New York were easily distracted, as he himself had been, and that politics—of the world, or, more specifically, the art world—was ever on one's mind. Thus, he asked to spend a second year at Olivet, once again supported by a Carnegie grant, but this time with the college pitching in to the funding as well.

THE MORE George grew to appreciate the American heartland, the less enamored he was with his Midwestern wife. Over the Christmas holidays of 1937, he had returned to New York, but instead of living with Susan in their apartment, he chose to take a room in a hotel. The physical distance from his marriage that George had deliberately created had become a chasm he was increasingly unwilling to bridge. He was ready to give up on the marriage entirely, and had written to Susan to tell her so. Susan believed that he still loved her but in his cool, unemotional way was unable to say so. Despite often accusing him of cruelty in his candor, she chose to disbelieve that what he said was true. She was at work on a large tapestry, like Penelope waiting for Odysseus to return from the Trojan War. "It is so tied up with you that I find it very hard," she wrote to him, "Only by compelling myself can I go ahead—once at it, I forget you."¹⁰

In the spring of 1938, Susan headed for the Midwest to visit her family, and in April she arrived at Olivet to spend a week on campus

in George's absence, poised to surprise him on his return from a trip east. She was eager to see his work on the mural, and to learn what she could of her husband's life without her. "Needless to say I am still in love with you," she had written to him at Olivet. "You are really the only positive thing in my life. Neither can I deny that physically you have given me endless joy."[11]

Susan continued to hope for reconciliation, but George had moved on. Most of all he could not forgive her dishonesty about the false pregnancy and the conspiracy with his father to preserve their marriage with a lie. "We hadn't intended to permanently deceive you," Susan said, when she eventually confessed to George her secret with Walter, many months after her fake miscarriage. "Lying became too easy, a habit," she admitted,[12] and so had both of their sexual dalliances. Trust on both sides had broken down over the years, and George was quite sure that there was no way to gain it back.

In October 1938, while putting the finishing touches on his mural at the Selinsgrove post office, George wrote to Susan in no uncertain terms: "I shall never come back to married life with you," he told her. "Kindnesses toward you do not mean, as I believe you imagine, that I still love you." He genuinely hoped that she would be happier without him. "Your future happiness is going to depend, not on keeping hold of me, as you have been inclined to think, but on giving me up."[13]

10

Midwest

AT THE time of Rickey's residency at Olivet, he was among the very few artists to have served such a role on a college campus. The very idea of an artist in residence at a college was new, and it was something of a leap of faith for all concerned. This was not the same as the utopian retreats conceived in the pre-Depression days, such as the Maverick Art Colony, in Woodstock, New York, founded in 1905; the MacDowell Colony, in Dublin, New Hampshire, established in 1907; or Yaddo, in Saratoga Springs, in 1929, where the artist was liberated from the usual cares of daily life and given a sanctuary for work and contemplation in idyllic rural surroundings, with no particular obligation to the host. In this new arrangement, artists were dispatched as lone messengers into the uncharted territory of the college campus. As John Held described his experience at Harvard at that time, "I was in the same situation as the Tenderfoot in the West, who had never ridden before and was given a horse that had never been ridden."[1]

Along with this novel assignment came difficult questions. To what extent should the artist be considered a member of the college

faculty? How much and in what way should the artist interact with the students? Was the mere presence of the artist in their midst enough of a reason to fund the program, and if so, how to define the value of that experience? As the first artist in residence to be supported by a Carnegie grant, Rickey was pressed into service as the corporation's spokesman and reporter at large. To the few models that existed beforehand he gave careful study. The Midwest had been the domain of the so-called Regionalist painters who derived their imagery from the familiar soil of their rural background. Grant Wood, whose static, storybook pictures were rooted in his life on an Iowan farm, was on the art faculty at the University of Iowa in 1934, when he engaged a group of students in the execution of his mural "Other Arts" for the university library. With panels surrounding the grand staircase, the mural evokes a pastoral tale of rural prosperity and moral rectitude. Wood helped his fellow Midwesterner, the Kansas-born John Steuart Curry, obtain the first artist-in-residence position at the University of Wisconsin's College of Agriculture, in Madison, in 1936. Completing the Regionalist triad and preceding the other two was the Missourian Thomas Hart Benton, who in 1930 was commissioned to paint a mural called "America Today"—a rollicking collage of images of the city and its people from all walks of life—for the boardroom of the New School of Social Research, in New York City.

In the winter of 1939, the Association of American Colleges, in collaboration with the Carnegie Corporation, sent Rickey on a speaking tour of various colleges around the Midwest. Traveling through Michigan, Ohio, Missouri, and Kentucky and speaking to faculty groups, student forums, conferences, and the general public, he was trailed by newspaper reporters all the way. With his natural eloquence and passion for his cause, Rickey exuded an intriguing blend of the Midwestern born and Oxford educated as he preached about art as an amenity to everyday life. He spoke of the democratic spirit of public art then prevailing, of the great mural tradition harking back to the frescos of the Renaissance, and the importance of patronage. "That great

artistic flowering of the Renaissance resulted not because so many men of genius were born at that time," he said, "but because there was something for talented men to do."[2] Here, at hand, he suggested, was another kind of Renaissance—this time on American soil.

Art should not be "highfalutin," Rickey told his audiences in folksy terms, nor the exclusive domain of the wealthy elite, nor a commodity for speculation. It should be made for the public and affordable to anyone for private consumption. Paintings should be "cheap and plentiful," he lectured, rather than "rare and expensive." He spoke of the doubtful merits of artistic "originality"—that modernist obsession—over technical skill, and the value of collaborative work. "Individual artists aren't important," he said; "it's artists in the aggregate that are." He viewed artists ideally as a giant collective of talent working together and predicted a hopeful change in the air: "Artists are escaping dealers' caprices by banding together and selling cooperatively," and with that trend, "mural painting is being revived."[3]

Clearly, Rickey had taken the New Deal and WPA rhetoric to heart. With his husky build and windswept hair, he had none of the airs of the effete or the dubious morals of the bohemian. For the Midwestern audience, his down-to-earth-ness was made to order. He had shed the mystique of Paris and donned the cloak of Regionalism. He was feeling his American roots and rediscovering with newfound fascination the unique flavor of his native land. Although he had received his formal education abroad, at this point in his life, he declared, "I've learned everything I know in the United States."[4] Furthermore, he asserted the validity of the Regional style. "The American expatriates in Paris produced nothing significant, either there or on their return," he boldly wrote in his report to the Carnegie Corporation, "while Americans at home, painting their own backyards, seemed to have something to say."[5] In the wholesale rejection of his European background, he was transforming himself into an American artist of his time.

Rickey's philosophy of the 1930s went hand in hand with his new

interest in mural painting. Even as he invoked the values of a conservative Regionalist, his greater interest was in the muralists at the other end of the political spectrum: In the growing mural movement in America, the most powerful inspiration came from three Mexican artists—Diego Rivera, José Clemente Orozco, and David Alfaro Siquieros, known as "Los Tres Grandes." All were political activists and agents of the Mexican revolution, and afterward were sponsored by the Mexican government to educate the illiterate population about the values of the republic they had just won. All had a feeling for human suffering and a fundamental distrust of big business and capitalism. But just as mural commissions in Mexico became scarce, all three took up residence in the United States. The timing was right for their invasion, and they found themselves lionized by the art establishment as models of a politically charged public art: of the people and for the people. They thrived on controversy and confrontation, and at the same time gladly accepted the hospitality and sponsorship of a capitalist society they reviled.

In 1932, the director of the Detroit Institute of Arts, the German William Valentiner, discovered that Rivera was fascinated by the car industry. Because Detroit was its capital, he invited Rivera to create a mural about the city for the museum. Marxist revolutionary that he was, Rivera was able to view progress above politics, and could not help but be impressed by what he witnessed in the operations of the Ford Motor Company. After spending time at the Ford River Rouge plant, drawing car motors and the complex of machines and assembly lines that made them, Rivera conceived of an epic sweep through the story of man and the machine in twenty-seven panels surrounding the museum's Neoclassical courtyard. Its completion in 1932 was a major event. Some objected to Rivera's depiction of the Holy Family in modern dress, others to the fact that the museum had hired a Mexican instead of one of their own, but the mural's celebration of the city's industrial strength was undeniable, and it was above all a

positive message about American business when it was most needed, especially in Detroit, where the Depression hit harder and faster than in any other city in America.

Rivera had provided an inspiring example for Rickey's students at Olivet; it was Orozco, however, who was the exemplary artist in residence. The same year in which Rivera created the murals in Detroit, Orozco was invited to Dartmouth College, in Hanover, New Hampshire, to teach a class in fresco painting and lecture on art. While there, he proposed creating a sequence of murals for the college library. Orozco fastened on the idea that Dartmouth was founded to educate Native Americans, and he placed them at the center of his composition. Challenging the traditional mythology of American history, he told a story of confrontations and a clash of beliefs between colonial Europeans and Indigenous peoples and between industry and agriculture. Incorporating pre-Columbian myths in the story of the Americas, he depicted sacrifice, confinement, and destruction. Orozco spent two years at Dartmouth creating his monumental, twenty-four-panel cycle, "The Epic of American Civilization." In its unabashed rendering of political rage and violence, the images were impossible to ignore, crowding around the student or visitor with overwhelming force.

Soon the word of Orozco's epic work spread abroad. Many Dartmouth alumni saw the mural as critical of their country and of their education, and they wanted it removed. But the art department did not back down, and it was supported by members of the faculty who had observed this mysterious, taciturn man tirelessly at work on his scaffold. For that Dartmouth generation, Orozco's "impact on the community as a whole was great," wrote Rickey, and "the force of his personality and the sincerity of his expression conveyed more about the importance of art than dozens of courses in history and appreciation." For Rickey, it was the "artistic ferment" caused by the mural that mattered most in the long run.[6] It proved that art was relevant.

During and immediately following Orozco's residency, the number of Dartmouth students electing courses in art increased three hundred percent.

THROUGHOUT HIS nearly five years as an itinerant artist of the Midwest, from Olivet to Kalamazoo and eventually to Knox College, in Galesburg, Illinois, Rickey retained a studio in New York City on the top floor of 30 East 14th Street, just off Union Square. When he first moved into the studio, Kenneth Hayes Miller, thirty years his senior and a painter of the urban scene and a teacher at the Art Students League, was the only other artist in the building. But soon the studios began to fill up with younger ones, among them Arnold Blanch, Doris Lee, Yasuo Kuniyoshi, Morris Kantor, Harry Sternberg, Whitney Darrow, and Rico Lebrun. All had either studied or taught at the Art Students League, and all in their own fashion were politically minded Social Realists. They were a mixed bag of backgrounds and nationalities—Lebrun was born in Italy, Morris Kantor in Russia, and Kuniyoshi in Japan—but they were united in their endeavor. Like the league itself, the building represented a collection of individuals, unified by their commitment to artistic expression and their belief that art could change the world.

Returning to New York for summers and vacations, Rickey was determined to remain a presence in the city's art world. Doris Lee and Arnold Blanch, who married in 1939, invited him to Woodstock, New York, where many of their Greenwich Village neighbors congregated in July and August. Woodstock, a sylvan retreat just over a hundred miles north of the city, was also the summer home of the Art Students League. George rented a house in Woodstock off and on, sometimes sharing with his younger sisters Jane and Alison; the Rickey family home in Schenectady was not far away. Thus, while he migrated from one Midwestern campus to another, he nurtured his contacts in the East. Aside from his role as traveling missionary for the cause of art

education, Rickey was evolving into Carnegie's man at large, connecting artists with residency positions across a swath of small Midwestern colleges and acting as intermediary for both sides.

Among the newcomers to the city was a young German artist, Ulfert Wilke, whom Rickey met in September 1938, soon after his arrival in New York. Born in Bad Tölz, Bavaria, in 1907, Wilke was a third-generation artist. His father, Rudolf Wilke, was a well-known caricaturist and illustrator and a regular contributor to the political satire magazine *Simplicissimus,* and though he died when his son was a small boy, Ulfert closely followed in his footsteps. He was thoroughly trained in both painting and printing techniques at the Kunstgewerbeschule, in Braunschweig. He traveled widely in Europe, acquiring a deep firsthand familiarity with the history of Western art. Later, while earning his living as a newspaper caricaturist based in Berlin, he studied under the German Expressionist Willy Jaeckel. By the age of twenty-two, Ulfert was well on his way to a successful career as the first winner of the Albrecht Dürer prize, as well as a scholarship to Paris.

In 1933, however, with Hitler's appointment as chancellor, came the abrupt end to that artistically fecund era. His mentor, Willy Jaeckel, like many other contemporary artists in Germany, was dismissed from his teaching position at the University of the Arts in Berlin. The writing was on the wall. Dismayed by developments in Germany and the devastating impact of the Nazi regime on the arts, Wilke was determined to make his home in America. Arriving in New York in September 1938 on a visitor's visa, he needed a job in an institution that could support his case for citizenship.

Eric Clarke sought Rickey's assistance in helping Wilke find a position at a college where he could lecture and work on his painting at the same time. On a break from Olivet in March 1939, George visited Wilke in his temporary digs at Greenwich House, a settlement for immigrants on Barrow Street in the West Village under the watchful eye of the social reformer Mary Simkhovitch. George immediately

saw that this neat little man, with his carefully groomed goatee, gentlemanly manner, and fluent English, also had "a very highly developed capacity to draw."[7] George asked him if he might be interested in Kalamazoo, where he was teaching part time and had some influence. Later, still addressing him formally as "Mr. Rickey," Wilke thanked George for his kindness, in hopes that somehow they might become, at least temporarily, "neighbors" in Michigan.[8]

Another important friend Rickey made during this period was the artist Philip Evergood. They met in 1935 as fellow exhibitors at the Uptown Gallery, and they would soon discover some common biographical threads, most notably that although they were both American born, both were educated in Britain from an early age. The son of a Russian father and an English mother, Evergood was educated at Eton College and Cambridge University to Rickey's Glenalmond and Oxford. Just as Rickey had gravitated from his history studies to drawing at the Ruskin School, Evergood had dropped out of Cambridge to pick up his art studies at the Slade School of Art in London. There he honed his drawing skills under the surgical instruction of Henry Tonks, and emerged a very accomplished draftsman before finally picking up the brush. As a student at the Slade, Evergood knew many of the same artists and teachers as Rickey did from his Ruskin School days—most important, his mentor Richard Carline, which made for a special bond. Also, like Rickey, Evergood had followed his British education with the requisite stint in Paris, where he studied painting with André Lhote some five years before Rickey.

Rickey, the fair-haired Anglo-Saxon, and Evergood, the dark-haired half-English, half–Russian Jew, made an interesting pair. Both were of muscular and stocky build, with a rumpled, tweedy sartorial style, and both spoke with an intriguing touch of an English accent. With their Oxbridge educations and strong opinions, one did not take up an argument with either of them lightly. To Evergood's brusque, sardonic wit Rickey added a quiet intellectualism. As artists they shared many goals and faced similar obstacles, and it came naturally to help each

other with problems and opportunities as they arose. The Depression, Evergood later reflected, had brought him to life as an artist, and the hardships brought them together.

More actively political than Rickey, Evergood was a member of the American Artists Congress, and in 1937–38 he was president of the Artists Union, capable of rousing speeches to its members and impassioned pleas to the government for support. By the time he and Rickey met in New York, Evergood was also a convert to Social Realism, painting politically charged images of class struggles and labor strikes.

In 1940, when Evergood was down to his last nickel, Rickey connected him to a possible residency at Kalamazoo College, where Ulfert Wilke was by then installed as a full-time instructor. As Evergood paraphrased Rickey's invitation some years later, it went something like this: "Would you want to pull up stakes for a year or two and do a Walkie-Talkie mural in a Midwest college?" (The term "walkie-talkie" or "Walking- Talking" artist was common parlance in those days for the part-painting, part-teaching position.) Evergood's question to Rickey was "How much cabbage is in the offing?" to which Rickey replied, "[T]he salary is a bare living wage, but you will have time for your own creative work and you will get a chance to whack at a big wall."9 Evergood was reluctant to leave his little studio in Woodside, Long Island, and so was his wife, Julia, a modern dancer, but money was money, and the kind of wall he could be offered for a mural might be on the scale of a Rivera or an Orozco.

With Evergood's interest in the project, Rickey wrote to Keppel's assistant at the Carnegie Corporation, Charles Dollard, pitching Evergood as an excellent candidate, not the least, he added somewhat facetiously, because he had "the apparently rare qualification of some college background."10 Dollard and Eric Clarke were favorably impressed with Evergood, for both his painting and his forthright character. But the college administrators, who would be matching the grant from Carnegie, were nervous about the darkly sardonic quality of Evergood's imagery and the ways that this might play out at

Kalamazoo. Rickey stepped in to interpret and advocate for his friend. After several meetings with all concerned, at which Ricky explained the role of satire in art and the importance of an artist with integrity, Evergood was invited to Kalamazoo: The college would pay half of his eighteen hundred dollar salary and Carnegie would contribute the other half. Having taught at Kalamazoo himself, Rickey coached him through the various personalities he would encounter there.

Evergood arrived in Kalamazoo in the fall of 1940 and would spend two years working there. Along much the same lines as Rickey's program at Olivet, he would involve the students in the process of creating his mural, from sketching to scaffolding. Once the painting was under way, his project would capture the attention and the appreciation of the entire college community. But at first, like Rickey before him, Evergood found the artist-in-residence experience full of surprises. As he prepared to tackle the stretch of wall he had chosen at the end of the new Welles Dining Hall—an epic forty feet long and twenty feet high—college administrators voiced concerns about the health hazards of marble dust and lime polluting the air in the environs of the kitchen. As a result, the mural would not be true fresco, but instead painted on canvas cut to fit around the arched doorways and adhered to the wall with gallons of white paste.

While it was suggested that he make it an honorific portrayal of the people of Kalamazoo, of their ingenuity and success, with picturesque town and country as the setting, Evergood regarded the city in a more nuanced way. He observed "an up and coming aggressiveness with its paper mills, foundries, tulip farms, checker cabs, black earth, sweet pure air." He was equally fascinated by its poor side: "slums, railroad tracks, little urchins with bare bottoms, pastry shops, cheap movies, liquor stores, lonely girls on street corners."[11] Carl Sandburg had the last word on Kalamazoo, as far as Evergood was concerned, when he wrote in 1920 "the sins of Kalamazoo are a convict gray, a dishwater drab."[12] In the end, Evergood's epic mural, "The Bridge of Life"—a lyrical, life-sized panorama—joined the city's gritty mills and

street life with the sweetness he also perceived. He also managed to suggest "the somewhat static smugness of the college campus inhabitants," at least for those able to see them.[13]

Meanwhile, Rickey was at work on an ambitious project of his own. This was a textbook of contemporary painting and drawing techniques, a book, in his words, "to satisfy the demand of painters to know what the other fellow was doing and why he does it," as well as a reference for future historians and painting conservators.[14] Mapping his research, he aimed for a cross section of artists from among his growing network. In his questionnaire for the project, he dug into technical details such as how many brushes they used at a time, in what sizes, and what they were made of (hog, sable, or squirrel?). About fresco he asked how many coats of plaster they used and the proportions of sand to lime, and whether they constantly wet the painting surface while working. He also asked more personal questions, about problems of inertia, distractions, or lack of stimuli.

For the artist in him, the project sprang from Rickey's struggles with fresco technique and the value he saw in pooling such specialized information. For the historian, on the other hand, the kind of primary research that was then available to him was simply irresistible. Like Vasari in his time, Rickey had access to a wealth of information just begging to be gathered into a usable form. The concept was right in step with the Depression-era impulse to inventory and to catalog, in such forms as the *Index of American Design* and the American Guide Series. The book was never published, but the depth of information he gathered for the purpose would be invaluable to him as a teacher for years to come.

11

Mexico

WITH HIS growing involvement in mural painting, naturally Rickey was eager to travel to Mexico and see the work of Los Tres Grandes in their true cultural environment. Even before arriving at Olivet, anticipating the mural project ahead of him, he had begun to explore the idea. He learned that his mentor from the Ruskin School, Richard Carline, was living in Mexico City in late 1937, and Sherwood Anderson, writer in residence at Olivet, offered him a letter of introduction to friends there. But it wasn't until the summer of 1939, at the end of his two years at Olivet, that circumstances converged in favor of George's first trip to Mexico. With travel companions Ulfert Wilke and a favorite Olivet student, Laura Berghorst, George took off by car for the border.

Mexico was enjoying a dramatic rise in tourism at the time, thanks in part to Americans traveling less to Europe amid the rumblings of war and also to the Pan-American Highway, completed just two years before, the only continuous paved road from the Texas border to Mexico City. American travel to Mexico in the 1930s was like the European

grand tour of an earlier century, with its mysterious pre-Columbian sites and colorful colonial and indigenous cultures. Here was a foreign country on their doorstep—accessible, inexpensive, and unlikely to get involved in the European conflict. To the natives, these visitors were "a tall fair race from the North, speeding in automobiles, yet stopping to photograph a donkey; a people at once supercilious and arrogant, yet curious and naïve; good-natured, yet ever oddly impatient for the butter, the pop, the gas, the air, the check—for service on the run."[1]

Crossing the Texas border in August 1939, George was almost instantly entranced. He and his companions had taken a leisurely four days to travel the seven hundred fifty miles from Laredo to Mexico City, "because everything was so interesting," he told his mother.[2] He was fascinated by the tropical plantations of mango, papaya, and corn on the steep shores of the Valles River and the Indian villages along the route. Arriving in Mexico City, George found the teeming urban scene rather cosmopolitan, like a city in Spain, except for the natives in serapes and sombreros everywhere he looked. After much searching, the three found a room with three beds for fifteen pesos.

At the National Palace in Mexico City, they visited Rivera's monumental mural depicting the history of Mexico, from the ground-floor courtyard all the way up the grand staircase, action-packed with history and legend, from the precolonial past to the Spanish conquest, to the revolutions and insurgencies of the native people against the colonizers. But after seeking out a good deal of Rivera's public works, George concluded that they were mixed in quality, "from very beautiful, simple work (the earlier)," he told Frank Keppel Sr., to later compositions he thought uneven—"confused, didactic, and even banal."[3]

Art critique aside, Rickey was eager to learn firsthand and at the source more about Rivera's fresco materials and technique. To that end, he was intent on getting instruction directly from Rivera's former assistants and pupils, wherever they might be found. The search eventually led him to a lithography workshop churning out political posters, where he learned of a plasterer-painter Rivera had worked

with closely named Antonio Pujol. Having made contact, it was the greatest challenge to get Pujol to show up when and where he said he would. But once they established a bit of a routine, over the course of several sessions in six weeks he showed Rickey where to get materials and demonstrated how he mixed the plaster and applied the paint to a wall. Excited, George planned to arm himself with Mexican tools and equipment that were unobtainable in the States, to be properly equipped for his next mural project.

The party also took trips south of the capital. They traveled through the spectacular volcanic mountains of Puebla en route to Cholula to see the Great Pyramid, and to Taxco, with its winding streets of white stucco buildings and its Mesoamerican artifacts "probably the most beautiful town in all of Mexico," George told his mother.[4] Although mural art had been the inspiration for his trip to Mexico, Rickey, like Josef Albers and other European modernists who had traveled there before him, was fascinated by the excavations of the Mayan and Aztec sites and ruins then actively under way, with scavengers of all kinds making the most of them. Like many a tourist, he collected tiny archaeological specimens, abundantly available at marketplaces and from street vendors, to bring home as souvenirs.

In the midst of their travels, on September 1, 1939, the party learned that Germany had invaded Poland, and two days later Britain and France declared war on Germany. Wilke feared that he might confront trouble at the border for his German citizenship and be held up in Mexico for months, if not years. With his teaching stint at Kalamazoo College beginning later that month, Wilke reluctantly cut his trip a few days short and made it safely over the border. But he could hardly be sure in the present political climate that immigration issues would not soon arise.

It was an uncertain period for George, as well. Since July, he had been negotiating his divorce from Susan. The marriage was effectively over. As far as he was concerned, all that remained was the logistics

of their settlement. Susan did not want a divorce. Not only was she still in love with George, but there were also appearances to keep up. "Naturally a divorce is extremely repulsive," she wrote to him, "but you insist upon it."[5] He proposed that they divide their joint property in half, based on their income and the value of their property at that time. Susan wanted some additional financial support from George, and he was willing to give it. The questions were, first, how much he could realistically afford given the ambiguous future of his employment and, second, how much would symbolically send the right message—enough to appear generous, but not so much that it made him look like the guilty party. Family members on both sides of the negotiations were involved in the back and forth between them.

Susan's older sister, Sarah Middendorf, wrote a pleading letter to Grace Rickey, saying that Susan did not have enough money to buy clothes appropriate to working at a Fifth Avenue gallery, and that George had been "mean and unkind."[6] George would argue that Susan had enough money to live on, more than at least two of his sisters, and that she simply needed to learn to manage it better. "If you give Susan more, she will spend more," he told his mother. "[S]he has never lived within a budget since we were married," and he strongly advised her not to get involved.[7]

Meanwhile, that year his sister Kate had married Harold Ball, a Nova Scotian twenty years her senior, and his sister Jane had married a sculptor named Guido de Vall, a Maltese who claimed to be descended from Italian nobility, and had moved to Los Angeles. That left two sisters unmarried: Alison, the youngest, and Elizabeth, the eldest, whose mental health had kept her from leaving home in Schenectady, adding to the considerable weight on Grace's mind, along with concerns about living on Singer stock. In June 1938 George wrote to his mother that the Singer dividend had been cut twenty-five percent, and he advised her to be prepared to restrict her expenses, and that all of his sisters should have their allowance cut. The following

year, Grace and Elizabeth moved from the former Landon home at 1412 Union Street in Schenectady to a somewhat smaller house at 13 Front Street, still within the historic stockade district.

Unlike George's younger sisters, who had formed close friendships with Susan, Emily—then living in Grand Rapids and having seen George regularly during his time in the Midwest—regarded Susan as an unpredictable and manipulative spouse, perhaps even, in the context of the divorce, a "gold-digger" and a "wolf in sheep's clothing." She told George that her husband, Percy, had been "wise" to Susan, long before she herself had "any inkling" of her questionable character. Susan's power over George, analyzed Emily, was in her unpredictability, her volatile temper, her self-destructive behavior, and her eternal pleas for his forgiveness. Emily advised George to move cautiously, to consult his lawyer in Battle Creek, and not to hurry "into an agreement you feel unfair."[8]

George need not have worried about his mother's loyalty or her prudent handling of the sensitive matter in the face of Sarah Middendorf's pleas on Susan's behalf. By August 1939, any affection Grace may have felt for her daughter-in-law had certainly waned; she distrusted Susan in her motives and behavior. She warned George "there may be a joker" in Susan's willingness to accept his settlement offer: twenty-five hundred dollars up front and an equal amount over the next five years. Grace was concerned that the ongoing payments to Susan might lead to endless bickering and stand in the way of future relationships when someday "you may meet a nicer girl."[9] But George was confident that with this settlement, Susan would have no claims on him five years hence.

George and Susan finalized their divorce in December 1939. That winter, with the Olivet residency ended, George decided to remain in Michigan and rented a summer cottage near the small town of Fennville, on the shores of Lake Michigan, for eight dollars a month. He stayed there by himself all winter, sketching, reading, thinking,

walking the icy shore, and keeping himself warm with a little coal stove, awaiting further developments to his uncertain career.

TEMPORARILY UNEMPLOYED, George was grateful to step into Ulfert Wilke's teaching position at Kalamazoo while Wilke traveled to Mexico for a few months, in order to return on a new visa with his petition for naturalization as an American citizen. While filling in for Wilke over the winter and spring of 1940, both as art instructor at the college and interim director of the Kalamazoo Institute of Arts, George was also casting about for his next post. With the Carnegie Corporation ever alert to opportunities for his employment, before long he was in demand as an artist in residence at another small college in the Midwest—Knox College, in Galesburg, Illinois.

As he had done at Olivet, Rickey planned to engage the students at Knox in a mural project. On his first visit to the campus, he had scoped out his prospects for the ideal stretch of wall and determined that the dining room in the men's dormitory was "crying out for decoration." He was eager to apply all he had learned in Mexico and try his hand again at true fresco, "which will mean very hard work but will be the most satisfactory thing in the end."[10] But he ultimately decided, or was persuaded, not to put his newfound knowledge to the test at Knox. As he had done with the Selinsgrove Post Office, he would paint the mural in tempera on canvas, "somewhat less spectacular than fresco," he confessed, "but . . . much less capricious in the execution."[11]

At the urging of college administrators, the mural would include prominent members of the Knox faculty. Rickey considered this an aspect of a job, comparing himself to the artists of the Italian Renaissance, when "pleasing a patron was a part of every artist's business." He also managed to put his own stamp on "The Offer of Education," depicting the faculty along with the famous figures of Western culture they taught—Shakespeare, Leonardo da Vinci, Charles Darwin,

Louis Pasteur, and Herodotus—like stars sprinkled across the heavens, offering their gifts to the earthbound.

Among the few students who were demonstrably devoted to the project, Beatrice Farwell, an art major in her junior year, stood out. Like Bill Dole at Olivet, Farwell was George's most enthusiastic apprentice. To her, Rickey was an inspiring teacher and mentor, "a heady breath of sophistication in that provincial heartland place," and "a fountainhead of shrewd advice." Among the lasting influences he had on her that year was to cause her to question her religious beliefs. As she was passing his studio one Sunday morning, he asked why she was wearing a hat. When she told him she was on her way to church, he said, "Haven't you learned that going to church is either a misunderstanding or an affectation?"[12] Just as George Lyward at Glenalmond had done, Rickey invited young minds to question their assumptions. Just as the Jewish girl he met in Heidelberg did with him, he gently poked fun at Farwell's church habit. She never went again.

After Rickey's time at Knox, he concluded that the caliber of artistic talent among the students in general was disappointing, but in the end, he wondered if the few who were really engaged with the project were all that really mattered. He had also enjoyed the company of faculty members who pitched into the project with gusto, helping him to trace his cartoon on the wall and working on various parts of the underpainting. As for the college president, Carter Davidson, Rickey could never be sure if the man was convinced of the worthiness of the project—of either the mural or the residency. George was not content to be a gift of the Carnegie Corporation if it was not going to lead anywhere. "I want to make my stay here the thin end of a wedge which will give the arts a wider place in the college life," he wrote before leaving.[13]

While at Knox, Rickey was compiling a thorough report on the artist-in-residence program for the Carnegie Corporation. For the past three years at each college where he had worked, he had kept a journal detailing his experience and assessing the success of his integration with the life of the school. He also invited reports from fellow

artists of the experiment, such as Philip Evergood at Kalamazoo, John Held at Harvard, Lucile Blanch at Converse College for Women, Gifford Proctor at Beloit College, and Paul Sample at Dartmouth. In summary, Rickey reported that it was simply the presence of the artist in their midst that was most important. The artist, as an autonomous figure, is inclined to take "a transcendent view of student problems." The artist offers a student "a chance to rub up against a fertile and inventive mind," for whatever his age, the artist "is still *discovering*, and so has a special sympathy for students, who are discovering too."[14]

The movement was growing, and Rickey could consider himself a significant contributor to its momentum, especially in the way of breaking the ice, for pushing the program forward, and explaining its mission and purpose to the often reluctant or befuddled college administrators. He also believed in the capacity of the artist to "educate the college president out of his fears" and ensure a continuation of the program.[15] Perhaps his greatest success in that regard was introducing Milton Horn to succeed him at Olivet. Leaving Olivet after two years, Rickey proposed that a sculptor take his place, partly because of an idea he had for sculptural embellishment over the arched entrance to the library. Milton Horn had a particular gift for integrating his work with architecture, and Rickey would also have recalled Horn's kindness to him when George first arrived in New York from Groton some five years earlier, when Horn had hosted a small gathering to view his work in his studio. Horn was happy to take the job at Olivet. He not only provided the sculptural relief over the door to the library, but he also became a member of the faculty for the next ten years. His tenure came to an end when the college retreated from its progressive program to its traditional religious origins. Brewer resigned and Horn resigned too, in 1949.

Among the most challenging aspects of the artist-in-residence program from the artist's point of view was the uncertainty of his position from year to year. George found himself in a kind of residency rut, and unsure of how to get out of it. As the year at Knox drew to a

close, Frank Keppel gently informed him that Carnegie would not be renewing the grant, "chiefly with your own welfare in mind," as he explained to George in March 1941, "I don't think it would be in your best interests to be supported, directly or indirectly, by Corporation funds any longer."[16] It was time to cut the Carnegie umbilical cord, and George knew it. As he wrote back to Keppel a week later, "I think it is probably a good opportunity to find work where the tenure will be somewhat more permanent and the future fairly secure." What he hoped for in a permanent position was to run a small art department in a progressive college, "where there was building-up to be done," or perhaps a small city museum where community education was a priority.[17]

Ulfert Wilke agreed with Keppel that George needed to settle down. "I think you ought to find another more permanent job," he wrote to him in May 1941; "the type of work you do now is too strenuous and it is difficult to hunt each year for a new place."[18] The head of the art department at Kalamazoo College did his best to connect Rickey to other college positions—at the Flint Institute of Arts, in Michigan, and Reed College, in Portland, Oregon—while Charles Dollard in the Carnegie office was advertising his credentials "in various academic markets," such as Vanderbilt University, in Memphis, and Muhlenberg College, in Allentown, Pennsylvania.[19]

As these prospects circulated, George took his second trip to Mexico, this time with his sister Alison and his former student at Olivet, Bill Dole. By that time he was less interested in studying mural painting than in simply absorbing the span of history that Mexico had to offer, from Mesoamerican to European, from ancient to modern. He was interested in the geometric architecture of the Mayan and Aztec monuments as well as the vocabulary of their carved decoration. He was discovering in a new way that abstraction spoke the same language across cultures and centuries, and that the power of the circle, the square, and the spiral was equal if not greater than the tradition of figurative painting in which he was then immersed.

12

Muhlenberg

"I APPEARED in Allentown in the autumn of 1941," George Rickey recalled years later, "as the first and sole art instructor in that serious, sequestered, Lutheran enclave."[1] In the small city in Pennsylvania, about ninety miles west of New York City and fifty miles north of Philadelphia, Muhlenberg College was established as a Lutheran seminary in 1848 and later named for the founder of the Lutheran Church in America, the German-born Henry Melchior Muhlenberg. When Rickey appeared, the college was nearing its one hundredth anniversary with its first non-Lutheran president, Levering Tyson, to lead it forward. An innovator with progressive ideas, Tyson ushered in a new era with his appointment in 1937, adding modern subjects such as sociology and psychology to the curriculum. He was also determined to establish a department of art from the ground up, as no art instruction of any kind had existed there before.

In some ways, Tyson saw this as an advantage; they could start "de novo," he said. He hoped to avoid a bland and stereotypical program, to do something significant, and to appoint a real leader, a "Professor

of Art, New Style."[2] He envisioned a teacher who could demonstrate to students the relevance of art to their other studies, who could work with the faculty to help make those connections, and who would discover and encourage whatever form of artistic activity a student might be inclined to pursue. Already, Tyson had approached the Carnegie Corporation for a recorded historical survey of the world's great music—a library of more than a thousand recordings—as well as the "Carnegie Teaching Set" for the study of art. It was logical, then, that he would also consult them in his search for an able instructor, with qualifications he admitted might be difficult to meet. With Carnegie's help, he found his man in George Rickey, and Carnegie funds to pay him as well, this time as a full-time member of the college faculty. Rickey's appointment at Muhlenberg coincided with Frank Keppel's retirement as president of the Carnegie Corporation, after fifteen years of enlightened support for art education.

From Rickey's point of view, the all-male Muhlenberg campus felt almost monastic compared with his previous experiences at Olivet, Kalamazoo, and Knox, something more akin to his boarding school days in Scotland, with its strikingly homogeneous student body of mostly Pennsylvania Germans from the Lehigh Valley. But he could not have been disappointed in the generous space they allotted him in terms of both scale and symbolism—a collection of rooms in the library building at the epicenter of the campus, with its distinctive bell tower and dome inspired by Christopher Wren's majestic "Tom Tower" at Oxford. There he established his office and private studio, and a large classroom for teaching art history on one floor and studio courses in drawing and painting on another.

By the time he arrived at Muhlenberg, in his mid-thirties, Rickey was still a young professor, but also a seasoned one. He was familiar with the situation of a small college introducing art to the curriculum. Coincidentally, the same year in which Muhlenberg hired him, he received his master's degree from Balliol College, Oxford (more or less automatically four years after matriculating, as long as he was

working in his field of study), which added luster to his appointment, not to mention perhaps greater credibility to the novel field of art on a conservative campus. For the time being, he would be a department of one, teaching studio art courses as well as art history. A dual career as both artist and history teacher was evolving into a natural fit for Rickey, and it lay before him as such into the foreseeable future. As he had written to Frank Keppel earlier that year, "[T]here must be a good deal of the teacher deeply rooted in me," and he reflected how, "my Groton experience wasn't a false start after all."[3]

Serving the Allentown community was very much a part of the Tyson plan, and toward that end, Rickey immediately had ideas for exhibitions in his lofty space in the library tower. While the high Gothic windows were an asset in their gift of natural light, they also left little wall space for hanging pictures. He solved this problem by designing freestanding panels to adjust to a variety of artwork and installations, and recruited a few students to help build them.

Like his friend Ulfert Wilke, Rickey was actively developing another string to his professorial bow as a curator of exhibitions. Rickey and Wilke kept up a lively correspondence about exhibitions for their respective college departments that served them both well. At Olivet, he had been committed to the idea of students being exposed to original works of art. One of several exhibitions he had organized at Olivet was a traveling show of prints on the theme of war, including contemporary German artists such as Otto Dix, George Grosz, and Käthe Kollwitz, along with the Mexican Orozco and contemporary illustrators such as Kerr Eby, from Canada, and the American William Gropper. When the exhibition traveled to Kalamazoo and other colleges in the area, he used it as a pretext for a symposium, "War and the Individual." Wherever he was posted, Rickey sought ways to bring art into the daily life of the college student and opportunities for stimulating discussion.

Early in Rickey's professorship at Muhlenberg, Wilke invited him to share a traveling exhibition of Josef Albers. Wilke had taken

a course with Albers at Harvard's summer school in 1941, and was greatly impressed with his teaching. Before fleeing Nazi Germany, in 1933, Josef and his wife, Anni Albers, had been former students at the Bauhaus, where Josef also taught. Fortunately, they were able to export their Bauhaus teaching methods and philosophy of design more or less intact to the experimental Black Mountain College, in Ashville, North Carolina, which opened that same year. Josef Albers became the first art teacher at Black Mountain; Anni taught weaving and textile design.

At Black Mountain, the arts were not peripheral but instead central to the program. The school became a magnet for European artists during the war and an incubator of European modernism in America. At its summer school, which Josef Albers initiated, the college converged artistic talents as diverse as Robert Rauschenberg, Franz Kline, Buckminster Fuller, Merce Cunningham, John Cage, Ruth Asawa, and Harry Callahan, each expanding on Bauhaus principles in her or his own way. For the postwar generation, this small and short-lived school had an outsized influence on the arts in America.

In practice he had evolved into a Social Realist painter; still, Rickey was intrigued by Albers, as much for his teaching methods as for the rigor and purity of his compositions. Earlier that year, on a lecture tour, he had visited the recently transplanted Bauhaus in Chicago and met its charismatic leader, László Moholy-Nagy. He may have also been aware of Josef and Anni Alberses' fascination with Mexico, where they had traveled extensively, deriving many of their ideas for abstract design and color theory in the Mayan and Aztec textiles and decorative stonework from the ancient sites of Mitla, Monte Albán, and Uxmal, then under excavation. To Wilke's and Rickey's joint request for an exhibition, Albers suggested a show of his new "Abstract Miniatures." Wilke was sure that Albers' "pure constructivism should be of interest to the general public."[4]

Whether or not pure Constructivism would be of interest to the general public of Allentown, Pennsylvania, it would become an

abiding interest for Rickey. Years later he would publish the most wide-ranging and comprehensive book on the subject to date. In the cool, abstract paintings of Albers—perhaps his first direct encounter with the Constructivist mentality at its essence—he discovered that a work of art could be completely free of narrative, symbolism, or indeed any suggestion of human expression whatsoever. Living with Albers' "Abstract Miniatures" on display in his gallery, Rickey's affection for them grew by the day. In fact, he was so taken with the Albers show that he bought a painting for himself, a small oil aptly enough called *Growing*—an abstract balancing act of building blocks in shades of blue and red. Excited as he was, Rickey did not expect the local population to feel the same way, and he admitted to Albers that his paintings were "somewhat baffling to most of the student body here."⁵ For him, though, their formal rigor and rationality had struck an unexpected chord.

Within a very short time and given a free hand with the Carnegie funds, Rickey was providing a steady flow of surprising exhibitions for both the college and the local community. As early as November, he was able to assemble a historical survey of five centuries of art, with twenty-eight paintings from a New York art dealer's collection, spanning the fifteenth century to the nineteenth, altogether valued at two hundred fifty thousand dollars. It was by far the most ambitious display of art the city had ever seen, and he persuaded the college to honor the occasion for all it was worth, with a grand opening reception for the local elite and visiting VIPs, complete with potted palms and cocktails.

At the other end of the spectrum, Rickey organized a light-hearted show of drawings by the *New Yorker* artist William Steig. At the same time, he was alert to the folk traditions of the region and opportunities to take advantage of local generosity and expertise. In March 1942, he displayed two dozen Pennsylvania Dutch coverlets: like so many treasured heirlooms of the people of the Lehigh Valley, familiar and dear to all.

Building an interest in art at the college from scratch, before long Rickey's efforts were met with tangible success. His evening classes were proving to be a huge hit with the community. Told to expect about twenty students in a studio class for adults, he welcomed more than sixty. His exhibition program was also garnering positive attention from the local press. But just as he was beginning to find his way at his first permanent teaching job since his Groton days, he faced an abrupt and unavoidable change of plan.

RICKEY WAS in New York for the weekend, painting a portrait of a friend from Paris, when on Sunday, December 7, Japanese warplanes attacked the US naval base in Pearl Harbor, within an hour killing more than two thousand Americans and destroying battleships and naval aircraft. Having hesitated to become involved in the European and Asian conflicts, FDR had no choice but to recognize a state of war with Japan, a resolution that passed in Congress a day after the devastating attack. Three days later, on Dec. 11, Germany and Italy, allied with Japan, declared war on the United States and congress reciprocated the same day. Public opposition to entering the war dissolved overnight.

Until that earth-shaking moment in history, the Rickey-Wilke mutual help line had centered on teaching positions, traveling exhibitions, and often romance, but now concerns about the draft dominated their correspondence. Every able-bodied man would be counted. Wilke's foreign status made this a complicated situation, as the fear of being captured in the United States as a German national was not unreasonable. It was fortunate that his application for US citizenship was in the works. "I believe that it is more likely that I will be drafted than interned," he wrote to George.[6] Not long afterward, Wilke was classified eligible for service, or 1-A, by the US Army, with reason to hope for a position as an artist for the armed forces, stationed at one of the forts. For the time being, he was to endure the humiliation of

induction—six hours at the Kalamazoo armory, where each recruit received a number written on his left hand and was then "inspected like cattles [sic]." Comparing this humiliation to civilian life, Wilke added ruefully, "The lack of friendlyness [sic] at the museum of modern art seems like mere courtesy compared to what you will face in the army."[7]

Wilke was assigned to paint army life, but the constant orders to move to the next base and the unknowns of his assignment and status were a trial, as was the regimentation, which was "worse than at the strictest times in school." He advised George to "stay out of it as long as you can—there is nothing to like about the army."[8]

In the midst of the spring term at Muhlenberg, Rickey registered for the draft and was also classified 1-A. He could be called up for service almost immediately. While he filed a special appeal to the draft board for a 2-A classification—a limited occupational deferment—the college administration accepted that he would have to take a leave of absence to serve the war effort, if not immediately, then soon. "Tyson has had the trustees vote me a leave of absence for the duration," he told his mother, "and has given me a letter of approbation in case there should be no college to come back to."[9] In 1942, with the country preparing for possible invasion, anything seemed possible. The college campus itself, like many others across the country, would be transformed into an army training base.

On the family front, George was happy to learn of his sister Alison's engagement to William "Bill" Ames, a modern composer whom she had been seeing for some time. "He may have a rather specialized temperament," George commented to Grace, "but so has Ali. I think it is a more than ordinarily good match of temperaments." George and Alison had been especially close in recent years while both were unmarried, and having shared summers in Woodstock as well as George's second trip to Mexico in the summer of 1941. Furthermore, Alison was a talented artist in her own right. George expressed his admiration for his brother-in-law-to-be, a Harvard man: "[H]e is

a quite highly evolved person and very intelligent." Ames was just over forty years old to Alison's twenty-six when the couple married, but they had known each other for some time. George reassured his mother that Ali "knows what she's doing and I should be inclined to let her handle it in her own way."[10] Befitting the conditions of wartime, there was nothing more for Grace to do but order an engraved announcement of her daughter's marriage to William Thayer Ames on March 14, 1942.

With the advocacy of Eric Clarke, at the Association of American Colleges, Rickey's occupational deferment from the army was granted, and he stayed at Muhlenberg through the academic year. With his departure, the art program would be suspended for the duration of the war and the remaining funds of the Carnegie grant put in escrow until his return. After classes ended, on June 1, he and several colleagues received the notice from the draft board with their date, hour, and place to report for duty.

Before departing for his first army post, George prepared a shoebox full of paints and brushes and left them in Schenectady with his mother, ready to send on to him wherever he landed. He also left a few drawings with Antoinette Kraushaar, of the family-run Kraushaar Galleries in New York. The gallery was known for American painting of the Ashcan School and 1930s Social Realism, and Antoinette was receptive to George's style and purpose. It was some comfort to know that he would be leaving behind a fragment of his artistic self in New York before facing the unknowns of his next destination and the state of the world at war.

As a professional man in his thirties, Rickey was less likely to be sent to the front, and he hoped to get straight into specialized work of some kind, though he did not know what that would be. In July he was flown to a Technical School Squadron in Miami to test for a position in the Army Air Corps. In a crowded but air-conditioned movie house, he took the gamut of tests in general science, math, and geometry, all quite simple by his standards, along with other tests that focused on

his observational skills—"sets of dots and dashes in pairs which you had to determine as similar or dissimilar." The results revealed that he possessed an exceptional mechanical aptitude, which qualified him for virtually any position. "This is interesting," he reflected in a letter to his mother, "as my childhood dream was to become an engineer, before I got side-tracked into teaching and painting."[11]

Rickey put photography at the top of his list of preferred job assignments, but in an interview with one of the classifiers, he was persuaded to take on something more stimulating than routine dark-room work. This "bright young fellow" recommended that he opt for more specialized work that required the highest standards in technical precision and mechanical ability. "I am not impervious to the flattery implied," he admitted to Grace, "it is secret, confidential work so I won't mention what it is. However this morning I was fingerprinted, and I shall be investigated by the F.B.I. before going to school."[12] Less than a week later, skipping basic training, he was told to pack up and be ready for shipping the next day, he knew not where, only that it would be cooler than Miami in August.

13

Denver

AFTER THREE tedious days of travel by train, George arrived at Lowry Field, in Denver, on August 7, 1942, the same day American forces landed on Guadalcanal. The war in the Pacific was heating up, the Americans shifting to a more offensive war strategy against Japan. George learned that he was stationed in Denver to attend gunnery school—an eight-week course in power-turret mechanics for the Army Air Corps. Lowry Field, fortunately for him, was a new base and with high ratings compared to those of many others. The food was good by army standards, there was a library, and visitors could be received in a servicemen's club. The Colorado climate reminded George of the Adirondacks at their best, mountain air and blue skies, and he was glad to be sleeping under a blanket again.

Once in Denver, and knowing he would be there for at least a few weeks, George asked his mother to send him the shoebox of paints he had prepared. Painting and sketching portraits was an ongoing interest, and there was no shortage of subjects in the barracks. Rickey's portrait sessions were soon to become a source of entertainment for the

men, as they stood around watching him at work, added their names to a waiting list to pose for him, and gladly accepted their portraits as gifts of the artist. For George, the exercise was not so much to amuse others as it was to satisfy his own drive, and he perceived that it could pay off in other ways as well. Although much about the regimen of army life was designed to discourage individuality, standing out in a crowd with a special talent or skill could work to one's advantage in attracting the notice of the officers that might lead to a promotion or a more interesting assignment.

Even more important in this regard were Rickey's detailed drawings of the military equipment the men were studying. The artist in him was challenged by rendering these complex objects, while the teacher in him was concentrating on another problem—how to make a better instruction book, "arranged . . . in such a way that the workings of the machinery was much clearer than in the charts they already had."[1] Unsure at first about promoting himself, George eventually drummed up the courage to show his drawings to the sergeant. This led to a meeting with the lieutenant, who was sufficiently impressed to ask George if he would consider being an instructor after he had completed the course.

Encouraging as this may have sounded, George explained to his mother, one can never be sure about anything in the army. After completing the course in power-turret mechanics, he lived in limbo for a few weeks. At one point he was on the brink of being shipped to Missouri for overseas training, at another he almost missed a court-martial for skipping KP (it had been a misunderstanding). But finally, in late November, he received his first promotion at Lowry Field, becoming a private first-class, assigned to the instruction and maintenance of aircraft guns. They gave him the nightshift, which was "a bit of a grind," he wrote to his mother,[2] but it also had its advantages—namely, that his days were free to paint and also to get off the base and explore Denver, just six miles away. He procured a bicycle and peddled into town.

To his great fortune, George had at least one very well-placed local

connection. This was Caleb Gates, an Oxford classmate and fellow rugby player who had since become chancellor of the University of Denver. Before long Caleb and his wife, Betsy, were offering George a bed to stay in the city on his nights off, and often a place at their dinner table too. Betsy, George observed, "runs the presidential household—9 inmates—without a quiver."[3] Thus began what he would later describe as his "double-life" in Denver during the war, one on the base and the other in town. Looking back on his time in the army, he admitted that he had been "lucky beyond anything I could have dreamed of."[4]

With his good manners and quasi-British accent, George—"a socially acceptable artist"[5]—was soon blending in with the mix of the Denver art scene. Caleb Gates had forged a strong relationship between the university and the burgeoning Denver Art Museum. At the time, the museum was a collection of galleries in the City and County building downtown, and it also held temporary exhibitions in the university's art school building, Chappell House. In search of suitable studio space he might share or borrow, at Chappell House, George was introduced to Anne Arneill Downs, who was director of public relations for the Denver Art Museum. A fashionable, somewhat older married woman with two teenage children, Anne had a studio where she painted in her spare time. She was happy to offer George the use of it, and to take him under her wing in other ways as well, such as escorting him to art openings and cocktail parties.

Denver was "a little, compact country town," remembered George of those days, "where everybody knew everybody who was anybody."[6] The very sociable Anne Downs knew "all the artists and kindred people" in the city,[7] such as the local poets Thomas Ferril and Marcella Miller Dupont, the modern architect Burnham Hoyt, and society figures such as Walter Paepcke, a Chicago industrialist and president of the Container Corporation, and his beautiful wife, Elizabeth, known to all as "Pussy." The Paepckes were then laying the foundation for the Aspen Institute—a retreat for cultural leaders in that remote

silver-mining town in the Rockies that would soon become a famous ski resort. Pussy Paepcke's background in art and design influenced her husband's philanthropic efforts. Walter's German background made them especially loyal to German culture, even in wartime, and his financial support of the Bauhaus in Chicago was significant. Pussy, aside from her own creative pursuits, lived for stimulating company. With his broad intelligence and curiosity about everything, his *"gemultlichkeit,"* George was soon to count among her favorite dinner guests.[8]

With the free use of Anne Downs's studio, George went into town almost every day. In return for her hospitality, George painted her portrait more than once, and in that intimate setting, he also painted her nude. George told his mother that having the use of a private studio had changed his life, that painting almost every day made him feel so much better. At least part of that better feeling was his developing love affair with Anne—his model, provider, and agent. As public relations director for the Denver museum, it is likely that Downs was instrumental in securing an exhibition of his paintings at Chappell House in March 1943, and in the library of Denver University in January 1944. A newspaper review noted the sculptural quality of Rickey's paintings, "producing mass rather than outline" and also his tenderness in the depiction of women, including "the small, glowing head of 'Anne.'"[9]

Rickey practiced his hand at art reviews for the *Rocky Mountain News* and the *Denver Post,* and gave lectures on art wherever he was offered the opportunity. He had developed a few stock lectures for a broad-based audience: one on mural painting, another on the European avant-garde, and a third on popular comic strips he called "Are Funny Papers Art?" He traveled to Colorado Springs to give a talk at the Fine Arts Center, where the Phillips Collection in Washington was storing its collection for safekeeping during the war. Although only a tenth the size of Denver, Colorado Springs was "quite a hotbed of the arts,"[10] with a lively audience for his lectures too. He spoke about artists in wartime, and of the difficult circumstances they had to work

under for the army. One such artist was his friend Ulfert Wilke, who was then stationed at a hospital in Clinton, Iowa, building morale for army invalid patients by painting images to order on their plaster casts. Rickey put Wilke in touch with the new director of the Denver Art Museum, Otto Bach, which resulted in a show of his wartime gouaches and a brief but very welcome reunion with George.

WHILE ENJOYING his time off in Denver, Rickey was inducted into more specialized work at the base. This was in the development of a computerized remote control target mechanism for the new B29 Superfortress. The plane was specifically designed for the war in the Pacific, with a pressurized cabin and the capacity to reach Japan at three hundred fifty miles an hour, carrying twenty tons of bombs. This was the plane that would end the war with Japan, dropping seventy-pound napalm bombs on Tokyo, Osaka, Kobe, and Nagoya in March 1945, and later the atomic bombs that flattened Hiroshima and Nagasaki in August of that year. In addition to its bombing capacity, the B29 had five remote-controlled machine gun turrets to fend off enemy planes. Positioned at the fore and aft, they could turn three hundred fifty degrees and therefore angled precisely in multiple directions. A twenty-millimeter cannon in the tail of the plane could also be released remotely. To improve target accuracy, a computer inside the aircraft made corrections for wind, temperature, altitude, speed, and range.

Computer technology was still in its predigital infancy, and the system took up a lot of space; the instruments needed constant refining, troubleshooting, and repair as well. Rickey's job evolved from gunnery instructor to computer technician. As his innate mechanical gifts emerged, certain fundamental experiences of his childhood were brought to bear—the dead reckoning of the needle of a Singer sewing machine, handling a rifle at Glenalmond, and, perhaps most important, sailing. He had navigated the family's thirty-eight-foot *Thora*

through the narrow openings and steep cliffs of Scotland's ragged west coast and tacked her back and forth amid the capricious westerly winds. He had a sailor's sense of the vicissitudes of wind and weather, and for the pitch, roll, and yaw of the boat as it forged its path through the elements.

Unexpectedly, Rickey's work for the army awakened another side of his artistic sensibility. His assignment as a highly specialized technician was something that not only came naturally to him, but also in which he took a certain delight. Freshly aware of his gift for mechanics, he felt an urge to apply it creatively. "It was there," he wrote later, "that I began to wonder whether I had a talent I could not exploit as a painter."[11]

In the spring of 1943, Rickey went on special leave for two months in New York to take a course at the Sperry Gyroscope Company on central fire control. While there, he may have seen Alexander Calder's exhibition at Pierre Matisse's gallery, of "Constellations," which coincided with George's visit. While Calder's Constellations were stable constructions alluding to the arrangements of stars, he was then developing another kind of construction that was to become his signature style. This was the mobile, a gently bobbing, floating collection of shapes speaking their own kind of celestial language. Later that year, in September, a major retrospective of Calder's work opened at the Museum of Modern Art. George was not able to see the Calder retrospective at MoMA, but he was sufficiently intrigued to obtain the handsomely designed and illustrated catalog of almost one hundred works of sculpture, drawing, and jewelry, which he absorbed with great interest. Here was an irrepressible spirit of invention, an elegant stylist, a genius of free form with the added intrigue of unpredictable movement. With military targeting accuracy now constantly on Rickey's mind, the spheres and orbs of a Calder mobile, gently moving on extended rods in a game of balance, gave poetic form to his military preoccupations.

During the last year of the war, in the spring of 1945, having risen

to the rank of staff sergeant, Rickey was transferred to the Army Air Force base in Laredo, Texas. As one of the few specialists in the B29 gunnery system, he would be assisting with further research for the National Defense Research Committee as the aircraft stepped up its firebombing missions over Japan. He would be sad to leave Denver: "I have been very happy here," he wrote to his mother, "but, having been so lucky, I can't complain of this assignment."[12] Departing for Texas and unlikely to return to Denver, he left behind an accumulation of paintings and drawings with a friend, the poet Tom Ferril, to store in his attic until the war was over, and a broken-hearted Anne Downs.

While Laredo had the pleasant association of being the gateway to Mexico, it was otherwise not a place that Rickey was happy to land in. It was hot as hell in summer, and there was no sign of anything remotely like the interesting society he had found in Denver, or the doting attention of Anne Downs and Betsy Gates. But it was in the artistic isolation of Laredo that he made his first mobile sculptures. In the army machine shop, he began to experiment with bits of scrap metal and glass he found around the base, constructing little sculptures with moving parts. It would take another five years of gestation before he knew what he wanted to do with these little experiments. First he would have to return to civilian life, reenter the art world of New York, and embark on the most important relationship of his life.

PART **TWO**

14

Edie

WHEN HE was finally and honorably discharged from the army, in October 1945, George Rickey, like every other civilian involved in the war effort, was eager to pick up the pieces of his life and put them back together again. He had some months to spare until the summer, when he would return to Muhlenberg to resume teaching. During the three years that George had been in the army, art instruction and all related activities at the college had come to a virtual standstill. He would have to revive it with all the energy he could muster. Ulfert Wilke encouraged him to give it up altogether. "I think you should do better," he wrote to George with typical candor. "Muhlenberg is a ghastly place."[1] But to George, a solid position as a college professor with a salary of more than four thousand dollars per year, in a town within driving distance of New York City, was a reasonable option for the time being.

Before he began teaching again, he would gratefully return to New York and his life as an artist while also taking advantage of the GI Bill to study at New York University's graduate program in art history: the Institute of Fine Arts, on the Upper East Side. An influx of

distinguished art historians had recently crossed the water, both during and after the war, many of them refugees from Nazi Germany, and they were laying the foundation for art history as it would be taught at the institute for years to come. Nothing could have been a greater gift to the field in America. At the time, art history was still dominated by German scholars. Indeed, the discipline itself was a German invention, beginning in the eighteenth century with Johann Winckelmann, who was the first to trace a development of classical Greek art over the course of centuries as an evolution of style. Later generations of German art historians had expanded on Winckelmann's example, further defining the ideas of beauty, craftsmanship, and artistic influence. They were reputed to be the greatest art historians in the world, and George was keen to learn more about their rigorous method and to try "a little academic art history to see what it was like."[2] Up to now, as an art history professor, he was entirely self-taught.

A former student from Knox College, Bea Farwell, was also studying at the institute, for her master's degree, while working part time as a docent at the Metropolitan Museum. In fact it was George who had first encouraged her to pursue a graduate degree, and he even lent her the extra money she needed to pay for her tuition at New York University. In return, it might have been in part thanks to Farwell that George decided to go to the institute himself.

As a graduate student approaching middle age, with considerable experience and knowledge already under his belt, Rickey was somewhat disappointed with the professors at the institute. As an artist, he was surprised at how ignorant they could be about technical matters, which occasionally led them to false conclusions. Martin Weinberger, for example, a leading Renaissance scholar, thought a painting by Titian at the Metropolitan Museum had been cut and repaired, whereas George knew enough about the size of the looms in the sixteenth century to counter Weinberger with the assertion that it was originally made of two pieces of cloth. He was intrigued by the Germans' investigative methods, but sometimes wondered, in their dry analysis

posited in their guttural German accent, how much they really liked art. Another professor, Otto Benesch, he thought rather dull on the subject of nineteenth-century painting, but perhaps that was because his expertise was in Rembrandt. Still, the institute was the exposure to academia he was longing for, and he was glad for the new acquaintances he made there and the furthering of his friendship with Bea Farwell.

He was also determined to maintain his presence as a working artist in New York and to play an active part in its postwar art scene. What a joy it must have been to reunite with old friends from the prewar days such as Philip Evergood, as well as with new friends recently migrated from Denver. Friends from his time in Paris were also converging on New York.

George was especially happy to see Dolores Vanetti, a friend from his Paris days whose half-length nude portrait he had exhibited at the Uptown Gallery in 1935. Dolores had moved to New York in 1940 as the wife of American Theodore Ehrenreich, a doctor, while she worked for the Office of War Information making radio broadcasts. By 1945, she had separated from her husband and embarked on a love affair with Jean-Paul Sartre, who had recently arrived in New York. Petite and piquant, Dolores was not only a journalist; she was also an actress, a poet, and an intellectual. She was friendly with leading artists and writers of the day, among them Alexander Calder, André Breton, John Dos Passos, Max Ernst, and Marcel Duchamp. Moving among many circles, she was fluent in English as well as the languages of artists, philosophers, antique dealers, birdwatchers, and jazz musicians. After meeting Sartre at the OWI recording studio, Vanetti made his introduction to America her special project. She led him to artists' studios, secondhand shops on Third Avenue, Chinatown, the Russian Tea Room, and the jazz clubs of Harlem. As one close friend later expressed it, Vanetti had "opened the door to another continent and given him all the keys to understand the United States."[3] In a similar way, Dolores might have shown Paris to George in the early 1930s.

A passionate collector of indigenous art, it is possible that Dolores was behind his first purchase of a work of art in Paris in 1934—a Dan mask from the Ivory Coast.

At the time of Vanetti's affair with Sartre, he was beginning his monthly literary review, *Les Temps Modernes*, and dedicated the first issue, in October 1945, to her. This apparently came as a shock to his wife, Simone de Beauvoir, who had remained in France; much as the couple famously tolerated, if not enjoyed, an open love triangle, Vanetti represented a real threat, for she was unwilling to play third wheel. Sartre would have to choose between them. For a period, he chose Vanetti. When he returned to de Beauvoir, Vanetti said good-bye for good.

Sartre's existentialism—his furthering of earlier phenomenological philosophers on the question of what it is to be human—was then beginning to infiltrate every subject in postwar intellectual circles, and his *Les Temps Modernes* would prove hugely influential in the dissemination of his ideas. The journal was at the crossroads of leading intellectual lights of both Europe and America. It "set the terms for every debate of any importance, not just in France, but around the world."[4] The first issue of the journal coincided to the very month with George's return from the West. Starved for the intellectual stimulation he had missed in Laredo, this importation of Paris café life to New York was a boon. One can easily imagine the meeting of minds between Rickey and Sartre, illuminated by the sharp wit, personal warmth, and adventurous spirit of Vanetti; the rambling philosophical discussions of art and culture both high and low; comparisons of the American with the French way of life and between Paris and New York.

Vanetti's introduction to Sartre soon bore fruit beyond the casually social. The August–September 1946 issue of *Les Temps Modernes*, for which Vanetti's apartment, at 57th Street and 1st Avenue became the base of operation, was dedicated to a multidisciplinary investigation

of American life by American writers. Rickey was invited to contribute an article, among fellow artists and writers David Hare, Clement Greenberg, and Richard Wright. He chose to write about movement, specifically the postwar American obsession with the automobile and the conveniences that were rapidly building up around it—the roadside restaurant, the gas station, and the motel—that paved the way to a new way of life, new social mobility, and new freedoms, including sexual. On the design side of his treatise, Rickey devoted considerable attention to a new spectacle born of the highway culture: the four-leaf-clover interchange.

With his Army Air Corps background in the recent past, he pictured this design phenomenon from above, admiring its beauty along with its functionality. "This pleasing white concrete monument on a well-tended lawn," he wrote, "allows the motorist to advance in any direction without being stopped by a red light or having to meet another car on the road."[5] One can look back now, as he could not at the time, to Rickey's gyrating stainless-steel sculptures of the 1970s, swinging in a conical motion but never meeting, and perceive their origins in his fascination with the four-leaf clover. Significantly, Rickey titled his piece "The Mobile Civilization," perhaps an indirect reference to his new interest in Calder and the possibilities of moving sculpture.

WITH THE Institute of Fine Arts on the Upper East Side his regular haunt, George walked the neighborhood in search of a suitable place to live and work. Before long, he landed the top-floor apartment of a brownstone at 444 East 79th Street, a derelict railroad flat with a kitchen at one end and a small room suitable for a studio—with the artist's ideal northern exposure—at the other. He persuaded the landlord to rent it to him for thirty-seven dollars a month and to give him three months rent-free for making it habitable.

One of his neighbors was a young woman he had been introduced to by the Gateses in Denver, who had moved to New York to pursue her interests in singing and theater. Eleanor Emery, known to all as "Cooie," was renting a furnished room in a building on East 75th Street, not far from where George lived, for eight dollars a month. The bathroom was down the hall and the Third Avenue El thundered by at all hours of the day and night. George lent Cooie a little fridge left over from his military service, and hooked up a two-burner hot-plate in her modest digs. Cooie's rooming-house neighbors included a "mad old woman" and a "sleazy young couple" who turned out to be petty thieves. Fortunately for Cooie, the sleazy young couple moved out, and in their place a young woman from suburban Pittsburgh, Edith Leighton, moved in. Cooie was immediately taken with her new neighbor, who would be sharing the bathroom down the hall. Five years younger than Cooie, at just twenty-one, Edie was finding her way in the big city. At a commanding six feet tall, Cooie remembered, "with a mane of taffy-colored hair she wore in a tight knot to her job and let fall past her shoulders on weekends," Edie brought a fresh breeze to the stale and depressing rooming-house environment. She was "brash, careless, full of enthusiasm."[6]

Cooie began to look after her younger friend in little ways. She would knock on the adjoining wall to offer her coffee in the morning and often supper at night, thanks to George's two-burner hotplate. Edie was bold and courageous in ways that made Cooie feel safe, just as Cooie supplied the stability and friendship that Edie needed in return.

Though not exactly a pretty girl, Edie was undeniably striking—a *jolie laide*. She was passionate about clothes and dressed with flair right down to her underwear, which also happened to be an aspect of her livelihood at that time. She was working as an editorial assistant at Carwil, a publisher of trade magazines for the underwear and hosiery industry. Aside from her busy office work, she scouted for locations for photo shoots, assisted photographers, and traveled back and forth from

New York City to Strasberg, Pennsylvania, twice a month to go over the proofing for the next issue.

Edie loved clothes, but she didn't mind taking them off either. For a nice girl from suburban Pittsburgh, she was remarkably uninhibited; in her fledgling career in New York, she had begun as an artist's model at the Art Students League. So when one day in early 1946, when George asked Cooie if she would pose nude for him, in her stead she recommended her friend Edie.

As Edie remembered their first meeting, she arrived at George's studio on East 79th Street after work and found him entertaining another young woman, Bea Farwell, who lived around the corner. They all sat in the kitchen and made polite conversation, until eventually Edie said in her typically no-nonsense way, "Now listen, if you're serious and want to hire me, my rates are the same as the Art Students League, and you better take a look at me."[7] Leaving Farwell in the kitchen, they repaired to the studio at the other end of the railroad apartment, Edie took off her clothes, revealing a voluptuous figure and some pleasure in showing it off, and George told her promptly and matter-of-factly that she was hired.

It was early spring, and the days were getting longer. Edie's moonlighting job as George's model began to follow a pattern. She would go straight from her office in Midtown to George's studio to catch the last of the afternoon sun. As the light faded in the studio, she didn't mind asking him to give her dinner afterward. In return, she offered to model for him on weekends, and promised it would be her turn to cook. At some point she also asked George, instead of paying her, to add up her modeling hours until she had earned enough for him to paint her portrait.

Edie's own creative aspirations, then unformed, took naturally to the bohemian way of life, and her genuine enthusiasm for art grew with the thrill of being a close witness to the serious artist at work, not to mention the object of his intense gaze. Edie was carefully sowing the seeds of commitment, becoming a fixture in George's life,

making herself indispensable, not only to his artistic cause but with her indelible domestic touch as well. She was also stirring the depths of his nature—an inclination toward a woman of spirit and creative ambition, who looked up to him as the older man but could also hold her own.

EDITH MACNAUGHTON Leighton was born on August 6, 1924, the daughter of Wilma and James Leighton, a civil engineer and a veteran of WWI. James was involved in many projects for the rapidly growing city of Pittsburgh, overseeing the construction of bridges and the related manufacture of safety equipment while working for the local firm of Williams & Company. He was the eldest son and one of seven children of George Leighton, also an engineer, who had suffered from the bends working on tunnels. Wilma Leighton, who was ten years older than her husband, was from Wheeling, West Virginia, and had served as an Army Red Cross nurse in WWI. Edie was their second daughter and was to become their only child when her sister, Wilma Theodora, died of mastoiditis at the age of four. Her parents never fully recovered from the tragedy and the imagined potential of their firstborn. Edie grew up with a serious case of survivor's guilt, which her parents apparently did little to diminish. Our lives ended when your sister died, they often told her. In many ways Edie strived to succeed and to prove herself as worthy of her parents' love as her dearly departed sister, with an underlying anxiety that would eventually extend to her marriage to her older man.

Edie spent her childhood in Bradford Woods, a rural suburb of Pittsburgh, in a country house on a two-acre property with a garden and an apple orchard. She attended the private all-girls Winchester-Thurston School in the upper-class Pittsburgh neighborhood of Shady Side. The headmistress at the time was the founder of the school, a somewhat fearsome Scottish spinster, "Miss" Mitchell, who required her students to curtsy before her. The school promoted

old-fashioned manners, but it was also progressive in its commitment to sending young women to first-rate colleges.

From the school yearbooks of the time, we can easily see that Edie had a standout personality. Remarkably tall, she was typically placed in the middle of the back row in group photographs—the top of the pyramid. A bright young woman who exuded confidence, daring, and a quick wit, and talked a mile a minute, Edie was nicknamed "Flash." She was class secretary in her senior year, and active in the music and arts clubs. In the extracurricular vein, she was also well known for her talents at cooking. Her parents had raised her to appreciate good food and the freshest possible ingredients they grew themselves in their garden. Her father had given her a subscription to *Gourmet Magazine* for her eleventh birthday. Her mother hoped that she would become a nutritionist. At school Edie was remembered for spreading the wisdom that food was the fastest way to a man's heart.

After graduating from Winchester-Thurston, Edie went on to the Carnegie Mellon Institute of Technology to major in home economics, but she left before graduating. She later took a secretarial course at Pittsburgh Business College, and at some point dropped in and out of Iowa State College, for reasons no one can remember. During the war, she worked for a time as a welder in a shipyard in Pittsburgh, though she was apparently turned down by the WACS, to her great disappointment, and perhaps even more to her father's. But with her variety of skills, Edie was on the path of an employable working girl until the more important job of wife and mother should materialize. At twenty-one, she left for New York with an irrepressible sense of adventure.

Being an artist's model at the Art Students League in New York came quite naturally to Edie, and later, working for a ladies underwear journal did not embarrass her in the least. She spoke of Carwil's *Hosiery and Underwear Review* as "a very glamorous publication," while she also enjoyed calling it, in jest, "The Unmentionables Monthly."[8] To be sure, her parents glossed over the details of Edie's

employment when asked in the polite circles of suburban Pittsburgh; Edie, they would say, was an assistant editor for a magazine publisher in New York.

Edie's magazine work highlighted another kind of talent that likely elicited George's admiration. Belying her flamboyant character, she could be very organized and businesslike. She was highly motivated by looming deadlines, and she had an impressive memory for details, names, and dates. She also had a great visual memory—for everything from what people wore to an occasion to what was served for dinner. With her imposing figure, commanding voice, and upper-crust Pittsburgh drawl with the frequent use of "marvelous" and "darling," Edie was effective at being heard. She was only twenty-two, but she already had a way of setting her terms and throwing her weight. All she needed was a cause to channel her prodigious energy.

George offered her both a channel and a challenge. As Edie availed herself to his cause, he could see that she could be a great asset to his life as an artist. She was a talented homemaker, and she could also type, she could file, and she could keep an enormous amount of information at her mental fingertips. How unlike the languid, and somewhat scattered, Susan Luhrs. How refreshingly frank and forthright compared to the confessional but also secretive Susan. Not only was Edie sexually alluring and fun to be with, she was also a woman he believed he could trust.

15

Engagement

RELUCTANT AS he was to leave the attractions of New York, including his growing romance with Edie Leighton, George was eager to make up for lost time when he returned to his post at Muhlenberg in the summer of 1946. He plunged into his work with renewed energy for his mission, determined to revive the interest in art that he had just begun to stimulate four years earlier. There would be studio classes in drawing and painting, both elementary and advanced. His art history program, instead of offering the usual survey, would focus in depth on two giants spanning centuries—Leonardo da Vinci in the first semester and Pablo Picasso in the second—as well as a general course in art appreciation. Among his studio offerings was a design workshop where students would be instructed in the principles of good design, use of materials, and the relationship of form to function. In a handsome flyer with a distinctly modern sans-serif typeface, he laid out his ambitious new art curriculum.

Rickey's extracurricular program at Muhlenberg reflected his careful following of the Museum of Modern Art, which treated all

modern media—photography, industrial and graphic design, architecture, and film—on equal terms with painting and sculpture. On Friday evenings in a makeshift movie theater he screened a selection of revivals, documentaries, and foreign films. In the gallery he exhibited photographs by Mathew Brady, Eugene Atget, and Walker Evans, representing three generations of the documentary tradition. Perhaps most important to him personally was the show he mounted of student work from the Institute of Design in Chicago: the transplanted home of the Bauhaus.

As an artist in the flux of change, Rickey had developed a fascination with the machine aesthetic that had infiltrated art and design teaching at the Bauhaus and beyond. A second wave of modernism was in the air, inspired by technical innovation and an international spirit. He felt a growing interest in trying something that went beyond painting. He had read everything there was to read on the subject of the Bauhaus in all its phases and locations, from its inception in the city of Weimar, Germany, in 1919, to its latest incarnation in Chicago under the direction of Moholy-Nagy in 1937 (with the enthusiastic support of Walter Paepcke as chairman of the board). With the Bauhaus as inspiration, Rickey aimed to instill in his students "a more sensitive awareness of the contemporary visual world,"[1] or what the Bauhaus-trained artist György Kepes called "the language of vision," equal parts art and science, with nature as their common base. In that postwar era, the technologies developed in wartime in the way of X-ray imaging, electron microscopes, and telescopes revolutionized the human perception of visual patterns in nature and opened up new fields of expression.

But Muhlenberg College was not as committed to these new ideas as George might have hoped. It seemed to him that he was doing his job, but the college was not doing its. The response to his art program was slow after the hiatus of four years. Rickey thought it was not being properly promoted, and admitted generally to "the inertia and

indifference to cultural values" on the part of the student body.[2] He also believed that the college administration could do more to publicize the events he was working so hard to bring to them. In the spring of 1947, in a manner that would become typical of his professorial years, he wrote a three-page letter to President Tyson, meticulously outlining his complaints with a list of suggestions on how to stimulate a greater interest in his program. At the same time, he acknowledged that Tyson had invested a lot of energy and faith in the art department, and that it was not his fault that the trustees had strenuously resisted an increase in the budget that could have made all the difference.

BACK IN New York on weekends, the opportunity for a turning point in the growing romance between George and Edie was eventually to present itself. George enjoyed hosting the occasional dinner party for a group of friends who informally called themselves the Culture Club. They met about once a month, taking turns hosting dinner, often taking in a play or a concert afterward. One night, when it was George's turn to host, he and Edie had worked late in the studio and he had not prepared dinner. Edie leapt at the chance to take care of everything. Up to then, George had kept his private studio model "strictly under wraps," as Edie recalled, but as the guests started to arrive, he could hardly help but invite her to join them at the table, where she did her best to keep their secret. Afterward she stayed to help clean up, and as she was bent over the kitchen sink, George wrapped his arms around her waist and said, as if reluctantly giving in to her charms at last, "I might as well marry you."

Casual and offhand as the quip might have seemed, Edie took it, accurately, to be George's backward way of proposing marriage. Then remembering the reservations expected of a well-brought-up American girl, she countered him with a challenge. "I drew myself up to my full six feet and said—not until we've known each other a full year,

dear."3 Indeed there was much for George to learn about Edie and she about him, and in the year that followed there were plenty of occasions to discover their differences along with their mutual pleasures.

They spent a few days on Cape Cod that summer; George had the use of a house in Barnstable and they invited Cooie Emery to join them as well as a former Groton student, Larry Nichols, and his wife, Moira. George made sketches of Edie on the beach and basked in the feeling of being nearly naked with her in the sun, refreshed by the sea, "like two primitive savages."4 The weekend was especially memorable for Edie's adventure on a sandbar. She had walked across the sand at low tide for a solitary sunbathe and fallen asleep. By the time she woke up, the tide had risen all around her. Madly waving for help, she managed to attract the attention of a young man with a boat capable of rescuing her, "like a mermaid on a rock," recalled Cooie, to the entire party's great relief.5

There were times when Edie's exuberance and sense of adventure overtook her usual common sense, and George loved her for it. To his quiet intellectualism, she brought humor and irreverence. Whereas George was patient and analytical, Edie was a whirlwind of activity, a scene-stealer. After Edie returned to New York, George stayed on in Barnstable. Reflecting on the weekend, he wrote her a letter with a list of pointers for their marital happiness.

"You are right," he wrote to her in late June 1946, "I do spoil you. I'm going to quit it, for your sake and mine. I am going to insist that you show up on time, that you tidy up after yourself, that you drink as much as you want occasionally, and not a good deal all the time, that you cook and wash up for me, that if you spill powder on the bathroom floor you clean it up, that you don't talk while I'm talking, that you use words correctly and in general keep your boobs in your bra when there are cape codders [sic] around, and in spite of all my meanness—that you love me."6

Edie took her turn to offer advice. "You simply must start taking

care of yourself, as I won't marry a physical wreck," she wrote to George in a maternal strain, "wear a heavier coat . . . eat regularly and well—lots of fruit and salads—I won't have you gaining weight . . . get some regular decent exercise . . . try to get to bed at a decent hour, as you always wake up so early, and you MUST have sleep."[7]

One evening in New York, after a huge row in the kitchen over no one remembered what, Edie began to storm out of the apartment, threatening never to return. But then she realized that George would be too proud to come after her, and that she would be too proud to go back, so she threw herself across the floor as if in a faint. George was wise to her act. "Come on Edie, get up," he said without blinking.[8] Not for the first time with a woman, as we have seen before, George knew he had the upper hand. Furthermore, having already tried and failed at marriage, he was determined to make it work. Toward the end of 1946, having survived some ups and downs, George and Edie were ready to let their families know of their intention to marry.

It is not surprising that Edie's parents were at first wary of George, seventeen years her senior, as the object of her devotion. That he was an artist "just shook them to the core," she later said, though they felt some relief in the fact that he was also a teacher. "What does George teach?" asked Edie's mother, to which Edie replied, "George can teach anybody anything," more or less putting an end to the conversation.[9] Edie's father, by nature, was more difficult to please. But ultimately, as Edie assured George, anticipating what would be a rather painful weekend visit with her parents in Bradford Woods, "they are both as eager to be approved of, as to approve."[10]

For her part, Grace Rickey was likewise full of questions about George's twenty-two-year-old fiancée, whom she had yet to meet. "We think the pictures look as though she is a very pleasant, lively girl," she wrote tentatively to George in November 1946, "and intelligent too." But there was a great deal more she wanted to know about Edith, her family, and her background. "Where did you meet her, and how long

have you known her?" she asked. "What are her interests in work and study, and has she an occupation? If so, will she continue it for a time after marriage—or anything else of interest?"[11]

At the time of George's announcement, Grace was staying near his sister Jane in Laguna Beach, California. Jane was in the midst of negotiating a divorce from her husband, Guido, now calling himself "Guy" de Vall, who had been carrying on an affair with a young photo colorist from Hollywood named Mary Marlowe. With three young children and Guido's uncertain career as an artist, the divorce process would prove to be a bitter and highly unsettling process for the entire Rickey family. Guido accused Jane of hiding her substantial family assets and threatened to kill her, or at the very least to abscond with the children. Meanwhile, Jane was building her case for full custody of the children and changing the locks on the house. Guido's volatile personality made every day unpredictable, every action a minefield. With this domestic drama swirling all around her, Grace had reason to think cautiously about her son's judgment based on his first marriage, which had also had its share of domestic violence.

George's sister Emily's marriage, too, had become extremely difficult. Percy Phelps had a stroke that rendered him paralyzed from the waist down and his speech impaired, turning Emily's professional life into that of a full-time nurse. With their two children, Rosemary and Walter, they had moved to Schenectady, so it was fortunate that the family home at 13 Front Street was of an ample size to accommodate them all.

As always, Grace had the health of her eldest child, Elizabeth, constantly on her mind. A reclusive spinster, Elizabeth suffered from depression and anorexia nervosa, though neither condition had been firmly diagnosed. She had lately become delusional, possibly as a result of being undernourished and anemic. In 1946, Elizabeth was on her way to weighing an alarming seventy-five pounds, and had trouble chewing as she had lost most of her bottom teeth. She spent her days sewing, comforted by the skills she learned as a young girl in

Scotland, and, when she had the strength, attending church services and doing charity work.

Grace worried about the disparity in age between George and Edie, calling it a "disadvantage," and suggested that it was something "to be squarely met." She reminded George that when he turned fifty, Edie would be only thirty-three, "and that is a lively age for girls these days," she added, subtly hinting that when the younger woman's sexual appetite would wax, his might wane. Most of all, she hoped that Edie was a woman of quality for her only son. She wondered if they should hold off marrying for a few more months. Jane considered George "as men go, quite a catch," and Grace herself assured him that "there's no reason why you shouldn't have someone from the cream of American womanhood."[12]

George was certainly a man of quality as anyone could see, despite his unpressed appearance. He was steadfast and hardworking, with a powerful intellect and good manners, and was honest to a fault. His firm background in teaching promised a reliable, if modest, source of income. But as we have already seen, he was not a man to stand still for long. Any woman interested in George Rickey would have to be ready to pick up and move house on a regular basis, and to follow the restless meanderings of his creative ambitions.

Indeed, George was entering a period of personal artistic uncertainty, feeling strongly a need for change but unsure of which direction to take it in. He was intrigued by his experiments with moving sculpture, but now back in New York, he wondered if he could take them seriously. His army base experiments were stylistically crude and symbolically limited compared with his epic mural paintings, with their themes of social reform and community. But with the end of the war came the end of the general interest in Social Realism and the belief in its program as an agent for change. Artists everywhere were turning inward, searching for meaning within themselves. As Sartre had helped to define the moment, it was an existential age or, as W. H. Auden famously called it, "The Age of Anxiety."

A new form of abstract painting was on the rise, one that would come to dominate the postwar American art scene. Breaking from the geometric, nonobjective style of the De Stijl, the Bauhaus, and other modern European movements of the early twentieth century, artists were engaged in something more spontaneous, personal, and expressionistic. Abstract Expressionism, as it came to be known, was a distinctly American product, though some of its leading artists were European born, such as the Dutch Willem de Kooning and the Armenian Arshile Gorky. Its origins were in France with Surrealism; especially influential was the Surrealists' fascination with the subconscious and abstraction as a kind of "automatic writing"—a spontaneous, physical expression of the self, a visual unfurling of a dream state. As a fresh approach to painting, this kind of abstraction had a more dominating effect in America than anywhere else.

Such spontaneity and introspection did not come naturally to Rickey, in paint or any other medium, and nor—at least not yet—did pure abstraction. At the same time, he felt the need to try a new approach, to leave behind a literal representation for a more personal dialogue with the self. He returned to biblical and mythical themes that, despite being an avowed atheist, he had occasionally employed in his earlier work. Taking a cue from Surrealism and dream imagery, he blended these themes with wartime memories and other personal preoccupations. In his 1947 drawing "Supper at Emmaus," three figures sit around a table playing cards while a ghostly vision of another figure rises in a curl of smoke from the ashtray. In another work, a depiction of Jacob wrestling with the angel, a strangely sinister beaked figure, its sexual suggestiveness alludes to a powerful new relationship with a woman. Nothing like the fleshy, docile nudes of his earlier years, these figures are engaged in hand-to-hand combat.

Rickey had also been studying Picasso closely, preparing lectures on his work for Muhlenberg and elsewhere. In one etching of around this time, called "Route 66," the influence of Picasso is overt, with

pieces of the female anatomy in a kind of cat's cradle of dynamic forms, with one foot distorted like a quote from Picasso's *Guernica*. In all, these works show an urge to join the latest wave of modernism, as well as an openness to the material of his own psychology in a time of momentous personal change.

IN THE spring of 1947, the Association of American Colleges invited Rickey on a cross-country lecture tour, which he gladly accepted. Edie was on his mind all the time, and physical distance made for a passionate correspondence between them. He longed for her lively company and he missed her in bed. "My sweet," he wrote to her, "if I had you here now your hairdo wouldn't last long, nor your lipstick, nor this well-made bed. I yearn for you!"[13] Edie wrote with equal ardor: "I am looking forward to being raped in the back seat," she told him after only a few days apart, "so am forewarning you—I will undoubtedly seduce you—be prepared."[14]

In their animated exchange, their thoughts and plans for their future as a married couple and the understandings they were eager to establish took shape. George wrote about his concern about the state of the world and whether to have children "who may live [in] a still tougher time than we." At the same time, he weighed the practical economics against the richness of life that children can bring. "Each child we have will make us poorer as we divide what we have into more parts, *but* actually, with each new child we shall be more richly endowed in every way . . . we will have less steak and chicken but we will have the luxury of a houseful of happy, lively, interesting human beings."[15]

Edie, for her part, wondered why he had worked so hard to reach that conclusion, "because it is the only logical thing to do, and so simple a conclusion to come to." But it was more than simply logical, as she added, "Children are a necessity, and you would be surprised I

am sure how easy it is to accommodate them."[16] George loved that she narrowed down his philosophical musings to the sharpest point, and her youthful, down-to-earth confidence in their future.

On the subject of money, George stressed the importance of living within their means and a conservative approach to spending. He could easily see how Edie's taste for expensive clothes and furnishings could devastate a bank account in no time. But he could also perceive her talent for numbers and her ambitions for organization and thrift. So he perceptively devised a plan that would put the control of spending in her hands. *"I don't want to be niggardly,"* he wrote to her, "so what I should like best is to have you sort of take over the budget problem as you have so efficiently on the housekeeping problem at 444 and keep yourself and me on a budget and you decide when we can afford to splash a little and when to stick to the routine. It is the routine that will make Europe possible. What I would love is to have you a sufficiently expert budgeteer so that *I* can have the pleasure of indulging you and committing some financial folly for your pleasure from time to time."[17]

Edie reassured him: "I do know how to shop and cook inexpensively—I think too that I've proven that," she wrote. But she also admitted that together they had been too extravagant, "on a lot of things—especially liquor, which according to my little accounts comes to much more than food, supplies, etc." It was not all her fault, she wrote. "Darling, if you must buy bonded bourbon, I will not be responsible."[18]

George's lecture tour also gave Edie an opportunity she had been longing for. By this time she had more or less moved into George's apartment on East 79th Street. Naturally, she had ideas of her own about how to decorate, and decided to test the waters while George was out of town. She coyly alluded to her plans, calling them "The Project," without ever letting on exactly what she was up to, except at one point to ask for a little financial help from him, which he trustingly gave. When George returned to New York several weeks later, Edie playfully blindfolded him and led him up the stairs to present the results with the maximum of drama. Blindfold removed, George

viewed a complete transformation of his apartment. Edie had painted the walls, hung curtains, slipcovered chairs in bright, patterned fabrics, and fashioned a coffee table out of an old gilded picture frame. She had flowers in vases and a crystal decanter of red wine at the ready. He must have been prepared to like "The Project," for it was at that moment, as Edie later told the story, that he drew an engagement ring out of his pocket—a cluster of rose-cut diamonds—that he had bought during his last stop, in New Orleans.

16

Chicago

EDIE'S PARENTS expected her to be married in an Episcopal church, and George, though an avowed atheist, was willing to go along with it. The only question was whether as a divorcé the church would sanction his marriage vows. A former student from Groton, Doug Auchincloss, recommended the priest who had sanctioned his own remarriage after divorce, the Reverend Ralph W. Sockman, at Christ Church on Park Avenue and 60th Street. Preparing for their interview with the minister, Edie wore a demure little hat decorated with pink silk flowers perched over her curled bangs and George came armed with his divorce decree.

"And this is your first marriage, Miss Leighton?" asked Sockman, to which George blustered forth, "Her first and her last!" With the success of this interview, they went straight down to Tiffany's to buy Edie a wedding ring. Choosing an extra-wide gold band, she declared, "I want everyone to know I am well and thoroughly married!"[1] As for George, he remembered feeling for the first time in his life that he

was being born again, even if not as a Christian. He was filled with excitement about the great adventure that lay before him, with Edie by his side. "I feel as though this were the only real beginning I have ever had since I was old enough to remember," he later told her.[2]

At four o'clock in the afternoon of May 24, 1947, family and friends gathered to witness their wedding vows. Christ Church was an impressive neo-Romanesque edifice with a richly decorated Byzantine interior, the half-dome of the apse encrusted with shimmering gold and colored glass mosaics. James Leighton led his daughter down the aisle accompanied by a very modern piece of music that George's brother-in-law William Ames wrote especially for the occasion, and which the organist, expecting the usual Mendelssohn, strained to play. The bride wore Balmain—a cream-colored satin skirt and tight-fitting, waist-length jacket like a riding habit—and a little felt hat draped with yards and yards of white chiffon. Edie's only bridesmaid, Pittsburgh classmate Beth Rocke, wore a sleek column of pale green and carried a bouquet of dark red cabbage roses dripping with ivy, while George's best man was the disheveled and accident-prone Philip Evergood, who had broken down on the West Side Highway in George's borrowed Nash on his way to the church. The Leightons hosted a reception at La Salle du Bois, a fashionable restaurant around the corner, decked out for the occasion with flower arrangements that matched the bride's bouquet, a towering white-frosted wedding cake, and punch.

George wondered what their parents would think of each other—Grace Rickey, the bluestocking socialist from Schenectady, and James and Wilma Leighton, of conservative suburban Pittsburgh. Meeting for the first time, they performed their respective roles with the good manners of well-bred Yankees. At least Grace and Wilma could talk gardening, and James happily discovered an old girlfriend in Levering Tyson's wife. The roster of other wedding guests, who had gathered from far and wide responding to some three hundred invitations, represented the many strands of George's life to date: family connections

from Scotland to Schenectady, students and colleagues from his teaching jobs at Groton and in the Midwest, friends from his army days in Denver and the art circles of Greenwich Village and Woodstock. Many continued to party after the wedding, uptown and down, and the newlyweds made the most of their many reunions for the next three days.

Finally they drove off to Woodstock, where they would be borrowing George's sister Alison's little cabin in the woods for their honeymoon. With its outdoor plumbing and rustic kitchen, it presaged many a camping adventure for George and Edie. Travel readiness was a feature of their marital bond and eating well was a requisite whether at home or on the road. Edie had packed a big picnic basket full to brimming with leftover chicken, asparagus, and the top of the wedding cake, along with a hamper of wine and Champagne enough to last them through the weekend. They arrived at their destination at dawn, having sat out a torrential thunderstorm on the side of the road.

Edie's mother had advised her to keep a large supply of linen towels for her wedding night, or morning, as it turned out. "That was the total—and end—of my sex instruction from my mother!" recalled Edie, who had apparently not revealed that she had been more or less living with George for months. Nonetheless, she enjoyed dressing the part of the virgin bride with an enchanting "wedding-night shirt" made of chiffon with lace sleeves, white ribbons, and embroidered flowers. Happy to be alone at last, George and Edie ignored all standards of bedtimes and mealtimes, and called it, for that brief, magical few days, "daylight losing time."[3]

Wedding gifts flowed in from all corners—Wedgwood vases and bone china teacups, money they added to the general fund, and settings of the silver pattern they had selected (Royal Danish). The question of what the bride and groom would give to each other was resolved several months later with the opening of an exhibition of Alexander

Calder at the Buchholz Gallery, at 32 East 57th Street. Curt Valentin, a refugee from Nazi Germany, had made the Buchholz Gallery one of the most prestigious in New York. Having worked for Albert Flechtheim in Berlin and Daniel-Henry Kahnweiler in Paris in the 1930s, Valentin had developed an infallible eye for modern art and a particular passion for sculpture. He had added Calder to his stable three years before.

The show of small Calder mobiles in December 1947 brought to mind creatures of all kinds. Works such as "Little Spider," "Stallion," and "Armadillo" made a delightful display of intriguing movement and technical bravura. Calder's work had also recently been endowed with the added weight of Jean-Paul Sartre's philosophical treatment on the occasion of his show at Louis Carré in Paris the previous year. He deemed it the perfect artistic expression of existentialism. Calder's playful variations of movement appealed to Sartre's love of chance and randomness. His mobiles, wrote Sartre, "signify nothing, refer to nothing but themselves. They *are*, that is all."[4] Valentin published the Sartre essay in his little catalogue of the show, and *Art News* republished it the same month, and the Sartre–Calder connection was thus laid in print if not in stone.

Between Edie's enthusiasm for the work and George's growing interest in making moving sculptures, the idea of embarking on married life with a Calder mobile seemed exceedingly apt. As a symbol of their new marriage, it combined joy and movement with unpredictability. George and Edie agreed to go separately to the Buchholz Gallery to select a Calder as their wedding gift to each other. With the synchronicity of lucky newlyweds, they chose the same piece—a bar of juggling linked parts balanced at the tip of a black three-legged stand with a bright red disc around its neck. Technically advanced, it combined the stabile and the mobile with casual elegance. With its title, *Wedding Veil*, it seemed to have been made with their occasion in mind. Delighted with the coincidence, George and Edie split the

three-hundred-dollar price tag, and the Calder, every move of which Sartre would describe as "a little private celebration,"[5] was all their own to enjoy. The newlyweds' life was thus adorned with the Calder sculpture, like a talisman of things to come.

IN THEIR new married life George and Edie would commute between New York and Allentown. Edie kept her editorial job at Carwil, having risen to the rank of assistant editor, while George rounded out another full year of teaching at Muhlenberg. He was also in constant demand at the college to serve on committees, attend meetings, and in general to deal with administrative tasks, all of which frustrated and bored him more and more. He was much more interested in spreading the gospel of art education than in the tedium of keeping house, and was glad to accept a lecture tour for the Association of American Colleges in the spring of 1948. On the road to various college venues, George felt a welcome sense of detachment from Muhlenberg and the breathing space he needed to revive his interest in teaching. Of one thing he was increasingly certain—that a coed college made for a livelier art department. "The girls are more responsive than all but the most gifted men," he wrote to Edie from the road.[6]

He spent an especially intriguing weekend in St. Louis, "quite fabulous in fact," he wrote to Edie.[7] George was fortunate to have a friend in the exuberant young director of the City Art Museum, Perry Rathbone, who immediately engaged him in the social rounds of local modern art collectors. The most exciting event of the weekend was their visit to the studio of Max Beckmann, who had recently emigrated from his wartime refuge in Amsterdam. Rathbone had helped to secure a teaching position for Beckmann at Washington University in St. Louis, and since his arrival with his wife, Quappi, Rathbone, and his wife, Euretta, known as "Rettles," had been the couple's constant hosts and guides to the city.

John Newberry, a curator from the Detroit Institute of Arts, was

also visiting St. Louis; adding considerably to the excitement, the visit to Beckmann's studio would include the unveiling of his portrait. Beckmann "looks like his self portraits," George told Edie, and yet the great artist in person was not as imposing as his painted self-image suggested. Rather, he was "quiet, assured, absolutely simple and unassuming." In the studio, he had lined up his paintings on a ledge with their faces to the wall ("a good technique," thought George). Beckmann asked Newberry if he was prepared to see his portrait, and after receiving a nod brought it forth, slowly and deliberately, and set it on his easel. The picture was "striking," wrote George to Edie, "very much Beckmann . . . then through the Beckmann you begin to see John . . . there was a likeness but remotely so."[8] The soft-spoken John Newberry expressed his approval without hesitation.

With this trial behind him, Beckmann invited them to see his winter's work, about nine canvases, one by one. George was especially taken with a small oil painting of Leda and the Swan, depicting Leda as a queen being comforted by her king, both nude, while the mysterious swan can be seen through the window, flying away. What was it that drew him to this painting in particular? Perhaps it was in the ways that its imagery resembled George's own recent painting, *Annunciation*, in which a winged, birdlike angel hovers over a contorted nude virgin who seems to be resisting the angel's phallic beak, powerful chest, and the branch of lily he brandishes like a weapon. Was Beckmann's *Leda* also a projection of George's relationship to Edie, his self-image as protector but also dominator? Without seeing the picture, Edie could hardly judge for herself, but she encouraged him to act on his instinct. "He could not stop talking about it," she recalled. "Finally I said why don't you write to Perry and see if you can buy it."[9] And thus, with Rathbone's encouragement, Beckmann agreed to sell *Leda* to George and granted his request to pay him in monthly installments.

✻ ✻ ✻

RICKEY FELT a degree of success for his goals at Muhlenberg when in 1947 he established an undergraduate degree in art and brought in two more faculty members—the designer Joseph Cantieni and the historian Robert Reiff—who would bolster the emphasis on modernism. With new faculty in place, he asked Tyson for a sabbatical at the end of the academic year in 1948, without saying that he would be actively searching for other job opportunities. He was ready for a radical change of scene. As for his painting, although he strived for meaning in his depictions of mythical and biblical subjects, he knew he was no Beckmann. He was determined to expand his horizon, as both artist and educator, and to take advantage of the GI Bill while he still could.

Rickey had first visited the Institute of Design in Chicago while on a lecture tour before entering the army, and the experience had lingered through his return to Muhlenberg. He had hoped to attract a graduate of the institute to teach in his department, but a Bauhaus-trained design teacher proved hard to capture, as graduates tended to go straight into professional design work. This gave him the excuse he needed to enroll in the program himself and experience the school as a student first hand. Most of all, he was interested in the famous foundation course, or *Vorkurs*, that laid out the Bauhaus principles across a variety of media. The pedagogical goal was essentially to offer the students an approach to problem solving rather than rote vocational skills. The program would offer him a new approach to teaching, but just as important, a reassessment of his own direction as an artist.

George's readiness for an artistic change of direction coincided with another kind of prospect on his horizon. Within the first few months of their marriage, Edie was pregnant. They were full of excitement by March 1948, when she began to feel the baby kick inside her. By June, George's sister Jane, in California, was sending hand-me-downs for the baby, imagining Edie in strong physical shape for the delivery. But George and Edie's high hopes were devastated in

early summer when she delivered their first child without a heartbeat. Edie's self-confidence as a childbearer was shaken to the core. She would need time to build back her strength. In a move she might have regretted, Edie opted to stay with her parents in Pennsylvania over much of the summer, visiting friends and generally recovering, both physically and emotionally, while George accepted an invitation from the University of Washington School of Art to lecture on modern art at its summer session.

Although she strived to be the perfect wife and homemaker and played the consummate hostess with cheer and aplomb, deep inside Edie suffered from self-doubt on a daily basis. The stillborn baby added to a nagging sense of failure she had carried with her for much of her life. Most of all, especially living at home again, she felt the scorn of her father, a feeling, she told George, she would "bear to her grave."[10] In her darkest hours, she would revisit a sense that her older sister should have lived, and that she could never make up for her parents' loss. In a blue mood fueled with more than a couple of martinis, she wrote to George, dredging up guilt from her childhood, her feelings of sexual inadequacy mixing with the loss of their child. George did his best to soothe Edie from afar. "I can understand the disappointment and the escape and the relation of little Rickey to it," he told her, but he encouraged her not to despair. "This specter of failure is exactly what you call it," he wrote to her. "It isn't really there." He loved Edie for her ability to laugh when she was most unhappy and above all to forgive her parents, "when they are still crucifying you on the cross of your childhood."[11]

He urged Edie to seek solace beneath the surface of things: "We have a deep life together that is a quietly running stream beneath all our trivial rounds of our work and the books we read and the cooking and drinks and the houses we live in and the decoration and even the baby we lost." Together, he hoped, they would transcend these hurdles and losses, not through material things, but through a nurturing of the intellect. "Together we shall win a great deal from life—not just a

job and a house and a car and a lilac bush and Beckmann and Calder, not just two or three kids, but we'll eat from the Tree of Knowledge together and find out what the real Cutting Edge is and what the Inside looks like when it is cut."[12] That summer he painted a ghostly *Pieta*, with the Virgin and Christ figure hollowed out like a Henry Moore sculpture. Nonbeliever he may have been, but George was not above using Christian imagery to express his own sense of tragic loss.

For Edie's part, she too felt a growing bond with her husband and the pleasure of yielding to his purpose in a union that made her feel whole. "For what is love but the giving up of your soul to find with another the one soul." At the same time, she was experiencing an awakening, a new eagerness to learn and to discover the "latent and untouched springs" of her own mind for another kind of fulfillment.[13]

Since before they were married, Edie's ambition had been to find the time to develop her own creative form of expression. Even though she acknowledged to George a feeling that "your work is to me, much more important than anything I could do," at the same time she felt the need to nurture her own. "Unless I can adjust my own life to accommodate what I want to do, I will be difficult to live with," she told him. She had a passion for fabrics of all styles and periods, and was developing a sophisticated eye for their design and technique; as she wrote to George, "This must be investigated more fully."[14]

With art-minded Pittsburgh friends, that summer Edie visited George Nakashima and his wife, Marion, at their home in New Hope, Pennsylvania. "It is wonderful and exactly what we want ourselves," Edie told George, describing the house in detail, with its modern sliding glass doors, interior stone walls, and unobstructed view of the hills. Edie loved Nakashima's furniture, "tenderly made of wonderful wood."[15] The Japanese American designer had grown up in Washington and had studied at the University of Washington in Seattle, where George was then teaching.

Meanwhile, George was much taken with Seattle. Entertained by faculty members at their homes, enjoying a glimpse of their family

life on their delightful patios overlooking Puget Sound with a drink in his hand, George told Edie it was the best faculty life he had seen anywhere, and a wonderful climate too—pleasantly cool for August, and it was light in midsummer until ten at night, rather like Scotland.

When the summer school session ended, George traveled down the coast to Laguna Beach to visit his embattled sister Jane and her three children. While he scouted for jobs on the West Coast and elsewhere, he really hoped to postpone "the whole Fall-1949 problem" until the following spring, and for the time being to look forward to the year ahead at the Institute of Design.[16]

GEORGE AND Edie arrived in Chicago in their brand new Crossley station wagon in the fall of 1948. They found a small apartment at 1026 North State Street, just a block from Lakeshore Drive and the waterfront. In the same year that George and Edie were married, Cooie Emery married Paul Harper, an advertising agent, and moved to Chicago. The Harpers were losing no time in building what would become their very large family, with six children in all. Edie and George were trying again. Happily reunited as neighbors, the two couples often got together for drinks and meals. Having packed nothing in the way of cooking equipment except for a double boiler and a cocktail shaker in their move from New York to Chicago, Edie was poised to embrace the challenge of producing a dinner for four in their mini kitchen, which was also their bedroom. Cooie admired Edie's flair for decorating their simple apartment, as well as her talents as a cook; Paul discovered what his wife already knew: that George was "a man for all seasons, he knew something about everything," which made for lively discussions on innumerable topics of mutual interest. When George talked about art, it was often in the context of its relationship to history. These associations were at his fingertips, ready to grasp and connect to whatever was the conversational topic at hand, with plain speech and intellectual force. He held strong political views, mainly to the left

of center, but was never pontifical; instead he typically imbued them with what Paul described as his "Scottish common sense."[17]

Rickey's stint at the Institute of Design came too late to experience the leadership of its founding director, Moholy-Nagy, who had died two years earlier. Moholy-Nagy had been followed by the architect Serge Chermayeff, Russian born but educated in England, who was, to quote Rickey, "more English than the English." He may have been a brilliant architect, but he was, in Rickey's opinion, a "disaster" as an administrator, and toward Midwesterners "terribly snobbish."[18] Chermayeff's appointment coincided with the school's move to the former Chicago Historical Society building, at 632 North Dearborn Street, near the Loop, and soon afterward its incorporation into the Illinois Institute of Technology. As its new leader, he was charged with expanding the curriculum and tightening the program. He faced a young faculty who were largely Bauhaus educated, including many recent arrivals from Europe. It would not be easy to live up to his predecessor, the charismatic and visionary Moholy-Nagy, who epitomized the fluid cross-fertilization among media as painter, photographer, filmmaker, and stage designer.

Rickey had arrived at the Institute of Design in the midst of the school's struggle to redefine itself. Thankfully, however, the frequent rows between Chermayeff and the faculty were of no real concern to him. At the age of forty-one, he was much older than his fellow students, and older than many of his professors as well. He felt more like a detached observer, playing a double role in his mind as both student and teacher. For Rickey, the foundation course was a course in how to teach a course in design. In the back of his mind, he might have also expected that its technical and conceptual lessons would help to prepare him for his next artistic breakthrough.

The course focused on both the actual and the perceptual creation of volume, turning two dimensions into three in a variety of ways. One exercise was in the principle of "virtual volume" in the creation and rotation of wire constructions. In all of their exercises,

students learned to consider space, light, material, scale, and struc-ture. "Economy of means" was a pedagogical goal forged by Josef Albers—to design an object without any wasted material—and his powerful example extended to Chicago. One of George's most chal-lenging assignments was to make a camera bellows out of a single piece of paper. "Like a sentence of death," wrote Rickey of this rigor-ous test, "it concentrates the attention."[19]

For the course in product design, George analyzed problems of control, strength, angle, weight, pressure, and fatigue. His notes on a design for a matt-cutting machine show the process of his prob-lem-solving mind at work. "The point of a blade need not act as a fulcrum in order to do its job," he concluded, and "the control of the blade can easily be built in, except for the start and finish of the stroke."[20] These product-design exercises focused his engineering skills in practical ways, and in a physics class he studied the effects of light, optics, and color theory. Across the board, he developed his technical skills in mechanical drawing, plaster casting, metalwork, photography, and topography. Working for months under the sword of Bauhaus principles, art and industry became one and the same, fused in his head as never before.

One member of the faculty, the adventuresome German-born Peter Selz, became a good friend. "[George] was twelve years older and wiser," recalled Selz.[21] Together they took a great interest in Moholy-Nagy's theories that had been laid out in his 1929 *The New Vision*, as well as in the latest ideas of the inventor and designer Buck-minster Fuller, who was also on the faculty of the institute that year, working with a group of students on developing a sustainable home. At the time, Fuller was revolutionizing concepts of shelter and trans-portation, such as the geodesic dome and the revolutionary Dymax-ion Dwelling Unit and the corresponding Dymaxion car. Technical innovation in art and architecture in the example of Fuller and others was in an exciting postwar flurry of development. As Selz recalled, "Everyone there was discussing the potentials of kinetic sculpture."[22]

A guest speaker that year who particularly riveted Rickey's attention was Naum Gabo, the Russian Constructivist who first expanded the idea of sculpture to include a "fourth dimension"—namely, movement—with his path-breaking *Kinetic Construction* of 1920. Gabo's slender motorized vibrating metal rod on a small wooden base created an illusion of volume. With this piece, Gabo demonstrated his absolute rejection of mass and volume, of carving or modeling, in the traditional language of sculpture. In their place he embraced the void. "Space and time are the only forms in which life is built," wrote Gabo in his Realistic Manifesto of 1920, "and hence art must be constructed."[23]

DURING THEIR year in Chicago, Edie's fragile sense of self-esteem was given a great boost with George's suggestion that she have her portrait painted by Max Beckmann. Having paid off his purchase of Beckmann's *Leda* in installments over several months, George made his request, and Beckmann accepted.

In March 1949, George and Edie took the train from Chicago to St. Louis to spend the weekend as houseguests of Perry and Rettles Rathbone. The Rathbones, who had each sat for a Beckmann portrait, knew just how to set the stage. On Saturday night they hosted a small dinner party with Max and Quappi Beckmann and the modern art collector Joseph Pulitzer Jr. and his wife, Lulu. Edie found Beckmann a rather stern and silent presence, and she was conscious that he was studying her throughout the evening "with his intense and piercing eyes." But she was charmed and reassured by Quappi, "so light, so delicate, and graceful, so socially accomplished," who spoke perfect English and smoothed the conversation along by quietly translating everything Max said, "never interrupting the flow of conversation."[24] Two days later, Perry and George drove Edie to Beckmann's studio and left her there for the morning. Over the next few hours, Beckmann made several charcoal drawings of Edie's head, with artist and

subject communicating in a mostly silent rapport. Beckmann told Edie he was pleased with the drawings, though he did not show them to her. He asked her to follow up by sending him some photographs.

It was several months before Beckmann felt ready to show Edie and George the result. The Beckmanns had by that time left St. Louis for New York, where Max had a studio at 39 West 69th Street. Quappi and Curt Valentin joined George and Edie for the unveiling. The picture was facing the wall: Max invited them all to sit and then paused before turning it around to face them. Unmistakably Beckmann, with its strong black outlines of her head and shoulders and a richly textured purple background, it is also unmistakably Edie, with her long face emphasized by a daggerlike nose, columnar neck, and the dangling, silver fish earrings that she had worn at dinner the night before the sitting. "Is there anything you vant changed?" Beckmann asked Edie. There was not.[25]

17

Europe

HAVING COMPLETED the foundation course at the Institute of Design in the spring of 1949, Rickey had absorbed what he needed from the program and it was time to move on with his career, though he was not immediately sure where to. The break from teaching had been the distance he had needed to recalibrate his priorities, as an artist and as a teacher, and while interviewing for teaching positions in Minneapolis, Champaign, Illinois, and Bloomington, Indiana, he was determined to extend it as long as possible.

That year he was invited to illustrate a collection of short stories by Chekhov in a special edition published by Rodale, in Emmaus, Pennsylvania. In his depiction of Chekhov's characters, Rickey's skillful line drawings with washes of color show a light touch and a relaxing of the somewhat tortured style of his biblical subjects. But while light, these Chekhov illustrations related to his serious respect for caricature and the comic strips of the day as an art form. Because of their close relationship to contemporary everyday life, comic strips "are an art form however base they may be," Rickey explained to Eric Clarke. "Great

art is more likely to come to America through refinement of these than through intensive study of the old masters."[1] With an innocent prescience, he had lectured on the subject of comic book art some twenty years before Pop art burst onto the American scene.

At the same time, George felt no waning of his interest in the old masters, and the Chekhov commission provided him with a small but welcome travel fund to nurture it. With the future still unknown, George and Edie decided to spend the next few months of their freedom in Europe. It would be Edie's first trip abroad and George's first in fifteen years. He was eager to show Edie the great sights and to revisit the scenes of his youth and childhood. He also wanted to spend time just looking at art, without trying to paint at all, to refresh his habits of seeing and view the old art anew. For her part, Edie was thrilled with the prospect of traveling abroad, brushing up on her French and devouring guidebooks amid a flurry of packing and shopping for the trip, including a summer's supply of Philip Morris cigarettes.

In New York in April, just as they were boarding the French ocean liner *De Grasse*, George was handed a telegram. Henry Hope, head of the art department at the University of Indiana in Bloomington, was confirming his offer of a teaching position for the coming September. What a relief it was to take off for Europe knowing there was a job to come home to, and the one George had most hoped for.

Aboard the *De Grasse* they found their cabin comfortable, the food excellent, and the weather fine. They enjoyed the babble of mostly French passengers all around them, a middle-aged "lady painter" from Rochester at their dinner table[2] and a musical Italian-Swiss couple who were their deck-chair neighbors. After a smooth crossing, they docked in Le Havre at the end of April and made their rendezvous with George's Oxford classmate Leonard Snow to embark on a rambling road trip through France into Italy, with Florence their destination.

They drove through the bucolic Yonne valley and stopped in the busy town of Auxerre, thence "floated down the Rhone Valley on

Cotes-de-Rhone, Cotes-de-Provence," Edie reported to her parents. "Snogs is quite a wine man and we did the gamut from Montrachet to Château Neuf du Pape." In Burgundy they tasted snails and toured a deep cave where the vintners bottled their wine by candlelight. Visiting the fifteenth-century Hospices de Beaune, Edie was particularly taken by the enormous kitchen with its huge fireplace and great copper pots and utensils, the nuns in their white linen coifs, and every door with elaborate iron keyholes and gigantic keys to match. As they traveled through Provence, she swooned at the cream white houses and red tile roofs, scarlet poppies against dark green cypress trees, and the Mediterranean "too blue to be true."[3]

In Florence they settled into a *pensione* on the Via Romana overlooking the Boboli Gardens. For a modest two dollars and seventy-five cents a night, they had a large room with a shared bath down the hall and three meals a day. George read with delight John Ruskin's *Mornings in Florence,* and with his Renaissance studies at the institute under his belt, he was eager to refresh his acquaintance with the wonders of Florence. He led a rigorous sightseeing regimen, spending hours at the Uffizi, the Pitti, and the Bargello, until they closed their doors at four o'clock and the churches opened. Thence to Santa Croce, Santa Maria Novella, and to Brunelleschi's Baptistery, where the sculpted bronze doors by Ghiberti had just been cleaned and restored to their original brilliant gilded bronze. Edie proved herself to be an indefatigable sightseer, eager to learn at George's elbow, and freshly aware that these familiar images from illustrated books were so much more thrilling to see "in the flesh" and where they belonged. Snogs was also an enthusiastic sightseer, though more apt to quit early for a refreshing ice on the piazza.

All in all, they were struck by how bustling and prosperous Florence seemed in the war's aftermath, the shops full of linen and china, the grocers with plenty of meat and vegetables, cheeses, and cakes. They were delighted with the price of dinner in a restaurant, and Chianti at fifty cents a bottle. For the American traveler on a budget,

life was blissfully cheap and the Italians welcoming. "Except for the destruction you see occasionally you would not know there had been a war," George wrote to his mother. "[H]ere in Florence everything seems bursting with prosperity . . . how much of it is due to the Marshall Plan I don't know."[4] Attending a concert or the opera, they were struck by the fine ladies of Florence cloaked in mink and ermine.

But signs of war were still to be seen as they traveled through northern Italy en route to Paris in early June. Every house along the road to Milan had been bombarded, and many of the bridges destroyed. Crossing the border into Switzerland, the scene was quite different—all the houses and roads in good repair, neat and clean. They began their climb to the Saint Gotthard pass, a steep winding way, mostly dirt but paved at the hairpin turns, the landscape wild and the weather stormy, as they navigated roads carved through snowbanks ten feet high. Now and then through the clouds they caught a glimpse of the spectacular mountains. They stopped for a rest near the French border a thousand feet above the clouds in Neuchâtel, where they could see the range of Alps a hundred miles away.

"PARIS," GEORGE wrote to his mother in June, "is like this—spacious, spring-like, rather gay."[5] When Snogs returned to England, George and Edie rented a little apartment on the rue de Grenelle with a "Hollywood" bed, which when folded into the wall allowed for a pleasant sitting room. On the street below was all they could possibly need in the way of provisions: patisserie, charcuterie, and a little grocery store. And it was only a ten-minute walk to the Trocadero and the Place de la Concorde.

They dropped in on the offices of *Les Temps Modernes* and picked up a few extra copies of the August–September 1946 issue, with George's essay on American road culture. They had lunch with Jean-Paul Sartre and went to see his new plays, *Red Gloves* and *Les Main sales*. They looked up the artist Janice Biala, whom George knew

from Olivet when she had lived with Ford Maddox Ford. Since Ford's death, Janice had moved to Paris and married a French artist, Daniel Brustlein, who was creating cartoons for the *New Yorker* under the name "Alain." Thanks to Janice, Edie found a very good dressmaker to make her a chic suit and blouse, with fabric she'd picked out at the Galeries Lafayette.

For Edie, Paris was a revelation, "indeed the most beautiful city I have ever seen," she wrote to her parents.[6] She and George enjoyed the art museums, the ballet, the theater, and the movies. They danced till dawn at a bal musette and then walked all the way across the city to the market at Les Halles, where the stalls opened at five in the morning. Edie was enchanted by the French touch—the carrots in pyramids and wild strawberries in little baskets with their foliage intact—and collected fresh cut flowers to brighten their apartment. She practiced her French wherever she could with her indelible American drawl, and forever after peppered her speech with French words and phrases. From then on they would go not to a gallery opening, but rather to a *vernissage* and a picnic in the park was a *déjeuner sur l'herbe*.

They went on pilgrimages, first to Chartres, where they spent an entire day wandering around the cathedral, climbing the bell tower, and appraising the stained-glass windows. They spent four days at Bourbonne-les-Bains and traveled from there to Colmar, with five changes of train, to view the famous Grünewald alterpiece.

After the luxuries of Florence and Paris, they were struck by the austerity of Britain, when they arrived in August for the last leg of their European tour. It was a shock to see parts of London devastated by the war, such as the tremendous destruction around St. Paul's Cathedral, which stood miraculously unharmed amid a sea of ruins, weeds waving among the rubble. The Singer building, by Finsbury Square, as George dutifully reported to his mother, had also survived the bombing, but it was left in the midst of acres of flattened buildings. Rationing was still imposed on gas and many foods; he and Edie could count on

a steady diet of turnips, cabbage, and potatoes. Welcomed by Leonard Snow in his spacious house in Sunbury-on-Thames, they brought their allocation of ham, butter, and assorted cheeses from France. It was just as well that Snogs had kept his excellent wine cellar from before the war, so although they drank "mildly," Edie told her parents, they drank well—a red 1928 Bordeaux with the main course, a 1924 Château Yquem with dessert, followed by coffee and a one-hundred-year-old brandy, "just like honey."[7] The Snows kept chickens on the tennis court. Their charming garden extended all the way through a rose-covered trellis to the Thames River. On fine days they had tea on the lawn.

They had hoped to get tickets to the Edinburgh Festival, then only in its second year, but all the performances were sold out. Disappointing as this was, their main purpose in Scotland was for George to catch up with old family friends. A full schedule of lunches and teas awaited them.

George found Helensburgh quite unchanged, with all the familiar shops on the high street just as they were, the gardens and window boxes tidy and green as ever. It was the people who had changed. George faithfully recounted to Grace the news he had gathered of everyone they knew—who had gotten married or divorced; how many children and where they lived now; who had retired, taken ill, or died; and, he assured her, how everyone spoke of the "gap left since your departure."[8]

They visited Clarendon, which had passed into private hands. No one was at home, but the gardener let them inside and they explored the house from top to bottom. In a highly detailed report to his mother, George noted every single thing that had changed inside the house: Gas had replaced coal in the fireplaces, walls that were papered were now painted and stenciled, a partition had divided her bath and dressing room into two baths, and the billiard room had been made into a dormitory. The garden was in regrettable shape, Grace would be sorry

to hear, with not enough hands in wartime to keep the shrubbery shapely and the weeds at bay, and half the beds in the rose garden had been turfed over. In this new postwar era, their life in Scotland was now emphatically in the past.

Although the Walter Rickeys had left Scotland after Walter's death, fifteen years before, George was grateful for the presence of Scottish relatives who were still in place. Walter's niece Margaret (George's first cousin) on a visit to Glasgow from Michigan had met and fallen in love with a Scotsman, Donald Macdonald. After carrying on an episto-lary transatlantic romance, they finally married, and Margaret moved from the United States to Scotland. Edie and George visited the Mac-donalds, with their four children—two boys and two girls, ranging in age from twelve to two, "each blond and more pink-cheeked than the last"[9]—in Dunbartonshire, and the Rickeys were much impressed with the couple's resourcefulness in times of rationing. The Macdon-alds had chickens producing a supply of eggs and a garden full of vegetables, and they were fattening a pig on the garbage.

George went fishing with twelve-year-old Willie Macdonald, and Edie enjoyed long walks by herself on the heather-covered moor and coming in from the mist for tea by the fire. Margaret drove them to visit the Singer factory in Clydebank, where George found some of his father's former colleagues still at work.

They listened to everyone's opinion about British politics, the effects of the postwar Labour Party, then in power, and "the ster-ling-dollar crisis" that led to the devaluation of the British pound by thirty percent. With a general election in the year ahead, everyone speculated about which party would win, now that the Conservatives were gaining ground again after their huge losses to Labour just five years before. Snogs was of the popular opinion that "the socialists are bringing the upper classes down rather than the working classes up,"[10] and they heard much about the worker under the welfare state becom-ing too complacent, listless, and unproductive. As fond as George was of his cousin Margaret, they openly disagreed about politics—Margaret

was a staunch Conservative to George's leftist tendencies—while her children listened in on their heated debates with fascination.

Travel weary after almost six months abroad, it was with some relief that George and Edie sailed home to the states in early September. "It has been a good stay," George told his mother, "exhausting at times, but very satisfactory."[11]

18

Bloomington

"TOUT MARCHE bien," wrote George to Edie in September 1949, soon after arriving in Bloomington.[1] He had gone ahead for faculty meetings while Edie stopped in Pittsburgh to visit her parents and organize the move to their new home. The university provided them with a two-room apartment in faculty housing near the campus, and George with a studio in the cluster of the art department complex that had been improvised out of war-surplus buildings. The studio was large and bright, with a big sink, hot and cold running water, stools, tables, and racks, and, not the least, the unexpected luxury of access to a short-wave radio network. "I can't tell you how pleased I am with my studio," George told Edie.[2] He was soon at work to the sounds of classical music or the BBC news from London, and looking forward to displaying his latest gouaches in the faculty lounge.

Henry R. Hope was chairman of the art department at the university, having been hired in 1941 by the forward-thinking president Herman Wells for the purpose of establishing it. Like Rickey, Hope had

been a strong advocate for art education at the university level, and the GI Bill brought a postwar surge of interest in building these programs. Not only was a college education free for all who had served in the war effort, but the very meaning of a college education was changing as well. The young men who had been drafted at eighteen were in their twenties by the time the war was over. As George observed, they were too old and experienced for the routine of the required college freshman courses; they sought wider choices, among which the arts played an important role.

With a PhD from Harvard following several years in Paris studying at the Sorbonne, Hope's art scholarship was broad in its scope and sophisticated in its outlook, ranging from medieval art to Art Nouveau. But modern art was his passion; he had written extensively on Lipchitz and Braque, and he thrived on the company of living artists. George had met Henry Hope at annual meetings of the College Art Association. When he served as its president, Hope remained detached from any specialized circle and disentangled from the politics of academia. A natural leader, he was also a shirker of administrative tedium and unnecessary chitchat. At Bloomington he was known to leave the building through his office window to avoid a diversion in the hallway, a trait his faculty apparently accepted with amusement and equanimity.

Hope was happy to give Rickey a full teaching load along with some real theoretical and organizational problems to solve in his role as associate professor of fine arts. With his Bauhaus training under his belt, Rickey was convinced that design was at the core of every artistic discipline. "I like the approach of sifting out what the various visual arts have in common, then teaching those common factors in a basic course," he wrote to Hope. At the same time, he felt qualified to fill in the art history offerings at any level and on any subject, including the general survey course. "Assign me where I will help you most. I'll find out what I don't know," he assured his new boss.[3]

The strength of the art department and the scale of the univer-
sity—with some thirteen thousand students—made it a far cry from
provincial Muhlenberg. Hope had already attracted an impressive
array of talent to the Bloomington art faculty, such as Alma Eikerman,
a silversmith who taught jewelry, Karl Martz in ceramics, and Harry
Engel, Richard Millman, and Alton Pickens to run the painting stu-
dio. For art history, Hope had recruited specialists such as Otto Bren-
del, a scholar of classical art, and Theodore "Ted" Bowie in Japanese
art. Hope strongly believed, as Rickey did, in the value of students
seeing art directly, and to that end had established a gallery in the art
center with a full program of loan exhibitions. The university would
soon have a museum of its own, with Hope its director. His home was
also a museum in its own right.

"My first art faculty meeting, in Hope's living room," remem-
bered George, "was unforgettable for the eye as well as the palate,"
for Henry was a brilliant cook.[4] With his Connecticut Yankee accent
(with which he also spoke fluent French) and his old-school manners,
Hope was a seasoned host and a skillful choreographer of creative
personalities. Surrounded by his collection of modern art, by Picasso,
Matisse, Braque, Maillol, and Lipchitz, he created an aura of prestige
and innovation throughout his house and garden. Faculty meetings, it
felt to George, were more like parties at which business was informally
discussed.

The day Edie arrived by train from Pittsburgh, in October, Henry
Hope and his wife, the beautiful Sarahanne, known as "Sally,"
invited her and George for dinner. Aside from the Hopes' "bevy of
animated children," six in all, they were introduced to Bernhard and
Cola Heiden, German and Dutch, respectively, both professors in the
music department, and the two couples immediately discovered com-
mon ground. Bernhard's father had known Max Beckmann in Frank-
furt and collected his work. Edie and George could feel quite ahead
of the curve in that regard. "In our baggage was Edie's portrait by

Max Beckmann, with the paint scarcely dry," George recalled later.[5] With that first stimulating dinner party at the Hopes', George and Edie were relieved to find that Bloomington, Indiana, was not as they may have feared, "the sticks," at all.

Two years earlier Hope had invited Max Beckmann to teach at the university, and it was to his great disappointment that Beckmann accepted a post at Washington University in St. Louis instead. Hope remained determined to engage Beckmann somehow; in 1948 he invited the artist to jury a show of student work and met him for the first time. Edie's portrait may have helped to bolster Hope's courage in asking Beckmann to paint his entire family in a single group portrait. Beckmann was reluctant at first to take on such a project, but with the gentle but irresistible pressure from his dealer, Curt Valentin, he arrived in Bloomington in the winter of 1950 to meet the challenge. Beckmann succeeded in the end with one of his most unusual late works. In a narrow vertical canvas the size of a panel from one of his triptychs, he created a crowded, almost life-size portrait that shows each of the eight figures of the Hope family as an individual personality as well as a symbolic actor in the ongoing theater of life.

LIVING IN university housing on campus, George and Edie could easily participate in the kind of extracurricular activities they thrived on—concerts, plays, foreign films, and lectures. Edie looked for part-time secretarial work, but the pickings were slim in that small university town, and there was competition from the student population. George was confident that "with a little economy we shall get along fine."[6] He further assured Edie that there were many useful things to do at home of the kind that really appealed to her, such as cooking and making slipcovers, as well as volunteering her talents to the university's various cultural activities. With her interest in fashion and theater, Edie designed costumes for the 1954 convocation of the

university's Dance Workshop, for which she also performed, along with Sally Hope, in Cola Heiden's "Boulevard of the Abnormal," a modern dance composition inspired by the paintings of Paul Klee.

Along with their household furnishings, George and Edie had imported to Bloomington their growing collection of art. Max Beckmann's portrait of Edie as well as his *Leda*, Josef Albers's little abstraction *Growing*, a Mark Tobey watercolor, and Calder's *Wedding Veil* together formed a kind of artistic cradle of George's evolving creative ambitions. Once in Bloomington, they added another Bauhaus artist, Lyonel Feininger, to the collection. George was intrigued by Feininger's depictions of boats amid the forces of nature and his ability to reduce them to a dynamic web of lines. At his request, Feininger was glad to send them a few watercolors to choose from. As if to honor their new Indiana surroundings, they chose *Barns*.

With the refining of his mechanical instincts at the Institute of Design, along with the conducive atmosphere of Bloomington and his ample private studio, George was at last poised to embark on a project that had been on his mind for months, if not years. He was ready to test his ideas for moving sculptures in earnest. While Calder provided a helpful model, George's first inspiration for moving sculpture reached back to his childhood. This was the Japanese glass wind chime that hung in the doorway of a neighbor's house in Helensburgh that fluttered and tinkled above his head with the brush of air when the neighbor, Mr. Paar, opened the door. An empty picture frame, damaged in their baggage during the move, offered the broken shards of glass George needed to begin his new project. He recalled an instructive moment while visiting a stained-glass workshop in Philadelphia, where he observed how the craftsmen cut glass with the help of a paper pattern, and how they hung the pieces together in the air before setting them in lead. With his initial efforts, George organized his cut-glass shapes in arrangements suspended from a wire, creating shimmering illusions of living creatures such as fish and birds, in midair.

Walter Rickey, circa 1913.

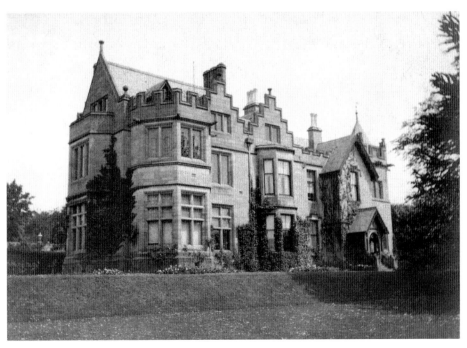

Clarendon, the Rickey home in Helensburgh, Scotland, 1921–35.

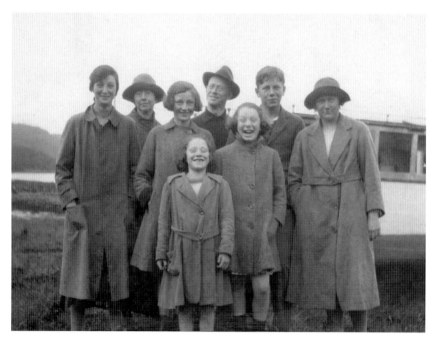

The Rickey family on a sailing trip in Scotland, circa 1920.

George and George Lyward,
Glenalmond, Scotland, circa 1925.

George and Susan Luhrs on the tarmac with the *Scylla*, Croydon, England, 1934.

George working on the Olivet College mural, Olivet, Michigan, 1938.

Philip Evergood working on his painting *Bride,* circa 1948.

George and Edie at their
wedding reception,
New York City, 1947.

Max Beckmann, *Portrait of Edie Rickey* (oil on canvas), 1949.

George Rickey, *The Annunciation* (oil on canvas), 1948.

George Rickey, *Phoenix*, Junior Art Gallery, Louisville, Kentucky, 1950.

David Smith
and Jean Freas,
Bloomington,
Indiana, 1954.

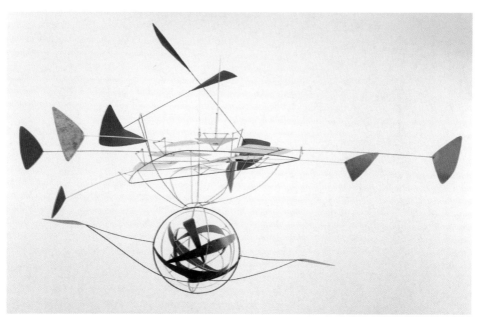

George Rickey, *Seesaw and Carousel* (stainless steel, brass, paint),
Baltimore Museum of Art, 1956.

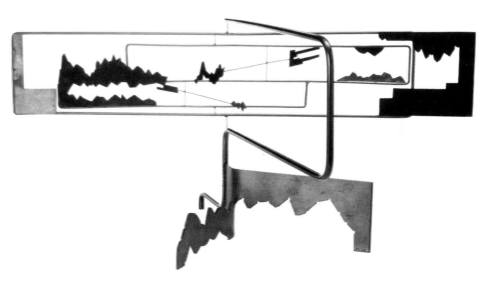

George Rickey, No *Cybernetic Exit* (brass, painted brass, steel), 1954.

The house on Hand Hollow Road, East Chatham, New York, 1956.

Edie and Stuart Rickey, East Chatham, New York, circa 1958.

George and Naum Gabo, 1963.

Edie at her desk,
East Chatham,
New York, 1964.

Edie modeling George's
Space Churn hairpiece
(sterling silver and enamel),
1956.

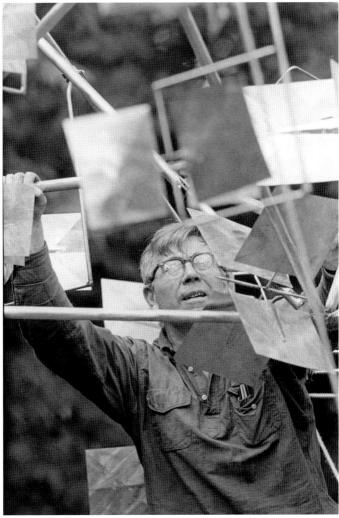

George at work on
Crucifera IV, 1964.

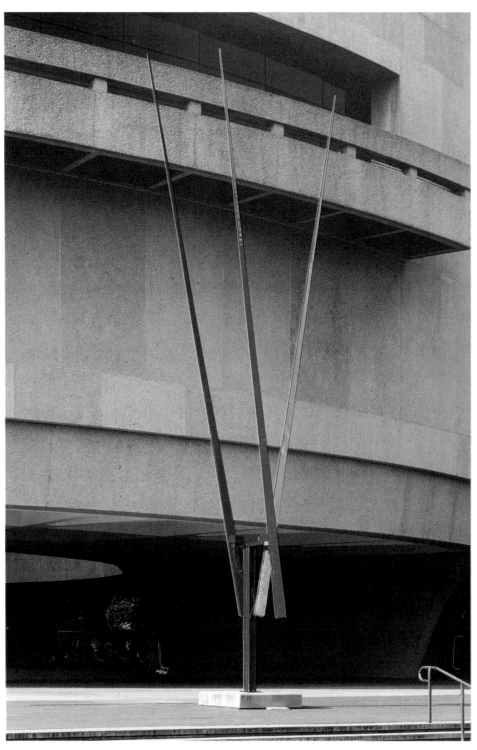

George Rickey, *Three Red Lines* (stainless steel),
Hirshhorn Museum and Sculpture Garden, Washington, D.C., 1966.

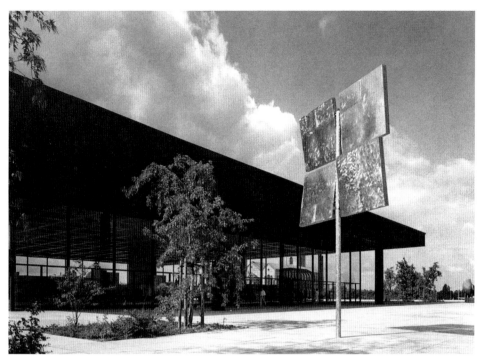

George Rickey, *Four Squares in a Square*, Neue Nationalgalerie, Berlin, 1969.

Don Mochon, *At the Rickeys'* (watercolor), mid-1960s.

Edie Rickey in the kitchen, Bundesplatz 17, Berlin, 1981.

Ed Kienholz casting Edie for The Art Show, Berlin, 1974.

The Rickey family, by celebrity portrait photographer, Arnold Newman,
East Chatham, New York, 1973.

Dennis Connors with George in the upper studio, East Chatham, New York, 1976.

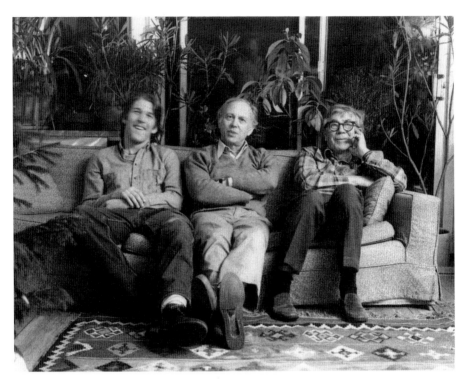

Philip Rickey, Ellsworth Kelly, and George, East Chatham, New York, 1976.

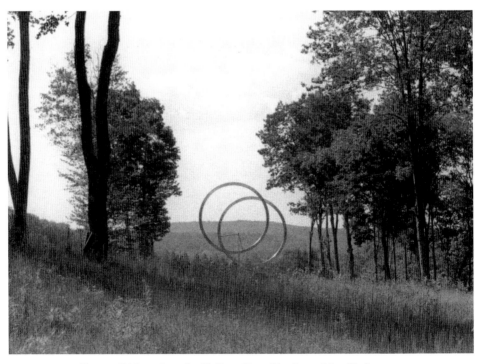

George Rickey, *Annular Eclipse*, East Chatham, New York, 1999.

At first, George was enamored with the addition of spontaneous sound to his sculpture—the tinkling of glass—but he soon gave up on the tinkle factor in favor of elements that hung together without touching. Concerned about the fragility of glass, he also sought alternatives in metal and plastic, scouring the university dump for odds and ends of stainless steel and other materials. Taking a cue from Calder's catenary structures, he created hanging vertebrae of linked wire, each one held aloft by a little sail, or petal, at its end. He gave them titles that evoked themes of nature or music: "Arpeggio," "Dragon Fly," "Blue Note," and "Foothills." The largest and most ambitious of these early Rickey mobiles was his flying "Phoenix" of 1950, with a six-foot wingspan, made up of at least fifty hanging, clear glass parts suspended from three horizontal bars.

Having earned a little extra money teaching at the summer school, George planned a road trip to the West Coast, his ultimate destination Laguna Beach to visit his sister Jane in the throes of her harrowing divorce from Guido. With Ulfert Wilke as traveling companion, in September he reached Seattle, where they planned to meet the artist Mark Tobey. Tobey had spent several years in Japan, and his subsequent painting style owed much to his study of Japanese calligraphy. His small, intricately layered paintings showed a craftsman's technique and a fascination with words that made for a language of abstraction quite distinct from the New York School. His work was of particular interest to Wilke, who was also experimenting with calligraphic forms. Apparently finding these fellow artists good company, Tobey gave them a tour around the local galleries of Japanese and Northwest Coast art, when George might have made the first of several purchases of Native American artifacts, and then agreed to join them on their road trip south, as far as San Francisco.

George at the wheel found Tobey "a rather exacting traveling companion," which meant frequent stops for coffee and ice cream along the way, and at mealtimes a search for the best restaurant in town. He also discovered that Tobey was a nervous passenger who suffered from

various minor ailments and was inclined to drive from the backseat. As they drove through giant redwood forests and along the plunging coastline, Tobey recounted the story of his life, his travels in the Orient, his disillusionment with New York, "his growing fame and poverty," and his practice of the Baha'i faith, though to George's relief he was "not in the least a proselytizer."[7] Before they parted company, George bought a Tobey watercolor called *Ancient Empires*, a souvenir of their travels and an example of Tobey's signature "white writing."

EVER MORE engrossed in his progress with moving sculptures, Rickey was eager for a meeting with the master of the mobile, Alexander Calder. In 1951, with the summer off and a trip east in the planning, he hoped to travel to rural Roxbury, Connecticut, where Calder and his wife, Louisa, had made their home in an eighteenth-century farmhouse on Painter Hill Road. At first making use of an old icehouse for his studio, Calder had since built a large studio on the foundation of a dairy barn that had burned down before their arrival, in 1933. Surrounded by nature, in 1934 Calder began to create outdoor sculptures for the first time, experimenting with the ways the wind propelled their movements. In that lofty space amid an open landscape of orchard and pasture, by 1951 his work had grown into bigger gestures and sturdier constructions.

Being of passing acquaintance socially through friends such as Dolores Vanetti and Curt Valentin, it is likely that Rickey was not too shy to get in touch with the artist directly. On May 25th, Calder wrote back with his signature bold black ink scrawled on a postcard, inviting Rickey to "come out for lunch" and, always ready for a party, adding "bring Robert and Mimi Laurent if you can."[8] Robert Laurent, a French émigré sculptor of figures carved in stone, was also on the faculty in Bloomington. They all convened on Painter Hill Road on Monday, June 4.

Although the visit was critical for Rickey, it was probably of little

consequence to Calder. Did Rickey bring along a sculpture or two for Calder to appraise or show him his work in any form? If so, did Calder see any potential for originality in Rickey's foray into mobile making, or did he regard it as pure imitation? Calder did not have the nature of the mentor, but nor was he guarded about his methods. In general, Rickey would have certainly have been impressed by the demonstrably free spirit of Calder's sprawling workspace. Here was a studio alive with sculptures in motion against a background jam-packed with myriad parts, tools, and materials, as busy and engaging as the personality of its resident artist. In particular, George might have focused his attention on a recent work (1950)—Calder's largest outdoor mobile-stabile to date and his first to use a bearing to keep it from flying apart with the wind.

Repairing to the house for lunch, George saw Calder's genius everywhere. He made kitchen utensils for Louisa whenever she expressed the need, such as wire grill racks and sieves, ladles and mea-suring spoons. He made rattles and pull-toys and a dollhouse for the children (he and Louisa had two girls), and he carved a toilet paper dispenser out of a piece of wood in the shape of a hand. Domestic life was of a piece with Calder's creative output, and country life made it boundless.

Following his visit to Calder's studio, Rickey's mobiles become looser, more curvaceous, and more playful. *Le Roi Soleil*, a circular burst of shiny brass and copper bobbing on the end of a stainless-steel wire, and *Flight of Swifts*, with black-and-white swallow shapes flying in opposite directions, attested to a new sense of possibilities. Ever more sophisticated and confident, Rickey experimented with various organizations of lines and weights. It was also around this time that he embarked on his first large outdoor sculpture. With a university research grant of five hundred dollars, he bought a three-by-eight-foot sheet of stainless steel to create *Silver Plume II*. With a striking resemblance to Calder's *Wedding Veil*, it consisted of a ten-foot tripod form with a cross bar balanced on its tip, hung with Calderesque wire

vertebrae of moving parts. Adding a strong third dimension, the cross bar could move three hundred sixty degrees. To keep the crossbar from flying away in a stiff breeze, he constructed a joint to insert into the neck of the base.

Rickey was greatly encouraged to be included in a show at the Metropolitan Museum in New York titled *American Sculpture, 1951*, with his mobile *Square and Catenary*, as well as an exhibition of American painting and sculpture at the Whitney Museum, downtown. Closer to home, he participated in the Annual Indiana Artists Exhibition, at the John Herron School of Art in Indianapolis. With this boost to his confidence, he began to show his work to dealers in New York. Packing a few small sculptures, he visited the Kraushaar Galleries, where Antoinette Kraushaar had kept a small inventory of his drawings during the war. There before her, he unpacked and assembled his little moving sculptures, and she was enchanted. In the summer show of 1951, she included Rickey's "Swallows," a flight of chevron shapes suspended from wire.

While mastering the balancing act between the linked elements of a Calder-style mobile took perseverance, Rickey found that Calder was not difficult to imitate. Indeed, this proved to be the challenge; it was difficult not to imitate him, to see beyond a system that he had so successfully concocted and for which he already seemed to have claimed the last word. Calder had "opened the door," as Rickey later said, but it did not seem at first to lead anywhere.

GEORGE'S OWN balance was severely shaken on September 28, 1951, when he received the sobering news that his sister Jane had committed suicide. A neighbor in Laguna Beach discovered her, slumped in the seat of her car in her pajamas, with the engine running. Her divorce from Guido de Vall was still pending after five years, with their three children—Frankie, Norman, and Louise—in the throes of an ongoing custody battle. At the time, Grace, Emily, and Percy were

living next door, looking after Jane and her family. Immediately upon her death, they packed the three de Vall children off to Schenectady. The divorce was final with Jane's death, but the custody battle between de Vall and the Rickey family had just begun.

"She was the closest of my sisters," wrote George to Nancy Blackie in Scotland many years later, when he dedicated a sculpture to her memory, "two years my junior, and a fellow painter."[9]

19

New Orleans

AFTER FIVE years of trying to produce a child, with a stillbirth and a miscarriage in their recent past, in March 1953 George and Edie were anxiously optimistic when Edie's next pregnancy approached full term. "How she can get bigger, I don't know," wrote George to Dolores Vanetti.[1] To the Hopes' young daughter Kate, Edie looked "as if she had swallowed a feather pillow."[2] Edie's due date passed. A week later, on March 23, shortly after George left the house to teach his first morning class, Edie bent down to pick up a penny from the floor and went into labor. George hurried back from his classroom to take her to the hospital. As the nurses wheeled her into the delivery room she warned them, "If you don't hurry, this baby is going to walk out!" at which point, they anesthetized her for the duration of her difficult delivery.[3] Their baby boy came out feetfirst, with the umbilical cord around his waist.

Soon afterward, Edie reported that she "felt marvelous," although she spent the next eleven days recovering in the hospital while George's mother and sister Emily came to Bloomington to welcome

the next heir to the Rickey family name into the world.⁴ They named him Stuart Ross Rickey, taking his first name from the George's family and the second from Edie's. The couple asked their newest best friends, Bernard and Cola Heiden, to be his godparents.

A few months into motherhood, Edie was happy to report to Dolores Vanetti, "Stuart could not be a more agreeable child. He's full of good humor with a sunny disposition and a charming smile." The baby had Edie's long legs, but altogether resembled his father more. Stuart was "the image of George with big dark blue eyes, reddish hair and a barrel chest." With typical high spirits, Edie assured the child-less Vanetti that their new baby was "good as gold, no trouble at all, and hasn't changed our life a bit," and with all the new conveniences available to the postwar American mother, such as diaper service and commercially processed baby food, "having babies in 1953 is easy as pie."⁵

In 1950, anticipating their growing family with Edie's pregnancy that year, they had bought a little house within walking distance of the campus, at 312 East 8th Street. Now, when their son finally arrived, they were fully ready to indoctrinate him into the world of art from his cradle. In his drooling infancy, Stuart was endowed with three paintings and a survey of the history of art. In turn, Stuart's arrival perhaps helped to spur George's first real commercial project—the "Mobikit"—a collection of parts for making mobiles in a variety of arrangements. Hoping to capitalize on the explosive popularity of mobiles and mobile-making in the manner of Calder then sweeping the country, George's kit aimed for creative and educational play, for in addition to mobiles as do-it-yourself modern home décor, there was a growing demand from teachers for a toy that demonstrated the principles of mobile-making. Rickey's Mobikit consisted of several thin wire rods in three lengths, plastic discs in primary Calderesque colors, and thread to hang them with, plus a four-page booklet of instructions, tucked into a cardboard tube. In the basement of their small house, George directed an assembly line of hired students to produce them.

He bought advertising in the *New Yorker*, the *New York Times*, and the *Saturday Review*, expecting to ride the wave of mobilemania. "Now we just have to wait for the orders to pour in," wrote Edie optimistically to Dolores in July. "I'm sec/treas. and with house/babe/garden, you can imagine that I've been busy."[6]

Despite the mobile craze, orders did not pour in for the Mobikit right away. Their commercial venture was off to a slow start and in fact it barely got off the ground. With its finicky little parts and lengthy instructions, the kit discouraged all but the most determined hobbyist. The popular TinkerToys of the day, inviting free play in abstract form, were self-explanatory; Rickey's Mobikit, on the other hand, was a test of artistic imagination, not to mention elementary physics, small-motor skills, and, most of all, patience that few children were likely to possess. The venture began deep in the red, and went briefly into the black before they abandoned it altogether.

But the concept of Rickey's mobile sculptures as an educational tool succeeded in ways he had not foreseen. He was invited to participate in a series of exhibitions in Louisville, Kentucky, by Sue Thurman, an enterprising young curator in charge of the Children's Gallery of the city's public library. Thurman's exhibitions, such as "Everything Is Growing" and "Bugs," sought to educate the young or uninitiated in the language of modern art. Consistently, Rickey's moving sculptures, among them the spectacular glass "Phoenix," with its six-foot wingspan—which miraculously made its way safely from Bloomington to Louisville for the exhibition—were named the favorites among children and adults alike. Other museums and galleries, such as the John Herron Art Museum, in Indianapolis, used Rickey's sculptures as springboards for art-making workshops. Thus in many ways, Rickey's role as an educator was spreading in new directions and to younger audiences.

The first Rickey sculpture to enter a museum collection was also especially playful in concept. In 1955, Adelyn Breeskin, director of the Baltimore Museum of Art, commissioned Rickey to create a moving

sculpture to hang in the stairwell in the children's division of the museum's Belle Boas Memorial Library. With his first public commission, Rickey was eager to make an impression. Over the course of countless hours and experiments, he constructed essentially two sculptures in one: a churning sphere suspended from a cluster of rocking horizontal bars. *Seesaw and Carousel* evoked an imaginary planet or a gigantic space toy as much as a child's playground alive with movement, with both parts rocking and circling, each setting the other in motion. As the sculpture neared completion in his studio, George feared it was too large, but once installed in the airy museum stairwell, it "shrank" to just the proper size.[7] However, his test was not over. Breeskin needed the approval of her acquisitions committee before the funds to pay for the moving sculpture came through. Some quibbled with the lower section, the sphere, which seemed "crowded" and didn't move as well as the cross bars above it. Obligingly, Rickey addressed this criticism, reducing the number of elements. Finally passing muster, *Seesaw and Carousel* entered the permanent collection, and was soon to become a beloved treasure among Baltimore museumgoers, especially with children.

Whereas *Seesaw and Carousel* alluded to the futuristic space-travel obsessions of midcentury, in another development around the same time, Rickey began to work with an ancient structure: the sailboat. In the most literal of all his sculptural work, he created rigging and sails of mild steel. Then, adding a unique piece of sailing technology, he balanced the hull on a gimbal. Used for centuries to hold a compass or a lantern on an even keel, in Rickey's boat mobiles it did the opposite—it rocked the boat in an allusion to its movements at sea. This gimbal device, directly inspired by the sailing trips of his boyhood in Scotland, would be essential to a small fleet of little Rickey boat mobiles. He would also employ the gimbal in many subsequent sculptures having nothing to do with boats at all.

In his first one-man exhibition at the John Herron Art Museum in Indianapolis, in January 1953, Rickey was able to show his rapid

development as a sculptor, with some hanging pieces, some standing, all moving. George was happy to report to Dolores Vanetti that at an earlier stage, museum- and gallery goers would comment on how much his work resembled Calder's mobiles, but now they commented "only on how they are different."[8]

FOUR YEARS into Rickey's professorship in Bloomington, in 1954, David Smith joined him on the faculty as a visiting artist. Rickey and Smith had met before the war and moved in the same circles in Woodstock in the 1930s. More recently, Rickey had visited Smith at his studio in Bolton Landing, in upstate New York, where he and his first wife, Dorothy Dehner, also a sculptor, had in 1940 taken up year-round residence. The sloping field at their doorstep was to become Smith's ever-expanding outdoor gallery, where he placed rows upon rows of sculptures like farm crops marching to the far end of the field, with a view of Lake George in the distance.

Having been a commercial welder working for the American Locomotive Company in Schenectady during the war, Smith recognized the possibilities of welding sculpture. Welded steel, with its tensile strength, could achieve cantilever and penetration into space never before imagined. For centuries sculpture was either carved or cast; Smith, following the example of Picasso and Julio Gonzales, opened up the field to free-form open shapes of intersecting lines and points of focus. Bringing industrial techniques to pastoral themes, Smith created three-dimensional drawings in space. By 1954, he had built a strong reputation, winning grants and accepting visiting artist positions around the country. Having recently divorced Dorothy Dehner he arrived in Bloomington with his new wife, Jean Freas, and their baby girl, Rebecca. The Rickeys were happy to welcome them and help them find a house to rent. Just a year apart in age, Smith and Rickey had more in common than first appearances might suggest. Both were born in Indiana, and both were sons of engineers, though

at different levels of the pay scale: Smith's father was a telephone engineer. Both came to sculpture by way of their work experience, and both were avid, ever-learning art historians. Now they had a new special language to speak together—the language of sculpture.

Smith must have been interested to see Rickey's new foray into mobile-making. The year before arriving in Bloomington, in 1953, Smith had made two hanging sculptures of welded steel, his first and only example of moving sculpture. *Parallel 42*, with its ragged shapes and asymmetrical countenance, was a far cry from the gay levitations of a bobbing Calder mobile. For Smith, it was not the dance of shapes that interested him but rather the concept of hanging, in this case a comment on the tragic events of the Korean War. By the time Rickey began making sculpture, he had fully absorbed the more or less apolitical doctrine of the Bauhaus. The one exception to this occurred the year Smith joined him in Bloomington, 1954.

It is likely that his only attempt in sculpture at political commentary was inspired by local events. In Bloomington that year, a group of students initiated the Green Feather Movement, a protest against banning the story of Robin Hood from school curricula for fear that it might inspire communist sentiments. Even though the Green Feather Movement spread to other college campuses, it escaped outright censure. "There was no campus witch-hunt," said Rickey, "but I think it was never very far away."[9]

What he created was a quietly satirical comment on the McCarthy hearings and the targeting of liberal-leaning university professors: It comprised four sculptures he called "Flag-waving machines." These little flag-waving sculptures were essentially compound pendulums. They consisted of a vertical rod at the top of which two little flags are set in motion by an armature of spinning circles around them, the whole piece rocking with a single weight below the fulcrum on a gimbal. Like many of Rickey's other pieces of this period, one kind of movement set another kind in motion, with engaging differences in pace and direction already more complex than a Calder mobile.

For some three years before Smith arrived in Bloomington, Rickey had sought out the technical expertise of others on the art faculty. Alma Eikerman, a metalsmith and jewelry designer, was a patient tutor in the basics of silver soldering. But these jewelry techniques would take him only so far. While in Bloomington, Smith gave Rickey a brief but career-changing tutorial—namely, a half-hour cutting and welding lesson with oxy-acetylene. This industrial technique combined the cutting and joining of metal with a single gas torch, greatly simplifying older methods. Just as welding had revolutionized Smith's approach to sculpture, so it would for Rickey.

Smith also advised Rickey to be more extravagant with his materials, refuting his strict Bauhaus training in economy of means and his natural Scottish thrift. Smith espoused the merits of stainless steel, one of several metals he employed, despite it being ten times the cost of mild steel. The strength and relative lightness of the metal had no equal, and for the outdoor sculptures that Rickey would eventually develop, and which he had already used in his *Silver Plume*, there was the added advantage of reflecting the colors of nature around it without rusting in the rain.

Rickey would forever after credit Smith with the welding lesson; however, he was perhaps less conscious of, and certainly less vocal about, the stylistic aspects of Smith's influence on him that are quite apparent in retrospect. In 1954 Rickey was working on a series of sculptures in brass and painted steel that he called *Little Machines of Unconceived Use*. Hung like swinging gates between two pivot points, these wide horizontal compositions suggested a kind of calculator or measuring tool. The same year, Rickey was commissioned to make a sculpture for a statistician. For this patron, he created swinging gates of nesting open rectangles that frame jagged horizontal silhouettes suggesting a mathematical graph. He called it *No Cybernetic Exit*, but it could just as easily be read as a hardedge mountain landscape, with near and distant views. One of Smith's signature works of 1951, *Hudson River Landscape*, makes an apt comparison. Whereas Smith's

"Landscape" captures a sense of movement in its lines and invites the viewer to move around it, Rickey's "little machines" actually moved to the touch of a hand or a passing breeze.

It was a particularly fecund period of development for both artists, and it is interesting to speculate how they might have stimulated each other. During their period of overlap in Bloomington, Rickey began to experiment with what he called "space churns"—spherical open cages housing a system of moving parts—which formed part of his Baltimore commission. The similarities to Smith's *Star Cage*, of 1950, and other works of interweaving lines in space are striking. Whether with stars or outer space, caged or churning, both artists were looking to the heavens for inspiration.

Rickey was moving away from hanging systems at about this time, preferring to build up. For him, this new verticality added suspense to the delicate climb of moving parts. He experimented with balancing shapes of equal size rather than the hierarchical flight of shapes of a typical Calder mobile, and discovered that his sculptures danced in a different way. The elements were more responsive to currents of air, and their movements more random, more varied, and less predictable than Calder's. It was around that time that he began to wonder whether Calder, brilliant and varied as his mobiles were, had said it all. "When I found he had not, I had to choose among the many doors I then found open."[10] The ease of imitating Calder, amply demonstrated by a spate of imitators at the time, was further reason to explore new directions. With Calder's popularity climbing along with a score of copycats, it was an idiom that by then could only look derivative.

The principle of the compound pendulum was essential to Rickey's first systemic departure from Calder's example. He embarked on a series of leaning towers that reversed the expected effect of gravity from the bottom up. He made the first of such works, which he called *Totem*, in 1954, the year Smith came to Bloomington. Coincidentally or not, Smith had quite recently begun his *Tanktotem* series— totemic shapes carved from water tanks—and other works addressing

verticality. While in Bloomington, Smith learned how to work with a power forge from a local blacksmith and completed ten vertical sculptures he called *Forging*. For the first time building upward, Smith might have taken a cue from Rickey's departure from the more or less horizontal catenary system of Calder's mobiles. Whichever way the influence flowed, it was an intensely exploratory period for both artists in which the presence of the other was stimulating, at the very least.

Their differences were striking too. As the art historian Reiko Tomii compared the two artists, Smith was a blacksmith, forging heavy steel parts in muscular gestures; Rickey was a silversmith or jeweler, creating delicate balancing acts of moving parts.[11] Smith's webs of welded parts created tension in his sculptures; Rickey's contemporaneous work with movement was evolving as if to set them free.

MUCH AS he was enjoying teaching in Bloomington and the company of colleagues such as the Heidens and visiting artists such as David Smith, by 1954 Rickey was on the alert for other job opportunities. As an associate professor, although likely to be promoted to full professor, there was room for improvement—a bigger paycheck, the security of tenure, and, not least, a greater control over his teaching load. Having arrived at Bloomington with an offer to fit into the curriculum wherever he was most needed, he had become more protective of his time in the studio, and balked when Hope casually sprang new teaching demands on him. He also discovered some fundamental differences in aesthetics and approach with other members of the studio faculty, and a lack of policy from the top. So when an offer came to chair the art department of Newcomb College, the women's college of Tulane University, George was receptive.

Crombie Taylor, then acting director of the Illinois Institute of Design, had recommended Rickey for the position. "I know of only one person I could seriously recommend to you, he was once a student here at the Institute of Design,"[12] Taylor wrote to Newcomb's Dean

John—known as Jack—Hubbard. Charles Dollard, of the Carnegie Foundation, also weighed in favorably, calling Rickey "one of the few young artists I know who has a really sound training in the history of art."[13] Dean Waggoner, of the Bloomington faculty, had perhaps the strongest words of praise for Rickey, saying that he was "the only member of the department who is completely at home in both aspects of the department [history and studio work]," and promised that "vigorous efforts will be made to keep him here," as it would be "well nigh impossible to replace him."[14] In courting Rickey, Hubbard promised an exceptionally able young staff and a facility that compared favorably to any other in the country. Rickey could picture himself in charge of a big university art department, with a greater control over his curriculum and the ability to build his own faculty. Not the least, New Orleans itself was a stimulating and responsive milieu for an artist to live in, a charming city of cultural depth and colorful history. His interest piqued, Rickey went down for an interview in May.

George was by then in a position to negotiate for a better salary. With Edie pregnant again, he had reason to recalibrate the family budget to maintain their standard of living in New Orleans. "I didn't enter this profession for the money in it," he wrote to Hubbard, "but at 46, with a couple of children who will be minors for a long time . . . I find the time past when I can work gladly for a junior salary and ignore the possibility of a much larger salary somewhere else, which, with the lines of two decades of teaching on my brow . . . might tempt me."[15] With Hubbard's better offer, he accepted the chairmanship of the art department of Newcomb College for a salary of eight thousand dollars per year, with medical benefits, full tenure after one year, and a semester's leave with full pay, as well as moving expenses from Bloomington.

That summer, Edie miscarried again. A case of pneumonia was perhaps partly to blame for the stillness of the baby inside her. She was confined to bed and finally miscarried two weeks later. It was just as well that the family would have some time to recover before their next

big move. Meanwhile, George was actively recruiting his Newcomb College faculty and planning his curriculum. He also made a study of the city they would soon call home, reading the "long and lurid," history of New Orleans, and assuming, as he wrote to Dean Hubbard, "it is calmer now, at any rate, in the academic groves."[16]

With Stuart, now a strapping toddler of almost two, George and Edie left for New Orleans in January 1955. On the eve of their departure from Bloomington, David and Jeannie Smith sent them off with their last supper and enough food to last them through the thousand-mile journey south. As usual, George left a few things behind. One was the large and fragile glass sculpture "Phoenix." Defeated by the challenge of moving it, he left it to its fate, hanging in the basement of the art building.

NEW ORLEANS in the mid-fifties was not exactly calm, not even in the groves of academe. The civil rights movement was gaining some momentum, although the city was still racially segregated in almost every respect. Rickey was soon to learn how this would affect his department's activities. Right away he wanted to host a meeting of the College Art Association, but where could such a body meet, when the hotels did not allow "colored people," of which the association counted a few members. With the Supreme Court ruling regarding Brown v. Board of Education, on May 17, 1954, the issue of segregation was lively. The ruling made it illegal to segregate black and white people in an educational setting; however, it would be a long time before the law fully took effect in conservative New Orleans, especially in a private school or university. Rickey found himself immediately in a struggle to pull off his meeting against these obstacles. The CAA president, Lamar Dodd, suggested they hold off hosting in New Orleans until the city digested the law.

John Canaday had been in charge of the art department at Newcomb for three years before departing to direct the Philadelphia

Museum of Art. In the interim, Alice Parkerson, who taught a decorative design studio with a strong emphasis on art pottery, was acting director. "The art department was fairly large and terribly disorganized when I got there," Rickey recalled,[17] and the art building, on closer inspection, was not as well equipped as he had remembered it on a previous visit. With considerable experience by then behind him, he sought to convene a sense of purpose among his faculty. His long-term goals were to enlarge the graduate program, to bring the undergraduate program up-to-date, add a degree in art history, expand the number of male students from Tulane, and refurbish the art department building. "There is a lot that is promising," George told Ulfert Wilke in May 1955. "The standard of student work is high, especially sculpture."[18]

In the camp of his greatest support was Alfred Moir, of the art history faculty, who had recently earned his doctorate from Harvard with a dissertation on Caravaggio's Italian followers. George and Alfred had first met at a College Art Association cocktail party in Philadelphia and were happy to reunite as members of the Newcomb faculty. Moir's flamboyant style and personal warmth kept the art history department from being stuffy. In turn, Moir appreciated how George could make people realize "that artists are not necessarily out-of-this-world aesthetes."[19] Moir was also an immediate hit with Edie as a drinking and smoking buddy, and she could flirt with him unabashedly, because he was gay.

Arriving in January 1955, the Rickeys were looking forward to settling into suitable housing near the campus. But it would be months before the house they were designated to live in, at 1307 Audubon Street, was ready for their occupation. In the meantime they were housed along with other faculty in makeshift Quonset huts left over from wartime. Months of living out of a suitcase was just one of many frustrations during their first year in New Orleans, especially for Edie; with two-year-old Stuart in tow, it was all the more so. In those strained circumstances, improvisation was a requirement at which Edie and

George were quite adept. They were campers, after all, if not always happy ones. John Clemmer, who taught drawing, and his wife, Dottie, would never forget their first dinner party at the Rickeys'. With their kitchen equipment still in storage, Edie used a porcelain chamber pot, in which she also washed the baby's diapers, to cook the spaghetti, while the family cat prowled the kitchen countertop.

Finally, in October, ten months after arriving in New Orleans, they were able to move into their house on Audubon Street. After a hot and humid September, they were ready to enjoy cool nights and autumn breezes, and as George wrote to Ulfert Wilke, "to eat our breakfast in the sunshine on our big back porch with the bamboo and bananas and the birds."[20]

As the new couple on campus, George and Edie added a welcome dash of color to the university social scene. "There was never a quiet moment around George and Edie"; as Clemmer described their effect on a gathering, "there was salt in the air."[21] Moir was more dramatic: "Edie and George hit New Orleans like an atomic bomb," he said.[22] Edie, with her tall, voluptous figure, her long hair twisted in a bun anchored by a twirling Rickey "space churn," and a red-headed toddler perched on her ample hip, was perfecting the art of making an entrance. Beside Alice Parkerson, a proper Southern lady in her tailored dresses, high heels, and pearls, Edie represented uninhibited expansiveness. While George was the industrious artist in his studio, Edie was actively cultivating her new image as the artist's wife and her new role as his personal publicist. At the same time, some remembered that her main preoccupation in those days was getting, and staying, pregnant.

20

East Chatham

AFTER SUFFERING through their first summer in sweltering New Orleans, George and Edie were determined to escape the following year. Roberta "Bobby" Alford, a former teaching colleague from Bloomington, offered them an attractive alternative in the summer of 1956—her farmhouse in the upstate New York village of East Chatham. Bobby and her husband, John Alford, were going to be in Europe for several months, and the house would be theirs rent-free in exchange for looking after the cat.

About a hundred and thirty miles north of New York City, in the northern reaches of Columbia County, between the Berkshire Hills and the Hudson River Valley, East Chatham was a sleepy, hilly hamlet with ponds and creeks to swim in and acres of woodland, far from the heat and toil of New Orleans. Up a hardscrabble dirt road called McGrath Hill, the Alford place was a modest 1870s white-clapboard farmhouse with a front porch that ran the length of it and overlooked a meadow. A big red barn that once housed livestock and hay offered

enough free space for George to set up his bench and tools and get down to work.

The proximity to New York City was appealing, especially because George was working up to his first one-man show of sculpture at the Kraushaar Galleries that fall. In the opposite direction, George's family in Schenectady was an hour's drive north. In the house at 13 Front Street, Grace lived with three of her daughters in various degrees of need—Elizabeth, the reclusive anorexic, Emily with her crippled husband Percy Phelps, and Kate with her husband Harold Ball, who had recently migrated from Nova Scotia for lack of work. Alison and her husband, Bill Ames, made regular visits from New York City and Woodstock. Thus, with George and Edie and now three-year-old Stuart spending the summer in East Chatham, the Rickey family circle was as physically close as it had been when, some thirty years earlier, they all lived at Clarendon.

Bobby Alford was by that time a friend of many associations. George had first met her in New York before the war, when she worked for Frank Keppel at the Carnegie Corporation. Born Roberta Murray, Bobby was from an old New York family—a Murray of Murray Hill—and a graduate of Bryn Mawr College. Bobby married the brother of her college roommate, Thomas Fansler; his sister, Priscilla Fansler, married Alger Hiss. As sisters-in-law and budding art historians, Bobby Fansler and Priscilla Hiss both worked for the Carnegie Corporation and together prepared a report on the teaching of fine arts in colleges and universities. Thus, Bobby, Priscilla, and George were members of the same youthful corps in the spread of art education in America. Bobby moved on to run the department of education at the Metropolitan Museum, hiring Bea Farwell as a docent, perhaps thanks to George's introduction.

By the time they met again in Bloomington, Bobby and Thomas Fansler had divorced and she had married John Alford, an English art historian. Bobby's sister Sarah, meanwhile, had married Donald Flanders, a scientist on the Manhattan Project and a close friend of

Alger Hiss. In East Chatham, along with the Alfords, the Flanderses bought a neighboring property on Salls Road, creating something of a family compound and an easy flow of casual visiting between the two houses, no matter who was living there. The Flanderses' son Steve, about fourteen at the time, began to hang around the Rickeys, and he was intrigued by George's activities in the barn. Always open to a young mind, George soon put Steve to work on simple tasks.

For George and Edie, with compatible neighbors and close family at a comfortable distance, East Chatham was the perfect escape from New Orleans, "remote from noise and gas fumes and the pressures of institutional life," wrote George to Ulfert Wilke almost as soon as they arrived. "It is cool and fresh and bright and a breeze passes by all the time."[1] For George, a house and a barn in the countryside enhanced the work environment in many ways. Beyond the practicality of space, the inspiration of nature in its constant parade of seasonal changes and weather conditions was all around him. Having begun his foray into moving sculpture with generic forms from the natural world—birds and fish—George would begin to drill down to a study of its more intimate and subtle movements at closer range. He began to realize how solving problems of weight and balance organically aligned his sculptures with plant life.

"Though I do not imitate nature," he later wrote, "I am aware of resemblances. If my sculptures sometimes look like plants or clouds or waves of the sea, it is because they respond to the same laws of motion and follow the same mechanical principles."[2] Whether art was imitating nature or the other way around, the relationship for Rickey was becoming symbiotic. Nature, as a sourcebook, charged his sculptures with new life.

In the late 1950s, new sculptures with titles such as *Wild Carrot*, *Queen Anne's Lace*, and various versions of *Tree* and *Vine* attest to Rickey's heightened awareness of nature's forms and movements. He also began a series of hanging, rocking, enamel painted squares and rectangles he called *Seasons*, with cool colors on one side and warm

on the other. As a kind of "kinetic painting," as George called them,[3] they suggested changing seasonal impressions of the same place—changes that were missing in the Deep South. He was moved "to *try out* a color phase even if it doesn't work," he told Wilke, to add a brightness and richness to his pieces even if adding color made it "less sculpture."[4] As he tentatively ventured on with his experiments, George discovered that East Chatham was more than an escape from the city heat and crowds: It was an inspiration.

So it was with more than passing interest that George and Edie noticed an abandoned white-clapboard farmhouse for sale less than two miles from the Alford house on Hand Hollow Road. On land that once belonged to a family called Hand (hence, Hand Hollow), the house and property had witnessed a succession of owners since the 1770s, but now it stood empty. The windows were broken, the chimney bent, the porch sagging, and the garden a mass of brambles and weeds.

For years, George had envisioned owning a house in the country. Newly married to Susan Luhrs, he had expressed his desire in a letter to his mother to live "just outside New York if we can find a cheap place in the country."[5] With his return to the same vicinity, his instincts were stirred as before—to live within reach of the city but far from the madding crowd, where he could work in peace and afford the space he needed both to make and to store his creations. The house on Hand Hollow Road, despite its ramshackle appearance, approximated his vision. Not the least of its assets was the small barn just behind it, where he could set up a studio almost overnight, much as he was then making do with a corner of the Alford barn, and in the meantime store his growing inventory of sculpture. For a sculptor observing the lifestyle examples of David Smith in Bolton Landing, New York, and Alexander Calder in Roxbury, Connecticut, this simple place seemed made to order.

Undaunted by how it looked from the outside, George and Edie asked to see the house. On a rather depressing tour of the property

with a broker from Chatham, they learned that thieves had stripped the house of its furnace, bathroom fixtures, and chimney flashing, and vandals had attacked the interior walls. But the property's dereliction was part of its appeal. Rescuing an old house from oblivion had a certain romance for the Depression-era generation. An ordinary farmhouse of some age, though hardly a precious antique, had earned its right to life. Its sad condition also made it affordable. A degree of dilapidation was a prerequisite for the modern sculptor's creative hideaway. It was the space around it that mattered, and the house would be more adaptable to their needs if it needed work in the first place.

Bobby Alford put the Rickeys in touch with a local lawyer and they began to investigate the situation in earnest. They learned that the property had a complicated history. The last owners, Harry and Beatrice Sonnee, had never finished paying off their debt to the former owners—the eleven surviving children of David and Sarah Budlong, who inherited the property in 1923. Furthermore, it was unclear whether other Budlong family members had an outstanding interest in the property, as the Sonnees had attempted to perfect the deed with the Budlong heirs but without success. Further complicating matters of title, Harry Sonnee later obtained an invalid divorce from Beatrice in Mexico. Following their separation, Beatrice lived alone in the house until mental incompetence required her legal guardian to move her to the Hudson River State Mental Hospital. The house had then stood empty for twelve years, an easy target of vandals and thieves.

With more investigation, the Rickeys discovered that a real-estate broker named Ray Barden had contracted to buy the property—the house, the barn, and twenty-nine acres of land—for three thousand dollars in a tax sale two years before. But Barden had hesitated to close the deal, because the house was in a state of limbo, unoccupied and lacking a clear title since 1930. Instead, he stood by with his contract, awaiting signs of interest. George and Edie learned that a

bordering neighbor, Robert Homestead, was also interested in buying the property, but it remained to be seen if he would be put off by the legal problems of the sale. Back in New Orleans, upon learning in October that Homestead had withdrawn his bid, George solicited his sister Emily's help as agent with further negotiations as they unfolded in his absence.

As a summer home for the near future, George envisioned making improvements to the house to "Woodstock standards," along the lines of his sister Alison's summer cabin, and not more.[6] Thinking ahead to obtaining title, in December, George wrote to his sister Emily outlining the first phase of work—installing electricity and basic kitchen appliances; glazing windows and replacing broken frames; jacking up the timbers in the basement; investigating the plumbing, the drainage, and the well; and a heavy clearing of the land around the house and barn—and estimating a maximum cost of one thousand six hundred and fifty dollars. "What the Sonnee house is good for, virtually at once," he wrote, "is studio and storage of my work,"[7] a driving force at least as urgent as the material comforts of his family. The location was just right, three and a half hours from Manhattan, and so was the price: three thousand five hundred dollars. Given George's eight-thousand-dollar salary from Newcomb, soon to be raised to ten thousand, it was affordable. He and Edie could make the house habitable with a modicum of investment, and they could go at their own pace. Without any unforeseen complications over the title, they were ready to buy the place, leaving details of the transaction in the capable hands of Emily.

BACK IN New Orleans, Edie and George were preparing for his promised sabbatical. Alfred Moir had recommended a stay at the American Academy in Rome, where he had been a fellow. Moir had also made Tulane a member of its institutional support. George would have a studio of his own, and Rome at his feet. In January 1957, with Stuart, then

almost four, the Rickeys would be sailing for France on the *Liberté*, to spend the next seven months in Europe.

The rough winter crossing made an indelible impression on Stuart. Some of the windows on the promenade deck were knocked out by a wave, the dinner plates had to be fastened to the tables in the dining room, and the movie lounge was cleared of chairs while the audience watched the terrifying *Moby Dick*, pitching and rolling on the carpeted floor. Safely landed in Le Havre, although a day late, the Rickeys spent a week in Paris, settling into a hotel right next to the Maison des Étudiantes, where a Newcomb College student was living for her junior year abroad and which proved a handy source for babysitters. Stuart "liked Paris, especially the Metro," wrote George to Emily, "and survived quite well."[8] A far greater test of Stuart's survival was their next destination, in the Bernese Oberland in Switzerland, where they went to "deposit" him for a few weeks at the Kinderheim Alpenblick—a little school of a dozen or so international children in the mountains. Recommended by Eve Vogt, it was about a two-hour drive from Bern.

Edie and George planned to spend the next two or three months at the American Academy in Rome, where children were not invited. Thus, much depended on the Rickeys' confidence in Stuart's caretakers, who seemed, at a glance, "very experienced and sensible," George told Emily. "There was snow and a lot of children around on small skis," he wrote, and Stuart "*immediately* went out onto the slope with the others and began to play."[9] Leaving him there, they drove back to Bern for the night and planned to phone the next day to see how their son was getting on. With the coast apparently clear, they traveled on to Florence to visit Bill Dole, who was also on sabbatical with his family, and finally to Rome.

"The academy is a sort of dream institution," Rickey wrote to Dean Hubbard at Newcomb. Its grand purpose-built villa on the Via Angelo

Masina, designed by the American firm McKim, Mead, and White in 1894, was high on the Janiculum overlooking all of Rome and the snow-tipped Apennines beyond. But inside, a modest way of life prevailed, "very simple," he reported, "slightly monastic even, except that they feed you well and there is wine, red or white, on the table at dinner."[10] The bedrooms were fairly spartan; bathrooms were shared. Their fellow guests—distinguished scholars, architects, and composers—with whom they convened for meals, had much to offer. "In less than three days we have learned far more about Rome, what to see, where everything is, and how to live here than Baedecker could ever tell," George told Emily.[11] Trusting that Stuart was safely ensconced in the Alps in the snow, George and Edie had the luxury of time to themselves to explore Rome at leisure. George was also pleased with his studio, and soon set to work.

In March or early April, they found an apartment in the bohemian and working-class neighborhood of Travestere, where Stuart would join them for the remainder of their stay. From then on, Edie was fully occupied with domestic life, shopping for food and keeping Stuart busy with trips to the park and the beach as winter turned to spring.

In their new neighborhood, George explored the Porta Portese flea market and picked up a cache of old watch parts. Attaching their small, circular shapes to a wheel spinning around a straight stem on a gimbal, he created *Travestere Flower*. In these found objects he stumbled on a new form—the rotor, or wheel—which could easily have been inspired by the example of David Smith, not only in his tendency to incorporate the found object, but also, specifically, the introduction of wheels. With *Tavestere Flower* as a start, Rickey would soon put the rotor to use in a variety of larger sculptures.

Another unexpected inspiration came with his visit to the Cornaro Chapel of Santa Maria della Vittoria to see Bernini's *Ecstasy of Saint Teresa*. Bernini's extraordinary stone carving was cause enough for wonder, but the sculpture was further brought to life by the effect of the light shining through the dome above into its elevated aedicule,

illuminating the golden rays of light that seem to shower on the figures below. The magical stagecraft of the vertical gilt-wood rays became Rickey's obsession then and there. He began a series he called *Omaggio a Bernini*, clusters of stainless-steel blades thrusting upward and outward. It was an ambitious and somewhat complex gateway to the increasing verticality and structural vigor of his sculpture, and presaged the blades he would soon develop into a signature form. Thus from an unexpected corner, Rome delivered the inspiration Rickey was looking for. Not only that, for the first time he captured the attention of the Museum of Modern Art. His *Omaggio a Bernini* would be included in the circulating exhibition *Recent Sculpture USA* in 1959.

Fulfilling his role as department chair during his time abroad, Rickey would be checking in with various art students from Tulane who were studying in Europe, assessing their experience and progress, looking into more opportunities for the junior year abroad program, and meeting artists and professors he might recruit as visiting faculty in Venice, Florence, Milan, Rome, Paris, Hamburg, and Ulm. In a general way, he was interested in sizing up the art school experience in Europe compared with its American counterparts. Whereas Europe was a bed of riches for the art historian, he found the practicing art student experience rather limited, except in Germany, where the Bauhaus had left a strong legacy of art and design teaching methods, especially in Ulm, where a new school had opened in 1953 by the former Bauhausler Max Bill.

While in Europe, Rickey was approached by the United States Information Service to lecture on art during his travels through Germany, in the agency's effort to promote a positive view of American culture abroad. Rickey was especially well suited to make a favorable impression in Germany, with the mechanical sophistication of his moving sculptures. During his stay there, he was asked to create a work of sculpture for the Amerika Haus, in Hamburg, where he was also given an exhibition. It would be the first showing of his sculpture in Europe, and one that would forecast his important relationship

with Germany in a few years to come. At the opening of his show in Hamburg, he met Kurt Kranz, a graphic artist and former Bauhaus student, and on the spot invited him to be a guest lecturer at Tulane.

At the same time, George was advising Emily on European travel and study prospects for her teenage children, Rosie and Walter; in return, Emily was acting as their agent in the purchase of the Sonnee house in East Chatham. With the title finally cleared, giving Emily power of attorney, George was eager to move ahead. Ray Barden, who had eventually purchased the place for fifteen hundred dollars, raised his price to thirty-seven hundred, which George was able to meet by borrowing from the earlier sale of their house in Bloomington and other savings. The deed and the house were theirs, free and clear of clouds, on September 19, 1957.

BEFORE THE Rickeys' return from Europe, at the end of the summer, they had accumulated a great deal of baggage. George's latest work comprised a significant part of it, but Edie joyfully added her weight, with Italian copper pots and pans and other household equipment, with the prospect of furnishing a permanent home in East Chatham. George flew ahead to New Orleans, leaving Edie and Stuart and their load to follow by freighter at the end of September. By that time, they were already bracing themselves for the culture shock of returning to New Orleans, and, adding to that, further housing upheaval.

At the end of August, they had learned that they would immediately have to vacate the house on Audubon Street—the university planned to demolish it to make room for a power plant. George was furious. Never one to be too shy to air his opinions and complaints, especially to his superiors, Rickey wrote a blunt review of the family's disappointment to Tulane's president Rufus Harris. "[Edie] and Stuart will not be coming back to New Orleans till they can be assured a quiet life," he told Harris in no uncertain terms.[12] It was not only his family's domestic comforts that concerned him: He stressed the

importance of offering reliable housing to attract good faculty to the college. At the same time, he pressured Dean Hubbard to solve their housing problem as soon as possible. He could not bear the idea of Edie again going through the stress and the improvisations she had already endured.

George was equally surprised by the university's decision to renovate the art building in their absence, and at their return to find it "just torn to pieces. No light, no water."[13] At times he felt close to quitting. "Teaching will be very inefficient for the first month," he wrote to Edie. "No one will have offices or studios, but I proposed that we start."[14] It would not be until January that George and Edie were able to move into a new house at 2808 Calhoun Street, with an increase in rent and the added burden of subletting a basement apartment to Tulane faculty.

That spring, at the end of the school year, they took up residence in their new home in East Chatham. With the initial work on the house—the roof repaired, basic plumbing in place, and a coal stove for heat—overseen by Emily, they could be comfortable over the summer and even into the fall. "The house is wonderful," George wrote to Ulfert Wilke from his makeshift desk, a six-foot-long board on trestles. "It is still in a very unreconstructed state, but we have the essentials and the good features become more and more apparent each day." He pictured a monastic furnishing of the bedrooms and modest luxury downstairs. They peeled off the old wallpaper, revealing the gray-stained plaster underneath, which George thought rather lovely. "I may just leave it that way and hang paintings against it, like an old Italian palace," he told Wilke.[15]

He was equally excited about his barn studio, despite the paucity of natural light and the coldness of the stone floor. Five-year-old Stuart helped his father tear out the chicken-wire fencing inside and to set up his bench and tools, for the first time becoming viscerally aware that his father was not just a college professor but also an artist, and that he needed a special place to do his work.

In September, George returned to New Orleans, leaving Edie and Stuart in East Chatham for the fall. Stuart would be going to kindergarten at the public school there and George would come north for Thanksgiving, hosted by his mother and sisters in Schenectady. Now that they were just an hour's drive away, Edie was getting to know the Rickey family as never before. The atmosphere at 13 Front Street, "to say the least, is odd," she reported to George in early November. Basic to the problem, in her opinion, was the female-dominated household, with "no male figure to give a focus to the activity."[16] The three sisters in residence there—Elizabeth, Emily, and Kate—lived in a constant state of tension and irritation among themselves; their mother kept an impartial distance. Stuart's early impressions of his grandmother's house were, in retrospect, like something out of a short story by Shirley Jackson. The front parlor was dim and formal, the staircase was steep, the whole house smelled strange, "and there were all those aunties."[17]

Elizabeth was so frail and thin you could practically see through her, Emily was erect and forbidding and her husband, Percy, was bound to a wheelchair, Kate dwelled mysteriously in the shadows, and "Grammy," with her wrinkles and jowls and her long gray hair in a loose bun, was the uncuddly matriarch. Stuart was by that time better acquainted with his grandparents in Pittsburgh. The Leightons offered the old-fashioned pleasures of apple picking in their little orchard, "Ahni's" soothing custards, and after-supper card games with "Grandpa" that comprised the memories of his early visits to Bradford Woods.

At the public school in New Lebanon, where he entered kindergarten, Stuart remembers being made fun of as a city kid in the country. But contempt went both ways. Between his European travels and his city life in New Orleans, it is no wonder that he felt he knew more than his classmates. His kindergarten teacher was struck by Stuart's intelligence, but also by his impatience with the other children and his tendency to dominate them "by telling them that he is the only one who knows anything . . . by destroying or tearing down whatever

anyone else is doing or saying," she wrote in a worrying report to his parents.[18]

From New Orleans, George sought to advise Edie, hinting at an underlying problem at the heart of her parenting style. "I think [Stuart] needs firmness at home but not needling," he wrote to her. "[H]e may be taking out on his classmates at school revenge for some of his frustrations or defeats at home."[19] Edie professed that she found him no trouble at all, and "I honestly try not to nark or needle."[20] George promised to take more of an active role in parenting Stuart when they returned to New Orleans.

In October, Edie learned that she was pregnant again. From the start, the couple lived in fear of another miscarriage. As she moved safely through the first trimester, they began to tell friends and family their good news. The baby was expected in May, but the pregnancy was very difficult and required her to lie low. At the end of her second trimester, having returned to New Orleans, Edie stayed nearly a month in the hospital there, bleeding a little every day, receiving transfusions to make up for what she was losing—at thirty-five dollars a pint, which George would make up for over the next year by donating his own blood. At seven months, the doctor decided that it was safe enough to deliver the baby prematurely, when it would have, as George explained to Ulfert Wilke, "a fighting chance" of survival.[21]

On March 21, 1959, two months early, Edie gave birth to their second son. They named him Philip, after Philip Evergood. "Edie has almost completely recovered," George wrote to Antoinette Kraushaar in mid-April. "[T]he baby is out of his incubator and will be home at the end of the week . . . we sing some quiet Te Deums."[22]

21

Guggenheim

As HIS reputation emerged in the arena of contemporary sculpture in the late 1950s, Rickey sought to distance himself from the word *mobile*, which inevitably brought the work of Alexander Calder to mind. Indeed, ever since 1931, when Marcel Duchamp coined the term for Calder's moving sculptures, it had become inexorably bound to Calder's name. While at first, Rickey's use of the word helped to associate his work with a known idiom, it was now high time to make the distinction. He was sure that he was doing something different, and he wanted that difference to be noticed. In search of alternative terms, he lit upon the more scientific word *kinetic*, which the Russian constructivist Naum Gabo used to describe his "Standing Wave" or "Kinetic Construction" of 1920.

Gabo's lecture at the Institute of Design in Chicago in 1949 had left a deep impression on Rickey. The revolution in sculpture that Gabo espoused alluded to the larger context of twentieth-century progress and its obsession with speed—air travel, space travel, the motorcar, X-ray vision, and telecommunication. Gabo offered the conceptual

framework Rickey needed to position himself in the developmental arc of the later twentieth century.

In 1958, with his exhibition at the Kraushaar Galleries approaching in December, the time seemed right for George to apply the new term *kinetic sculpture* to his work. As he explained to Antoinette, this older term used by Gabo enlarged the field beyond the one Calder had made popular, "and . . . so often brings to mind something hanging and made of wire."[1] He had at first encountered resistance from Antoinette to the "alien term to her rather comfortable fire-side interior," George recalled, but in time she had warmed to the idea.[2] "By all means 'kinetic sculpture,'" replied Antoinette. "I think it will help to increase the distance from Calder."[3]

The art critic Selden Rodman, who had visited Rickey's studio at Tulane and commissioned a small sculpture for his personal collection, further aided Rickey's growing distance from Calder around that time. When in 1954 Rickey delivered the piece (a flag-waving machine) to Rodman in Oakland, New Jersey, the critic promptly subjected him to a recorded interview on the spot. Among his questions, he asked Rickey to define his indebtedness to Calder. Rickey tactfully and tactically replied, "I'll leave the percentages of indebtedness or divergence to you to determine, but I will suggest that it's much too rich a field for any one man to exhaust." A lively dialogue followed on the various approaches to abstract art, the place of machines in art, and the role of humor and emotion. In his relation to Calder, Rickey ventured that he was less interested in conveying gaiety and wit, and he even suggested that Calder might have suffered from that assumption. Movement, after all, is not always gay. It could just as easily have "tragic implications."[4] Just as his book *Conversations with Artists* was about to go to press, Rodman included his conversation with Rickey, placing him in the exalted company of Calder, David Smith, Jackson Pollock, Mark Rothko, and many other leading artists of the day.

※　　※　　※

BY LATE 1958, Rickey was increasingly impatient with the adminis-
trative tasks he faced as chairman of the art department at Newcomb
College. The ongoing refurbishment of the art building made teach-
ing and working within it complicated and frustrating, and the staff
was in a constant state of flux. Rickey had added to his art faculty with
Hal Carney, a favorite graduate student from Bloomington, to teach
painting; Tom Hardy, of the Kraushaar stable (with David Smith's
nod of approval), for sculpture; and Jean Seidenberg, Realist painter
and jack of all mediums, who filled in where needed. George was
gratified by the growth of his graduate program: Students converged
from all over the country and even from abroad. But cordial as his
relations appeared to be with Jack Hubbard, the dean did not display
a firm hand or even much interest in supporting the improvements to
the department Rickey was overseeing, nor to the Rickeys' personal
housing situation, which left a lingering impression of neglect. Fur-
thermore, the increasing demand among private collectors for his lit-
tle moving sculptures had Rickey working in his basement studio at
Tulane for long hours. He closed the door and instructed his secretary
that he was not to be disturbed. His mind teemed with ideas. There
was no time to lose, but his job made for considerable distractions
from his progress.

As a member of the art faculty at Tulane, Rickey could hardly avoid
becoming involved with the Art Association of New Orleans as well
as the Isaac Delgado Museum of Art, which had honored him with a
one-man show the year after he arrived in New Orleans. Arthur Feitel,
a member of the board since 1933, had brought in the museum's first
professional director, Alonzo Lansford. Feitel also intended to break
up a conflict of interest between the Delgado and the art association,
which essentially used the museum as its private art gallery. But Lans-
ford was unceremoniously fired in 1956 by an insurgent group of board
members determined to take control. Rickey was charged with the
awkward task of seeking Lansford's replacement.

He recommended Sue Thurman, who had distinguished herself

as the imaginative young director of the art gallery at the Louisville Public Library. George was confident in her professional abilities as well as in her social gifts, though when Thurman accepted the position, in 1957, he had to warn her, "It's a tough situation in many ways."[5] He did his best to prepare her for the contentious state of the art community as well as its native resistance to the idea of a woman director.

Serving on various committees at the museum, Rickey was involved in Thurman's political struggles, particularly with the new chairman of the board, Charlie Kohlmeyer, whose wife, Ida, was a popular local artist. Fearing that the Kohlmeyer camp might treat Thurman just as badly as they had treated her predecessor, he spoke in her defense on numerous occasions, and felt guilty when he was not present to counter the strong winds of Kohlmeyer and his cohorts. Indeed, not everyone on the board was happy with her appointment and Thurman found herself, as George had warned, in the crosshairs of local interest groups of artists, politicians, and socialites. Undaunted, she strived to redefine the museum's mission along broader lines, increased the staff, and renovated the building. She took the required interest in local artists, but also expanded the exhibition program beyond the regional with such triumphs as *Early Masters of Modern Art*, in 1959.

Edie followed the museum politics with rapt attention from the sidelines, and her own strong opinions. It was in New Orleans, some would say, that Edie's public persona as the flamboyant and outspoken wife of the famous artist came into its first flower. A city small enough for her to become a well-known figure almost overnight but big enough for her sophistication, New Orleans was a natural background for her coming out, and when it came to departmental infighting, she was not shy about airing her ideas, whether attacking their foes or defending their friends. Most of all she was in the business of advocating for George, who seemed unable to avoid becoming embroiled in disputes, whether his own with the college administration or the museum's with the Art Association.

Although Rickey's appointment at Tulane was his most prestigious

yet, it was beginning to feel like a challenge beyond its worth. In a new phase of his life, with his growing family and his reputation as a sculptor gaining ground, his priorities were shifting. He lived for the free time he could salvage to work in his studio. In the winter of 1959, he resigned as chair of the department and recommended Bobby Alford as his successor, "one of those rare chances to appoint a really able woman," he told Ulfert Wilke. That spring, when Alford accepted the position, Rickey told Antoinette Kraushaar, "She made a very good impression on the faculty and I believe she will be exceptionally skillful with the undergraduates," adding his confidence that as old friends, they would work together very well.[6] With Alford taking charge as chair in 1960, Rickey had less on his mind and slept better at night.

AFTER A full ten years devoted to moving sculpture, Rickey had quite a lot to show for it. Experimenting with a variety of balancing acts, he was combining swings with pivots, rocking parts with fluttering parts, circles churning within circles, towers of pins upon pins. His sculptures flirted with instability but always returned to equilibrium. He composed with the hard rules of geometry while achieving a lightness and lyricism. Fascinated as he was by the spectrum of possibilities he was discovering in smaller works, it was time to rise to the challenge of outdoor sculpture, to meet nature head-on, to test his work against its forces, randomness, and wide-open spaces. It was time to enter a direct dialogue with the wind as an equal player in his design.

As he confided to Bill Dole, his friend from Olivet days, his vision of the next phase of his work, in the spring of 1959, was "much larger pieces for outdoors, which will be hard to show but will be important to have made."[7] He needed time off from his academic responsibilities to achieve those goals. "The paramount problem is to produce, produce, produce," he told Ulfert Wilke, "and to get the teaching into

proper perspective." If he sometimes doubted the validity of his under-taking, a favorable review from Bob Coates in the *New Yorker* of his latest show at the Kraushaar Galleries helped to strengthen his case to the public, as well as to himself. As he told Wilke, "I should take myself as seriously as [Coates] takes me."[8]

In 1960 Rickey applied for the prestigious Guggenheim fellowship, with the prospect of devoting a year to creative work on "technical and design problems of kinetic sculpture." Though he considered himself working in "a rather lonely idiom," at the same time, as he wrote in his application, "I can't help seeing 'Kinetic Sculpture' as one of the most apt and timely modes of expression of our epoch and I can't help feeling that I am working on the frontiers of it."[9] If granted the fellow-ship, he planned to spend most of his time in East Chatham, where he could by then claim to have a private and permanent studio. As he explained in his application, he would be developing ideas for smaller pieces as well as large-scale sculptures, taking on the new technical challenges that scaling up would involve.

His references for the grant came from a range of professional colleagues spanning the years—artist friends such as Philip Evergood and Ulfert Wilke and fellow teachers such as Harry Prior, a colleague from Olivet, who had become director of the American Federation of Arts in New York. Two glowing references came from professors at the Rensselaer Polytechnic Institute, in Troy, New York, an insti-tution Rickey already had his eye on for possible future employment: Edward Millman, whom he had known in Bloomington was a visiting professor of art, and Don Mochon, an old friend from Woodstock, who was a professor of architecture. All had positive things to say about how intelligent and hardworking Rickey was, and how worthy his experiments with moving sculpture. Philip Evergood summed up Rickey's sculpture more passionately, saying simply, "[T]hey stir me tremendously, excite me, bewilder me and intrigue me. What else is Art supposed to do but this?"[10]

While awaiting news from the Guggenheim, Rickey accepted an invitation from Bill Dole to teach a summer seminar in art criticism at the University of California Santa Barbara, where Dole was chairman of the art department. Dole also promised a one-man show of his sculpture at the university art museum that summer. Thus in June 1960, the Rickey family headed west in their VW minibus, camping all the way through Texas, New Mexico, and Arizona to California. Edie was a creative cook of one-pan dinners over a propane stove on the tailgate. Philip, at just over a year old, slept in a playpen under the stars and took his very first steps once they had safely arrived in Santa Barbara. The Doles lent them their ample Craftsman-style house in town for the duration of their stay while they decamped to the Hollister Ranch forty miles up the coast.

Between the pleasures of the beach for the Rickey and Dole children (to Stuart, the Dole tribe of six were familiarly known as the "Dolies") and the company of old friends, there was much to like about Santa Barbara, and its climate, especially compared with the sultry summers in New Orleans was, "astonishingly cool, even cold," George reported to Jack Hubbard.[11] He also pointedly commented on the spacious and well-equipped art department at UCSB. Besides the seminar he was conducting, Rickey had another project to brew on that summer. After writing a chapter on kinetic sculpture for a book called *Art and Artist,* published by the University of California Press in 1956, he was urged to consider expanding his contribution into a book of his own. Here was a way to break new ground as both practitioner and historian, to teach beyond the classroom, unencumbered by physical space, complicated personalities, and administrative headaches.

Rickey's foray into art criticism underpinned his own activities as an artist and widened his range of connections, which, looking ahead, as he always did, would help to define his place within a developing trend. Earlier that year, he had given a lecture at the Metropolitan

Museum in New York on the subject of kinetic sculpture, "with a fairly modest reference to my own involvement," he told Perry Rathbone,[12] who had left St. Louis to become director of the Boston Museum of Fine Arts, in hopes of further shopping his lecture around the museum circuit.

WITH HIS Guggenheim fellowship granted, starting September 1960, Rickey returned east that fall, not to New Orleans, but to his new home in East Chatham, to continue his work in earnest. With a cadre of three young men to help with improvements around the property— Grant Joslin, a favorite Tulane graduate student; Willie Macdonald, George's Scottish cousin, then eighteen; and Willie's friend Alistair Ward—he reconstructed the barn to be a workable studio into the winter months. Meanwhile, thanks to sculpture sales, the installation of a proper furnace in the house freed up the kerosene space heater for the studio. In eight weeks they were "essentially finished," wrote George to Bill Dole, "but it just about finished Edie who had these gaping young mouths to fill and their dishes to wash and their eternal presence."[13]

But by the end of a beautiful October, George and Edie were free to enjoy their family life and work in peace for months ahead. Philip was a toddler and Stuart would enter second grade at the public school in New Lebanon. Willie Macdonald stayed on to run errands for Edie and assist George in the studio, saving up to travel around Central America. "Keep doing what you're passionate about," George advised his young cousin, "and you'll live for a long time."[14]

It was a relief not to be in New Orleans amid the unsettling civil rights struggle over school integration. "The school situation here is horrible," George wrote to Perry Rathbone from New Orleans in May 1960. "They will probably close the schools. This gives urgency to the thought of getting out of the South and I am beginning to feel that

I owe it to the kids to work where they can get a decent education."[15] Later that year, in November, race riots over school desegregation broke out in New Orleans. For the Rickeys, a village school in upstate New York was becoming preferable to the fragile state of education in New Orleans.

By midwinter, a few months into his Guggenheim fellowship, George found that his sculptures were taking longer to produce than previous work had been, as he strived to refine his craft and develop ideas of greater complexity. He had produced at least seven small new pieces, many evoking forms of nature, such as *Sedge, Sunflower, Ripple,* and *Espalier.* He planned other experiments with outdoor work on a larger scale, perhaps even a fountain. He was also experimenting with a new kind of bearing he called a "knife-edge"—the same kind used to support the pendulum in a tall-case clock—that reduced friction and allowed for a wider range of movement. But these developments would take time. He applied for an extension of his Guggenheim fellowship in early 1961. "I believe that, with no break in continuity, I can solve present problems, accelerate my production of sculpture, break some new ground, and achieve a new plateau to advance from," he wrote to Henry Allen Moe, of the Guggenheim Foundation, in January.[16]

As Moe had advised him not to be optimistic about his chances, Rickey wrote to Dean Hubbard of his intentions to take a leave without pay from Newcomb for another year, no matter what. He figured that with a few sculpture sales, living simply in the country, the family could get by. "Chances are probably against my getting [the Guggenheim]," he wrote to Hubbard in January, "but I should like to be free to take it. So I ask for a second year's leave without pay . . . whether I get the fellowship or not."[17] Another reason he gave Hubbard for taking time off was the advantage he saw in an emphatic break between his chairmanship and that of his successor, Bobby Alford, during which a complete class of graduate students would come and go. Rickey furthermore suspected that Alford would be happy to have him out of

the way, as their differences in style and approach had begun to reveal themselves.

Hubbard granted him a second year's leave of absence without argument. But this time, with Bobby Alford's support, he would devise a way to discourage Rickey from returning to Newcomb College altogether.

22

Bewogen Beweging

"I HAVE the feeling that we are entering another period of change and rejection of the orthodox," George wrote to Ulfert Wilke in the spring of 1959, "which is now certainly the New York School."[1] Abstract Expressionism, which had dominated the art world's discourse throughout the 1950s and was taught in every art department of every school, seemed to have run its course. Detractors emerged among artists and art critics alike, challenging the selfhood of painting and the exclusive men's club mentality of the Ab Ex crowd in New York. Pop art was on the rise, refuting the primacy of the personal and the painterly. Conceptual art and performance art were changing the rules of art-making and the very nature of art viewing, forcing a more interactive and immersive experience for the viewer, and public sculpture took on a new importance. An atmosphere of instability was in the air, perfectly timed for the fourth dimension—movement—to assert itself in its many emerging forms.

With the new year of 1961 came an important opportunity for Rickey to enhance his reputation overseas. He was invited to send a

piece to the Stedelijk Museum, in Amsterdam, for an international exhibition of movement in art, the first of its kind, called *Bewogen Beweging* in Dutch, meaning "Moving Movement," to open in March 1961. Not only would this be a fitting context for his work; right away Rickey perceived an opportunity to raise his profile as an art critic as well, especially because he had already written a number of articles and presented lectures on the subject of kinetic sculpture. He proposed a review of *Bewogen Beweging* to Hilton Kramer, editor of *Arts Magazine*, who promptly assigned it to the September issue. George's studio work would therefore be interrupted by a trip to Europe to view the exhibition, but the connections he would make with artists and collectors on an international scale at that critical juncture in his career were too important to miss. He sent his sculpture for the exhibition on ahead and packed a few more in his suitcase before flying to Amsterdam, in April.

Bewogen Beweging was the idea of Pontus Hultén, the innovative young director of the Moderna Museet, in Stockholm, who had zeroed in on the state of the art world in the flux of change and conceived a show to capture it. The exhibition catalogue was highly unusual in itself. A tall, narrow, vertical paperback folded in half, the size of a road map, it contained capsule biographies of all eighty-three contributing artists from eighteen countries. A silhouette of Marcel Duchamp's 1916 *Bicycle Wheel* was the cover motif, honoring the creator of the first moving sculpture in the history of modern art.

With Duchamp as figurehead, a playful neo-Dada spirit dominated the exhibition. "The Stedelijk Museum has finally succeeded in becoming the madhouse it has been called many times before," declared one local critic.[2] A funhouse atmosphere pervaded the building; viewers were invited to interact with the artwork in all kinds of ways. Calder mobiles performed to the breeze of the crowd and the touch of many hands. Large and ungainly machines by the Swiss artist Jean Tinguely, assembled from cast-off found objects and scrap metal, could be turned on and off with a switch. Tinguely's "meta-matic"

painting machine, powered by a gasoline engine, spewed forth rolls upon rolls of loosely painted paper while pumping its exhaust into a balloon to the point of bursting. A sculpture by Robert Müller called *The Bicyclist's Widow*, with a motorized plunger pushing up and down through a bicycle seat in a sexually suggestive way, was removed from the gallery on charges of obscenity.

But public outrage only added to the sensation of the show, the whole point of which was to demonstrate a state of the art world breaking all previous boundaries. By the time Rickey reached Amsterdam, on Easter weekend, the crowds had been so great at the Stedelijk that quite a few pieces had been damaged and taken down, including his only work in the exhibition—*Ripple Variation VI, 1960*—so it was just as well that he was on the spot to repair it and restore it to view.

On the trail of his review, Rickey sought out artists and organizers in Amsterdam, Paris, and Stockholm. He spent an entire day in Paris with Daniel Spoerri, a Tinguely protégé who had helped to organize the exhibition in Amsterdam, and was happy to recount the history of its development and make further introductions to other artists in the show. A few days later, Rickey met the Venezuelan Jésus Rafael Soto, whose three-dimensional abstract compositions of horizontal lines against black backgrounds created an optical effect of movement, as George put it, "like two superimposed fences seen from the train," and Yaacov Agam, with his "polyphonic" paintings that changed optically depending on where the viewer stood. Over a drink at Les Deux Magots, Agam "launched into a torrent of abuse of Spoerri and the whole handling of the show," George reported to Edie. "Agam considers that Spoerri used the show to advance his friend Tinguely and everything else was subordinated to that."[3]

In Paris, he dropped by the gallery of Denise René, a pioneering dealer of the kinetic movement, who introduced him to two French-Hungarian artists—Victor Vasarely, known for his brightly painted geometric optical illusions, and Nicolas Schöffer, who created kinetic sculptures based on cybernetic theories—both of whom

expressed much the same charged emotions about the exhibition as Agam. Although they all admired Tinguely, they thought he was being "corrupted by his success" and that the other artists in the show were being held as "hostages" to give a background of respectability to Tinguely's circus of insanity. Schöffer, Vasarely, and Agam were "serious, meticulous 'researchers' with a strong sense of order and no impulse to be sensational," George told Edie. "This of course is my slant too, and I would fare much better in a show that kept sensationalism out."4

Indeed his single small piece in an exhibition of two hundred thirty-three works could easily be lost in the shuffle, not to mention damaged, and he was not alone in that regard. "Quieter and far more significant works had little chance to be seen, to be contemplated, or in some cases to survive," wrote Rickey in his review for *Arts Magazine*. A single piece by Harry Bertoia, a "sound sculpture" made of standing metal rods, "was mangled and silenced by many fevered hands. In Amsterdam twenty percent of the exhibition ended up in the basement." Rickey asserted that although *Bewogen Beweging* was certainly an international art show about the art of movement, "it is not what it purports to be." He bemoaned "the highhanded and erroneous implication that neo-Dada works must be accepted as the characteristic and important aspect of contemporary Kinetic art."5 There were many other avenues for optical or participatory movement that were new and worthy of attention, he believed, from all over the artistic map, other than Tinguely's chaotic machines.

As a kinetic sculptor, Tinguely represented the opposite end of the spectrum from Rickey. Tinguely's was movement for the sake of humor and self-destruction, irony and chaos, traits in common with Dada and performance art, whereas Rickey's work was all about balance, equilibrium, and quiet contemplation, in the tradition of Mondrian and Albers. Different as they were, Rickey and Tinguely, each in his own way, helped to challenge the assumption that art was supposed to stand still, and both promoted the currency of the word *kinetic*.

Duchamp, Gabo, and Calder had broken the ice in different ways, but by the 1960s, Kinetic art was no longer an isolated or occasional experiment. Most significant, *Bewogen Beweging* announced the waning of the preeminence of Abstract Expressionism and of painting in general. Sculpture was in the forefront and movement was in the air.

RICKEY'S ROLE as critic opened doors to artists who could be valuable guides to the European art scene. In this new arena, he perceived a window of opportunity. He was actively in search of a dealer to handle his work abroad. With a few small works in his luggage and a batch of photographs in hand, he distributed them like calling cards to his growing network wherever he went. "This is one way of getting a little known and providing a base for future contacts," he wrote to Edie. "The reaction to the photos has been without exception, immediate, strong, and enthusiastic. They wonder why they haven't heard of me." In Europe, Rickey perceived circles of artists that crossed national borders; he observed how catalogues of artists' work circulated among them, kept them in touch, and stimulated further activity. "In some ways," he told Edie, "I think it would be easier to make a reputation in Europe than in the U.S."[6]

He was also glad to see that in Europe the term "kinetic" was becoming generic—in French "art cinéetique," as distinct from "le mobile," which implied a Calderesque construction. In general he saw a more widespread interest in Kinetic art in Europe than in the United States, and an opportunity to expand his reputation as a sculptor on the cutting edge. As an artist in his fifties, he would pursue that edge like a man at least ten years younger. Excited by his enthusiastic reception, he envisioned buying a VW minibus that could carry a complete exhibition of his small works, driving around Europe and assembling shows on the spot in Paris, Milan, or Hamburg.

He was also sizing up his New York dealer in a new light. Antoinette Kraushaar did not have the European connections he now

sought. "Antoinette," he wrote to Edie, "has no prospect whatever in developing international reputations for any of her artists."[7] The gallery's strength, developed by her father, John, was in American art and with a largely American following. For Rickey, at that point, it was decidedly unhelpful to be associated with the Ashcan School and other more traditional painters in the Kraushaar stable, as he forged his way into the new avant-garde. He had his eye on other New York dealers who were more involved with experimental art and with a broader international reach.

Traveling on to Italy, one of his goals was to find a known gallery in Milan to show his work, which "with a good catalogue will make more impression on American museums (and dealers) than any New York reviews," he explained to Edie. In Milan he met Arturo Schwarz, an art book publisher who had recently opened a gallery of modern art with a particular strength in Dada and Surrealism. Rickey's inclusion in *Bewogen Beweging* was enough to pique Schwarz's interest. He offered Rickey a show on the spot and promised to produce a catalogue. But when George realized that he would have to pay out of his own pocket not only for the catalogue (the cost of which, he later discovered, Schwarz had greatly exaggerated) but for the gallery's overhead as well, he decided not to go along with the dealer's "greedy terms." But reluctant to lose this important contact, "the most avant-garde" dealer in Milan,[8] he sold Schwarz three small sculptures out of his suitcase and promised more down the line.

The gesture was not wasted. Rickey's limited involvement with the Galleria Schwarz would introduce him to one of the most important patrons of his life. This was Pieter Sanders, a Dutch collector with a passion for modern sculpture. A man of modest wealth and discerning taste, Sanders was a law professor at Schiedam, near Rotterdam, which boasted the tallest windmills in the world. Wind-driven structures had therefore long dominated his landscape, but he had never thought of them in artistic terms until he encountered Rickey's work for the first time at Schwarz's gallery. Fascinated, he bought a sculpture to add to

his collection, and to contemplate its implications as an entirely new form of art.

George's hectic travels were relieved by visits with old friends. In Bern he visited Eve Vogt and her husband, the Swiss graphic artist and poster designer Hans Thoni. Eve was working on a book about shells and George brought her a sand dollar, something she had heard of but never seen. Reaching Italy in early May, he stayed with Cola and Bernhard Heiden, who were renting a villa in Fiesole, in the hills above Florence, where a nightingale sang outside his bedroom window. Inside there were two pianos, so Cola and Bernhard could both carry on with their work. "Bernhard is pushing ahead with his opera," George told Edie, while he and Cola planned to go into Florence to "look at some of the things one doesn't usually see,"⁹ such as Andrea del Castagno's *Last Supper* at the convent of Sant'Appolonia.

In Rome, he caught up with Ulfert Wilke, then a fellow at the American Academy in that city. He was impressed with the studio Ulfert had been given—"white walls, very high ceilings in an old palazzo behind Teatro Marcello." But on the whole the academy, just a few years since his own residency there, now seemed to him rather staid and out of touch, "just as removed from Rome and the rest of the world as ever." He also had lunch with Tatia and Cy Twombly in their palazzo near the Campo del Fiore. "[Twombley's] paintings are imitation scraffiti [sic] from walls, done on white canvas with lead pencil, rather original, not unrelated to Ulfert's and Steinberg's calligraphies," he reported to Edie.¹⁰

DURING HIS European tour, George received the good news that his Guggenheim grant would be renewed for another year. Edie, "after practically hanging on the mailbox for a week," had opened the highly anticipated letter at home in East Chatham and cabled him right away to tell him that the joyous news had finally arrived. Proud of her husband as she could be, Edie was also relieved to feel that

they could now better afford to move ahead with some more home improvements. "With this in the bag we can go ahead on the house with a much easier mind," she wrote to George.[11] Most of the basic construction had been completed and the plumbing, heating, and electricity were fully functioning. Now the time had come for decorating and finishing details, at which Edie thrilled and excelled. She hoped to get the rooms painted and papered, floors sanded and garden planted, before George returned home from Europe, in May.

Spending many weeks in East Chatham alone with her two small children, Edie was adjusting to her new social landscape. "The children are growing and getting more civilized," she told Jack Hubbard, but with babysitters in the area "rare as hen's teeth,"[12] they kept her busy. She was enjoying the stability of a permanent home and the creativity of decorating and equipping the kitchen to her taste and needs. She was also beginning to find a few kindred souls in the area. By far her most important new friend was Georgia "Pinky" Carroll, a petite, gamine beauty recently widowed by the death of her husband, John Carroll. Both artists, Pinky and John had moved east from Detroit and bought a farmhouse just two miles away from the Rickeys', on Gale's Hill Road. Edie and Pinky quickly discovered their mutual pleasure in a dry gin martini, and as artists' wives and women alone in the country, they were a great comfort to each other.

With her farm the meeting point of the local fox hunt, Pinky was connected to the horsy set of Old Chatham, the last stop on a spur of the New York Central commuter line and therefore a convenient weekend getaway from the city. East Chatham, by comparison, eluded definition. It was a mailbox address, a sprawling landscape of farms gone to forest, and not much more. Columbia County was beginning to attract weekenders and summer people, but the year-round population consisted for the most part of tradesmen and farmers.

Like Stuart, Edie was a fish out of water; Pinky Carroll filled the social void. Tiny Pinky and tall Edie confided in and counseled each other in all kinds of personal matters of home and husbands, and

Pinky's cozy farmhouse was a regular escape for Edie and her boys in the doldrums of late spring in East Chatham. In April, a celebration of the year-end filing of taxes led from martinis to supper by the fire to watching the Academy Awards on television. The women fed Philip on cocktail frankfurters and bedded him down in his playpen while Stuart fell asleep on the couch. For Stuart, looking back on those years, Pinky stood out for providing "a taste of [Upper] East Side sophistication in the middle of nowhere."[13]

While adjusting to life in the country, Edie was taking on the role of an artist's executive secretary in earnest. From the home front, she kept track of George's business and fielded all manner of correspondence. With her friendly, chatty letters and animated phone conversations with dealers, museum curators, collectors, and art faculty at Tulane, she added the intimate touch to George's business style. She took over a ground-floor room at the front of the house and set up her desk by the window, books and papers piling up all around her Royal typewriter and telephone in a flurry of daily correspondence.

George's exhibition prospects were indeed demanding, but he was determined to honor them all, eager to experience a variety of museum venues and commercial galleries lining up for one-man shows in both Europe and the United States in the year ahead—at the Phoenix Museum, in Arizona, and the University of Oklahoma, and commercial galleries in Los Angeles, Berlin, and Wiesbaden in the pipeline. He was also looking forward to showing recent sculpture at the Kraushaar Galleries, in New York, in October. The demands on his production were so great that Edie wondered if he was realistically capable of fulfilling them all.

Long before the advent of interactive digitized spreadsheets, which would have served her well, she created a work plan on paper of all the sculptures George expected to produce over the next year to fulfill his obligations to galleries, private collectors, museums, and public spaces.[14] She calculated the time it took to pack and assemble sculptures, included contingencies such as if work should sell, and

reserved about eight weeks of his time under a special category called "new experimental work" that she knew he would count on. "Now this is a pretty massive list," she advised, "I'm not saying you can't do it because I know you can—but I think you should have it in mind before you commit yourself to Milan."[15] Far beyond the duties of wife and mother, Edie was proving herself to be a *secrétaire extraordinaire* with a unique style and inside knowledge of every facet of her husband's operation.

By the end of May, between Denise René in Paris and Arturo Schwarz in Milan, George had managed to unload all of his hand-carried sculptures, and with his pocket full of German marks, he bought a new bench shear to take home. He was exhausted from his travels and looking forward to returning to East Chatham, and to his wife and family. "It has all been interesting but I have been lonely," he wrote to Edie from his last stop, a visit with Leonard Snow in Suffolk. "I want to get back to our quiet life (!) or at any rate our home life . . . and we must plan our time a bit so that we are not too exhausted to make a little love."

From a distance, he contemplated their sex life and its room for improvement. Lately it seemed that with their busy lives and schedules and different internal clocks—he was sleepy in the evening and she in the morning—timing could be difficult. He also felt her reluctance to initiate sex, and he begged her to be more candid with him about her needs and fantasies: "if it is posture or timing or preliminaries or violence—tell me." He longed for her touch, and to know that "you are swept away as I am."[16]

As frank and forthright a character as Edie certainly was outwardly, she concealed a shyness about expressing herself sexually, at least to George or, at any rate, lately. Apparently for her, their sex life lacked the romance or the sense of adventure she craved. In their almost fifteen years of marriage, she had developed passionate feelings for other men, though however much or little these flirtations went beyond fantasy is hard to say. Random notes and drafts of letters

she may never have sent indicate that in 1961, at the time of George's European tour, she was, at the very least, emotionally involved with his former graduate student, Grant Joslin, a handsome young self-destructive lady-killer with a drinking problem who had lingered in the area after assisting George in his studio. Just as George was begging Edie to be more honest with him in bed, she was accusing Joslin of not being honest with her. Meanwhile, to the unsuspecting George, she faithfully reported the litany of business news and accounts of the day and the latest gossip from New Orleans.

DURING HIS extended Guggenheim fellowship, in the fall of 1961, Rickey was invited to substitute-teach a course in design at the architecture school of Rensselaer Polytechnic Institute, in Troy, an easy forty-minute drive from East Chatham. This was thanks to an old friend from Woodstock days, the painter Don Mochon, who was director of the gallery there, and Edward Millman, a former colleague from Bloomington. Although RPI was a technical school, Rickey's role was to engage students in the expressive, creative, nonpractical side of architecture.

Meanwhile, accepting of Rickey's prolonged absences as they appeared to be, the Tulane administration's loyalty to him was eroding. During his close to seven years on the faculty, he had spent less than half his time on campus. Even as a tenured professor, having relinquished the chairmanship of the department to Bobby Alford, he was not immune to the treachery of internal politics. In the spring of 1962, halfway into his extended Guggenheim fellowship, Hubbard told him bluntly that he and Bobby Alford would prefer it if he did not return, and that if he did, "it would be in a very circumscribed role,"[17] and his salary would be reduced. Despite the fact that George was already considering asking for a third year off, he was not happy about being more or less asked to resign, and was quite sure that his efforts over the years were not fully appreciated. He had left the department

to his successor much improved from the way he had found it, and was proud of the achievements of his graduate students.

"Your coming to Newcomb has been full of surprises and revelations for me," wrote George in a note to Bobby Alford[18] that he may never have sent. To acting dean William Woods, he spelled out the meaning of the proposed plans they had made behind his back as "quite openly designed to make further service at Tulane unattractive to me . . . I have, after reflection, decided not 'to kick against the pricks' and so tender my resignation, effective July 1."[19]

23

Heirs to Constructivism

FOR RICKEY, the year 1962 was off to a promising start. His work was in demand all over the map, including in March, a one-man show at the Primus-Stuart Gallery, in Los Angeles, during the liveliest art week that city had ever seen. The gallery district along La Cienega Boulevard in Beverly Hills was striving to keep pace with Midtown Manhattan, and David Stuart, founder of Jazz Man Records and an avid collector of pre-Columbian art, had opened his gallery with Ed Primus just a year before. A parade of art-world celebrities arrived in the City of Angels from the East Coast and Europe. Jean Tinguely, Robert Rauschenberg, Robert Motherwell, and Edward Kienholz opened shows the same weekend as Rickey's. Niki de Saint Phalle performed her first "shooting" behind a nightclub on the Sunset Strip, opening fire on capsules of brightly colored paint embedded in a massive field of white assemblage. John Cage, icon of the musical avant-garde and creator of happenings, was in town, as was the trim and elegant Leo Castelli, rising dealer of Pop art in New York.

Altogether "lots of the art people and bearded circuit were there,"

George wrote to Edie,[1] in the midst of an exhausting carousel of parties and openings.

Amid the din of Pop and performance art, Rickey both fit in and stood out. His sculptures were playful and unpredictable in the spirit of the times, but they were also gentle and contemplative. With Tinguely and Rauschenberg in their neo-Dada fervor on display at the same time, George felt that he "did not suffer from the comparison."[2] As he was installing the show, passersby on La Cienega peered through the windows with rapt curiosity, and a few pieces were sold before the show opened. All the important local collectors were there, not just to look: They were there to buy. George was pleased that his work would be joining the good company of contemporary artists collected by Gifford Phillips, nephew of Duncan Phillips and a well-known local collector of Abstract Expressionism; Edwin and Cherie Silver, prominent collectors of pre-Columbian and African art; and Taft Schreiber, a media executive whose modern art collection would eventually form the basis of the Museum of Contemporary Art. Schreiber bought one of the largest pieces in the show—a hanging horizontal plane of hundreds of moving parts that Rickey called *Nuages*.

Even more significant in the long run for Rickey was that Schreiber brought the uranium tycoon Joseph Hirshhorn to the opening. Hirshhorn was already well known on the gallery circuit, and would soon be even better known after a major show of his collection opened at the Guggenheim Museum in New York later that same year. He scooped up four Rickey sculptures on the spot—*Vine, Marsh Plant, Bouquet,* and *Interview*—according to George, miffing other collectors with shallower pockets. Hirshhorn's enthusiasm went even further. He was so taken with Rickey's work that he commissioned a larger outdoor version of *Summer,* a cluster of curved vertical blades, for the garden of his new house in Greenwich, Connecticut.

Antoinette Kraushaar, who split the dealer's commission with Primus-Stuart, was the go-between over the next few months as George tackled his largest outdoor piece to date. Ten feet tall, this

bouquet of stainless-steel blades, tapered and slightly curved at their tips, suggested grasses waving in the breeze. Still in the learning stages of large outdoor sculptures, Rickey would be testing the outer limits of his technique—handmade knife-edge bearings resting on gimbals— against the forces of nature. There was an aesthetic consideration too: an inverse ratio between size and speed. The larger the sculpture, the more slowly he wanted it to move. By late summer, he was ready to take the sculpture down to Greenwich and set it up in the garden, "for what tailors would call a fitting," he wrote to Hirshhorn.[3] The fitting, as it turned out, "was not exactly a success,"[4] he admitted to Ulfert Wilke.

After being held up in a meeting with Antoinette Kraushaar in the city, he arrived at Hirshhorn's late in the afternoon. Hurrying to erect the piece in the fading light, he failed to secure the blades properly, and a high wind the following day sent two blades crashing to the ground. Returning home, Hirshhorn was "in quite a stew about the whole business." The deal was not off, but it was "suspended"[5] until Rickey could prove the sculpture to be sufficiently weatherproof, which he regarded as perfectly fair. With outdoor sculpture soon to shape his career, the importance of his work being mechanically sound could not be overestimated.

Back at his workshop, he continued to refine the sculpture through the fall and into the winter, watching over its performance under the weight of rain, snow, and ice. Looking back, Rickey would reflect that *Summer* was the piece he learned on.

As RICKEY was becoming known to art dealers in both America and Europe, he was ever more alert to those who might show his work to its greatest advantage. After brisk sales in Los Angeles, he was cautiously optimistic about his May exhibition at the Galerie Rudolf Springer in Berlin, to which he was planning to send some twenty pieces, among them a sixteen-foot outdoor piece for the gallery courtyard. Springer

promised a catalogue—essential to the spread of his reputation afield—and George called on his old friend Henry Hope to write an introduction. Hope was glad to oblige. The art market was relatively small in Berlin, but the well-connected Springer had deftly organized for the show to travel in August to the Kunstverein (a noncommercial association for contemporary art), in Dusseldorf, and in October to the Hamburg Kunstverein, all part of his strategy to build Rickey's reputation in ways that would benefit them both. George shipped some sculptures on ahead for his string of shows in Germany and packed a few more in his luggage. On board the S.S. *Hanseatic*, he looked forward to ten quiet days at sea, during which, he told Springer, "I shall think and write and watch the water."[6]

Springer took Rickey under his wing for the better part of the weekend of the show's opening, walking him around West Berlin, and over a leisurely lunch explaining who was who and how business was done, all with a wry sense of humor and an upbeat business spirit that inspired confidence. Springer was an old friend of Henry Miller and, George suspected, as he told Edie, "there was a good bit of Miller-style life in [his] past." But unlike Miller's situation, Springer's extended family's publishing business ensured his financial security. George felt encouraged that Springer was willing to take his time, perhaps years, to build his reputation in Germany. If Springer's efforts proved successful, George figured, he'd be "over the hump as far as professional acceptance in Europe is concerned."[7]

With the Galerie Springer's prospect well in hand, Rickey was already courting a dealer in New York. He had been first in touch with George Staempfli earlier that spring, expressing his desire for a New York dealer with wider contacts in Europe. Staempfli, a Swiss-born gallerist with strong European connections who had opened his doors in New York in 1959, was immediately receptive. He told Rickey that he had been interested in his work for some time, and already owned "a small, but exquisite piece."[8] Springer fully endorsed George's courtship with George Staempfli in New York, and advised him not to be

sentimental about his plans for leaving Kraushaar. "It is business and you have to go where it is best for you," he told Rickey.[9]

Just before George departed for Europe, James Mellow, an editor from *Arts Magazine,* asked if he would be interested in reviewing a major retrospective of Alexander Calder, opening at London's Tate Gallery in July. Rickey expressed some qualms about the comparisons that would inevitably be drawn between his work and Calder's and that if critical, he might be accused of jealousy. "However, I think I can be reasonably detached about this," he assured Mellow, "and place him in his historical context and give him his due as a very important originator without tripping over my own purposes as a sculptor."[10] The retrospective begged for an assessment of Calder's development over thirty-six years. Concerned as Rickey may have been about the task, he would seize the opportunity it presented like a rock climber, picking his way to the top.

It was probably just as well, in this case, that Rickey and Calder had not developed a friendship since meeting at Calder's studio in Connecticut in 1951. It seems that Calder had taken no more interest in Rickey's foray into Kinetic art, and Rickey had taken what he had to learn from Calder and moved on. By this time, deeply involved in his own kinetic experiments, Rickey could bring to his critique real experience and with it a unique set of criteria for judgment as perhaps no other artist or writer was then capable.

The Tate show was big—an avenue of eighty pieces spread through six galleries—and it was popular. A playful atmosphere, as Calder inevitably inspired, prevailed and visitors were invited to touch the mobiles to make them move. Overall the show was appealing, but Rickey felt that each piece was "drowned out by the visual din of the whole." Calder was the most famous American artist alive; his place in history was secure. "He has delighted the world," wrote Rickey, "but with what?"[11]

What is he? Is he good? Is he, though a success as a popular enter-
tainer, a superficial artist? Is he the lucky (or unlucky) stumbler
on the right thing (getting sculpture into the air) at the right time,
who has been trapped by his luck, or is he one of the great innova-
tors of the epoch? Is he possibly a frustrated painter, able, through
a mechanical device, to make a reasonable facsimile of sculpture?
Why does a lot of Calder seem less impressive than a single piece?
Is there a Calder myth?[12]

Having asked the key questions, Rickey then proceeded to take Calder
apart, limb by limb. Calder was not an engineer; in fact his engineer-
ing was "elementary and often misconceived. His metalwork can be
labored, clumsy, and antiquated." Rickey did admit to the charm of
Calder's simple technique, but he questioned his refusal to learn to
solder or weld metal, preferring to rivet or bolt his parts together. Most
of all, Rickey criticized Calder's command of movement. Especially
in the larger pieces, which he could not have made by his own hand
alone, the solutions to balance and movement sometimes seemed
patched, clumsy, and ineffective. In the thirty years since his break-
through *Calderberry Bush*, Calder had shown "very little advance in
the expressive use of movement." Without exactly saying so, Rickey
was asking the reader to consider the difference between his work and
Calder's, as well as the advances he himself had already made by the
early 1960s in the variety of movement and the refinement of his engi-
neering skills in his quest for originality. Calder "is the most easily imi-
tated sculptor alive," Rickey went on, "and he has founded no school.
He has ignored the vast possibilities of the Kinetic art he introduced
and has left their realization to others." In a devastating metaphor, he
wrote that "the Master of the Catenaries has become the prisoner of
the chain he forged." But Rickey's review ended with abundant words
of praise for the other side of his sculptural oeuvre—the stabile: "It is
in the stabiles that Calder is most free, most serious, most imposing,

most the sculptor, and very possibly most durable . . . Here is the work of an original mind, humble and honest, carving the void."[13]

Rickey's review might be read as an attack not so much on Calder as it was on the art public that was so easily convinced of his genius. Although one critic later called the review "uniquely spiteful," he also acknowledged that it raised the problem of how easy Calder was to like and to imitate, ingredients that made him famous but also prey to serious art critics.[14] Rickey was not alone in questioning Calder's stature. Another British critic called him "a rococo craftsman" whose work belonged "not in the Tate, but in the Victoria and Albert Museum, alongside other amusing, elegant objects made for our domestic use and delight."[15] Two years later, Thomas Hess, the editor of *Art News*, reviewing Calder's retrospective at the Guggenheim Museum, wrote, "Calder has the gift of buttering over all his weakness with ingeniousness and charm—layers and layers of innocent fun. His exhibition is enchanting—if you don't stop to look."[16] But Rickey had the technical experience to question Calder's work in ways that no one had done before. Even though he would admit that Calder had established a new art form on a worldwide stage, he was by then quite certain that his solitary reign over moving sculpture would not last forever.

OVER THE years, Rickey had developed exceptionally broad artistic taste. In his art history lectures, he discussed a range of styles, from Titian to Picasso, and from the Bauhaus to the comic strip. If there was a prejudice to detect, it was for the attention some artists or movements had received that was unjustified in comparison to some others he considered of equal value. A few years before, it was Abstract Expressionism; more recently, it was Pop art. But there were artists who were tapping another vein that was being overlooked. This was in the legacy of Constructivism, broadly speaking—a kind of non-objective, abstract art that made no personal reference to its maker or anything but itself.

It was this non-objective thread through Modernism then emerging, especially in Europe and South America, that Rickey was determined to follow in "its quiet continuity."[17] Increasingly, he regarded the New York art world with skeptical detachment. *Bewogen Beweging*, along with other art happenings in the 1960s, had loudly contested the primacy of the New York School. Emotional coolness was the new counter mood to the Expressionists' ethic of individualism. Pop art exemplified sixties cool in the United States, but there was a parallel development, equally cool, in the offshoots of Constructivism that was not as well known or understood, especially in America. But now that the European economy was picking up speed after its long postwar recovery, so was the European art world gaining ground and introducing its own particular tendencies.

Rickey's art-world ramblings around Europe as both artist and critic had alerted him to a whole new web of connections. "I began to realize the breadth and strength of the forces behind this disciplined non-objective art and how little of it was known . . . in spite of isolation, there was an astonishing concurrence in their thinking." So in the spring of 1961, having been invited to expand his essay "Kinetic Sculpture" into a book for the University of California Press, he countered with a proposal to write about a modern tradition that lacked the critical attention it deserved: namely, Constructivism. A wide-ranging term, difficult to define, he admitted that it was "better revealed by works of art than by words."[18] For Rickey, this was also more than just a book—it was a platform for him to define a tradition and to discover his place within it. Like his review of *Bewogen Beweging*, the book would serve not only his scholarly purpose but also his desire to make connections with fellow artists, including many he had long admired.

To begin with, it provided him with a reason to meet Naum Gabo, one of the founding fathers of Russian Constructivism. Fortunately for Rickey, Gabo had emigrated from Berlin and settled with his wife, Miriam, in Middlebury, Connecticut, an easy day trip from

East Chatham. Rickey wrote to Gabo in January 1963, and it was no exaggeration on his part to say that he could not imagine writing the book without paying him a visit and hearing "first hand some of your reflections and comments on what has happened to the principles of Constructivism in the last forty years."[19] When they finally met, at Gabo's Breakneck Hill residence in Middlebury six months later, they covered so much ground over the course of an afternoon that George could barely contain it all. On his next visit with Gabo, he would buy a small piece directly from the artist—an abstract wood engraving on translucent Japanese paper called *Opus 4*.

The book also made for his first meeting with Josef Albers, who had left Black Mountain College when it closed in 1957 to direct Yale's Graduate School of Art and Design. Albers was pleased to learn that Rickey was working on such a book, and observed that although the Constructivist "attitude" seemed out of fashion, interest in it was growing. "I still believe that carrying our head on top of our physique is a significant indication that seeing and thinking is not below instinct and emotion," he told Rickey.[20] But he did object to Rickey's emphasis on his work as optical illusion, or as the father of a movement closely associated with Kinetic art, recently coined, to his despair, Op Art.

Altogether the project inspired meetings with forty artists from all over the world, many little known outside their region. In large part, Rickey attributed their "concurrence of thinking" to a mutual rejection of the Expressionist or *art informel* that had dominated the art scene in the postwar years. Instead, they instinctively embraced a disciplined non-objective art, sculpture that was built rather than carved, paintings that were constructed according to considered mathematical calculations rather than created in a burst of feeling or instinct. Gathering the material for his manuscript, Rickey spent countless hours in archives and museum collections, and in conversations with curators, gallery directors, and art historians. In London he followed the short-lived Signals Gallery's stable of South American artists such as Lygia Clark, Pol Bury, and Carlos Cruz-Diez. In Paris he plumbed

the history of the gallery of Denise René, a pioneer dealer in Kinetic art and a champion of the Constructivist impulse in many forms.

Visiting artists in their studios, George could not resist the urge to add to his growing collection, often by negotiating a trade with a piece of his own. On the whole, he sought works that fit his budget as well as his carry-on bags. Altogether the project resulted in the acquisition of some eighty objects, which began to crowd the walls and tabletops of the Rickeys's East Chatham home, their little museum in the woods.

The book would be seven years in the making. Originally projected for publication by the University of California Press in 1963 as *Constructivism: An International Survey,* a picture book of one hundred forty-six pages, it expanded over the course of research and writing into *Heirs to Constructivism,* and was eventually published by George Braziller in 1967 as *Constructivism: Origins and Evolution.*[21] For Edie, in her capacity as typist, researcher, and keeper of the files, it was simply "The Book."

As THE hectic year of 1962 drew to a close, George told Edie, "I'd really like to have no shows of any importance in '63." That spring he retreated to Yaddo, the artists and writers colony in Saratoga Springs, New York, to focus his attention on writing a first draft. "It is all very simple here and just right," he reported to Edie. "The isolation is like a boat."[22] As typist on intimate terms with every word of his manuscript, Edie offered her editorial comments from East Chatham. In addition to congratulating him on having "broken the back" of the book, she warned against projecting "a pedagogical tone."[23] She gently illuminated redundancies, and suggested that some points might be expanded on and others compressed. "Very glad to have comments on ms, all well taken," George replied.[24]

In addition to being George's editor when needed, Edie was essentially his executive secretary, as well as his librarian, registrar, cataloger, accountant, publicity director, packer and shipper, shopper of

tools and parts, and keeper of all calendars. It was at about this time that George began to pay her a salary. His mother was a firm believer that wives should be paid for their work when it extended beyond the usual domestic chores, and George adhered to the same philosophy. Here was a way for him to liberate Edie from having to ask his permission to indulge in her own fancies, such as new clothes and jewelry for herself and extravagant gifts for others. Her salary was to have nothing to do with the household accounts. The icing on the cake was that it was also a tax-deductible expense of his business.

Nor were the Rickey children immune to their father's enterprise. After being delivered home on the school bus from New Lebanon, nine-year-old Stuart would often head out to his father's studio, where George would put him straight to work. Stuart recalled his father's endless filing of metal parts to a smooth finish and the extreme tedium of much of the process. They listened to the radio while they worked, sometimes to classical music broadcast from WGBH in Boston, at other times to radio plays or entire novels read aloud.

His father's arsenal of tools was arrayed around the studio. There were his filing tools—a set of Swiss patternmaker's files in various shapes, wet-dry emery paper, emery cloth, crocus cloth for a mirror finish, rouge, and cotton buff. There were what George called extensions of his fingers: pliers, tweezers, vises, and clamps. For cutting, he used a bolt cutter for rods, tin snips, pedal shears, and hacksaw, and, when necessary, a torch. There were drills, too: a hand drill and "roto-tool" for getting into tight spots, and hammers—small plastic ones, a leather mallet, and an "odd little hammer for the purpose"[25] he had made himself. For joining metal parts he used fire: sometimes Presto-lite torches with a very small tip, generally oxy-acetylene with a tiny, inch-long flame, and silver solder, using a special alloy for stainless steel. He enjoyed the small scale and simplicity of his studio, "almost like a kitchenette."[26]

In the kitchen, Edie swayed to the bossa nova rhythms of Getz and Gilberto as she cooked, and often sang. Equally interested in

efficiency in her small kitchen as George in his "kitchenette," she had all her tools lined up within reach. With Philip in a high chair, the family gathered for dinner at seven. Afterward, when the boys went to bed, George would head back out to his studio to work until he was too tired to do any more.

When George and Edie traveled, they often sent Stuart to visit his maternal grandparents in Bradford Woods. James and Wilma Leighton doted on their firstborn grandchild. Further building the relationship was a steady flow of typed letters from James to Stuart for some time even before he was able to read them, as if to offer an alternative to his life with his bohemian parents, should he ever need one. Much as he enjoyed their undivided attention, Stuart recalled that his grandfather was "very stern, very Republican. Always took me to get my hair cut . . . I mean real buzz cuts. He was a bit of a snarly curmudgeon." Edie's relationship with her parents was strained, remembered Stuart, "cordial at best." Edie was an only child, "but not psychologically . . . the older sister was always there . . . the good sister, the perfect sister,"[27] who had died at age four.

Living in East Chatham, Edie made regular visits to the Rickey family in Schenectady, enlivening the scene with her small boys and a whirlwind of newsy chitchat, as at the same time her sisters-in-law became ever more deeply entrenched in their private, sullen habits and battles. Grace's health was declining, adding another medical concern, along with Percy's paralysis and Elizabeth's anorexia, to the household. Grace had remained the quiet pillar of emotional stability even after her daughters took over the running the house, and when she died, in March 1963, at ninety, Front Street lost its center of gravity. "An epoch has ended," George wrote to Ulfert Wilke.[28]

For Jane's son Norman de Vall, that loss of gravity was profound. As a child he had valued his grandmother's lengthy visits to Laguna Beach to support his mother in the midst of her divorce, and now, a grown man of twenty-three, he remembered their abduction to Schenectady immediately following her suicide. Norman had arrived in New Jersey

Harbor on a Danish banana carrier he had boarded in Ecuador a few weeks before. By sheer coincidence, his ship had docked just hours before his grandmother died. George was there to meet him at the pier and drive him immediately to Schenectady. Entering the house on Front Street on that crisp winter day, Norman found it unchanged, "the smell of the seldom opened dining room still was the same combination of musk and camphor wood." Embarrassed to have been out of touch for twelve years, Norman entered Grace's bedroom and was by her side just in time to hear her say, "I was waiting for you to come."[29]

When the mortician appeared at the family wake for sherry and cucumber sandwiches and pulled out his catalog of urns, Norman was outraged. He took the mortician by the cuff of his collar and steered him out the door. They could make their own urn for Grace's ashes, he announced, returning to a roomful of his astonished family. And so within the next few days, Norman and George created an urn out of stainless steel in George's workshop. For Norman, it was the beginning of a new relationship with his uncle, as both workshop assistant and favorite nephew. For George, while he had lost his mother, he had gained a third son.

For the time being, George's sisters would remain in the Front Street house. But with Grace no longer presiding there, George and Edie were happy to take away the Rickey mahogany dinner table with extra leaves for a large party, and the full set of Queen Anne chairs, soon to serve them in an era of entertaining a steady stream of artists and collectors to East Chatham. Edie had also made the final move from storage in New Orleans while George was in Germany in the summer of 1963 to install *Twenty-four Lines* at Hamburg's Kunsthalle. Leaving Stuart at Camp Treetops, in Lake Placid, and Philip at home with their neighbor and housekeeper Myrtle Kie, Edie headed alone to New Orleans to meet the movers and spend a week in late May clearing their belongings out of the basement at 2808 Calhoun Street and sculptures out of storage—altogether adding up to a vanload of

more than seven thousand pounds. "I was organized to the finger-tips," she proudly reported to George. She had a good time visiting old friends, "drank enough to sink 2 battleships," and found that her attitude had changed. No longer emotionally involved with the factional infighting they had been immersed in at the museum and the university, she realized how happy she was to be living in East Chatham. "Our life and environment, your work, our children—in fact the whole picture is so blissful that if we had tried to design the ideal situation, we could not have come up with anything better."[30] The fact that her latest archenemy, Bobby Alford, still summered in the house on McGrath Hill, less than two miles up the road, would be only an occasional social inconvenience.

Edie hoped to have everything unpacked and sorted for George's return in July. Piles of boxes of china, glass, and kitchenware were three deep, and by July 3 she was "in the home stretch." She had sorted the dishes and shelved the books in the front room, which was her office and also now the library. But when it came to sorting the papers, she was "DROWNING," in capital letters, reduced to "an absolute pulp." As for whether to keep or throw out George's many assorted "Notes of Great Thought," as she called them,[31] she was in a constant quandary.

24

Documenta

RICKEY'S HIRSHHORN commission, *Summer III*, was still on trial with the collector when it traveled to an important exhibition of modern sculpture in Battersea Park, London, in the summer of 1963. This was a collaborative venture between the London County Council and the Museum of Modern Art in New York, with Rickey's old friend from Chicago Peter Selz as guest curator for MoMA. In the company of Barbara Hepworth, Henry Moore, John Chamberlain, and Alexander Calder, "the most elegant (and only mobile) conceit comes from New Yorker, George Rickey," wrote the critic for the *Spectator*.[1] Very favorably received by critics and public alike, to George's great relief *Summer III* also withstood the test of London's gale-force winds. At the show's end, and after repairing some damaged parts, he would finally deliver it to Hirshhorn's home in Greenwich for keeps.

Public sculpture was enjoying a renaissance that the Battersea Park exhibition did much to amplify. Sir Herbert Read contributed the introduction to the exhibition catalogue, confirming its museum-worthy status. Rather than the traditional monuments to war

heroes, royalty, and elder statesmen, the modern public sculpture was an object of contemplation in its own right, adding a human dimension and voice without a political narrative; it was open to personal interpretation. As modern sculptures took their place in the public parklands and cityscape, they also brought high art to people of every walk of life. As with his public murals of the 1930s, Rickey was instinctively prepared to play his part in the trend.

The Institute of Contemporary Art, in Boston, where Sue Thurman was the newly appointed director, that spring honored him with a retrospective exhibition with some fifty works for both indoors and out. Gearing up for the ICA's publicity effort, Public Relations Director Francie Hughes cultivated the artist's wife as the main attraction at the press reception, especially for the women and society reporters. Here was a story about how the "Juno-esque dynamo" runs her husband's business and manages to cook and decorate at the same time.[2] Sue Thurman assured Hughes that Edie would play her part magnificently. Thurman remembered Edie's staunch support throughout her difficult leadership of the museum in New Orleans, and had had many opportunities to witness her unique talent for operating a roomful of people.

For Boston, a decade later, Edie's style was in full flower. The more famous her husband became, the more she dressed the part of the grand dame. She wore his sculpture on her head as if on parade. In her upper-crusty lockjaw she talked about all the amazing people they knew and the places they'd been, which George would not have cared to boast about. She would toss in a foreign phrase or a four-letter word or a sexual innuendo to keep her listeners on their toes. "Rickey's wife," wrote a Bloomington columnist, "is a complete contrast to her husband—a tall, imposing, helter-skelter, dotty, totally charming chatterbox of a woman." Edie's sartorial style was increasingly outlandish, even camp, though she denounced the appropriation of the word by the advertising and media worlds. "When they start advertising shoes from Macy's as being 'camp' the word just becomes so . . . so

. . . déclassé.["]3 Edie was in a class by herself; she was High Camp. As family friend Werner Feibes gently put it: "You might say that [Edie] overacted her role."[4]

At the same time, George's two-year courtship with George Staempfli's gallery in New York was approaching the point of commitment, with tentative plans for a one-man show in November 1964. Rickey personally felt optimistic about the year ahead while admitting, "it seems ironical and even impious that life should go on and possibly even improve," he wrote to Staempfli. For Americans, the year 1964 had begun with a somber heart. President Kennedy had been assassinated just a few weeks before, on November 22, 1963. "The three years will seem like the Golden Age," lamented George to Ulfert Wilke upon hearing the news, "full of danger but full of hope and also with extraordinary accomplishments—like the Peace Corps." He thought Lyndon Johnson a better politician than Kennedy, but he was "not a world citizen. The bright Harvard men will drift away and [Pablo] Casals will not play at the White House."[5]

BY FAR the most pivotal event for Rickey that year was his invitation to show at *Documenta*, the international modern art exhibition in Kassel, Germany. *Documenta* would signal the beginning of his life as a full-time professional artist and, with it, the end of his teaching career. It would also forecast the flowering of his long and productive relationship with Germany.

Documenta, the brainchild of the art history professor Arnold Bode, was an ambitious new international Modern art exhibition that was Germany's answer to the long-running Venice Biennale. Held every four or five years, its premise was to establish postwar Germany as a vital center for innovative artistic production and to banish the legacy of Nazi prejudice against Modern art once and for all. Its inaugural show, in 1955, marked the first time since the Nazi regime that German artists met with other European artists to "re-engage in a

conversation that has been interrupted for so long," explained Werner Haftmann, one of the founders of *Documenta*.[6] "Surrounded by ruins," commented artist Heinz Mack, "we were enclosed by a cultural cemetery, an information vacuum."[7]

Kassel, an otherwise culturally barren, provincial city leveled by the war, halfway between Frankfurt and Hamburg, became a new epicenter of the avant-garde, an appropriately blank slate. In 1959 *Documenta II* had opened the doors to American artists for the first time, with Abstract Expressionism the predominating style. Cold War politics intensified during this time and a divided Germany was at the heart of the struggle. In 1961, the wall was erected between East and West Berlin. In June 1963, John F. Kennedy attempted to strengthen relations with West Germany with his highly publicized visit to Berlin, where he was forever remembered for his famous speech of solidarity with the West Berliners, proclaiming, *"Ich bin ein Berliner."* Kennedy's assassination further encouraged *Documenta*'s organizers to embrace American artists, to integrate them in the European mix and forge connections that transcended politics.

To be included in *Documenta* was a great honor, and Rickey was determined to rise to the occasion with an ambitious new outdoor work—his tallest standing blades to date. Bode also sought his advice about other American artists working with movement and light. A year before the opening of *Documenta III*, Bode took Rickey on a tour of the buildings and grounds of the Fridericianum, a vast Baroque museum in which the exhibition would be held. Climbing ladders and threading their way through a succession of galleries undergoing renovation, large and small, George was impressed with Bode's eye, his intellect, and his imagination. Bode was keenly interested in dramatic and unconventional installations and favored site-specific concepts for the exhibition. He was therefore especially receptive to a group of avant-garde artists from Düsseldorf who were experimenting with light and movement in new ways.

Founded by Otto Piene and Heinz Mack, with Günther Uecker

rounding out the inner circle of three, these young artists called themselves the Zero Group. "Zero is silence, Zero is the beginning, Zero is round, Zero spins, Zero is the moon," they wrote in a joint poem defining their artistic outlook.[8] Zero is also the last number spoken before a rocket takes off into outer space, a new frontier on everyone's mind amid the highly charged and symbolic space race between the United States and the Soviet Union.

The Zero Group rejected the traditional use of paint, instead concocting new formulas with smoke, fire, nails, and mirrors. They were against the subjectivity, the isolation, and the pessimism of Abstract Expressionism. In a utopian spirit, they favored group experiments, dancing light, and real movement. As a group, Zero was a loose coaltion, identifying with many artists outside of Germany. Lucio Fontana, from Italy, was a father figure. He called his colored light environments "Spacialism," and his slashed painted canvases revealed a confounding third dimension. The "Nouveau Realistes," led by Yves Klein and Jean Tinguely, were also spiritual brethren in their performance pieces, linking Dusseldorf to Paris. Group Zero also embraced the far-flung artists working under the banner of the "Nouvelle Tendence," such as the Serbian Marko Mestrovic and the Brazilian Almir Mavignier, who favored both actual and virtual movement, both kinetic sculpture on the one hand and the optical illusion of movement on a flat surface on the other. Gruppo T, founded in 1959 in Milan and including Davide Boriani and Gianni Colombo, explored still other ways of showing the relationship between space and time, through kinetic and optical means.

One way or another, all of these overlapping artistic groups, as well as individual artists such as Rickey, were challenging the supremacy of the flat surface of abstract painting that was then enjoying a second wave with the so-called Color Field painters—Morris Louis, Kenneth Noland, Jules Olitzki, and others—then championed by influential critics such as Clement Greenberg.

Earlier that year, Howard Wise, a New York dealer, held a

path-breaking show in January 1964 called *On the Move*, which merged these various international trends under the banner of Kinetic art. It included a piece by Rickey, *Crucifera II*. There was a sense of discovery across borders, the same that Rickey was discovering in his research on Constructivism, for which he cast an ever wider net. Later that year, in Paris, Rickey was represented in Denise René's tenth-anniversary show of Kinetic art, along with Julio Le Parc, Jésus Rafael Soto, and Carlos Cruz-Diez. Rickey was happy to find himself circling in the same orbit as these South American and European innovators, most of them half his age. "He could have been almost my father," remembered Heinz Mack, "but the way he treated me and other artists of my generation was just colleague to colleague, youth to youth . . . very sincere but at the same time very light, very open-minded, very youthful."⁹

ON HIS way to Kassel, in late June, Rickey stopped in Venice for the opening of the thirty-second Biennale, looking forward to hobnobbing with the artists, dealers, and collectors who flocked to the event from all over Europe and America. "The important thing at the Biennale is the people one bumps into," he told Edie, and to be sure, he encountered many friends and acquaintances, such as Jack Tworkov and his sister Janice Biala, also an artist, whom George knew from Olivet days; Louise Nevelson; and Ben Nicholson, "with a halo of white hair going around with his young wife" (his third, Felicitas Vogler). He lunched with Joe Hirshhorn, who was so harassed by dealers that he swore he would never come to the Biennale again; and dined with the witty, intellectual Ad Reinhardt, whose clean, abstract paintings George admired, along with the mysterious Venezuelan artist Marisol Escobar, "who is beautiful and poker-faced but quite a character."¹⁰

Casing the American pavilion in the Giardini, George found "the acres of action painting quite depressing," but the Venice Biennale—in a step ahead of *Documenta*—would also be importing American

Pop art that year. George sought out the show of Jasper Johns and Rob-
ert Rauschenberg in the former American consulate on the Grand
Canal, in an overflow from the American pavilion, and admitted that
the two young artists "came through with a good deal of power."[11]
Rumor was already rapidly spreading that Rauschenberg would take
away the Golden Lion award that year. The thirty-eight-year-old
Texan would be the first American artist to win the coveted prize (and
two million lire), and that was not without its critics. Once official,
many believed it was orchestrated by his clever Italian dealer from
New York, Leo Castelli, who represented several other artists in the
show. But a segment of anti-American sentiment did little to diminish
Rauschenberg's growing reputation, as well as the emergence of Pop
art on the international stage. All in all, with the thirty-second Venice
Biennale, there was no denying that American artists had become
international leaders in contemporary art.

In late June, when George arrived in Kassel to meet his shipment,
he found his sculptures unpacked and "lying around the place in a
rather dismaying disarray."[12] Not only that, he also learned that the
organizers had neglected to reserve any specific sites for his sculptures.
But this momentary crisis was soon enough turned to his advantage:
His two smaller pieces—the vertical *Sedge* and the horizontal *Land-
scape*—would find their place in the semi-enclosed spaces created by
the ruins of the old Orangerie. With a young German artist, Jurgen
Gramse, who had been assigned to help him assemble his work for
the exhibition, George went to work. Once the sculptures were up
and running, he was pleased with their prominent positions in the
good company of Calder, David Smith, and Norbert Krïcke. For his
signature *Two Lines Temporal* (or "Zwei Linien"), at more than thir-
ty-two feet his tallest piece to date, there was nowhere left to place it
but on the enormous lawn in front of the building. Rickey was invited
to choose a spot amid its great expanse. A concrete base would be
poured on the spot.

Group Zero, meanwhile, had planned a spectacular centerpiece

called *Light and Motion* in its dedicated third-floor space inside. Piene, Uecker, and Mack collaborated on a work that brought together various kinetic sculptures hanging in a choreographed arrangement of automated movement, lighting up and darkening as they turned. Outside, on opening night, was another spectacle that would long be remembered: Rickey's *Two Lines Temporal*, gleaming silver against a full moon and a clear sky, its blades in a dialogue of unexpected movement, commanded the entrance to the show. An electricity failure interrupted the opening ceremonies, adding further drama to the moonlit sculpture and garnering that much more press attention.

Seen by all two hundred thousand visitors to *Documenta*, its prominent position was, for George, "a windfall."[13] With its sleek lines, its utter lack of message, and its oneness with natural causes, it moved, to use Hayden Herrera's analogy, like God's compass in medieval images of Genesis; while at the same time it was like a flag-bearer for the art of the future. As Otto Piene recalled, it was "absolutely one of the magic moments in the history of Kinetic art . . . we were entirely united."[14]

"I BEGIN to feel the shortness of time," Rickey wrote to Ulfret Wilke in July, soon after he returned home.[15] Now that his blade pieces were widely known, he was determined to add another concept in the works, altogether different but equally ambitious. This was a series of works he called *Crucifera*, after the botanical term for a type of plant with four equal petals. Composed of clusters of four-bladed stainless-steel rotors attached to a central stem, Rickey's towering Crucifera sculpture gently rocked from a base weighted with square blocks, creating currents that made neighboring rotors spin in the opposite direction. The randomness of the movement with the masses of sparkling little parts too numerous to count and the sequence of movement impossible to chart added to its mystifying and mesmerizing effect. Thus, just as Rickey was reducing his sculpture to the most minimal of forms with his *Two Lines Temporal*, he was also reviving the intricacies of

small parts that began with his plant forms of the 1950s, but with a larger overall effect. He was striving for "a motion so complex you can't read it,"[16] and which in its complexity took on an organic form, like a wave.

He was also furthering his series called *Nuages*, comprising horizontal planes of hundreds of shimmering seesaws. One of the most ambitious of the series, made up of almost four hundred folded stainless-steel squares, took its place like a silver cloud over the newly inherited Rickey mahogany dinner table, responding to a summer breeze through the window or the heat of a candle flame, gently rocking as if to the beat of the bossa nova. Edie told their admiring guests that when the time came for cleaning *Nuages*, all the little parts were dishwasher safe.

At the same time, Rickey was mulling over an idea he had quietly nurtured for a while: a water-driven sculpture. This obsession had been given a boost from Pieter Sanders, who had acquired several of Rickey's sculptures since first encountering them at Arturo Schwarz's gallery in Milan. Serving on Rotterdam's advisory committee on public sculpture, it occurred to him that Rickey might be persuaded to create something for the city. Sanders was struck by his comment in his article "Morphology of Movement," for the *Art Journal*, in which he suggested his ongoing quest for "unexplored kinetic territory,"[17] including a water-driven sculpture. In the process of building an underground transit system, the city of Rotterdam would be dismantling an existing fountain at the center of the massive Hofplein traffic circle where four wide avenues converged. Sanders proposed that a Rickey sculpture might take its place.

With his usual can-do spirit and great excitement, Rickey accepted the challenge. Besides his longstanding interest in making a sculpture with water, he may easily have been motivated by the important precedent of Gabo's giant sculpture in Rotterdam in front of Marcel Breuer's Bijenkorf department store building. With engineers and town planners doubting the viability of the proposed construction,

Gabo had finally enlisted the skills of a bridge builder, and the piece was erected in 1957. Gabo thus threw down the gauntlet, and Rickey picked it up.

THE ATTENTION brought to Rickey's work at *Documenta III* eventually won the kind of notice he had felt somewhat lacking for his work in New York. At the close of the show, New York Governor Nelson Rockefeller bought Rickey's *Six Lines Sedge* for his private collection in Pocantico Hills. As a New York politician from an influential family of art patrons, Rockefeller's interest was prescient. And so was that of his trusted advisers at the Museum of Modern Art. At the end of September, George and Edie received a visit from Alfred Barr, along with his longtime curator, Dorothy Miller, of the Museum of Modern Art. Barr, having noticed Rickey's works at *Documenta III* for the first time, expressed a keen interest in seeing and learning more. It was a beautiful fall afternoon. The birdlike Barr brought his binoculars for birding, and they all had drinks on the lawn before touring the sculptures indoors and out. Barr apologized for not knowing Rickey's work better, but he had a kind of laser vision for quintessential pieces by artists at the peak of their powers. As much as he admired Rickey's recent *Crucifera* pieces, he remained fixed on the blades. Imagining its powerful presence in the museum's sculpture garden, he and Miller settled on *Two Lines Temporal*, still in Kassel. George's Kassel assistant Jurgen Gramse disassembled the piece and prepared it for shipping. In New York, Rickey was on hand to oversee its installation in the museum's sculpture garden.

Thus, direct from a major international show in Europe to the American pantheon of Modern art, George Rickey had arrived. The year 1964 was a turning point for him in terms of his professional and artistic development. With *Two Lines Temporal*, he had released himself from all direct references to nature in both form and title. The confidence he showed in its simplicity signaled his embrace of the

Constructivist origins of his scholarship. As Reiko Tomii has written of that moment in Rickey's career, he had finally become a true Constructivist, by the very set of standards laid out in his book on the subject.[18] And like its soaring thirty-two-foot blades, Rickey's reputation had reached a new high. Sales, commissions, and invitations to exhibit were flowing in at such a pace he could hardly keep up with the demand. But what was he to make of it all? Where did his work stand in the confusing art world of the 1960s?

"I don't know if I'm in or out of step—either would be dangerous," he wrote at the end of 1964. "My concern with 'movement itself'— Gabo's phrase—leads me into ever deeper, if narrower water. I will never explore the whole gamut of it—the possibilities are too wide."[19] Then in his late fifties, he calculated the time he had left to break new ground to be about ten years. "We should probably be pruning our styles instead of adding new factors," he told Ulfert Wilke, "or exploring attractive new alleys. We are already the age of late Rembrandt."[20]

David Smith would not quite live to that age. On May 23, 1965, he died in a car crash, at fifty-nine. On a hot May 26, George and Edie drove up to Bolton Landing for his memorial service. Down by the lake there was a bandstand with the coffin at its center and surrounded with flowers. Loudspeakers positioned on the roof of the bandstand blasted a Bach cello aria across the field of folding chairs. A bus full of art-world celebrities unloaded from New York. After the service, George wanted to see David's work just as he left it. Skipping the reception, he and Edie ventured up to Smith's studio. "Great rows of sculpture stretched down from the house," he wrote to Wilke, "perhaps a hundred pieces, some rusting from 20 years before, some painted, some very new, in stainless steel, and already an advance on the Cubi series. They were in the order David himself had been making them for several years . . . very few artists can have seen their oeuvre set out like that. That he should have done it rather than have others do it for him, was characteristic of him." Indeed, Smith vastly preferred seeing his work in a natural setting, in a dialogue with nature. Unlike Rickey,

whose work requires a collaboration with nature to perform, Smith's sculptures, after his death, would for the most part live indoors. But that would not diminish his greatness. "I believe that what he has sown will last longer than a season," wrote George to Ulfert, with characteristic understatement.[21]

Meanwhile, as George's reputation grew, greetings from his former wife, Susan Luhrs, now Mrs. H. D. Barrow, came from across the continent. They had not been in touch for at least twenty years, but Susan, now in Juneau, learned of George's rising reputation as a modern sculptor. Since she had last seen him, she had earned a degree in anthropology and taken a special interest in the Native Americans of the Northwest coast, and was working as a curator at the Alaska Historical Museum. Wanting to "breathe some fresh air into it," she sought George's advice on where to look for Northwest coast artifacts and what to read.[22] She also wondered whether George could be persuaded to come to Juneau to judge an Alaskan art show. With the distance of time and four thousand miles between them, it was an opportunity to put their failed marriage behind them once and for all.

In East Chatham that Thanksgiving, George and Edie inaugurated the mahogany dining room table with special guests from Europe—Günther Uecker, Heinz Mack, and Marisol Escobar. George and Edie had recently introduced a guest book the size of a large artist's sketchbook and invited their friends to take a whole page to express themselves. The poker-faced Marisol filled her page with a simple line drawing of a chrysanthemum; Uecker and Mack meanwhile made sculptures in George's studio and left them as gifts to their host.

25

The Workshop

IN THE five short years since George Staempfli had opened his gallery at 47 East 77th Street, he had proved himself a leading-edge international art dealer in New York specializing in sculpture, with a stable including Max Bill, Jean Tinguely, and Harry Bertoia. Adding to Staempfli's prestige were the high-quality catalogues he produced with his family's private press for each exhibition. Rickey's first one-man show at the gallery, in the fall of 1964, gave him a fresh start at exactly the moment when New York woke up to the currency of moving sculpture, assuring him that he had landed in the right place at the right time. A fine review in the *New Yorker* expanded his reputation as an artist who combined the sophistication of an engineer with a poetic inclination in equal measure.

By the end of that year, between Staempfli and David Stuart in Los Angeles, Rickey's sculpture sales had netted an impressive seventy thousand dollars. He had also made substantial sales independently, which brought in some sixty thousand dollars. Therefore, although Rickey was happy to give Staempfli his official representation in the

United States, in cases when he had originated the sale or commission directly from his workshop, he was reluctant to share even a reduced ten percent commission with his new dealer. "The last thing I want is to compete with your efforts," he wrote to George Staempfli, "which have succeeded so very well. But I should like to preserve the independence of my own separate efforts thus far. You will find me frank and scrupulous in carrying out our agreement."[1]

Looking ahead to the coming year, Rickey was sure that Staempfli's proportion of sales would rise and his own would fall, especially as he hoped to spend more time working and less time preparing for shows and entertaining visitors in his studio. Staempfli was rightly inclined to trust Rickey in matters of accounting; however, the arrangement was not without interpretive complications that would continue to arise in the years ahead. Smoothing the relationship between George Rickey and George Staempfli was the gallery's codirector, Phillip Bruno. Half a generation younger than the sculptor, Bruno had grown up in Paris and New York and had developed a sure eye for artistic quality and originality, with charming manners to match. Both George and Edie took an immediate shine to him, and he looked up to George like an older brother.

The lonely field of kinetic sculpture that Rickey had described in 1960, in his first Guggenheim fellowship application, was becoming quite crowded. Kinetic art was distinctly on the ascendency, and Rickey's work was much sought after as a quintessential example of the trend for many group exhibitions in the United States and Europe. Peter Selz, his colleague from Chicago's Institute of Design, was actively developing ideas for a major show of Kinetic art at the Museum of Modern Art, where he was then curator of painting and sculpture. Like Rickey, Selz had been captivated by the idea of moving sculpture as far back as the 1940s, when László Moholy-Nagy outlined its theories. Kinetic sculpture, Moholy-Nagy declared in 1947, was "the fifth and last of the successive stages in the development of plastic form."[2]

Motion and speed were integral to the art of the early twentieth century, with the Italian Futurists' efforts to describe motion in plastic form, the Cubists' many-faceted view of an object, and the Russian Constructivists' experiments with actual movement. But the artistic temperament of the postwar epoch had put this kind of experimentation to the side in favor of introspection, and artists had trended toward the painterly and the private. The scientific realm of kinetic sculpture remained a latent tendency, waiting in the wings. But now, with the advent of the 1960s, the time had come for new experiments with movement along with the revival of interest in earlier forms. Moholy-Nagy's motor-driven *Light Prop for an Electric Stage*, of 1930, was one of the earliest examples of kinetic sculpture. A gift to Harvard's Busch Reisinger Museum, it had languished in storage in so many rusted pieces; now, it was intricately restored and brought to life again, as was Moholy-Nagy's 1922 forecast that eventually the art viewer would be actively engaged in a sculpture's movement and activity, or a "partner with the forces unfolding themselves."[3]

In 1960, Selz had presented Kinetic art at the Museum of Modern Art with a highly memorable event: Jean Tinguely's runaway performance piece, *Homage to New York*. In the museum's sculpture garden, Tinguely assembled his twenty-seven-foot-high, self-destructing machine of myriad found parts, including a meteorological trial balloon. With an audience assembled, he set it in motion, along with a cacophonic soundtrack, spinning and pulsating until it burst into flames. To Tinguely's great disappointment, the fire department promptly arrived on the scene with hoses and axes to put an end to it, though a few bits and pieces were salvaged for the permanent collection.

A year later, at MoMA, the curator William Seitz presented in the auditorium the spellbinding *Tangible Motion Sculpture*, performed by the New Zealand artist and experimental filmmaker Len Lye. With his motorized wiggling strips of stainless steel with musical

accompaniment, Lye was reaching for "the inner echo" of movement within his own body as well as the beauty of curling smoke, a windblown leaf, a flapping flag, or waggling spermatozoa. With these path-breaking events at MoMA, Selz began to build his idea for a comprehensive group exhibition of kinetic sculpture.

From its inception, Selz sought Rickey's advice, mining ideas over frequent informal conversations and rummaging through his personal archive in East Chatham. Ever the historian, Rickey shared with Selz a range of associations, from Leonardo da Vinci to Isaac Newton and Albert Einstein, and examples of kinetic design from eighteenth-century automata to weather vanes, fountains, and cuckoo clocks. But while many of these moving spectacles of the past were engineered to repeat themselves or move to a regimented program, modern Kinetic art was intentionally indeterminate, unpredictable, and random, whether mechanized or driven by the laws of nature.

In character with the antic art world of the day, the elusive concept of movement was appropriately radical and open-ended, with a solid past and a future stretching to the far horizon. It was also, in spirit, optimistic. As Selz observed, this new generation of artists "seems perhaps more affected by man's ability to leave the earth and move into outer space than by his failures on this planet."[4] Indeed, the United States versus the Soviet Union race for the moon was in a dead heat.

By the time the exhibition was fully developed, Selz had left MoMA to become the founding director of the University Art Museum at the University of California Berkeley, and took the kinetic show with him. He planned *Directions in Kinetic Sculpture* for Berkeley's brand-new art gallery in 1966. Earlier that same year, William Seitz opened *The Responsive Eye* at MoMA, an exhibition that featured a roster of international artists then working with the effects of optical illusion, promptly coined by a journalist as "Op Art."[5] George had met many of the artists in Europe as fellow exhibitors at *Bewogen Beweging*, among them Vasarely, Agam, and Julio Le Parc. Unlike recent heroic trends

in abstract painting, these optical studies represented "a surrender of the human privilege of expressing meaning," remarked Rudolf Arnheim, an art theorist and perceptual psychologist, as he toured the show.[6]

By this time, the pioneering dealers and curators of Kinetic art found themselves competing with one another for loans, with group exhibitions being held in New York, Amsterdam, Tel Aviv, London, Brussels, Glasgow, Buffalo, Bern, and Venice. Even so, Selz managed to represent a stimulating cross section of style and concept for his show. He asked Rickey to contribute an introduction to the catalogue, building on his growing reputation as a major spokesman of Kinetic art, the voice of reason in a world gone slightly mad.

International in scope, the show featured fourteen artists, among them Zero Group member Heinz Mack; the Belgian Pol Bury; Fletcher Benton, of San Francisco; Len Lye, from New Zealand; and Takis, a Greek living in Paris. From Lye's walloping, sonic gestures to the infinitesimal mechanical movements of Pol Bury's flathead nails projecting from a wooden board, artists navigated the kinetic landscape in a variety of ways—some using motors (Bury), others magnets (David Boriani, Takis), and, in Rickey's own case, the natural forces of wind, which he likened to Hans Haacke's use of water and Heinz Mack's use of light. "Chance replaces free will," wrote Rickey about his fellow exhibitors, the artist "abdicates authority in favor of chance, he chooses not to choose." All of this "supports the idea of impersonality." Yet, he argued, the scientific and nature-oriented leanings of Kinetic art did not eliminate the personality of the artist. "Nature becomes an ally of the artist, not his replacement."[7]

Indeed, personalities abounded among the exhibiting artists and during a panel discussion that was part of the opening festivities. Rickey, the graying sage, with the somber Takis, the feisty Len Lye, and the playfully irreverent Harry Kramer, fielded questions and comments in a packed auditorium. The exhibition attracted record

crowds, many, to Selz's delight, from the student population. It was a show one "watched" rather than saw; the crowds of visitors were "spectators" as if in a theater rather than viewers in an art gallery.

No matter how one looked at it, sculpture had moved off its traditional pedestal into the uncharted realms of the kinetic imagination. Furthermore, in doing so, the Calder "myth," as Rickey put it, had been successfully exploded. "Recent kinetic art has been due entirely to others," he wrote, "and comes principally out of Constructivism—a school very remote from Calder's romantic space drawings."[8] He was also to subtly put Tinguely in his place. As in his review of the Calder retrospective at the Tate in 1961, Rickey acknowledged Tinguely's popularity and charm, and then delivered a quiet blow to his technical aptitude, at the same time implying a certain lack of depth in his message. "Tinguely is garrulous," he wrote, "entertaining, impudent, seductive and subjective, a mixture of Til Eulenspiegel and the Pied Piper, a Swiss clockmaker with a difference and with echoes of the brutal wit of Urs Graf and the mechanical fantasies of Paul Klee, both fellow-Swiss. He can be loved. He is an adept and energetic mechanic with a limited repertoire well-suited to his purpose."[9]

IN 1965 Joe Hirshhorn commissioned another large outdoor work. Visiting Rickey in East Chatham, he was enamored with a pair of thirty-two-foot steel blades towering over the farmhouse and painted fire-engine red. George had built the sculpture in a rehearsal for *Two Lines Temporal* for *Documenta* in 1964. Using mild steel to save money, he painted it red to keep it from rusting. As a unique prototype, he gave it to Edie as a gift. Hirshhorn wanted to buy it, but because George would not sell, he commissioned an almost identical piece, with three blades instead of two. Furthermore, he wanted it in stainless steel, which is difficult to paint. Rickey had by this time generally abandoned using color in his sculptures, preferring to draw

attention to their movement, or what he called "my new box of colors,"[10]—namely, gravity, momentum, inertia, moments of rotation, acceleration. But eager to please a loyal and important patron, he enlisted the help of young assistants and met the challenge of building and painting Hirshhorn's *Three Red Lines*. For greater stability, he also replaced the knife-edge bearings with machine-made ball bearings for greater stability. That same year, with the gift of Hirshhorn's collection to the nation, an act of Congress established plans for the Hirshhorn Museum and Sculpture Garden on the Washington Mall. A circular concrete building, designed by Gordon Bunshaft, showed obvious references to the Guggenheim Museum. Rickey's *Three Red Lines* would command attention up and down the Mall during and after the construction of the building, signaling the excitement in store for the public when it eventually opened, in 1974.

Well before that, *Three Red Lines* was given its Washington debut. In September 1966, the Corcoran Gallery organized a Rickey retrospective of more than fifty sculptures made over the previous fifteen years, including Hirshhorn's latest acquisition, planted like a tree on the lawn at the corner of 17th Street and New York Avenue. The Corcoran was a prestigious venue—the grand old lady of art museums in Washington—with an art school and a tradition of support for living American artists. But by the end of the show, *George Rickey: Sixteen Years of Kinetic Sculpture*, he wondered if it had been worth the tremendous toll it had taken on him, and on Edie too. The staff of the Corcoran left all loans and shipping arrangements to the Rickeys, an exhausting administrative task to perform at a distance, and with a formal black-tie dinner on the night of the opening about to begin, George was up a ladder in his work clothes, installing the show all by himself. At the show's close, the sculptures were returned to their lenders, most of them private collectors, with broken pieces and missing parts, which only the Rickey workshop was capable of fixing. It could not have helped George's lingering attitude that the reviews of the show were mixed. The *Washington Post* critic called it "meaningless

complexity," the shapes of the sculptures themselves "trivial and inexpressive," and concluded that "the endless crisscrossing of the giant needles seems without feeling and to no purpose."[11] Thus, Rickey was not immune to the kind of criticism he leveled at Tinguely, whose work was, at the very least, entertaining.

RELUCTANTLY, AT the end of 1965 Rickey retired from teaching at RPI with the conclusion of his five-year contract. *Documenta III* had put him firmly on the international map, and he had to admit that there was no way he could keep up with the demand for his work and a teaching load as well, even with just one course, one day a week. But after twenty-eight years as an educator, George would never really give up teaching. He was instinctively alert to a teaching moment and any opportunity to nurture an inquisitive young mind.

Just as his sculpture encourages the mind to grapple with the unknown forces of nature, Rickey never stopped asking questions, of both the times he lived in and times past. He was a stickler for accuracy, but ever conscious of nuance, seeking every side, in search of the balance. Conversations with George circled through topics, meandered and then halted at a point, a question, such as the origins of the Electoral College, or how the word *happiness* made its way into the Constitution of the United States, or the entomology of the name *Inca*. Entertaining at home in East Chatham, a question would come up and George would reach for a book on his well-stocked reference shelf, and then another, considering the various accounts, adding up the facts and weighing the opinions, arguing, joking, engaging all present in his tireless quest, until there were books all over the floor and the subject had been exhausted.

Edie embraced her role as the artist's wife unreservedly, and many would say that she was central to his success. This power couple had their roles clearly defined and their routine was inviolate. Each morning began with the plan for the day. They called it "the board

meeting": Edie sitting up in bed in her dressing gown and George in a chair opposite, both armed with a yellow legal pad in one hand and a coffee mug in the other. From there they would dispatch to their respective posts with a full agenda—George to his workshop, Edie to her typewriter and telephone—and then meet again for lunch.

As demand for his work increased, George recruited assistants, some locally for their specific skills, such as the professional welder John Dean, others from art colleges and graduate programs, and one from just next door, the enthusiastic twelve-year-old Peter Homestead, who was willing to do anything just to be around the Rickeys; he would mow the lawn, babysit Philip, feed the cat. In time, Peter would become one of George's most highly skilled craftsmen. Rose Viggiano, another young East Chatham neighbor, worked summers for both George and Edie, beginning with polishing Edie's collection of copper pots. When she was fourteen, George taught her how to weld.

By far his most senior employee was Roland Hummel, a colleague from RPI who taught structural engineering to architecture students. George needed a professional engineer to gauge the viability of his outdoor sculptures and to ensure their safety in public places, as his endless tinkering with Hirshhorn's *Summer* had demonstrated. The arrangement with Hummel began informally, with George conferring with him over a concept for a sculpture. Roland would calculate the ideal weight of a piece for its length in order to move within the desired range of speed and make sure of its durability in strong winds. Hummel was thorough, exacting, and strictly business. George valued and respected his work unwaveringly, but didn't always show quite the level of appreciation Roland would have liked as a key collaborator. As Rickey's work increased in value, Hummel asked to be paid in sculptures, trusting, quite correctly, that in time he would earn what he deserved.

George also needed strong and able young assistants on a full-time basis to help carry out the tasks of cutting, bending, and welding. It

was also essential to "grind" a stainless-steel surface to create a texture that enhanced the reflection of its natural surroundings, a technique he had taken after David Smith and made his own. Over the years, at the urging of Staempfli, Springer, and other dealers, he was also beginning to work in small editions.[12] Once he had made the prototype, this kind of routine building was perfectly suited to assistants, freeing George to work out new ideas on paper and tinker with models at his bench.

In 1965 he hired John "Chip" Cunningham, who had just earned his graduate degree in sculpture at Yale. Because Cunningham had also worked in a neutron-activation laboratory, in addition to his manual skills he was able to talk physics and engineering with his new boss over a cup of coffee in the morning, though he quickly ascertained that George was more an intellectual than a scientist or technician, more concerned with ideas than with the tools necessary to express them.

Furthermore, for an artist with a growing international reputation, with individual pieces selling for tens of thousands of dollars, Rickey's little barn workshop appeared strikingly primitive. Cunningham remembered that he used an electric saw designed for wood to cut stainless steel. Welding went on in the front room, where sparks fell into the cracks of the wooden floor, and no one wore a safety mask as they breathed in the poisonous fumes. The backroom was reserved for the less toxic job of assembling.

No matter which space George and his assistants worked in, it was chilly in winter. "George was very careful about money," recalled Cunningham. Between his Yankee roots and his Scottish childhood, he was not inclined to splurge on equipment, or heat, and he wore his plaid flannel work shirts till they were threadbare. But working in the Rickey studio had its overriding benefits. George enjoyed encouraging young intellects, and his workshop provided him with many such opportunities. "I never met an artist so aware of history," Cunningham remembered, and with such "an

extraordinarily intelligent mind."[13] George also responded to many a call as a visiting artist on college campuses, including a full term at Dartmouth College in 1966. Steve Day recalled Rickey's visit to the Hartford Art School in Connecticut that same year, when Steve was then a third-year student, and the great impression George made. In 1966 Day approached Rickey for a summer job, which to him felt "like calling on Mick Jagger to see if he wanted to hang out." During an interview in the kitchen—which Day remembered as a humbling performance on his part—he answered "No" and "I don't know" to most of Rickey's questions. But George sized up his candidates as much for their interest in learning as for the knowledge they might already possess. At the end of the interview, George said, "You're not exactly what I'm looking for, but I'd like to hire you anyway. Can you start Monday?"[14] It was Friday.

Day began his job as third in command, and eventually proved himself indispensable. If he did not have Cunningham's science background, he did have an innate gift for mechanics and a determination to figure out how things worked. As a teacher, George was practiced at drawing out each of his assistants' particular talents and also managing his expectations of their performance. This equation was to play out especially well in his employment of Steve Day, who would become a veteran of the Rickey workshop.

TECHNICALLY, THE mid-1960s was a period of transition for Rickey, with both the scale and the nature of his work requiring more teamwork than ever before. He also needed the resources of a machine shop to make parts such as the ball-bearing housing and shaft to exact specifications. His unique handmade knife-edge bearings did not always hold up to a strong wind, and some of his larger sculptures had suffered as a result. Nelson Rockefeller, for example, had problems with *Six Lines Sedge*, the piece he bought from *Documenta*. After exchanging the sculpture for another of similar scale (*Five Lines in*

Parallel Planes) that later suffered damage too, Rickey was persuaded to start replacing his knife-edge bearings with the more reliable ball bearings routinely. As he struggled with these changes to his methods, it was helpful to engage with the younger minds and muscle of his assistants.

Many big projects were in the works at the time, including the monumental *Crucifera III* for the shiny new building of the Lytton Savings Bank, in Oakland, California. Commissioned by the architect Kurt Meyer, the sculpture took George most of the summer of 1965 to complete. It required hundreds of little four-petal stainless-steel parts, as well as machine-made nuts and bolts and ball bearings of various sizes and weights. With its myriad parts suspended from a complicated tetrahedral infrastructure with a horizontal span of more than thirty feet, the piece would stand twenty-one feet off the ground. George consulted Roland Hummel as his professional engineer and hired a local welder for the sensitive task of soldering the superstructure. To test the sculpture's moving parts, George took the wheel of Cunningham's van, Chip held a branch of *Crucifera* out the window, and they drove along the country roads at top speed, rotors spinning, until they were sufficiently confident in the sculpture's performance and durability.

It was also essential to know how much weight was needed to hold the thirty-foot chassis in place in an eighty-mile-an-hour wind. For this test, George borrowed two hundred cement blocks from the radiation lab at RPI and hung them on the chassis. Five-year-old Philip was thrilled to take part in the process, moving cement blocks around the outdoor worksite in his little red wagon.

Another major commission for Rickey at around that time was *Six Lines in Parallel Planes* for the new State Office Building Campus in Albany, part of Governor Nelson Rockefeller's sweeping reconstruction of the state capitol. The sculpture was to be installed in front of the Department of Employment in a reflecting pool, with five blades tilting from its slender trunk. The blades were meant to rock back and

forth without touching one another, and return to their resting position safely and consistently. Addressing this challenge for the first time on that scale, George had adapted springs much like those of a screen door and hoped for the best. On the appointed breezy summer day, with the help of Chip Cunningham and Steve Day, he transported the piece to Albany to meet the crane drivers and their equipment.

A Rickey installation, as one critic observed, was like the then in fashion "Happenings"—group experiments on a public stage with an uncertain outcome.[15] As the team was installing the piece, with a crowd of interested employees on their lunch break gathered around to watch, the wind picked up and the blades bowed down like the branches of a tree. With every bow, they gained momentum until the mechanism broke under the pressure and one blade disengaged from the trunk and fell into the reflecting pool, at which point "everyone's faces turned white," Steve remembered. The day after the disaster, George asked him to drive out to Nassau to get some shock absorbers from the Honda motorcycle dealer. "There's a whole world of shock absorbers out there,"[16] said Day, and none of them was perfect for Rickey's purposes. But from the Albany incident onward, George would be endlessly adapting and designing shock absorbers to suit his needs.

"George was more interested in making things work than *how* they worked," Day recalled; he was not a "gearhead."[17] Rickey's workshop style reflected this. He respected his tools but was not in love with his equipment. "One of the problems I have with my helpers when they start," George said in an interview, "is that they try to do everything with tools when sometimes it is much faster by hand. I want to keep fabrication simple and direct and uninvolved and unpretentious."[18] He was frugal with materials, acquired only what he needed, and adapted slowly to new methods. His assistants learned to work by his ways. But he also learned from them. "I never saw him lose his temper," recalled Cunningham.[19] And for Steve Day, it was a dream job. Working for George Rickey, he said, was "the real deal."[20]

Edie, meanwhile, in her capacity as executive secretary, enlisted

Chip Cunningham's wife, Belinda, as second typist. While correspondence with dealers and collectors multiplied, work on the Constructivism book was ongoing. For a short time, between the board meeting in the bedroom and the beginning of a day's work in the studio, George would sit on the sofa in the living room and produce enough pages of his manuscript in long hand to keep Belinda busy transcribing at the typewriter for several hours. While Belinda hammered away at her keys in the front office, Edie was typing letters to collectors and dealers and shouting or swearing like a sailor into the phone. There was a sense of chaos, remembered Chip Cunningham, but also "a sense that they were doing something really important."[21]

Myrtle Kie helped with all kinds of housework, including cooking dinner three nights a week, and was on hand to move in with Philip when George and Edie were traveling; by this time Stuart had left home for boarding school—Eaglebrook, in Deerfield, Massachusetts. During the growing season, there was a steady stream of "garden girls" who kept the flowers and vegetables flourishing, for Edie's flower garden was a passion for her and the vegetables and herbs essential to her kitchen. All through the summer months, the Rickeys lived on their fresh bounty, and what remained was pickled or frozen.

In 1966, George began making plans for a new studio building. A former student at RPI, Doug King, who had also been his teaching assistant, had visited East Chatham on several occasions. Fascinated, King had come to know the whole family and their interesting way of life, so different from his own conventional small-town background in Topsfield, Massachusetts. Comfortable with King's skills and familiarity with the setting, George engaged him as architect. There was a forty-year age difference between them, and Doug felt that George was taking a great leap of faith to entrust him with the job. The new studio would be situated directly opposite the house on the other side of Route 34.

At first, concerned about the vulnerability of his wooden barn workshop, George envisioned it as simply a fireproof storage building—a

purely functional concrete bunker. Then he thought it might double as guest quarters, as he and Edie increasingly entertained friends from out of town and abroad. Reluctant to define its exact purpose, George said only that it would be a Bauhaus-style building, "an interesting study in black, white, and grey."[22] King was patient with George's meandering thoughts, and it became a collaborative process. The building's uses would evolve and adapt to George's needs; like his sculpture, he liked to think in terms of its endless, interchangeable possibilities. But with the increasing scale of his projects and the growing number of his staff, it seemed obvious that he needed a bigger space in which to work. King drew plans for a forty-by-forty-six-foot square space with a ceiling height of nineteen feet. In case of the need for even more height, they incorporated a pit in the workshop floor, which increased the depth by ten feet. A flight of iron steps would lead to office space above. With his staff crowding around him, George eventually came around to seeing it as an ideal place to locate his assistants, leaving the upper studio his alone to escape to for a welcome spell of solitude.

PART **THREE**

26

Berlin

IN AUGUST 1961, cranes began to lower concrete blocks along the border of East and West Berlin, eventually to extend twenty-seven miles through the sprawling city. An additional seventy miles of wall would enclose West Berlin from the surrounding Soviet-controlled East Germany. "It's not a nice solution," said President Kennedy upon hearing the news, "but a wall is a hell of a lot better than a war."[1] Unappealing as it was, the erection of the Berlin Wall protected each side from the other in the growing hostility of the Cold War and diminished the perceived threat of Soviet Premier Khrushchev attempting to take over the city entirely. As a result, political tension in Europe subsided somewhat. As the historian David Clay Large put it, "Instead of bringing war, the Berlin Wall helped to keep the Cold War cold."[2]

At first the wall was low and fairly porous, but over the years it would be made higher and more forbidding, brightly lit and closely guarded, until by the late 1960s it became lethally dangerous for East Berliners to attempt to cross it. At the same time, West Berliners felt more isolated than ever in an island of the free world surrounded

by the Soviet bloc, and the wall had a deadening effect on the once vibrant city. For West Berliners, a greater than ever dependence on government support over its own self-generated economic health was dispiriting, and they also felt abandoned by their allies.

As in the 1920s, with the cost of living there a bargain, West Berlin attracted the poor and the alienated. In many ways, it was a liberal city-state, all the more so in contrast to its Soviet surroundings, but also compared with the rest of West Germany. West Berlin had its own set of laws. Abortion was legal there but not in Bonn. There was no military conscription in West Berlin, which in other parts of Germany was difficult to avoid, so young men moved to the city to avoid the draft. With the groundwork already laid by an earlier generation for sexual experimentation and an acceptance of extreme behavior, the capital of the Cold War was a magnet for rebellious, creative spirits that made for a thriving underground. The Stasi kept strict order in the East, but there was an "open-air theater of the grotesque and forbidden" going on in the West,[3] as if to thumb its nose at the Soviet bloc and skid dangerously close to the other side of the barbed wire. At the same time, West Berlin was a sophisticated city, with its wide avenues and shops and cafés on the Kurfürstendamm; modern with its clean and efficient U-Bahn; and able to carry on in many ways much as before. The city was loaded with contradictions. "Berlin is full of history but is a-historical," said the art historian Jörn Merkert. "It's a conceptual city."[4]

On the government level, West Berlin's isolation called for an aggressive program of cultural revival—to keep in touch with the evolving art scenes in Europe and the United States—and an injection of funds to make it possible. A young journalist, Peter Nestler, wrote a series of columns called "The End of Illusions" for an Argentinian weekly, about the need to address the identity crisis that Berlin was suffering. The series so impressed German Chancellor Willy Brandt that in 1963 he invited Nestler to accompany him on a trip to New York for a meeting with the Ford Foundation. Soon afterward, Brandt

put Nestler in charge of an artist-in-residence program sponsored by the German Academic Exchange Service, the Deutscher Akademischer Austauschdients, or DAAD, with an initial grant of eight million dollars from the Ford Foundation. To that end, the DAAD, for which Berlin had a small outpost, began inviting artists, writers, and musicians to come to the city as guests of the government, with no obligation other than to live and work there, all expenses paid. It was Nestler's conviction that in bringing world-ranking artists to Berlin for a year that they might profit from their stay but also contribute: "It was not only important that people were well known, but they were able and willing to communicate." Lacking a background in the art world, Nestler sought the advice of the artist Hann Trier, "who knew everybody everywhere."[5] It was Trier who suggested that he extend an invitation to George Rickey.

The warm reception of Rickey's work in Germany, from his representation by Rudolf Springer in Berlin in 1962 to the exhibitions and commissions that followed, was in part due to his sculpture's mechanical precision, which appealed to the German public. The high-profile attention his work received at *Documenta III* and his association with Group Zero added another layer to his affinity with the German art scene. In October 1966, Rickey received a letter from the secretary general of the DAAD, Hubertus Scheibe: "I have the personal pleasure of asking you if you would consider a stay in Berlin," he wrote, "and what tentative date would suit your plans."[6]

For Rickey, the invitation to Berlin was attractive, but he hesitated. A whole year away from his workshop was a daunting prospect. He felt committed at home, too deeply involved in his various projects to embark on another life, even if only temporarily. On the other hand, it seemed fitting to enter his sixties with a complete change of scene. Finally he decided that "the only way to prove that I was not too old and fixed in my habits to move to a new environment, would be to move to it."[7] Here was an opportunity to set aside the daily pressures of his workshop and to open his mind to new ideas. His book,

Constructivism: Origins and Evolution, had been picked up by Braziller and would be published in 1967, a huge project off his mind, and off Edie's desk as well.

By that time, George could depend on experienced assistants to carry on in his absence in East Chatham. Stuart was a boarding student at Eaglebrook School in Deerfield, Massachusetts, and Philip would likely benefit from a change from the Lebanon Valley School, where as a third-grader his special-educational needs were not being fully met. Edie, for her part, would welcome the escape from East Chatham, especially in winter. She was eager to support George in this venture, and would be happy to widen their circle of friends, in addition to her hunting ground for jewelry, clothes, household furnishings, and cooking ingredients in a new shopping frontier.

For George, a preliminary visit to Berlin was imperative before he would accept. In March 1967, he met the buoyant and energetic young Peter Nestler, who promised Rickey he would find both a suitable studio and a home for his family. In June the invitation from the DAAD was official, and Rickey agreed to a stay of just six months. "I am looking forward enormously to this withdrawal from the New York scene, which I find very exhausting," wrote George to Joe Hirshhorn. "I [will have] an opportunity to develop new ideas in tranquil surroundings."[8] Having stayed at home on countless occasions when his parents were traveling abroad, Philip was thrilled to be issued his first passport and proudly broadcast the news among his third-grade classmates that he was going to live in Europe.

GEORGE SHIPPED ahead several crates of tools and a few sculptures in pieces, then he, Edie, and Philip made a January crossing on the HMS *Queen Elizabeth* to Southampton and flew to Berlin a few days later. Peter Nestler met the Rickeys at the airport in his Peugeot, delivered them to the Plaza Hotel to drop off their luggage, and then whisked them off to look at apartments. In the suburban outskirts of

West Berlin, in the neighborhood of Dahlem, they found their tempo-
rary home—a furnished, second-floor apartment in an imposing turn-
of-the-century house across from a wooded park on Bernadottestrasse.
The neighborhood was full of American diplomats, military officers,
and others with professional obligations in Berlin. The US Army bus
to the Kennedy International School, which Philip would be attend-
ing, stopped on the corner every weekday morning at eight o'clock,
and the U-Bahn station, with connections to the center of the city, was
a five-minute walk. A block away on Bernadottestrasse, George found
a studio with high ceilings and good light.

"We are installed in one of those old spacious houses in Dahlem,"
wrote George to George Staempfli, "amid a lot of once elegant but
now faded furniture and drapery." By early February he had set up his
studio, adjusting to its limited electrical outlets, lack of running water,
primitive oil stove for heat, and a noisy next-door neighbor. Kenneth
Armitage, a British sculptor also in residence with the DAAD that
year, was helpful in pointing George in the direction of art-supply
stores and machine shops. "It has taken a bit of scurrying around to get
basic tools, tables, acetylene, etc.," he told Staempfli, "but I've learned
my way around Berlin in the process."9 Edie meanwhile would be
learning where to buy food, bed linens, and kitchen equipment.

In his Berlin studio, George looked forward to relieving himself
from directing his staff in the construction of large pieces, and to mov-
ing ahead with some new ideas on his own. Just as he began to feel the
danger of stagnating on the popularity of his blade pieces, at sixty he
would be entering new territory. "I am very anxious to make headway
with my planes, cubes, tetrahedral, etc. so that I am fully operating in
that world as I was formerly with lines," he told Ulfert Wilke.10 He was
particularly interested in the geometry of squares, and of the possibili-
ties of making a moving square out of multiple squares.

For a while, he worked in welcome serenity. But it was not long
before the demand for major new works and loans caught up with
him. Thanks to Pieter Sanders, the new Kröller-Müller Museum of

Outdoor Sculpture, in Holland, invited Rickey to exhibit seven pieces in an exhibition called *The Silence of Movement*. Werner Haftmann, who had been a key adviser to *Documenta* from its inception, had recently been appointed director of Berlin's Neue Nationalgalerie of modern art and was overseeing its striking new glass building by Mies van de Rohe, the architect's last major work. Haftmann commissioned Rickey to make a piece to be placed at the entrance of the museum on a square stone plaza, an offer George could hardly refuse. He was also invited to exhibit in *Documenta IV*, opening in Kassel in June, so there was little time to lose. The committee asked for three new works, for which he would need the help of a young assistant. Thanks to the DAAD network, he found a twenty-seven-year-old graphic arts student from the Hochschule named Alex Markhoff, who had the bench skills George required and also spoke English.

EDIE WOULD meanwhile be resuming her managerial role at her desk in Berlin, with no decrease in its complexities regarding the comings and goings of Rickey sculptures to various venues and back again. "Everything was arranged by Edie," Peter Nestler remembered with wonder, "and she could do five things at the same time: smoke and telephone and cook, play music and make plans."[11] But Edie needed assistants, too. She hired a part-time typist, and it was immediately evident that Alex's girlfriend, Benigna Chilla, also an art student, could be helpful in other ways, such as looking after Philip when she and George were busy in the apartment or traveling throughout Europe on business. Alex and Benigna—helping hands when the Rickeys were in Berlin, holding the fort when they were away—would soon be like family.

As an essential aspect of their role in stimulating the Berlin art community with the artist-in-residence program, Peter Nestler and his wife, Veronika, a pediatrician, entertained constantly in their spacious third-floor apartment on Carmerstrasse. The tireless Veronika would

return home from the children's clinic at five in the afternoon, and by five thirty would be welcoming artists, writers, and musicians, who kept their own hours, "and of course became tired later than we did," Peter recalled with a laugh.[12] The Nestlers' son, Piers, was the same age as Philip, and Edie and Veronika enjoyed an instant rapport. To Dolores Vanetti, Edie described their social life in Berlin as "mild . . . but enough to satisfy."[13]

At first a fish out of water, Edie soon found her element. Her natural flamboyance was well suited to the city's historically edgy atmosphere. As a couple, it was Edie who stood out at a party, physically towering over her husband as the woman behind the man. "You could have overlooked him, he was small," the artist Regina Gecelli recalled, "but she was eye-catching."[14] Edie worked on her German from the ground up, and wherever possible dotted her English with German words and phrases in her upper-crust Pittsburgh drawl. Just about everyone was *mein Liebling*. To natives, she was the object of *belächeln*, or fun, but "not negatively," said Nestler. "She was very, very witty, very quick, very intelligent, so she was very much liked . . . Edie had all of Berlin in her arms."[15] The Rickeys were just the kind of power couple the DAAD program envisioned, mixing easily with both local artistic circles and visiting creative talents from Europe and beyond.

A network of art-world connections spanning the United States and Germany soon emerged in Berlin, ensuring a degree of continuity to the Rickeys' transatlantic life. Tillmann Buddensieg, a German art historian who had taught at Harvard and Stanford and whom they had known as a guest lecturer at the University of California Santa Barbara, had returned to Berlin with his wife, Daphne. Edie and Daphne, a painter and fabric designer, shared a passion for textiles and were soon to develop an intimate friendship. A young art dealer from Brooklyn, Michael Cullen, lived and showed his wares in the same grand turn-of-the-century building on Carmerstrasse in which the Nestlers lived. He had developed important contacts in London

and carved out a niche market in modern prints. The year the Rickeys arrived in Berlin, Cullen had a show of prints and drawings by David Hockney, which put his Galerie Mikro on the map. About five years before, Hockney had spent a weekend in East Chatham with George's former Tulane student Mark Berger. While there, Hockney made a portrait of Edie on the inside of a small, folding matchbook with a fine black pen, shown "with my stringy bangs and my glasses,"[16] which she had treasured. Since then, Hockney had become very well known and much sought after. Seizing the opportunity to raise her own profile as host to the famous artist, Edie promised Cullen that she could persuade Hockney to come to Berlin for his show. She offered him a cocktail party before the opening but he preferred a small breakfast on the following Sunday morning.

Edie was happy to practice her talent for entertaining on a new audience and with new ingredients. She quickly adopted the European habit of going out for food every day, making the rounds of specialty shops with her little net bags. "Marvelous pastries and delicatessen," she reported to Phillip Bruno. "You can get whole truite au bleu in aspic, beautifully decorated, to take home in little plastic containers, wild food (hares, partridge) and of course pork in every form."[17] She invited to dinner their growing social network of friends—the Nestlers, the Buddensiegs, Hann and Renata Trier, and Werner Haftmann with his beautiful Swiss bride, Roswitha. Their adventurous and clever compatriot Michael Cullen was also a regular and favorite guest. Edie was loud, remembered Cullen, "but joyously loud."[18] Charmed by Cullen, George and Edie agreed to support the young man's art gallery with a loan from George's ongoing European earnings.

They kept up with the news of the world, reading the *Paris Tribune* every day and the London papers on Sunday. From the United States there were constant reports of political and racial unrest. The year 1968 was one of the most tumultuous in American history. The Vietnam War was at a crisis point; with the ongoing Tet Offensive

carried out by the North Vietnamese forces, the purpose of America's involvement was in grave doubt. That year saw the height of demonstrations against the war, as college students staged hundreds of marches and sit-ins across the country. In March, President Lyndon Johnson stunned the country when he announced he would not seek reelection. In April, Martin Luther King Jr. was assassinated in Memphis, Tennessee, where he had traveled to support striking sanitation workers, and soon afterward race riots occurred in more than a hundred cities. In June, Robert Kennedy was assassinated after winning the Democratic presidential primary in California. Before the end of the year, Richard Nixon would win the White House.

For the Rickeys, the distance from home felt strange, but it was also liberating. "News from the states is very depressing," Edie wrote to Phillip Bruno, "but being away gives one a kind of perspective. Berlin is actually, psychologically, in a kind of glass bubble—everything is as if seen through the glass and sometimes darkly," and Edie was happy to keep it that way.[19]

That glass bubble also contained world-class art and music. The Dahlem Museum, which at the time housed the Old Masters collection of the state museum, including important works by Rembrandt, Titian, van der Weyden, and Bruegel, as well as pre-Columbian and Oceanic artifacts, was a five-minute walk from the Rickeys' apartment. Musical performances were a frequent diversion at both the Berlin Philharmonic and the opera, where Edie enjoyed the long intervals at least as much as the program—"long enough to get food and drink which everyone does," she told Phillip Bruno, "and I have discovered the perfect combination: a *wurst* (the long delicate ones) which comes on a china plate with a piece of bread and a split of champagne!"[20]

They drove along the Wall one Sunday, and planned to make the crossing some day. But visiting East Berlin was a time-consuming and depressing process, and they had other priorities. Besides, on a daily basis, one was hardly conscious of the division; as Edie commented, "The city seems so untouched."[21]

*　　*　　*

DURING THEIR six months in Berlin, George's nephew Norman de Vall came for a visit. Norman, who had been working as a stevedore at various Pacific ports for several years, was in Europe on a mission: He was intent on acquiring an old two-masted Galease cargo schooner still to be found in Denmark and sailing it with a full load from northern Europe to San Francisco in the spirit of a "Protect Our Waterfront" campaign. George shared Norman's passion for boats and he and Edie were both happy to support his colorful ambition, and they also extended an open invitation to visit them in Berlin. Norman took them up on it, arriving unannounced in early March. Let into the building on Bernadottestrasse by the *Time* magazine journalist Peter Ross Range, who lived downstairs, he surprised them in the middle of dinner, to their cries of joy.

Already having proved himself an able assistant in George's studio, Norman was the Rickeys' favorite nephew. His turbulent childhood, between his mother's suicide when he was eleven years old and his father's psychopathic behavior, gave Norman a great need for a stable family that the Rickeys could provide. George enlisted his help in the studio while Edie doted and flirted with the strapping blond-haired, blue-eyed young sailor, "our darling Norman," who flirted back.

George promptly enlisted Norman's help with ongoing projects. He was planning three ambitious new works for *Documenta IV*. For one of them, he was offered a small room of his own—approximately fifteen feet square with a high ceiling—that called for a total kinetic environment. Artists such as Lucio Fontana, Piero Manzoni, and Lucas Samaras were exploring the expressive possibilities of an enclosed room in a variety of forms in the late 1960s, and immersive art was very much in the air, furthering the idea of the fourth dimension in new ways. The space allotted to Rickey suggested to him a variation on the square planes he had been working with lately, in a tight horizontal pitch. In this new conception, the four squares would be

fitted to hang from the ceiling of his little room, highly polished like a mirror, and activated by a hidden fan above. He designed the walls and floors in alternating black and white. The effect on the viewer entering this enclosed space, with its moving mirrored ceiling, was to disturb one's sense of gravity, like being on a moving ship, or, as the art critic Wieland Schmied described it, "a visible expression of the uncertainty of our standpoint in the world."[22]

Along with the trend for immersive environments, interactive art had begun to infiltrate the European art scene. Adapting, Rickey brought a deliberately interactive component to another piece for *Documenta IV.* This was a new version of his *Space Churn,* a theme he first mined in 1954 but had lately put aside. His new work consisted of seven concentric circles of diminishing size, each one pivoting inside the other with a diamond shape at its center. A crank on the base invited the viewer to set the churn in motion.

In addition to Alex Markhoff and Norman de Vall, Rickey would need the help of local machine-shop fabricators, known in Germany as *schlossers,* for the cutting and fabricating of the *Documenta* pieces, as well as his piece for the Neue Nationalgalerie, *Four Squares in a Square.* Paul Kruger's machine shop in Berlin allowed for its monumental scale as well as any refinements. The piece also required from George a new skill: exact mechanical drawings. Up until then, he had worked "like a tailor who cuts directly out of the cloth."[23] Rickey was impressed with the precision of the schlossers' work and the surprising success of their first collaboration. "I drew it out meticulously," he explained, "certain parts full-size, certain parts to scale . . . I calculated the weight. I calculated how much lead there ought to be. I calculated some of the 'moments' and so on. Then they followed it. And it came out exactly. To their surprise and mine."[24]

NORMAN DE VALL was doubly welcome in Berlin to keep his young cousin company. At twenty-eight, he was considerably older than

Philip and could straddle the generations in often helpful ways. Philip, who bravely marched off to meet the school bus every morning in his lederhosen, book bag slung over his back, was struggling with his schoolwork, especially math, in the international program of the Kennedy School. Norman was sensitive to Philip's struggles, having had some of his own, and disputed George's notion that Philip should simply memorize the multiplication tables, just as he had been made to do as a boy. Norman felt confident enough in his familial status to advocate for Philip. "I became very outspoken about Philip's learning curve and his ability," Norman recalled. "You can only push so far and so hard, and get positive results."[25]

Norman could also provide a convenient solution to the summer-vacation question. George and Edie would be meeting Stuart, then a student at Phillips Academy, in Andover, Massachusetts, and a responsive sightseer, for a tour of Europe, while Norman invited Philip to join him in the dockyards of Aalborg, Denmark, for another kind of adventure. He had bought a cargo schooner in June, and he could use some help fixing it up. With Philip's enthusiastic consent, Alex and Benigna drove him to Denmark in their little Citroën deux chevaux and delivered him to Norman at the docks, where they would also join the work party.

Camping in the foc'sle of a cargo ship in the northern coastal port of Aalborg, Norman enlisted Philip's help on the boat, along with an enthusiastic band of Danish "waterfront waifs" (Edie's phrase), to scrape paint and perform other odd jobs, and in the evenings they worked on the model boat they had begun in Berlin, altering it here and there to more closely resemble Norman's new schooner. In the midst of this, Norman taught Philip some math fundamentals in a hands-on practical style, such as how to divide using a folding tape measure. A few weeks later, they returned to Berlin, with Philip feeling a great deal worldlier than before.

By the time school resumed, Edie had recalibrated the amount of attention her younger son needed every day. "It is now very plain," she

wrote to George on the road, "that from the time [Philip] comes home I have to concentrate absolutely on him and then have no time for anything else." Inconvenient as it was, Edie glowed with the improvement in Philip's schoolwork and in his general attitude: "He is very sweet and good and conscientious about doing his work."[26]

PHILIP HAD spent the second half of his third-grade year at the Kennedy School, so it seemed a good idea to extend their stay in Berlin through his full fourth grade, into the spring of 1969. Adding, if not leading to this decision was the increasing attention George was receiving for his work in Germany and Holland. The Museum Boijmans Van Beuningen, in Rotterdam, planned a one-man show, as did the Kunstverein in Munich. In Berlin, he was invited to exhibit his work at the Haus am Waldsee, in Zehlendorf, with another guest of the DAAD, the abstract painter Piero Dorazio. A young art history student in need of some extra cash, Jörn Merkert, was thrilled to assist George with the installation of the show. Soon Jörn would be assisting Werner Haftmann, director of the Neue Nationalgalerie, where he would be involved in another exciting Rickey installation, *Four Squares in a Square*, to be placed in front of the new Mies van der Rohe museum building. With its base hidden under the pristine stone pavement to ensure a Miesian lack of clutter, Rickey's perfectly pitched four rocking squares was clearly made for the architect's late masterpiece; at the same time, it happened to coincide perfectly with the artist's interests of the moment.

In addition to these commitments, a particular project was constantly on Rickey's mind. He had promised Pieter Sanders that he would complete his design for a fountain in Rotterdam that had by then been under development for five years. Since the project's inception, Rickey had refined his use of shock absorbers and tackled several projects in outdoor spaces, so although he was in new territory in terms of a sculpture with waterworks, he had developed ways to

create elements that could turn freely without touching—essential to his design. Having made various models for the purpose of discussion, he had designed a central tower of basins, standing eighty-two feet off the ground, surrounded by nine movable stainless-steel rectangles. A cascade of water pumped from below would, along with the forces of the wind, animate the rectangular planes.

Pieter Sanders had nursed the final proposal through to a signed contract with the town authorities, with a one-to-ten test model due in January. In his studio in Dahlem, George created a model of the entire piece, experimenting with water circulating from a pump, until he was tentatively confident in its performance. At the end of May he shipped the model to Rotterdam in several pieces, and with the help of the schlosser Kooiman in Dordrecht made it ready for mounting: balancing the planes and adjusting the amount of lead weights inside.

Once at the site, anticipated conflicts with the city's public works promptly emerged. The size of the foundation necessary for the water-works would be difficult to fit without disturbing a tangle of gas and water pipes and electrical systems underground. For the time being, the model would stand in the middle of the Holfplein traffic circle for the rest of the winter, dry and uncovered, while city officials consid-ered its feasibility. Bolstering the case for the fountain, the Museum Boijmans Van Beuningen included a full-scale model of the fountain as part of Rickey's one-man exhibition, with its opening in August that year. Rickey also created a sculpture that consisted of the two top-most rectangles of the fountain design, which attracted very positive reviews. "The Rectangles are apparently a sensation," George wrote to Edie, "right on the street beside the museum. People stop in their cars and get out to walk around and gaze. It is big enough to impress deeply."[27] When the show came down, the *Rectangles* stayed, testing the sculpture's viability through the winter weather, holding Rickey's place in Rotterdam until the following spring.

Back in Berlin, George spent two days grinding the surfaces of his sculpture parts for the Neue Nationalgalerie. "It is quite astonishing,"

George wrote to Ulfert Wilke, "how this little Berlin sojourn, which started so quietly, and with no ambition but to make little pieces in my Dahlem studio, finished with such a bang and involvement in the biggest pieces of my life."[28]

In April, Norman de Vall enlisted Alex Markhoff as one of seven crew on his fifty-six-year-old, one-hundred-ten-foot Danish cargo sailing ship, and they sailed into a freezing rain bound for Edinburgh, their first port of call, with a cargo of Guinness stout, Tuborg, and Drambuie. The Rickeys were there to wave them off. In June 1969, George and Edie packed up all the furnishings they had acquired over the course of eighteen months, George's tools, some finished sculptures, and pieces of others still in the works.

27

Bundesplatz

PERIODICALLY DURING his eighteen-month residency in Berlin, George returned to East Chatham to check up on the progress of various projects in his workshop. In June 1968, he arrived in time to see the lower studio, designed by Doug King, almost finished, the windows in place and electricity and plumbing soon to come. "The studio is turning out very beautifully," George wrote to Edie, of his little Bauhaus workshop in the woods, "and the space is very satisfactory."[1] Outside, moving sculptures encroached on the landscape in every direction, from the lower studio to the upper one and around the house. For his sixty-first birthday, on June 6, George invited about fifty friends, among them Dolores Vanetti and Ulfurt Wilke and various neighbors, for a picnic and cocktails and a stroll around his latest work. Joe and Olga Hirshhorn called on the phone to sing a happy-birthday duet.

The reliable Myrtle Kie was on hand in Edie's absence to cater and housekeep, and George told Edie that she handled it all very well. Myrtle had continued to work part time in their absence, keeping

the house in order. But the year away had also proved the Rickeys' need for full-time administrative assistance in East Chatham. Doris "Dot" Wadsworth, a friend and neighbor with secretarial experience, had expressed interest in part-time work. Thus, for a trial period of six months, George improvised an office upstairs from his now "old" studio in the barn, furnishing Wadsworth with typewriter, adding machine, and file cabinets to take care of routine office work, such as payroll, bills, accounting, and travel.

At around the same time, a middle-aged couple from Scotland, Billy Lamond and his wife, Ella, who had been working as caretakers down the road, were available to fill in the gaps. Billy was generally handy and he knew how to weld. Ella could cook and clean when needed. In the face of the unknown flux and flow of help in the house and workshop, Billy and Ella added a layer of security. Their Scottish background made for a special bond with George that some-what relaxed the rigorous standards he maintained for everyone else on his staff.

Upon their return from Berlin in the summer of 1969, George would be turning his attention to the Far East—a major commission for Japan Expo '70, the first world's fair that country had ever hosted. The theme of the show, "Progress and Harmony for Mankind," called for futuristic architecture spread over eight hundred acres of land near Osaka that until three years earlier were covered with bamboo groves and rice paddies. A museum was built on the site for the display of art, ranging from ancient to contemporary, in themes that aimed to show the differences as well as the harmony between East and West. Rickey was one of fourteen artists, along with Kenneth Snelson, Eduardo Paolozzi, Jean Tinguely and others from around the world, asked to produce sculptures and participate in a symposium funded by the Iron and Steel Federation. He was excited at the prospect and willing to sacrifice a few commissions for Staempfli in order to devote his attention to this special project. Coinciding with the moon landing

in July of that year, he conceived of a large new space churn, for the first time more angular than circular in shape, to be constructed on the spot.

In October, Rickey flew to Osaka on his first visit to Asia. "I have been here a week and very little has been accomplished," he wrote to his accountant Louis Bernstein, "except getting more deeply befogged in the mysterious East. Some of the other artists, who have been here a month, are at their wits end."[2] If George was befogged, he was also determined to outwit the Japanese when it came to the financial arrangements of the commission. Ever attentive to income-tax consequences (audits had become an annual trial every April), he proposed to forgo his salary for installing the piece and instead, after lending it to the Expo, to donate it to the sculpture park, which was likely to become a permanent feature of the fairgrounds, even though he was disheartened by the Expo site. "Most of the buildings are a dreadful kitsch," he wrote to Edie. "It is immensely extensive and yet crowded and jumbled. I have lost a great deal of enthusiasm for the project as a whole." Meanwhile, he had to get on with making a model for his *Space Churn with Squares* before overseeing its construction and installation at the end of November. He hoped Edie could fly over for some sightseeing day trips and then to Hong Kong, though he had to warn her that "Osaka is a seething commercial city completely uninspiring to look at,"[3] and that there would be no opportunities for her to dress up, no social occasions.

In Edie's absence, he had the animated company of fellow exhibitor François Baschet, who with his brother Bernard created experimental musical instruments such as an inflatable guitar and an aluminum piano and, thus equipped, performed "sound art." For George, the presence of Baschet and his entourage in the atelier, adjusting the pitch and timbre of his musical sculptures, brightened his days. Baschet also made an excellent sightseeing companion. The two visited temples and shrines and lunched together almost every day. But as he toiled on with his sculpture for the Iron and Steel Federation,

George found the personnel in Osaka "unbelievably indecisive and uncommunicative," he told Pieter Sanders.[4] The studio was poorly lit, badly equipped, cold, and dirty. Although George had prepared for their shipment six months earlier, the materials for his sculpture were not in place for his arrival, and when they finally appeared, they were the wrong size.

In addition to his anxiety over the construction of his piece, working with unknown fabricators and unfamiliar wind conditions, George was aggrieved not to hear from Edie more often, especially at that distance and with so many projects in the works. In Rotterdam, the arm of his *Two Rectangles* outside the Museum Boijmans had bent under stress, and at the city hall the aldermen were divided about the placement and viability of his fountain in the Hoftplein traffic circle. Pieter Sanders urged him to come over as soon as possible for consultation with the Burgomaster, but George was reluctant to spend more time and energy on the fountain without a firmer commitment from the city. At the same time, he faced another major civic project, another challenge to worry about. In his urban renewal overhaul of the state capitol, Governor Rockefeller had commissioned Rickey to create a sculpture for his massive new Empire State Plaza in Albany.

There were financial anxieties as well. The cost of fabricating his sculptures had risen disproportionately to their sales price, Rickey told Staempfli, which explained why after a bumper year, he seemed to have not made any money. Meanwhile, in Berlin, George had been persuaded to back Michael Cullen's art gallery by lending him the proceeds from his foreign commissions, but Cullen was not complying with the terms of their agreement—to pay him back in increments on a monthly basis, and with interest. George was feeling keenly the lack of communication from Edie on the other side of the globe. "Quite apart from any impulses of sentiment," George told her sternly, "I have to be informed of what is going on in the business, and I mean constantly and immediately . . . so I can determine what action to take, if necessary, from here."[5]

Back in East Chatham, Edie was still catching up with the backlog of business following their return from Europe, simultaneously fielding phone calls from George Staempfli and directing Steve Day in the studio. Dot Wadsworth was busy keeping up her end with typing and filing, and both were doing their best to stay on top of the seven or eight different balls that were then in the air. "I don't think you realize how much picking up there always is to do after you leave," Edie wrote in a letter that crossed his, and she also stressed the difficulty of sourcing his technical files because of the way he took notes, "with figures, speculations, notes, and drawings on the same sheet of paper."[6]

IN SEPTEMBER, with the close of Expo 70, Rickey's *Space Churn* was placed on reserve for what was to become the National Museum of Art, in Osaka, and George and Edie looked ahead to the following winter. Their year in Berlin, along with other factors at home, had altered the shape of their lives. Philip had entered the Eaglebrook School as a boarding student in the fall of 1969, following Stuart, who had graduated and moved on to Andover, leaving George and Edie more or less free to roam during the school year. Having tested the management of the house and the workshop in East Chatham from the distance of Berlin, they both felt a strong urge to make a habit of living somewhere else for several months of the year, for the kind of refreshing change of scene Berlin had been for them. The only question was where.

Amid these musings, at least for the winter ahead, the question was more or less decided for the Rickeys when the DAAD once again invited George to Berlin, this time for a six-month residency beginning in October 1971. They returned to Dahlem and found a house to rent on Miquelstrasse with a small, enclosed garden growing wild and a heated garage with sufficient light for George to set up shop on the spot.

Now George was determined to limit himself to experimental

work on a small scale. He sought "a recovery of lost innocence"[7] that he had hoped for in 1968 but had not achieved. He longed to return to the simplicity and directness of working and discovering with his hands, with no idea where it might lead but with the hope that it would be interesting. He packed a minimum of tools—a hammer, a pair of pliers, a coil of galvanized wire, and an electric hand drill—and within these self-imposed limits, he began to construct little pieces out of wire, hammering one end flat like a paddle to catch the air and twisting the other in a spiral as a counterweight. These delicate little sculptures delighted him, and he worked long hours in peace and solitude.

Inspired by ancient Etruscan jewelry, he also made pieces for Edie—a hair comb, or tiara, that bobbed as she moved, and earrings, single lines kept aloft by a little squiggle of counterweight at each end.

As much as he wanted to keep things simple, George would need to train a new assistant in Berlin, as Alex Markhoff with Benigna Chilla had by then migrated to upstate New York, where they were both teaching. Hann Trier recommended another young art student from the Hochschule, Achim Pahle, who was studying graphic design and photography. The young artist did not consider himself qualified in any of Rickey's three requirements—that he could speak fluent English, drive a car to run errands, and weld; however, the job interested him. He had been deeply impressed with Rickey's *Four Squares*, in front of the Neue Nationalgalerie. At their first meeting, "this gentle bear-like older man," as Pahle recalled, put him to the test. Could he explain how he had made the counterweights at the end of his wire pieces? Though Pahle was unable to answer the question, George was satisfied with the young artist's curiosity and intelligence. The next day Pahle was off to get himself a learner's permit, and the work began. George gave him a helmet and told him to watch him weld, and soon enough handed him the torch and said, "Now you do it."[8]

During their six-month stay in Berlin, in 1971–72, Rickey visited the studio of another guest of the DAAD, the California artist George

Baker. A few years younger than Rickey, Baker was also making wind-propelled kinetic sculptures. In a quiet West Berlin neighborhood, in the large, mainly residential complex called Bundesplatz, Baker's studio, number 17, was a small square basement space with high ceilings and an interior balcony that raised it just above street level. Baker was seeking a larger studio, and invited George to make use of it while he was away.

In his growing relationship with the German art world, Rickey had also encountered some business complications, and the need for legal support. In 1970, he began working with a young lawyer in Berlin, Volker Henckel, to oversee his sculpture contracts in Germany. A sophisticated young man with a light touch, Henckel spoke perfect English and was familiar with American law. His wife, Helga, had worked for the art dealer George Wittenborn in New York, so they were also familiar with the ways of the art world. Almost as soon as they met, the most urgent order of business for George was to retrieve his money from Michael Cullen's bank account and put an end to their agreement. Henckel began with a polite but firm letter to Cullen, demanding repayment of the loan. Getting no response, Henckel felt he had no choice but to stage a raid of his Gallery Mikro shortly before the opening of a Jim Dine show, while Cullen was away in Cologne.

Henckel arrived with a bailiff and a police officer at the gallery on Carmerstrasse, and Peter Nestler was urged to drop in as a witness. Movers carefully removed the entire Jim Dine show from the wall, packed the pictures into a truck, and drove away. Soon afterward, Cullen produced a check for thirty thousand marks, with subsequent payments to come in the form of works of art by Jim Dine and others. George congratulated Volker on his deft work, calling it "a master stroke!" Said Henckel: "It was rather dramatic."[9]

* * *

As MUCH as they had enjoyed Berlin, it was an island in the middle of Soviet-controlled East Germany and thus was not as accessible as other northern European cities George and Edie had come to know. They considered other options for the following year. Rickey's Dutch patrons were as numerous and important as those in Germany. Amsterdam was an attractive alternative, especially as Cola and Bernhard Heiden were spending summers there, and they thought about sharing a long-term lease on a little attic apartment in an old house. Rotterdam was also becoming familiar territory, with the strong support and friendship of Pieter and Ida Sanders in place. The fountain project was ultimately abandoned due to complications between the foundation and the public works underground; to make up for it, Rickey's *Two Rectangles* would be permanently installed on a pedestrian walkway, the Binnenwegplein, in the center of the city.

In the opposite direction, George and Edie considered a winter retreat to Southern California, with its strong clientele for Rickey's work and the couple's many personal ties in Santa Barbara. In 1970, the Santa Barbara Museum of Art, with the curator Ala Story, organized an exhibition of eighty-four works from the Rickeys' collection, art that had been acquired over the course of George's writing on Constructivism. The show, *Constructivist Tendencies*, illustrated his thesis with actual works of art. It would tour to several university museums across the country over the next two years. Thus, California beckoned them in many ways, and the climate certainly added to its appeal in winter, but George equivocated. Amsterdam "could be more interesting, even if not so warm," he told Ulfert Wilke.[10]

Meanwhile, their attachment to Berlin continued to grow. When George was called away on business, Edie found herself alone in the city, and she found that she didn't mind. "It is a very interesting condition!" she told George, and though she felt a need for structure, which her German lessons and swimming dates with Daphne Buddensieg provided to some extent, she also enjoyed the lack of it: "There is also

something rather blissful about being able to sit and read for hours and just fix a bowl of soup for a meal."[11]

She tried to cut back on her drinking, which she knew had become a problem. George enjoyed drinking too, but he never got drunk, and he was often distressed by Edie's behavior under the influence of alcohol. In company, her liberal use of four-letter words and sexual metaphors embarrassed him. When they were alone, she would attack him in ways she would not have dared to do sober, for she knew too well, just as George's first wife did, that her criticisms were not rational enough to stand up to him in an argument. At such outbursts, George would either make light of her grievances, which only served to intensify them, or quietly retreat to another room and wait for the cloud to pass. At the height of his own aggravation, he would sharply bark at her to stop, and she would, instantly, as if wakened from a bad dream. He was convinced that alcohol was her demon, her problem and not his. In 1973, when Edie decided to give up hard liquor, George noticed the difference in her behavior and outlook right away. Her anxiety diminished noticeably, and her sunny temperament shone through the clouds again.

Taking the bad times with the good, George remained positive about their marriage of twenty-five years. "The quarrelsome moments are not our typical moments," he wrote to her. "We really have a lot of very interesting and very good times together and we have a great deal in common."[12]

But as their married life expanded geographically, along with the need to employ others to look after things when they were living abroad, Edie's sense of her role needed bolstering. In East Chatham, Dot Wadsworth was proving to be a very good secretary. And with Stuart and Philip out of the nest, Edie wondered at her diminishing importance to George's cause, other than being a friend, companion, hostess, and keeper of the calendar. She knew George appreciated the personal touch she brought to his relationships with clients and dealers and her steel-trap memory for the minutiae of every part of

the business, and she knew that he liked to bounce ideas off her, "but really it is pretty much as a sounding board . . . since you almost always have already decided what you are going to do . . . if I don't happen to agree, which does sometimes happen, you have to spend time and energy persuading me which you shouldn't have to expend."[13]

Edie had been her husband's generously salaried assistant for several years,[14] and enjoyed her private income to indulge in as she pleased. But she began to question her obligation to work for George, as well as his obligation to employ her. Did he really need her? "I'd rather resign than get fired,"[15] she told him in a particularly charged moment of doubt.

An interesting conversation with the avant-garde composer Morton Feldman, also a guest of DAAD, left a strong impression on Edie. Feldman had posited that artists' wives were happier when their husbands were struggling, and that once they became successful, they lost their sense of purpose. Feldman's own marriage, he believed, had broken up for that reason, and he was applying the same psychology to several artists he knew. This concept struck a chord with Edie. What was her function now, with all the help they had, and with George's work such a success? Her faith in his genius, which had buoyed him through his transition from conventional painter to groundbreaking sculptor, had run its course, and her administrative skills were now shared by others. The success she had worked so hard to build presented an entirely new challenge—to stay relevant. "If I don't do my work, what is the point of me?" she wondered.[16]

Other relationships began to fill the void. She became friendly with Dr. Peter Mietusch and his wife, Janna, who owned a lakeside house in Frohnau, just outside Berlin, and often invited Edie for the weekend when George was away. Through Janna, Edie came to know her brother Martin Grossman, who had recently returned to Berlin from England. Fluent in several languages, Martin made a living as a translator, writing German subtitles for English and American feature films while aspiring to film camerawork.

Darkly handsome and elegantly mustachioed, in his aspirational late thirties—ten years Edie's junior and almost thirty years younger than George—Martin made a charming companion for an evening at the ballet or a movie. He solicited Edie's advice with decorating his new apartment, and she was delighted to lend her eye to the project and her hand to sewing cushion covers. She lent him money for the little domestic things he needed, such as kitchen equipment and tableware. With her youthful, soul-searching male companion, Edie felt young again and all the more aware of George's rigorous self-discipline and constant preoccupation with his work. Martin Grossman was someone to dote on, flirt with, cook for, and confide in. In their decorating schemes, they enjoyed a shared aesthetic, and in their confidences a sense of unrealized creative potential. Martin stroked Edie's ego whereas George often wounded it, by reprimanding her for a mistake or simply neglecting to praise her enough for a job well done. With Martin, she felt confident in ways she never felt with her husband. "Even after twenty-five years," she confessed to George in March 1972, "I'm still rather afraid of you."[17]

She made little gifts to Martin—clothes, books, Champagne, and caviar. In return he was her dashing escort, and flirtatious enough to hint at the vague promise of an illicit love affair to break forth at last in some tropical paradise they might travel to together, as long as she was paying the bill. Before long, she fancied herself in love with him and he with her. To whatever extent Martin felt the same way, he was happy to meet her important friends and to accept her financial support.

As BOTH grew increasingly attached to their Berlin lifestyle, albeit in their separate ways, George and Edie decided to sublet their rented house in Dahlem and return the following year. George would no longer be sponsored by the DAAD, but he saw the advantages of living in Berlin at his own expense. By the time their lease was up on

Miquelstrasse, in the spring of 1973, spending the winter in Berlin had become something of a habit. With the boys away at school—Stuart at the ultra-traditional Andover and Philip at the progressive Buxton School in Williamstown, Massachusetts—there was little reason to stay home. Rather than look for another apartment or house to rent in suburban Dahlem, George proposed that they make do with his new studio at Bundesplatz as their winter residence, at least for the year ahead.

Edie was undaunted by this prospect. Perhaps it reminded her of the early years of their marriage, when they had adapted themselves to myriad little apartments, in cities from Chicago to Bloomington to New Orleans. At least in retrospect, Edie said she was "overjoyed, when, after being married to an artist for twenty-five years, I was finally able to live in his studio!"[18] It would also relieve her of the burden of driving him back and forth from Dahlem to work every day.

"Our Berlin life seems to extend itself without volition," George wrote to Ulfert Wilke. "It is useful to have some kind of pied-à-terre there while it continues. We may find that our search for the ideal spot to spend 3 months in Europe every year will be ended by circumstances rather than by careful selection."[19]

The Bundesplatz studio was filled with crowded work surfaces, bits of metal, tools, and half-made sculptures. The air was damp and smelled of welding, the walls were moist, and a layer of metal dust coated every surface. The grinding noise of electric tools was constant. Edie endeavored to establish the boundaries between work and living space where she could. She hung a curtain around their double bed below the balcony. She organized her mini-kitchen—a bar-size fridge, a very small oven, and a two-burner electric stove—and in another closetlike space her mini-office with typewriter, Dictaphone, and telephone. Thus, as Edie cheerfully told their friend Nan Rosenthal, "it has worked out very well. When I'm typing, the studio sounds are no louder than my machine, and when I'm in the kitchen, they don't bother me anyway—even with both G. and Achim going at it .

. . in fact the whole place is not only cozy but there's lots of space for all that is necessary and since G. spends hours grinding and polishing etc., and I spend hours chopping, cooking etc. it is very pleasant having these activities take place right next to each other just separated by a curtain."[20] American friends were especially amazed at the modesty of their Berlin digs, and the way that George and Edie managed to work so harmoniously side by side.

The studio also had a small garden in the back, where George could test his outdoor sculptures against the elements. Tucked into the inner courtyard of Bundesplatz, once George had laid down his tools for the evening, the couple enjoyed almost country quiet, with nothing but birds and an occasional plane flying overhead.

28

The Walled City

BERLIN WAS "a very strange, surrealistic city," recalled the artist Christo, who in 1976 began to lay the groundwork for his monumental project to wrap the Reichstag. He regarded the physical barrier between East and West Berlin as "almost Kafkian." For many foreign visitors, there was a fascination with the city on the other side of the Wall, with its network of spies and dangerous crossings after dark, which for Christo was also "very, very romantic."[1] Flying over enemy territory to reach Berlin's Templehof Airport in itself reinforced the sense of the walled city as an outpost. Crossing the border by train or car was unpredictable and often unpleasant. Berlin in the 1970s was difficult to get to, far away, and little known. "If Berlin is discovered," said George Rickey, "it is finished."[2]

For him, as he came to know it, Berlin was a rare combination of big metropolis and small town in a way that reminded him of New York in the 1930s, when the little shop around the corner carried everything he needed and where he had painted in a building full of artists at work in their studios, all of them supported by grants

and government programs. Among Berlin's visiting artists, there was a sense of community, collegial support, and a willingness to step away from the rat race of the New York-centric art world and savor a slower pace of life.

Also, much as he did in the 1930s, Rickey found himself in a similar position in his capacity to help other artists. Just as he had been an adviser to the Carnegie Corporation, recommending artists for residencies and teaching positions to Eric Clarke, so Rickey became an informal adviser for the DAAD, as Peter Nestler was always receptive to his ideas. One of the artists Rickey recommended for the program was the sculptor Kenneth Snelson, whom he had met in 1967 when they both were included in *Sculpture of the '60s*, at the Los Angeles County Museum of Art. As Snelson recalled, they felt an affinity right away, in their ways of "putting things together" that "were quite harmonious."[3]

Twenty years younger than Rickey, Snelson was working with a similarly engineer-minded approach to his sculpture in stainless steel. Having started out as a painter, in 1948 he had studied with Josef Albers and Buckminster Fuller at Black Mountain College, which led him to alter his course. Like Rickey, Snelson found his true calling in the study of three-dimensional form and issues such as tension and structural integrity, which Fuller was then exploring for his geodesic dome, and for which he invented the word *tensegrity*. Snelson's towering structures of stainless steel and wire were as intellectually intriguing as were Rickey's slow-moving blades, and with a similar impossible lightness. Like Rickey, Snelson did not consider himself a "technologist"; rather, he was interested in figuring out how to make his sculptures stand up and hold together through trial and error. Rickey regretted not knowing Snelson in time to include him in his Constructivism book, but it was not too late to recommend him for a residency in Berlin. Snelson and his wife, Katherine, and their two-year-old daughter arrived in Berlin in 1973, by which time the Rickeys had established themselves as regulars.

One of the enriching aspects of the DAAD program in Berlin was that artists who might otherwise have found little affinity at home found the time to discover their common ground. Friendships formed around exchanges of information such as finding suitable studio space and where to buy oil paint, which in that compact, sheltered city naturally evolved into social get-togethers. Another guest artist of the DAAD in the early 1970s was Edward Kienholz, the self-taught creator of life-size semi-Surrealist tableaux, which he assembled from cast-off parts and amplified with recorded sound. Darkly humorous and weirdly powerful, Kienholz's assemblages stripped away the genteel facade of American life to reveal its fascinating underbelly. Kienholz had first met George Rickey in 1962, when both were exhibiting in Los Angeles. George showed his delicate balancing acts at Primus-Stuart and Ed premiered at the Ferus Gallery his first room-sized tableau, *Roxys*, a macabre vision of a 1940s Nevada brothel with a cast of grotesque prostitutes posed around a Victorian parlor, a jukebox playing laconically in the background. By the early 1970s, Kienholz had carved out a singular reputation in the United States. He also had a growing number of enthusiastic followers in Europe.

In 1973 Kienholz arrived in Berlin and settled into an apartment not far from the Rickeys, on Meinekestrasse. The year before, he had met and married Nancy Reddin, his third wife, who was also his first artistic collaborator. "George was kind of square," Nancy remembered of her first impression,[4] and old enough to be her father, but she soon appreciated the depth of his knowledge, the openness of his mind, and the patience with which he answered her many questions. In Edie she found a soul mate, and as younger wives of famous artists, though there was a ten-year age difference between them, they bonded right away.

On the surface as well as in background, Ed Kienholz and George Rickey could hardly have had less in common as artists, but on a more profound level they made a perfectly balanced connection, as opposites sometimes attract. George found Ed's tableaux "sometimes quite

deep and poetic,"⁵ whereas Ed, with his working-class background and high school education, marveled at "the fund of information stored in George's head." With characteristic Kienholz imagery, he regarded George as a "living encyclopedia."⁶ Edie provided another kind of information, such as who was who in the Berlin art world, and she regaled Ed and Nancy with stories of their trials and adventures.

Edie's art-world babble would eventually be saved for posterity in a Kienholz tableau. Ed was working on a piece for the Berlin Art Show in 1974, with an idea that he had been brewing for several years. He called it *The Art Show*. The setting was a Los Angeles gallery opening circa 1966 for which he would create figures standing around, looking and talking about art, "speaking all that twaddle that critics write, which doesn't have much meaning and no one really understands or gives a damn about anyway."⁷ The individual voices would project from air-conditioning vents he had recovered from an automobile junkyard in Los Angeles, with tape recorders hidden inside the figures and activated by an on-off button on the floor. He needed about twenty volunteers to be 1960s art gallery–goers, collaborating with one another as to what they would wear and what they would say. Stockholm Museum director Pontus Hultén volunteered, and so did the sculptor Eduardo Paolozzi, who was in Berlin on a DAAD fellowship that year. Edie was thrilled to offer her body and her babble to the cause.

The session called for Edie to strip to her underwear to be lathered with grease and covered in wet plaster from head to toe for several hours, until the plaster dried and hardened and could be removed. Edie opted to strip naked and endure the plaster on her bare breasts, applied by the equally bare-chested Ed. As Nancy recalled, Edie had no self-consciousness whatsoever; she talked and smoked throughout the process, recounting the story of her life until she was finally released from her mold. After two more days for the molds to completely dry, Nancy would brush on a coat of polyurethane, and the figures were ready to be dressed.

The Art Show project was taking so long that the Kienholzes decided to sell their Los Angeles house and divide their time between their home in Hope, Idaho, and Berlin. That art-world babble and New York phoniness that Ed Kienholz was so happy to get away from was exemplified by a visit from Clement Greenberg to Berlin in the early 1970s. On the invitation of Amerika Haus, Greenberg, the most high-profile art critic in America (other than his archrival, Harold Rosenberg), was invited to present a lecture. "Nobody understood him," recalled Michael Cullen,[8] and it was not because of a language barrier. Greenberg's New York–centric art-for-art's-sake colloquy seemed as flat as the picture planes he passionately espoused. Unapologetically pro-American, he told the assembled that New York since 1940 was the center of the art world, that major art could not occur without exposure to New York, and that everything was first seen there, no matter where it came from. He talked down to his Berlin audience, implying they were provincial and out of touch.

Rickey, who had the honor of touring him around the city museums and landmarks and taking him to lunch, found Greenberg inarticulate and evasive, and his knowledge of art history both shallow and shaky. He shot from the hip in his judgments. He confused Picasso with Braque and Bach with Handel. "His audience wondered," Rickey recalled, "how he could be so famous or wield so much power. I suggest that his judgments have been accepted by a still more naïve new culture, new money (but rather rich) group of collector-dealer-curator disciples."[9]

IN THE spring of 1973, Edie funded Martin Grossman's holiday in Tenerife, perhaps hoping for an invitation to join him, which never came. She saw him off to New York from Berlin with a set of silver cufflinks she had engraved with their initials—his and hers—and a key ring with their initials and birthdates and a miniature telephone to remind him to call. She equipped him with introductions to a list

of friends who would entertain him and act as her private bankers in the further funding of his travel and entertainment, should he run low. She trusted him because she wanted to, and felt on sufficiently intimate terms with his family to feel safe with her trust. Her lavish patronage, she hoped, would keep them constantly in touch. But by late March, her efforts to communicate with Martin—by cable, long-distance phone calls, and to friends who could report on his whereabouts—led her to question her investment.

Edie was tempted to justify Martin's neglect as the result of his emotional instability and confusion about his sexual orientation. He offered the classic excuse—"I'm not worthy of your love"[10]—which made her feel worthless. At the same time, Martin was courting a young sound editor, Frederick Schwartz, as well as a lady violinist. On a ski holiday with Philip in Anzère, in a chalet lent to them by Martin's family, Edie poured out her anguish to her confused teenage son, her problems with George and her sexual longing for Martin. Alarmed at his mother's state of despair, fourteen-year-old Philip tried to comfort her, though at his age, he hardly knew how.

To what extent George was aware of Edie's intimacy with Martin is difficult to say. He was not the jealous type, and he knew she needed friends just as much as he needed his solitude. An early advocate of sexual freedom within a marriage, he had quietly tolerated over the years her flirtations with his younger colleagues or assistants, including his own nephew. Several had suffered the awkward experience of Edie making a pass at them. As a teenager, Rose Viggiano had the impression that Edie "just saw these guys in the workshop as meat."[11] Since his marriage to Edie, there is no evidence of George's own infidelity, or even so much as inappropriate flirtation, as much as he enjoyed the company of attractive women. But George would be the first to admit that there was an object of Edie's jealousy, and that was the Muse, whom he often referred to as his mistress. He confessed to "a lifelong affair" with this decidedly female figure,[12] which had left his first wife, and now his second, in the wings.

Back in East Chatham on a midwinter visit in 1974, George was reviewing their bank statements from Berlin and noticed a payment to Martin Grossman for 13,350 marks from several months before, with no deposits in return from him. "I fear Edie may have been taken for a ride," wrote George to Volker Henckel;[13] he set to rummaging through Edie's files in search of further enlightenment of her private schemes. Face to face with Edie's latest obsession, which seemed this time to be more than a passing fancy, he was alarmed to learn the extent to which she had invested—both emotionally and materially—in the relationship.

Henckel knew all about the loan, as Edie had asked for his help with a contract, promising she would let George know. Skeptical of the arrangement from the start, Henckel warned her of a repeat of the unfortunate Michael Cullen affair, but she would not be deterred, and she did not let George know. In addition to the loan from one of their several Berlin bank accounts, George discovered payments of more than forty-eight hundred dollars from an American bank account, which altogether added up to almost ten thousand dollars. George also came across a stash of Edie's letters to Martin, which for some reason she kept copies of. "You are, by all odds, the most selfish, self-centered, neurotic, immature, self-indulgent, careless, thoughtless, inconsiderate, cavalier person I have ever had the misfortune to meet," she wrote to Martin in an undated letter. "Forget the 'rapport'—the LOVE—purely one-sided as I now see it." She assured him there would be no more "hand-outs." As she told him frankly, "I have 'invested' in you far more than any sane person would."[14] Finally admitting defeat, Edie turned to Henckel for legal recourse.

For George, although it was a relief to know that Edie's love affair with Martin had run its course, it was unsettling to confront on paper her passion for another man. Her love for Martin was apparently not reciprocated and never sexually consummated, but it represented a betrayal nonetheless. George was learning something more than about the lovestruck basis for Edie's lending spree. He was learning of

her need for independence from him, and for a new sense of purpose. Along with her letters to Martin, he found her letters directed at him, George, but never delivered, showing her intense frustration, her fury at his cool head, his tendency to reason, to instruct, and to scold.

Alone in East Chatham with hardly a word from Edie in three weeks, George reflected on their marriage with his usual temporizing, but with perhaps tougher questioning than ever before. He added up the pluses and minuses of their married life, he weighed the pros and cons of their staying together or splitting apart. As rational as a system for designing a kinetic sculpture, such as locating the point of balance with an aim to stimulate the "recurrent dramatic crises which occur in all engines,"[15] he analyzed the state of their marriage. Just as tinkering with twisted wire and balancing pins helped him to think, so did putting pen to paper.

"Whatever E's professions of *love* her hostility to me is deep," he wrote as he reflected, "shown by her sudden and violent and inexplicably triggered attacks when she's caught off-guard or has had some alcohol." She had devoted herself to his art, but in George's estimation she had not, in all those years, identified with his "artistic purposes, struggle for meaning, clarity and unadorned truth." He could not help thinking that his "aesthetic lies outside her taste."[16] Over the years, like many couples, their sensibilities had diverged as they became more themselves. Her sexual appetite had grown while for him its importance had diminished in relation to his sculpture. Still he expressed an eagerness to please and bemoaned her reluctance to express herself, but she may have felt a lack of warmth in this assignment, and his emphasis on "timing" was too much like calculating the movement of a new work of sculpture. In her dalliances with younger men, the novelty and excitement was all Edie needed to be aroused, whereas sex with George had become a job, a fulfillment of the contract. She preferred to lavish her words of love on a man who would never give back, and hang on, as if to a life raft.

George didn't want to lose Edie, but he did want to test her

with the option of leaving him, suspecting that she "lacks the courage, decisiveness, and forethought to declare herself and do it." As George perceived it, Edie's opportunity lay in the next five years as she approached the age of fifty, while there was still the possibility for her to remarry. It was time for her to choose "either to go her own way or come to terms with her half-life with me."[17]

29

Open Rectangles

"How do George and Edie fit together?" their friend the curator Jörn Merkert often wondered. "They are so different—nearly opposite in their temperament and mood and their education and understanding of life—so what sticks them together?" Edie would say, "Oh Jörn, you know I am a butterfly! But George is my anchor."[1] Jörn could see that George loved that butterfly in Edie and the butterfly nature that alights here and there, feeding on flowers and fluttering on, in a way that was missing from his own highly logical and deliberate tendencies. She was like a mirror image of him, thought Jörn, but a distorted one as in an amusement park: a *Verzerrungsspiegel*.

George offered Edie a lot of freedom to fly around. He also provided protection, and the financial security to indulge in her many acquisitive passions as well as her frequent bursts of extravagant generosity. In the mid-1970s, George and Edie were as wedded as ever in their day-to-day lives and common history, but farther apart in the tug and pull of their differing natures and pursuits.

Whether or not George confronted her with the choice of leaving him, Edie opted to stay in what he called "her half life with me," with her unpredictable emotional uprisings part of the bargain for the entire family. As Philip recalled, his mother was prone to stormy announcements such as that she was leaving for Baja California, never to return, driving off in her car and coming back with a bag of groceries an hour later. He remembered a particularly grisly fight in Rotterdam, which he feared had put them on the brink of divorce. But when the fights were over, the truce grew stronger, like a re-welding at the joint. Resigned to their differences, they carried on as an imperfect but sturdy pair. On and off, Edie would attempt to cut back on her drinking. When she limited herself to wine, it seemed to George that she nagged him less. George assured Ulfert Wilke that "[Edie] has settled quite contentedly for this life."[2] He had given her permission to leave and she had chosen to stay. Yet he regretted that they were no longer in a growing or "mating" relationship. It was more one of companionship, of individuals who have adapted to living and working side by side while going privately in their minds their separate ways.

For some time, George had been struggling to create a sculpture with a new form of circular motion—not just to spin in place on a pin as in the space churns, but for the movement itself to draw a circle in the air. In Berlin, during the winter of 1974, with Achim Pahle's assistance, he began experimenting with a single circle of wire, essentially a drawing of the movement in space. By setting his element at a forty-five-degree axis rather than the usual ninety degrees, he forced it to move in a conical loop, away from the center. With the development of conical motion, he would create not only a new visual complexity but also a new level of psychological tension to his work.

"We are conditioned from infancy to observe, follow, and interpret movement through a plane," wrote Rickey, "such as a falling stone, a thrown ball, the rotation of a wheel where the axis is 90 degrees to the plane of the wheel."[3] Departures from planar movement are

disturbing. Explaining this phenomenon, Rickey likened it to a joy ride at a carnival or a boat rolling and pitching in the waves—tantalizing, dizzying, unexpected, and dangerous.

For his new invention, he devised a new shape: two open rectangles. With their movement activated, the elements would swing away from each other, from a vertical to a horizontal position, passing each other by a hair's breadth before returning to the vertical, side by side. In motion the rectangles do not quite touch, though they almost do, leaving the viewer in suspense. "Like people," Rickey once said of his signature blade sculptures, "two are more interesting than one."[4]

If his work can be interpreted as a metaphoric expression of his personal life, this new development is worth considering in light of the state of his marriage in the mid-1970s. Though he himself may not have consciously seen it that way, it is difficult to ignore the correlations between the technical breakthroughs at that time and the new challenges of his life at home, as if he had been asked to describe them in cool, geometric form. When the wind picks up, the elements swing in opposite ways; when it dies down, they line up together again in repose.

Rickey introduced a special term for the movement of these new pieces—"excentric," not to be confused with a related and more common word, *eccentric*, but that which means geometrically off-center. From his first experiments with excentric movement in wire, he progressed from open rectangles to blades and from blades to square planes. With each new shape and each additional element, the movement brought on a fresh element of surprise. "New ideas have come to me in the last year which excite me and demand development," he told Ulfert Wilke. "I am glad this can still happen."[5]

SINCE HIS first involvement with Rickey in the installation of his show at Haus am Waldsee in 1969, Jörn Merkert had become the assistant curator to Werner Haftmann at the Neue Nationalgalerie. In 1973 he

was involved in the planning of a Rickey show that the gallery would share with the equally prestigious Kestner-Gesellschaft, in Hanover. Jörn and Edie made a highly compatible pair of coworkers on this project, chain-smoking in Jörn's little office as they pored over checklists and shipping plans. Jörn was also the host of some memorable parties in those days. He lived in a kind of commune of like-minded, creative young men in a big apartment on Fasanenstrasse, in a shabby part of town. All young and poor, Jörn and his flatmates enjoyed gathering friends to their Ping-Pong table for a pot of lentil soup. When there was need for a tablecloth, François Baschet, the artist George had befriended in Osaka, crafted one out of the pages of a porn magazine. He also made an inflatable guitar, and played it.

Edie added her own variety of entertainment to such an evening. Her favorite party trick was to unclasp the hairpin that held her long black tresses in a bun at the back of her head and flip them in front of her face like a curtain. Then, like a figure in a circus sideshow, she would part the curtain, put a cigarette in her mouth, light it, and exhale a big gray cloud of smoke through her hair. She also sang popular love songs from American musicals, and she danced an imitation of the high-kicking Tiller Girls. Jörn, a cultural omnivore, brought out the camp in Edie. "The whole point of camp is to de-throne the serious," wrote Susan Sontag,[6] who more or less defined the term in her "Notes on 'Camp.'" There was an aspect of self-deprecation in Edie's acts. Like a clown, she epitomized the camp attitude—according to Sontag, a victory of style over content, aesthetics over morality, irony over tragedy. One day at the gallery, as he was preparing to receive an important visit from Joseph Beuys, Jörn got a call from the desk that Edie and Naum Gabo's daughter, Nina, had dropped in to see him, and they would not be turned away. He encountered them dressed up like cowgirls, in high-heeled boots and fringed leather jackets. Edie had little pistols hanging from her ears. Jörn loved Constructivism, but he also loved Dada.

When Jörn moved from Fasanenstrasse to an apartment on the

Hildegardstrasse, not far from the Rickeys at Bundesplatz, Edie would call him up and say, "Why don't you come over for a little *Abenbrot?*" which meant a little bread and cheese and a simple bottle of wine. Jörn became a regular at the Rickeys' many informal gatherings in the studio. At the end of the day, Edie rose from her mini-office and laid a pretty table, and George put down his tools. As Jörn recalled, "The pace of everyday hurly-burly existence suddenly stands still in a mysterious way; perhaps because here work, private and social life are indissolubly woven together in a way almost reminiscent of the middle ages."[7] He marveled that Edie always had stories to tell, at how she stirred the pot while talking on the phone, at how George listened so well and had so many questions. There was hardly anything that didn't interest him. His book on Constructivism was, for Jörn, "a Bible."

Jörn had a fund of ideas for an outing—a picnic on the Pfaueninsel, a wooded island in the river Havel, with fountains and strutting peacocks, or a drink at sunset in the baroque palace gardens at Charlottenburg. He accompanied Edie for her favorite pastime, browsing antique stores and flea markets. In Berlin she became fascinated by a uniquely European artifact: the tailor's measuring stick, dating back to the 1600s, known in German as an *Ell*. From simple to elaborately detailed, *Ellen* were beautifully turned and often veneered, demonstrating the high standard of craftsmanship of their tailor. It is likely that Edie's instinct to collect a particular tool in depth was spurred on by Daphne Buddensieg, who collected several categories of kitchen utensils, such as tea strainers and cheese graters, far beyond their practical use. Edie would eventually assemble a collection of more than a hundred *Ellen*.

Although Edie appeared to enjoy wearing her husband's genius on her head—literally—George wondered if those fluttering hairpieces and quivering earrings actually weighed upon her and robbed her of her own sense of identity. Unlike George, she loved lavish and intricate

displays of skill, as demonstrated by her new passion for miniature mosaic jewelry. She was drawn to dramatic gestures and forms, like the voluptuous pleated evening clothes of Issey Miyake and the bold colors of Kenzo. George's hard edges and monochrome steel blades lacked the extravagance and intricacy she craved. She was attracted to their elegance, but less to their quiet, philosophical evocations.

As if to counter the simplicity and stark minimalism of his little wire adornments, Edie began to design and commission her own pieces of jewelry, to her own taste. Achim Pahle introduced her to his brother-in-law, Peter Fidel, a jeweler with the skills necessary to fulfill her wildest dreams. She invited Fidel to make a little railroad of rings across her fingers on both hands. She also commissioned a wire cage and circus stools for her "bestiary" of rings made by the New York jeweler Boris LeBeau—a monkey, a snake, a bear, an elephant, and a frog prince. Fidel created a silver head of a mink as a clasp for her mink collar, or *flohpelz*, and a series of ocean images: a belt buckle in the form of a wave and a brooch in the shape of a fish. At one point, short of funds, she traded a Rickey sculpture worth fifty thousand dollars for the jewelry she commissioned from Boris Le Beau.

LIKE THE Rickeys, Ed and Nancy Kienholz took to Berlin in just the way Peter Nestler and the DAAD had hoped they would. Far from the fickle and "phony" art world of New York, they could practice their art in peace and with an enthusiastic and sophisticated following. "Berlin is a city full of questions, not answers," said Peter Nestler,[8] and the artists who enjoyed living there thrived on that uncertainty. For Ed and Nancy, there was the fascination of the recent past to rummage through as a way of orienting themselves to a culture and its history. In the Berlin flea markets they scouted around for all kinds of industrial and domestic cast offs—a chocolate mold, a washboard, bits of machinery, and symbols of industry such as the Mercedes-Benz star

emblem. Ed, a gruff and imposing figure, drove a tough bargain over the smallest thing, while Nancy often snuck the vendor some extra cash on their way out.

Drawn to uniquely German artifacts, Ed and Nancy landed a cache of old Bakelite radios, known as *Volksempfangers*, once used for Nazi propaganda. How to incorporate this relic of German history into a Kienholz tableau became their latest obsession. An idea began to crystalize in February 1976, when George and Edie persuaded Ed and Nancy to join them at the Berlin Opera for Wagner's *Ring Cycle*, which meant a commitment to the series of performances over the course of four weeks. Ed, who had never been to an opera, was at first skeptical but soon fell under Wagner's spell. Nothing could have been more German and, to his eyes, more surreal. The grotesqueness of fat old ladies playing sexy young women was to him like his *Roxys* brothel with a Romantic German accent. He was soon to incorporate Wagner's music in a series of new tableaux. In *The Kitchen Table*, two radios grimly faced each other on the surface of a cast-bronze table, wired with recorded fragments from Wagner's *Ring* that played when the viewer pressed a pedal on the floor.

As the Rickeys were spending part of the year in Berlin, there were ongoing projects on both sides of the Atlantic, with sculptures started in Berlin later finished in East Chatham and sculptures begun in East Chatham finished in Berlin. George was adapting to working in two studios and coordinating the work of two sets of assistants. While Achim Pahle would be helping George with a large sculpture in Berlin, Steve Day, back in East Chatham, would be organizing the ball bearings for the piece and then sending them over by airfreight for the installation in Germany. In a similar way, American friends visited the Rickeys in Berlin and German friends visited them in East Chatham, making for a unique bicultural community of their own creation.

George and Edie were becoming accustomed to their transatlantic commute; they were leading a double life.

When George and Edie were in East Chatham, Achim and his wife, the artist Margarete Fidel, used the studio on Bundesplatz. They took care of the mail and the rent, kept the place clean and looked after, and, when the Rickeys were expected back in town, stocked the fridge and pantry with food and picked them up at the airport. When George left Berlin in May, he would give Achim a to-do list, but with a lot of flexibility. East Chatham had a different atmosphere. "It was more of a factory," observed Pahle, who had spent time there too; "Berlin was a lab." Achim felt fortunate to be present for many of George's initial experiments with the germ of an idea, the endless trial and error, and the miraculous times when "certain days it just works."9

AT THE close of *Constructivist Tendencies*, which had been initiated by the Santa Barbara Museum in 1970, having traveled to several venues from coast to coast, George and Edie decided to donate the entire exhibition to the Neuberger Museum of Art, at the State University of New York Purchase, its last stop. The Purchase campus was Governor Nelson Rockefeller's flagship for the arts. In 1969, he had attracted the important collection of Roy Neuberger as a promised gift that would form the foundation of the museum's collection of modern and contemporary art.

By the time their Constructivist art collection had ended its tour, George and Edie had filled their walls with other works of art, many, such as German Expressionist works, dating back to the early years of their marriage. Still, they would be sad to say goodbye to the accumulations over the many years of writing The Book, each piece with a story of its own. Edie had been reluctant at first to make the gift. But with a typical sense of fun and creativity, she figured out a way to make up for it.

The artist Richard Pettibone, who specialized in miniature reproductions of modern art, had recently moved from Los Angeles to upstate New York, not far from the Rickeys. In the tradition of the collectors of the Renaissance, George and Edie commissioned Pettibone to create miniature reproductions of many of the pieces in *Constructivist Tendencies*. At the Neuberger, Pettibone viewed the collection with Edie as guide while his wife, Nancy, made careful photographs. When the box of miniatures arrived in East Chatham, Edie framed the pieces and hung them in the guest room, which she christened the "Pettibone Parlour."

In many ways, the era was made for a sculptor of Rickey's distinct gifts. Public art and corporate art were rising trends in the contemporary art scene. Increasingly in the 1970s, his work was in demand for large urban public spaces, banks, and government buildings. His *Two Lines Oblique* enhanced the Empire State Plaza in Albany, with its delicate moving spires towering over the reflecting pool. He thought the sculpture was somewhat engulfed by the buildings, but altogether held its own. *Twelve Triangles Hanging* animated the atrium of City Hall in Fort Worth, Texas. In January 1975, Rickey flew to Hawaii to discuss a sculpture commission for the Federal Courthouse in Honolulu, carrying in his suitcase a maquette for *Two Open Rectangles Excentric*, which he would subsequently produce full scale.

But there were also quieter, more contemplative sites for his moving sculptures. From Japan, a commission came from the Open Air Museum, on the island of Hakone, where in 1976 he installed *Two Lines Vertical*. And earlier, in 1974, the small city of Munster, Germany, commissioned a public sculpture in a small park setting, where *Three Squares Gyratory II* was installed. Although the local population had a difficult time warming to its steely presence, Rickey's work paved the way for several even more challenging works in the city, by avant-garde sculptors such as Carl Andre, Richard Serra, Richard Long, and Joseph Beuys.

As the demand for his sculpture in public places grew, Rickey

looked back on an earlier era of public art in which he had also played a part, and so had many of his friends. Philip Evergood died in March 1973, by which time his paintings were out of fashion and his name less well known than it was at the peak of his powers. In September of that year, Rickey revisited Kalamazoo to see for the first time Evergood's 1940 mural, *The Bridge of Life*, at Kalamazoo College. He was impressed with its scale, and that some of the figures were life-size. "It is absolutely characteristic Phil," he reported to Ulfert Wilke, "with fairytale-like allusions to workers and real fantasy with children and flowers—truly lyrical."[10] But he was also discouraged to see that thirty years later, the college did not seem to appreciate its treasure. The painting was dirty, and the view was obscured by subsequent reconfigurations of the building. If the college would only show an interest in the mural's history and its ongoing care, Rickey was sure that Evergood's reputation would endure and that the mural would prove significant. He may have also wondered about the fate of his own murals of the 1930s, though at that point, they seemed to have little to do with the sculptor George Rickey had become.

30 ●

Retrospective

SINCE LATE 1969, Rickey had been corresponding with Harry Abrams about a monograph of his work. Abrams had created a special niche in the way of high-quality art books in a rising postwar art market, and the Rickey monograph would be part of the publisher's series on major contemporary artists. To editor Paul Anbinder's initial inquiry, Rickey responded that he would be happy to hear "what kind of book you have in mind."[1] After a first meeting, he was reassured to learn that he would be taking an active part in every aspect of the design, photography, and text, and, as it turned out, some fund-raising too. The book would be several years in the making.

Rickey recommended the art critic Nan Rosenthal to write the scholarly text. As a historian of modern art with a dissertation on Yves Klein, Rosenthal was well qualified for the task at hand. Moreover, as the former wife of Otto Piene, she was a family friend, and one particularly familiar with the context of George's development in the kinetic field. Edie, in the meantime, gathered photographs of George's work,

from his earliest indoor experiments of the 1950s to his latest monumental works of public sculpture.

The editors also called for informal photographs of the artist at work and at home. The photographer Carl Howard had already made an extensive photo-essay of George in the mid-1960s, but the monograph also called for an official portrait photograph. During the Christmas season of 1973, the celebrity portrait photographer Arnold Newman arrived in East Chatham to capture George in his studio, as well as for the delicate assignment of a group family portrait. Stuart, then a junior at the University of California Santa Barbara majoring in film studies, asked Newman if he could shadow him as he worked. With his own Nikon F, he trailed Newman, with his battery of cameras of various formats, fascinated by his process and the way he assembled the family around the dining room table for one session and in the library for another. Stuart and Philip take up their posts at the left and right with the laconic resignation of young adults. George, rumpled and informal, is in the seat of command in the middle; Edie towers over them all, the top of the pyramid.

To help raise the funds for the lavish publication—about ten thousand dollars—George was pressed into service creating limited editions of his work: first, a two-color lithograph for a deluxe edition of the book and, later, a work of sculpture for early subscribers. He came up with an idea for a weather vane, a bar of stainless steel with moving ridges like the back of a porcupine, flipping to and fro with the breezes. While the Rickey workshop was making multiple weather vanes in the summer of 1975, Rosenthal, by then a professor at the University of California Santa Cruz, developed her text. George guided her through the complicated language and theory of his many technical and artistic developments over the years in exhaustive detail, and in a way that would set the standard for all future essays about his work. When the handsome, almost one-foot-square, four-pound doorstop of a book was finally published, in 1977, with tipped-in color plates and

silver-embossed linen binding, it was perfectly timed to coincide with George's seventieth birthday.

That same year, in a major historical survey at the Whitney Museum of American Art, 200 *Years of American Sculpture*, Rickey was hailed as "the major spokesman for kinetic art."[2] It is unfortunate that Edie's father, James Leighton, had died the year before, in August 1976, having married a second time after Wilma died in 1964. Thus neither of Edie's skeptical parents lived to see just how famous her artist husband had become.

Months ahead of time, Edie was also planning an elaborate surprise birthday party in Berlin. In collaboration with Werner Haftmann, the party would be staged at the Neue Nationalgalerie in October. With George's thirty-foot-high *Four Squares in a Square* animating the plaza in front of the museum building, it was a fitting site for the celebration. Edie commissioned a young American composer, Maurice Weddington, to write a piece of music for the occasion.

George and Edie had first met Weddington, an African American from Chicago, as fellow guests of the DAAD. Weddington had since settled more or less permanently in Berlin in an apartment not far from the Rickeys, and a neighborly friendship ensued. A woodwind musician, Weddington felt an instinctive musical affinity with George's wind-driven sculpture, and he was more than delighted to take up the challenge of creating a piece of music for George's landmark birthday. The result was a modern composition for woodwinds, with sixteen players in four sections of four. In a reference to Rickey's *Four Squares*, Weddington called it "Four-ever Present." As with a Rickey sculpture, Weddington conceived of the piece to be seen, and in this case heard, from all angles, and arranged the musicians to surround the audience on four sides, with two conductors standing back to back.

At seven thirty in the evening, three hundred guests arrived in the large square space and sat on the floor. Haftmann made a moving tribute—to George for his creative achievement and to Edie for her part in enlivening the artistic community of Berlin over the past several

years. Weddington's music then enveloped the crowd with subdued lyricism, with flutes, clarinets, and oboes performing a gentle tone poem as unpredictable as the slowly rocking squares of stainless steel outside.

As HIS market expanded in Europe in the 1970s, Rickey's relations with the Staempfli Gallery began to fray. With his new status as an international artist in great demand, Rickey quibbled with both the terms and the conditions of his contract with Staempfli. To begin with, it came down to a question of scale. By that time building his reputation primarily on his outdoor sculptures, Rickey had outgrown the confines of Staempfli's Upper East Side gallery. But space was not the only issue that George Rickey had with George Staempfli. A contentious discussion over the commission rate and the extent to which Rickey was responsible for the sale of his own work was ongoing. Staempfli was growing impatient with the nitpicking. "If we have to devise a system where we have to compute your 'tangible salesmanship' by multiplying the minutes you were face to face with the client, with the ounces of liquor consumed, then divide this with the mileage driven to your studio and the number of months we have been corresponding with the client previously," he wrote to Rickey in 1970, "we will soon stop speaking to each other."[3]

Rickey was insulted by Staempfli's condescending tone, and responded with an equally condescending "Come, come . . . you are really much nicer than that," and a proposal to clearly delineate what Staempfli sold in the gallery from what Rickey sold directly from the workshop, for which he would not owe Staempfli a commission at all. If clients had come at the direction of Staempfli, he could take ten percent; sales from the premises of the gallery would earn the usual one-third. Rickey also proposed calculating the commission after deducting the cost of making the piece. "For a painter," he argued, "a relatively low proportion goes into his production cost; for a sculptor,

it can be very high."⁴ He reminded Staempfli, too, of the extra services he provided in the way of installing a sculpture for a client, and then his promise to maintain it in good working order. As many times as their contract was revised and rewritten, the relationship between the two Georges remained touchy and disputatious, and Phillip Bruno, the man in the middle as codirector of the gallery, sometimes found himself the unhappy scapegoat of their disagreements.

Over the years, Rickey had also been concerned about the pace of sales, which when brisk added unwanted pressure to his workload and staff, not to mention his creative process. He suspected the dealer's greed in his constant pressure for new work while his own net profit— after the dealer's commission, the cost of construction, and taxes— seemed pitiful in light of his prodigious efforts. He was eager to keep some sculptures in reserve, both for his family and for his old age. On the other hand, he could be impatient with Staempfli when sales were slow in New York, as they were in the 1970s, with rising inflation and a sputtering economy due to the global energy crisis. "George, let's face it," he wrote impatiently to Staempfli on July 16, 1975, "I don't really need a New York gallery. The fifteen month drought when you sold nothing and I sold in the six figures elsewhere confirmed this."⁵

In May 1975, Rickey showed small indoor pieces at the gallery, while at the same time he showed fifteen outdoor sculptures on the plaza of Fordham University's Lincoln Center campus. Rickey covered the expenses of the Fordham installation, including a night watch-man, to ensure the safety of his sculptures amid the alarming rise of crack and heroin addiction in New York, and with it, street violence and vandalism. Staempfli would handle sales of the outdoor work for only twenty percent. That year, Rickey strove to simplify the agree-ment with Staempfli even more. He proposed that Staempfli handle sales of small indoor sculptures in his gallery and that Rickey would handle all outdoor pieces and commissions, which he had been more or less doing anyway. Then he proposed to take "a Sabbatical" from

the gallery until at least 1977. He was tired of the effort of mounting exhibitions, not just in New York, but in Europe too.

Rickey was not a man prone to empty threats, and he had meant it when he told Staempfli that he no longer needed a New York gallery. The workshop in East Chatham and its surrounding landscape were as good a setting as any other to show his work to its best advantage to clients and collectors. And with the artist on hand to talk person-ally about his work and his wife to host the prospective clients over a leisurely lunch, a visit to the Rickey studio was "a one-two punch," Philip Rickey remembered.[6] Edie would cook a great lunch with a liberal flow of George's home-pressed hard cider and "they would buy two sculptures instead of one." Stuart described his parents in their seasoned roles as "a tag-team."[7]

THE WINDING down of Rickey's relationship with Staempfli coincided with a restructuring of personnel in East Chatham and the hiring of new staff. To begin with, ever since Steve Day's departure to teach at Skidmore College, George needed a skilled assistant to handle the gamut of construction details. Dennis Connors, a Vietnam veteran who held a master of fine arts degree in sculpture from SUNY New Paltz, had already assisted with the installation at Lincoln Center, and later in the fabrication and installation of *Two Open Rectangles*, in 1976, by which time George was calling him "my right hand." Hiring Connors on a regular weekly schedule, he started his salary at three dollars and fifty cents an hour, with additional gas money for his com-mute from New Paltz.

Just as he needed Dennis in the workshop, George needed a full-time professional administrator in the office. Dot Wadsworth had retired, and though Edie was still active when in residence, she was equally needed as cook and hostess for the increasing numbers of houseguests and day-trippers who came to view George's work.

Birgit Mieschonz, a trilingual Dane, had come to the United States from London, where she had worked in the Danish Embassy, to take a job at the Danish consulate. With her American husband, David Mieschonz, and their daughter, Maria, she had subsequently moved upstate, where she and David were both employed by George's Scottish cousin Donald Macdonald, who had moved to the States some years before to take over his father's thriving international business in sheepskin coats, called Antartex.

As Donald was winding down the business in the late 1970s, George asked him if Birgit was available for hire, for he had immediately warmed to the bright young European with her perfect English. Her command of German was also a great asset, for there was quite a lot of business correspondence with Germany in those days. Although Birgit had no background in art, she was intrigued by George's work and the internationality of his operation, and felt an immediate compatibility with the man himself.

Birgit started work on the ground floor of the workshop, but George soon moved her to a small square cube up a flight of iron steps on the second floor. Her job was mainly administrative, but it also demanded an intimate knowledge of the sculptures. When clients came calling, Birgit had to be ready to take them around and speak intelligently about the work. "This was the most difficult part to learn," she said,[8] with the sculptures' highly technical titles, like an inventory of forms and movements, and George was a stickler for accuracy.

Another hurdle was getting to know the boss's wife. Birgit vividly recalled her first impression of Edie at her desk in the front office at the house, "her long legs wrapped around each other like snakes, smoking a cigarette, talking on the phone. She loved the phone!"[9] Worried at first about losing her relevance to the attractive and capable young Dane, Edie kept a cool distance. But within a few months, Birgit's no-nonsense style, her industriousness, and her warmth won Edie over, and she realized that Birgit was an asset to her too, and that their roles were sufficiently different. Birgit's correspondence was strictly

business and business-style; Edie was the social secretary, adding her chatty, personal style to the voluminous Rickey correspondence with a flurry of family news and gossip, shopping tips, and favorite recipes.

PHYSICALLY, THE Rickey estate was growing in every direction. George had become chronically acquisitive. He sometimes bemoaned the increasing complexity of his life and longed for earlier, simpler times, but whenever a house or barn came up for sale along Route 34, he would buy it. He acquired these buildings as rental properties for investment and income, storage space for his sculptures, and guest housing, in no particular order. As his estate grew to more than two hundred acres and fourteen buildings altogether, the space to display his sculptures also expanded.

The extensive grounds in East Chatham made a natural setting for George's outdoor work and an arresting sight for anyone driving the quiet Route 34. He also set up special places for smaller, indoor pieces not built to withstand the elements. One such venue was a small barn up the road that he converted into a lofty gallery. Another was the front room in the house, where he and Edie exhibited their treasures from travels far and near—Peruvian textiles, oriental rugs, and Shaker furniture—along with small kinetic pieces by George. With his abiding interest in material culture, George also hung his collection of antique Shaker tools in the front hall and entertained visitors by challenging them to identify their uses.

To add variety and drama to his outdoor installations, George hired his neighbor, Reggie Sherman, to thin the woods, and where there was a wet spot, to dig a pond. He placed sculptures here and there on lawns and meadows, hung them from wires strung between trees, and stationed some over small bodies of water. As if to make up for the failure of the Rotterdam fountain project, he conceived of a sculpture that used water as a shock absorber. This was a set of three stainless-steel rhombus shapes planted directly in the ground, with

elements acting as paddles installed in a narrow tank full of water underground. The paddles served as breaks when the wind blew the rhombuses to and fro. As he would have known from his childhood at sea, light winds allowed free movement of the paddles, while high winds increased their resistance. He also created a lake at the top of the hill behind the house for recreational swimming and boating and stocked it with trout and bass for fishing. In 1974 he bought an additional eight acres connecting the lake to Route 9 to the west, as a gift to Stuart on his twenty-first birthday.

George gave Edie a special project of her own. This was a run-down 1825 wood-frame house, two and a half miles up Hand Hollow Road on Route 5, with a spectacular view twenty miles to the east across the Lebanon valley to the Berkshire Hills. His idea was for her to restore it as a rental and perhaps eventually for them to retire to. In the meantime, it would be an outlet for Edie's talents at furnishing and decorating, which he knew she loved to do. Daphne Buddensieg had the feeling that Edie did not really enjoy her special project as much as George had hoped she would, perhaps because she sensed he was trying to get her out of the office. But after a slow start, he was encouraged to see that Edie became attached to the house and proud of her achievement in modernizing it while retaining its neo-Classical proportions. She promptly rented it to a young professional couple, and reserved a little goat shed on the grounds for future development.

In 1978, George found a two-bedroom apartment to rent in New York at 39 East 12th Street, not far from where he had first established a studio in the 1930s. Like most Rickey properties, it would serve more than one purpose. When his "sabbatical" from the Staempfli Gallery evolved into a permanent departure, George needed a New York address to meet with collectors and curators, as well as a pied-à-terre. The apartment would also be a place for Stuart to live as he embarked on a career in filmmaking. George introduced him to the documentary filmmaker Michael Blackwood, who was working on a series of films about modern artists. For his *Masters of Modern Sculpture*,

Blackwood had traveled to East Chatham to interview George. Soon afterward, he hired Stuart as a sound editor for *Photography and the American West* and other films to come.

THE GERMAN-BORN director of the Guggenheim Museum, Thomas Messer, had over the years kept up with Rickey's work, but after visiting East Chatham, he was struck by the variety of the sculptor's oeuvre as a whole. "The opportunity to look at your work not merely in fragments as I had done before," he wrote to George in August 1977, "but in context and thereby to gain some insight about the evolution of your sculptural thought has enriched me greatly."[10] Rickey had first shown *Six Lines in a T* in the Guggenheim's international exhibition ten years before. Messer's comment was further vindication of the value of showing his work in East Chatham, without the constraints of a New York art gallery. The immediate result of Messer's visit was the loan of *Two Open Rectangles Excentric, Variation VI*, to be installed in the sunken garden in front of the museum. The two men were also by then seriously discussing the possibility of a Rickey retrospective the following year.

With approximately seventy-five works, large and small, Rickey would be taking over the entire exhibition ramp of that unique museum space from top to bottom, as well as the rotunda, the roof, and a section of the sidewalk on Fifth Avenue. Acting more or less as his own curator, Rickey rose to the occasion in full force. "For your show," he wrote to Messer, "I would really like to push everything else aside and concentrate my resources on making a coherent statement of what I have been attempting to do for the last thirty years. It will be my best and last chance to do this."[11]

The Guggenheim exhibition had only an eight-month lead time and would enjoy a brief run. It would open right after Labor Day 1979 and close six weeks later. There was no budget for an exhibition catalogue, but because the catalogue of his retrospective at Amerika Haus

in Berlin had been published earlier that year, George and Edie were both quite relieved to be spared the labor of preparing another. The entire Rickey staff would be involved in the exhibition effort, beginning with Roland Hummel overseeing engineering issues—the size and weight of the bases, the strength of the bolts, the placement of fans to mobilize the indoor pieces and their electrical cords and outlets, and the special considerations of wind on the roof.

The museum would be borrowing most of the sculptures from collections both private and public; a few, however, would come straight from the artist's workshop. No matter where they came from, the Rickey workshop staff was on hand to assist in the installation over the course of a week. Achim Pahle flew over from Germany in August as courier for a few works borrowed from German collections. He then drove into New York with sculptures in pieces both in and on top of the Rickey van, while some of the larger pieces traveled from the workshop in a flatbed truck.

Hurricane David was making the rounds of the East Coast the weekend the show opened in New York. Pounding rain accompanied the last day of installation, and high winds sent the sculptures on the roof on a wild ride, dipping and shimmering under rolling clouds and bursts of blue sky, a severe test of their viability in strong winds—they survived, thanks to Hummel's exacting calculations. *Seesaw and Carousel*, Rickey's 1956 commission from the Baltimore Museum, hung center stage over the reflecting pool inside, while myriad small sculptures played to the fans up the ramp.

"The opening was great fun, masses of people," Edie reported to their friend Irma Cavat in Santa Barbara.[12] In terms of museum attendance and popularity, the Rickey retrospective was a success, one of New York's best-attended exhibitions of the year. The moving sculptures outside the building attracted crowds in record numbers, with long lines gathering in front of the museum on Fifth Avenue, and their enthusiasm was sustained inside. Among the New York

art critics, the reaction was more reserved. The Rickey retrospective "comes none too soon," wrote the *New York Times* critic John Russell,[13] by which he seemed to imply: just in time to rescue his reputation from the sidelines of the New York art scene. Rickey had been left out of the critical discourse in recent years as he continued to build his reputation overseas. Russell gave the show a respectful review, but he dodged the opportunity, or the challenge, to place the work in the arc of the late twentieth century. Kay Larson's review for *The Village Voice* also reflected the sense of déjà vu, admitting that to see Rickey's work again was a pleasant surprise—"a bit of '50s technology that looks good even in the high-tech, post melt-down '70s."[14]

Looking good "even" in the late 1970s appeared to be a positive assessment, but it begged this question: Was Rickey's work still relevant? The kinetic movement had lost the momentum and high spirits it had ridden through the previous decade. The space race was over, and the mid-century obsession with speed and technology plunged with the energy crisis and the economic woes of the "melt-down" 1970s, just as it had during the Depression. Though Rickey was an established contemporary artist with universal appeal, and though his work was compatible with the growing trend for public art, this was not the same as attracting the attention of the New York critics. There was an increase in the general interest in sculpture at the time, but Rickey's work was out of step with the new discourse. His work was minimal in its hard lines and metal fabric, its mathematical foundations, and its sculptural form, but it was too delightful to be demanding in the ways of minimalism as it was then being defined. Although it physically challenged the space around it, his work did not philosophically question the validity of the museum or gallery environment in which it stood, along the lines of then trending institutional critique.

As for interacting with nature, a younger generation had taken the concept to an entirely new scale and miles from the urban centers to the remotest stretches of landscape, from Robert Smithson with

his 1970 *Spiral Jetty* on the northeastern shore of Great Salt Lake, to Walter de Maria with his 1977 *Lightning Field* in Catron County, New Mexico.

By the late 1970s, the New York critics were as New York–centric as ever. Their attention centered on the inward-looking all-American movement of minimalism, reflecting the dark post-Vietnam years and the disillusionment of Watergate, self-absorbed in a way that seemed to ignore the rest of the world. As the curator and critic Alexandra Munroe described the state of the art world at that time, "America's largesse, its confidence and courage as a beacon of freedom and self-expression went into a vast retrenchment."[15] Having focused his efforts on Germany and Holland, where he was embraced, Rickey had become something of an outsider in New York, much like his European and South American and Asian counterparts. Kinetic art was passé. Influential sculptors such as Mark di Suvero and Lynn Chadwick, who explored ideas of balance and movement in the 1960s, had moved on. Calder, who remained popular with collectors, was otherwise history.

Rickey was also undeniably a classicist. His sculptures moved, but they also stayed put on their pedestals. Like traditional sculpture, his were structures one could move around and know one's place in relation to. The new sculpture of the minimalists—by Richard Serra, Donald Judd, and Carl Andre—was big, imposing, and mysterious, as if interrogating the space around it wherever it landed. In a lecture at SUNY Purchase in 1980, as if to distance himself from these new trends, Rickey bemoaned the "epidemic vice" in the enormous scale of new painting and sculpture, as well as the tendency of artists to use commercial fabricators to realize fantasies impossible in their own studios.

His lecture was published back-to-back with an essay by Donald Judd in the *Art Journal* that year. Judd, like Rickey, had been an art critic as well as an artist, but as someone a generation younger, he brought a very different thesis. He rejected any concept of artistic

tradition in favor of a new language. He created boxes, factory-made, that eschewed the monikers of either painting or sculpture. Whereas Judd's work was entirely preconceived, Rickey retained a degree of improvisation as he worked. And though Rickey had championed the impersonal nature of Constructivism, he was not prepared to give up all connection to the artist's hand. Distrusting the polemics of the new trends, he believed that "[p]osterity will vote heavily on the side of objects rather than concepts."[16]

But no matter what anyone wrote or said, Rickey was solidifying his base, in America and around the world, transcending the transitional moment in contemporary art from the remnants of the zany 1960s to the austerity of the late 1970s. As for the attention, or lack of it, from New York critics, he did not seem to care. "George was not too concerned about reviews," recalled Birgit Mieschonz.[17] Accolades came from elsewhere. As an artist for public spaces, his star was still rising.[18]

31

Hand Hollow

AT THE time of the Guggenheim retrospective, Maxwell Davidson, a young New York art dealer, responded to a client's request for a Rickey sculpture. Davidson asked his high school classmate Nan Rosenthal if she could make the introduction. "He's in the phone book," answered Rosenthal. "Just call him up."[1] The client changed his mind, but by then Davidson's interest was piqued, and with his wife and business partner, Mary, he decided to make a visit to the Rickey studio anyway. Face to face with the artist, Davidson felt an immediate kinship with Rickey's work. The kinetic element added for him an extra "punch" that he found irresistible. By the end of a congenial afternoon in East Chatham, he had bought two sculptures and written George a check. Fully trusting that the check would clear, George wrapped the pieces in newspaper and loaded them into the trunk of their car. It was to be the beginning of a long and fruitful relationship.

Davidson was a private dealer in the secondary market in modern and contemporary art. He had recently opened a gallery in the bottom two floors of a brownstone on East 78th Street. A friend had advised

him that to really make a difference as a dealer, it was important to represent living artists, and though hesitant, Davidson had taken this advice to heart. In George Rickey he saw the opportunity of a lifetime—representing a major American sculptor with a retrospective at the Guggenheim Museum just behind him. From Rickey's point of view, the fact that Davidson had a garden in the back of his townhouse gallery suitable for the display of small outdoor sculptures added to the young dealer's appeal. Boom years for the Rickey market were still ahead. For an artist in his seventies, he remained extraordinarily productive, tirelessly fascinated by the new ways that he could conjure with movement as he continued to mine the depths of his imagination.

Max and Mary were always happy to visit East Chatham to see George's latest work, the master and the workshop in action, and stay on "for one of Edie's great meals." In 1980, Rickey agreed to a one-man show in Davidson's gallery. The difference between Max Davidson and almost every other art dealer Rickey had worked with over the years was that he was willing to play by George's rules. They had a simple agreement. When Davidson sold a work out of his gallery, or whenever he brought or sent a client to visit the Rickey workshop, he would take a commission. If he had nothing to do with a sale, he would not. He trusted George to be both businesslike and scrupulously honest about the arrangement, with good reason. "George's word was his bond," he recalled. On one occasion, Davidson sent a client to visit Rickey in East Chatham. Angling for a better price, the client suggested cutting Davidson out of the deal. But Rickey stuck to his price, and promptly sent Davidson the percentage he owed him for the sale. "George didn't take advantage," said Davidson.[2]

Nor did George let anyone take advantage of him. Traveling up to East Chatham with a private collector one day, Davidson advised the man that Rickey did not like to be bargained with. Once at the studio, the collector zeroed in on a sculpture and asked how much. George stated his price, seventeen thousand dollars, whereupon the collector offered him twelve thousand. George considered this a moment, and

then led the collector to another, smaller sculpture and said: "This piece is twelve thousand dollars."

"You don't understand," the collector said. "I'm interested in *that* piece."

"No, *you* don't understand," George answered evenly, "*That* piece is seventeen thousand dollars; *this* piece is twelve thousand dollars."[3] In the end, the collector paid the asking price for the piece he wanted. Max observed this transaction with great interest. He was learning from George the importance of standing one's ground.

He also learned from Edie, different things. Max would show George one of his sculptures that he had found on the secondary market. George would say oh yes, I made that in Bloomington, and then Edie would correct him. No, no, George, not Bloomington, you made that one in New Orleans, and so-and-so bought it and gave it to their son, recounting the entire history of the object's creation, ownership, and whereabouts. The personal details—the human interest—was the key to her remarkable memory. She meandered from one association to the next, attaching other branches of the story as she went. As George sometimes chided, with an Edie story, "there's only a 50% chance of getting to one's destination."[4]

A TYPICAL day in the Rickey workshop of the 1980s began with the arrival of the workshop staff at eight in the morning. Birgit Mieschonz would begin her day at nine, climbing the iron stairs to her office. George, breakfast and board meeting with Edie behind him, would arrive soon afterward to check in with his crew. At the start of a new project, George, Dennis Connors, and Roland Hummel would put their heads together to discuss the feasibility of the work and the details of its construction. Roland did the math, calculating the weights and sizes of the parts and the thickness of the sheet metal. Dennis made detailed mechanical drawings. He ordered the pipes and bearings from a machine shop, and in the workshop oversaw the construction

of the handmade parts. Often George and Dennis would go together to the various machine shops in Pittsfield, Torrington, Grafton, or Albany to pick up the parts they ordered—the stainless steel, the bearings, the snap rings, the tubes—and banter with the engineers.

Sometimes the machinists came to the workshop to study the mechanical drawings, to make sure they got their part right. "It was all very complicated," remembered Dennis.[5] With the very large pieces, much of the fabrication went on in various machine and fabricating shops and was later finished by hand in the workshop. George himself did a lot of the surface "grinding"—the brushed Rickey finish—with a big heavy disc sander, the "60 grit," well into his seventies.

Much of the day-to-day work involved packing, shipping, installations, and repairs to existing works. The 1980s were nonstop. Soon Rickey felt both the need and the confidence to put Dennis in charge of the workshop as foreman, as a skilled and careful craftsman with a soft-spoken manner and extensive experience in physical teamwork. George called him the "chef d'atelier," doubled his salary, and increased his workweek from three days to four. "You had to have a flexible personality," Dennis recalled,[6] to work with all the different types of people in the workshop, beginning with his exacting boss and then the assistants—from the salty, middle-aged Scottish handyman, Billy Lamond, to the college freshman on vacation. During the summer, there were typically as many as twenty on the payroll, between the shop and the grounds. Outside the workshop, Dennis dealt directly with fabricators and machinists, truck drivers and forklift operators, private collectors and museum curators.

Because of the distance Dennis traveled to work from New Paltz, about an hour's drive away, George offered him a place to stay in the studio three nights a week. Leaving his wife, Valerie, and their small children at home, Dennis made himself a little zone of privacy in a back room of the workshop as his sleeping quarters. One of the benefits of this arrangement was that Dennis was able to use the workshop for his own sculpture projects after hours. He was making surprising

assemblages of found parts, mixing media and messages in ways that questioned the pundits of politics and religion. George encouraged Dennis's work and was glad to provide the space and quiet he needed. When George came back from Berlin in the middle of winter to check on progress, as two men living alone they would often cook for each other. George would invite Dennis up to the house for supper, and in turn Dennis would invite him down to the studio where he cooked on a hot plate, and they would talk. Dennis was enthralled by George's stories of his childhood in Scotland, of his army days in Denver, and his friendships with the sculptors David Smith and Ed Kienholz. "He had an amazing mind for tiny detail," he remembered.[7]

WHILE THE Hamptons on Long Island boomed as upscale summer colonies in the 1970s, pricing out the artists who had settled there in the 1940s and '50s, the Hudson Valley offered a quieter and less expensive alternative. In 1970 Ellsworth Kelly, now a well-known painter of the Color Field School, was forced out of his New York studio at Coenties Slip and found an empty space for rent above a barbershop in Chatham. Finding the upstate surroundings conducive, he bought a house in nearby Spencertown. As a gay man in socially conservative Columbia County, Ellsworth mostly kept to himself, but George and Edie provided a safe haven and intellectual stimulation in their little oasis of modern art in the woods.

Ellsworth was a collector too. Like George, he lived with the art of his contemporaries. George and Ellsworth could talk about art for hours—not just their own, but the whole history of art: the Italian Renaissance, the design of churches, the origins of color pigments, the element of chance in art, the creation of illusion, the experience of a work of art in a natural setting, and the new importance and challenges of the site-specific.

Ellsworth was fascinated by the technical side of George's work— the balance he achieved between the appearance of lightness and

the strength to stand up to the forces of nature. George, sixteen years older, was a kind of father figure to Ellsworth, one of a choice few, including Alexander Calder.

Rickey's first contact with Kelly was actually some years before, in 1962, when he approached him for inclusion in his book, at that point titled "Heirs to Constructivism." Kelly did not consider himself an "heir to constructivism" and at first declined to be included in the book. But Rickey was not willing to take no for an answer. Four years later, with the book finally scheduled for publication with Braziller, he contacted Kelly again, explaining that he was not treating Constructivism as a movement, but rather as an attitude; it was not a style, but a tendency, and that the book, retitled *Constructivism: Origins and Evolution*, had become a wide-ranging discussion of non-objective art since 1945. Whether or not Kelly identified as a Constructivist, Rickey argued, he was dealing with many of the same optical phenomena as, for example, Brigitte Riley and Victor Vasarely, and also intersected with artists such as Hans Arp in his compounding of painting and sculpture. In the end, Kelly relented.

Ellsworth Kelly aside, for the most part George and Edie imported their artist friends from farther afield. Summer months saw a steady stream of visitors for lunch, dinner parties, and overnight stays—artists such as Otto Piene, Heinz Mack, and Marisol; Christo and his wife and collaborator, Jeanne-Claude; museum directors and curators, such as Carter Brown from the National Gallery; and private collectors Carl Djerassi, Joe Hirshhorn, and Rupert Murdoch. Edie was the Queen Bee amid their many social gatherings, enlivening one end of the dinner table with her colorful stories while George quietly anchored the other. "She had incredible energy," said Christo, "like some volcano." Jeanne-Claude described Edie as "the cork in a champagne bottle—once it's released—poof! It goes, and nobody can stop it."[8]

* * *

IN 1980, the Rickeys added another building to their country estate, when an ample, fully furnished Colonial on the corner of Route 34 and Route 9 that once belonged to a family called Sherman came up for sale. Right away George intended to put it to use in his next project—as a guesthouse for visiting artists. He was eager to repay his debt to Germany, in particular to the German artists he had come to know in Berlin. The more he found himself at odds with the New York art world, the more inclined he was to create his own colony, to encourage the artists he admired through his own cultural exchange program.

To be sure, George was also looking down the road to estate planning. By establishing a foundation with nonprofit status, he could have the pleasure of giving along with a significant annual tax deduction. Establishing the foundation in 1980, he called it "Hand Hollow," after the Hand family, who gave that little neck of the woods its name. He would personally invite each artist for a stay of two or three months.

But first there would be a significant financial outlay in creating living and working space for as many as six visiting artists at a time, and he was grateful for some support from the DAAD. The Sherman house was just a few hundred yards from the lower studio, with six bedrooms, a basement suitable for conversion, and a newly built tennis court. George expanded the workspace in both the upper and the lower studio to accommodate their guests. At the same time, he began to reserve space for his archives and an archivist, Steve Day's wife, Gail, who would also administer the Hand Hollow Foundation. A busy summer of planning and construction was ahead.

As much as Edie enjoyed the company of artists, the comings and goings of foreign guests all summer long added greatly to her catering and entertaining load. With construction and renovation projects in the works and ideas for more constantly flowing, George also talked of divesting property in almost the same breath. "He can't have it *both* ways," Edie wrote to Dolores Vanetti in exasperation. It seemed to her that "either we have too many buildings . . . or not enough space.

Either we have too many employees or we need more help." George's constant "intimations of mortality," in the way of his obsessive estate planning, did not lift her spirits either.[9] In his headlong race against time, Edie often felt left on the sidelines. In the development of his plans for the Hand Hollow Foundation, she claimed she was not even consulted.

For all of George's intimations of mortality, in those days the celebration of life took many forms at the Rickey estate. Like his father's recreation program for the Singer factory workers, George actively built a community spirit. There were birthday parties for every member of the staff, "even people who weren't there," recalled Dennis Connors.[10] For the annual Christmas party, the workshop was decorated with boughs of holly and Billy Lamond played country music on his accordion. In summer there were Scottish Highland Games such as George remembered from his boyhood, with men competing at tossing the caber around the lower pond and mountain races through the woods, and Billy added a touch of authenticity with the whine of his bagpipes. There was also an annual summer cocktail party and tour of the property to view the sculptures, which Edie dubbed the "Walkabout." The entire local community was welcome, and many friends came up from the city for the occasion. The normally dead-quiet Route 34 was lined with cars on the day of the Walkabout. David Lee, who joined the staff as a photographer and researcher, was given the task of mapmaking. Said Lee, "It was the party of the year."[11] Guests fanned out around the house, into the meadow, up the hill, and into the woods in a virtual fairground of stainless-steel spires, space churns, and gyrating open rectangles.

George's acts of charity and hospitality also took various forms. Where he saw need, he sought to fulfill it, such as paying for an assistant's hospital bills or lending the New York apartment to visitors from out of town. Most of all he liked to make the gift of education. For anyone who expressed a serious interest in continuing his education in any field, whether to earn a practical certificate in welding or a

graduate degree in landscape design, George would act as sponsor at whatever level of the individual's financial need.

He loved to encourage the young and to help steer them in the direction of their passion and talent. Mark Tavares, a workshop assistant, took a welding course at George's expense. Peter Homestead, the Rickeys' East Chatham neighbor who had worked in the workshop since the age of twelve, considered George and Edie the most important influences of his formative years. George trained him to be a highly skilled studio assistant, and also encouraged his own artistic efforts. As Dennis Connors remembered, "He always encouraged me and a lot of other assistants to keep pushing our own artwork and our own career."[12] George sensed an avid reader behind the quiet demeanor of young workshop assistant Mark Pollock, and invited him to borrow books from his personal library. Wendy Carroll, who worked in the workshop as well as the garden, lived in an apartment in the rafters of the upper studio rent-free, and when she left for Harvard to earn a degree in landscape architecture, George covered the cost of her tuition. When the bright young art historian Debra Balken was fired as curator of the Berkshire Museum, in Pittsfield, Massachusetts, George offered to support her through a period of financial stress. In the wider world beyond the immediate region, he served on panels and recommended young artists for grants and jobs and graduate degrees. Wherever he saw an opportunity to write or speak on an artist's behalf, he did. Robert Janz, an early workshop assistant, was ever grateful to George for supporting his Fulbright Scholarship to Spain, which he later said "transformed my life."[13]

Rickey had also embarked on a program of giving back to the institutions that had nurtured him. When Birgit Mieschonz arrived on the job, one of her first assignments was to research how much funding he had received as a Guggenheim Fellow in 1960 and 1961, and to then figure out how much that would be worth in today's dollars so that he

could donate the same amount to the Guggenheim for the benefit of a younger artist. It came to fifty thousand dollars.

Edie's generosity was of a very different kind. Old friends often resurfaced in their lives in the form of their blossoming children. She actively collected godchildren. When the journalist James Cox and his wife, Martha, had a baby girl, Giulia, Edie immediately stepped forward to offer herself. With the Coxes' enthusiastic consent, Edie bought a dollhouse, and over the next several years collected miniature furniture from her various travels. On Giulia's seventh birthday, she staged a dramatic presentation of the fully furnished dollhouse, charging Stuart with the job of photographing her entrance, the unveiling of her gift, and the look of wonder on Giulia's face. Some years later, when Giulia graduated from high school, Edie sent her a check for three thousand dollars to buy a car. When it turned out that there was no parking available to freshmen on the Bryn Mawr campus, Giulia asked if she could spend the money on a computer instead. Edie told her to spend it on any machine she wanted, "as long as you name it after me!"[4]

To their favorite nephew, Norman de Vall, she was equally practical. One day he was the astonished recipient of a miniature kitchen stove at his rustic home in Mendocino, California. Opening the tiny oven door, he unfolded a blank check from Edie with instructions to buy the stove of his dreams. One way or another, Edie would make each gesture unforgettable.

Cooie and Paul Harper's son, Billy, was George's godson, but Edie more or less took him over as her own when he visited East Chatham one summer. Billy, long-haired and handsome in his twenties, had dropped out of college to study music. His worried parents sent him up to his godfather and George put him to work sweeping the workshop and cutting up fallen trees for firewood. Billy was treated like a member of the family, invited for lunch and supper on the patio, and contributed his youthful views to the conversations about art

and current events. "The *New York Times* was delivered every day," recalled Billy. "Everyone was up on what was going on because we knew we'd be talking about it at dinner . . . they were all extremely well educated and very engaged in current events and social issues." Billy was fascinated by the "visiting dignitaries" who passed through over the summer—artists and collectors from Germany and across the country, and regular visitors from New York. He was particularly enamored with Dolores Vanetti, who collected wild mushrooms in the woods and wild thyme along the streams, and as the author of *The Querulous Cook*, she had sophisticated French recipes for almost everything. He was also gratified by the attention George paid to his musical aspirations, and it helped his case with his parents. "The fact that George took me under his wing had a big impact on my parents' perception of me," he said.[15]

When Billy got married, at a big society wedding in New York at the Episcopal Church of the Heavenly Rest on Fifth Avenue, Edie made a spectacle of her gift to him. At the bridal dinner the night before, she made a showstopping entrance with a huge box that she insisted he open on the spot. Inside was a beautiful handmade Irish harp with a card saying, "Every Harper should have one."[16]

"She was very generous," recalled Stuart, "but there were also times when the gift was calling attention to herself more than being the gift to the person."[17] There was certainly a touch of narcissism in Edie's gestures of generosity. George would say that Edie could be "impulsively generous to friends, but thoughtless about the ordinary needs of people less well-off than she."[18] Birgit noticed Edie's embarrassingly condescending and stingy treatment of waitstaff at restaurants, which she often felt compelled to make up for behind Edie's back.

Where did Edie and George's own two children fit into this intimate community? "Rickeyville," as Edie dubbed it, was like a kind of commune or college campus where George was the dean or Oxford don and Edie the eccentric den mother. While they gave

unconditionally to other people's children, their gifts to Stuart and Philip came with strings attached, and copious advice as well. For Stuart, they financed the apartment in Greenwich Village, but he would have to share it with George and Edie whenever they chose and with a steady flow of out-of-town guests as well. Stuart and Philip were part of the bigger estate picture, of inheritance-tax concerns and the longer view. Whether with gifts of works of sculpture or parcels of real estate, George always had his eye on their future after he was gone. Both boys had participated in their father's installations while on vacation from school, but they were not part of the workshop family. Edie loved her sons, remembered Giulia Cox, but it seemed to her that ever since they had gone off to boarding school at a young age, "they were quite estranged."[19]

At the same time, in the feudal arrangements of Rickeyville, Stuart and Philip were the nobility and the rest were serfs. But in the fine and occasionally fuzzy border between family, guests, and staff, it was easy to get caught by surprise in a misinterpretation of one's role and one's place. Edie might treat staff like family, but she could also treat family like staff. "What are you doing here?" she asked Philip one particularly busy day, and when he did not instantly respond to her command to pitch in, she told him flatly, "You're expendable."[20]

EDIE THRIVED on work but she also thrived on play. With more free time on her hands than before and a yearning for youthful company on her own terms, she developed a coterie of young women admirers, including some of Stuart's ex-girlfriends, for outings in New York. One was Alexandra Munroe, an art historian Stuart had met through mutual friends on a visit to Japan. Bright-eyed and adventurous, Alexandra was delighted to accompany Edie to the Russian Tea Room for early dinner before a concert at Carnegie Hall. Straight from her spa appointment at Elizabeth Arden's Red Door, Edie, "dressed in

costumes," recalled Munroe, "she always had an extraordinary hat, and her hat would always match her bag. I remember the watermelon hat and the watermelon bag." Munroe and her fellow Edie followers were expected to dress to the nines for the occasion. "We were all very jealous of each other."[21] Edie singled out young women of character, style, and promise, and then she would tell them how to be extraordinary, like her.

In the late 1970s, Edie began a tradition of taking off for a week in August to Ogunquit, Maine, a little coastal town that had long attracted artists, to visit Diane Carney, the widow of their New Orleans colleague, the artist Hal Carney. Edie brought her entourage—Benigna Chilla, recently divorced from Alex Markhoff, and their daughter, Milena, and Giulia Cox, who was the same age. Surrounded by women and young girls who loved her unconditionally, "it was vacation therapy for Edie," said Giulia, who has since become a clinical psychologist. At the inn where they stayed, the girls made a game of waiting on her, bringing "madame" breakfast in bed from the buffet in the dining room. At Diane's cottage, while Giulia and Milena and the Carney's young son played cards, Edie would make a spaghetti carbonara and "everyone would drink a ton of wine," Giulia recalled,[22] and the grown-ups would have their grown-up talk. For Edie, it was a time for drinking and venting.

For Giulia, these were profound and formative experiences. As an adolescent, she was let into the fascinating adult worlds of Edie and Benigna, and for the first time exposed to the emotional complexities of love and marriage. What was Edie's despair about? Perhaps that for all her talents and efforts, Giulia surmised, her performance was never good enough for George. Edie had an above-average need for praise, which was, as least lately, too sparing from George, as if the more she asked for it, the more he resisted giving it. The more time she spent enjoying herself away, the more of a sulk she became at home.

The Greenhouse, a luxury spa outside Dallas, offered another kind of escape and indulgence that she craved: to be waited on from dawn

to dusk, to be pampered with beauty treatments and health food, and to spend hours relaxing by the pool. "I enclose some pre-Texas notes," wrote George to Edie before her departure in August 1980, for he had complaints of his own for her to think about.[23] He listed evasion of her responsibilities, interference and meddling with the workshop staff, and in general her "prima donna" behavior. More and more, Edie did what she wanted, both on the job and off.

32

Returns

FOR GEORGE'S seventieth birthday, in 1982, the family gathered in Scotland to celebrate. This was thanks to the coordinated efforts of Barbara Grigor, founding chairman of the Scottish Sculpture Trust, and Peter Murray, founding director of the Yorkshire Sculpture Park, who together that year organized the first major retrospective of Rickey's sculpture in Britain. Grigor and Murray had met in Washington, D.C., at a conference in 1980, discovered their mutual interest in George Rickey and his roots in Great Britain, and on the spot made a plan to visit him in East Chatham.

At the time, the Yorkshire Sculpture Park, near Wakefield, was still in the nascent stages of becoming a major international museum for outdoor sculpture. In 1977, Peter Murray proposed siting sculptures around the rolling five-hundred-acre estate of Bretton Hall College, where he taught. From then on his concept grew, and by the early 1980s the sculpture park was becoming well known. Daunting as the exhibition was to consider from a distance, Rickey responded positively to Peter Murray, saying, "This would be my first full exposure

in Britain, and I think of Yorkshire, having produced Moore and Hepworth, as the cradle of modern British sculpture."[1]

But it was the Glasgow venue that was particularly poignant for Rickey, for this was *his* cradle. The show would be held at a suitably industrial site: the Custom House Quay, along the Clyde, which had lately become a park, directly across from the house where he had lived from the age of five and where his bedroom window looked out on the passing ships, and the cranes that built them, in the distance. Smaller, indoor pieces would be shown in a gallery created from an old vaulted wine cellar in what had once been the Saint Enoch Hotel. "The contrast between Glasgow and Yorkshire couldn't be better," wrote Peter Murray enthusiastically to Rickey. "In fact the different environments and layouts will create two distinct exhibitions."[2]

For this exhibition—spanning his entire career from the early 1960s to the present—Rickey would be lending a few sculptures directly from the studio in East Chatham as well as facilitating loans from private collectors in the United Kingdom and the Continent as much as possible. There were quite a few to call upon. Charles Jencks, the Postmodern architect and theorist, became acquainted with Rickey's work while teaching at UCLA in the early 1970s. Walking across the campus through the sculpture garden every day, he never failed to enjoy his encounter with Rickey's *Two Lines Oblique*, an elegant ballet that seemed to say "You can throw anything at me and I can roll with it," including, in that case, the Santa Ana winds.

Jencks's Scottish wife, the landscape designer Maggie Keswick, had the idea that a Rickey sculpture would look good at her family's estate in Dumfries, and the fact that George had grown up in Glasgow added to its appeal. So one day the couple called on him in East Chatham. After a long lunch and a tour of the grounds, Charles and Maggie bought *Two Open Rectangles Excentric IV*. To Charles, the near miss of the open rectangles as they passed each other made another kind of allusion to Scotland. "It's like a sword dance," he said.[3] At rest, it was a semaphore. Maggie's father, John Keswick, was soon

to grow so fond of the two rectangles gyrating on the lawn outside his window that by the time Barbara Grigor asked him to lend it, he was reluctant. He finally agreed. Years later, after Maggie died of cancer, Jencks commissioned Rickey to make a piece for the Maggie Center in Edinburgh, a sanctuary of spiritual comfort for cancer patients and their families.

Anticipating the exhibition in Glasgow, the lord provost gave Rickey an official welcome reception and a ceremonial key to the city. The show happened to coincide with the first ever visit from a pope to Scotland. In honor of the occasion, Rickey created a large sculpture made up of four moving *L*'s arranged as a cross and called it the "Papal Cross." With Grigor's encouragement, George promised a gift of the sculpture to the city along with another, *Three Right Angles Horizontal*, both to be placed in public parks. At the same time he made a gift of *Two Lines Up Excentric VI* to the Scottish National Gallery of Modern Art, in Edinburgh.

On the eve of the exhibition opening, in early June, the Rickeys were invited to stay at Charles Rennie Mackintosh's Hill House in Helensburgh, a cherished memory from George's childhood. It happened to be the night before the Blackie family handed over the house to the Scottish National Trust as a gift to the public. For one magical evening, the Hill House was all theirs. Family and friends gathered to celebrate the following morning in the Drawing Room, a creamy white interior decorated with delicate panels of stenciled roses and a bay window overlooking the Clyde, with Anna Blackie's black-lacquered writing desk anchoring one end of the room and a music alcove at the other.

Stuart, recently returned from an extensive tour of the Far East, and Philip, then an art major at Cornell, were there to help install the show, with Achim Pahle, whom George by then referred to as "my man in Europe."⁴ The Macdonald cousins were there in force, with Willie Macdonald and his wife, Mala, from their farm in Dunbartonshire, and Linn Macdonald with her husband, Jimmy Lee, from Kent.

Willie Macdonald's two teenage sons, Kevin and Andrew, were deeply impressed by their older cousin's art along with his bohemian lifestyle, and they thought Edie, with her raucous laugh and theatrical capes and liberal use of four-letter words, was "super cool."⁵ Both Kevin and Andrew were then students at Glenalmond, which made for another bond with their cousin George. With the Rickey family, including George's sisters Emily and Kate from Schenectady and the Scottish cousins from all corners, converging, Edie commanded, "Line up the blood relatives!"⁶ and they made a picture.

Barbara Grigor, a charismatic champion of all things Scottish, used the occasion to highlight sculptors such as Eduardo Paolozzi, Italian born and Scottish raised, and Isamu Noguchi, whose maternal grandmother was Scottish. Barbara's husband, Murray Grigor, introduced George to the Glaswegian sculptor George Wyllie, a conceptual artist with a satirical leaning and a way with words. Growing up along the Clyde, Wyllie was as sensitive to the life of the river as was Rickey, and they bonded immediately. Fascinated by movement, music, and astronomy, Wyllie sought, he said, "an equilibrium of understanding."⁷ Among his sculptural commentaries was "a Machine for the Equitable Distribution of Wealth," a performance piece consisting of scavenged cranks, chains, and weights that made a lot of noise while it purposely fell short of achieving its goal. Enchanted by his Dadaist spirit and makeshift technology, more reminiscent of Tinguey's machines than his own, Rickey invited Wyllie the following summer to be a fellow at Hand Hollow, where one of his site-specific works involved festooning toilet paper through the trees.

FOR GEORGE, the visit to Scotland called up memories of his childhood home and the people who had shaped his world from an early age. He thought of George Lyward, who had died in 1973. George had last seen him at a small exhibition of his sculpture in a gallery in London in 1966. They had drifted out of touch, but George thought

of him often, never failing to credit him with having directed him toward a life in art and teaching. In 1987, George was idly reviewing the latest issue of the *Glenalmond Chronicle*, the alumnae newsletter of his old school, when a letter from one Jeremy Harvey caught his eye. Harvey was seeking recollections of George Lyward, the subject of his doctoral dissertation. Lyward had gone on to found Finchden Manor, a therapeutic community for troubled boys, in Kent, and had made a reputation for unlikely interventions that worked. He was named to the Order of the British Empire in 1970 and was invited to preach at Westminster Abbey in 1971.

At the sight of Lyward's name, a host of memories welled up in George's mind. The very next day he composed a letter to Harvey, expressing his great interest in his quest. "I may be one of the very few survivors among Lyward's students," he told Harvey, and added that it was Lyward who inspired his desire to teach, "not through any proselytizing, but through a growing awareness of values, which, in turn, gave me the courage (or sense of adventure) to become an artist."[8] He promised to find the dozens of letters Lyward had written to him over many years after his graduation from Glenalmond, which he had safely kept, and photographs too. He urged Harvey to visit him in East Chatham, and promised that in conversation more memories would be coaxed forth. Harvey wound up spending a month in East Chatham as the Rickeys' guest in the so-called tenant house just up the road. With George Rickey's input, he added to his study of Lyward's career and his unusual gift for drawing forth the strengths within the hidden depths of adolescent boys.

Just as Rickey honored his favorite teacher, so was he honored by his favorite students. One of them from Groton, Louis Auchincloss, had become an acclaimed novelist whose work chronicled the New York society of old money he knew so well, and wrote about his patrician education at Groton in his best-known book, *The Rector of Justin*. When in 1986 Max Davidson collaborated with the modern art dealer Virginia Zabriskie on an exhibition of Rickey's work in Bryant Park

on 6th Avenue and 42nd Street, behind the New York Public Library, Auchincloss contributed a forward to the catalogue. He marveled at how their worlds had continued to cross and mesh over the years. "Rickey had made for me a weird sense out of our past and present," he wrote, "out of Groton and art."⁹

IN 1985, Rickey would return to another scene from his distant past. James Mullins, a librarian at Indiana University, had bought a decrepit house on West Washington and learned that among its previous owners was the family of George Rickey, and that George was born in South Bend. Under Mullins's initiative, four institutions—the Snite Museum of Art at Notre Dame, Indiana University, Saint Mary's College, and the Art Center of South Bend—collaborated on a citywide one-man exhibition to honor their native son. "The stars wheeled in their courses," said Rickey, "to bring it about."¹⁰ Although his memories of South Bend were faint compared with those of Scotland, George wanted to revisit his birthplace and was touched by the city's interest in his work. Ed and Nancy Kienholz flew in from Hope, Idaho, for the occasion, and Laura Berghorst, now Verplank, traveled from Michigan to reunite with her friend and mentor from their Olivet days. Several members of the workshop staff, among them Birgit and David Mieschonz and Dennis Connors, came along to assist. Adding to the retrospective spirit of the moment, Seth Schneidman, a cinematographer who had been working on a documentary about Rickey for several years, arrived in South Bend to screen a preview of his work in progress.

As always, Edie cut a striking figure. At the time, she was wearing a patch over her left eye due to a detached retina. While the black patch added a rakish accent to her sartorial allure, the loss of one eye affected her balance. On top of that, she was inclined to wobble when she had too much to drink, which lately, to close observers, was all too often. At a luncheon for the staff before the opening of the show,

Edie consumed her ample share of white wine. When lunch was over, the party got up to go back to work but Edie wasn't ready to go. Birgit stayed behind and finally persuaded her to leave. Reluctantly, Edie rose to her feet and made a tour of the table, pouring the dregs of everyone's wine into her own glass. As she headed for the door, tippling as she went, a waiter stopped her. She argued, but finally relinquished her glass.

Back at the exhibition site she loudly lit into Dennis for not coming back to the restaurant to get her. Birgit watched as George approached her, his face red as a beet, grabbed her by the arm, and hissed through his teeth, "Edie—stop it!" And she did, instantly, in what George would call her ability for a Jekyll-and-Hyde transformation when she was told she had gone too far. As Birgit had also observed many times, Edie "could switch on and off on a dime." Said one observer to Birgit as she ushered Edie away for a rest at the hotel, "You're a saint."[11]

IF STRESS and overwork were partly to blame for Edie's alcohol habit, as she often claimed, George was determined to reduce her load and direct her energies to more innocuous responsibilities, such as gardening and decorating. She had often talked about writing. One of her pet ideas was a joint memoir with friends such as Kate Dole, Jean Freas Smith, and Nancy Kienholz called "The Lives of the Wives." In her chatty letter-writing style, Edie wrote fluently, almost at the rate at which she talked, and especially when she used a Dictaphone, but the long-term discipline required for producing a book was by that time beyond her, if indeed it had ever been within her grasp.

George had tried over the years to deal with her drinking in what he thought was a reasonable way—admonishing her, urging her to limit her intake—yet he resisted the idea of locking up the liquor cabinet or removing it altogether for fear that she might simply leave the house to drink alone, sequestered from his disapproving gaze. Nor was he willing to give up drinking himself. At home Edie drank

openly at cocktail hour and secretly during the day. George lived in apprehension of her angry outbursts, never knowing when he might be ambushed by Edie under the influence. In his absorption in his work, he sought to distance himself. He knew that she was struggling with a disorder that was genetic, exacerbated by her own emotional needs. Her father was an alcoholic and almost lost his job as a result, but eventually managed to get his habit under control. Could Edie do the same?

For his own sake as much as for hers, George was also trying to rein in Edie's involvement with the workshop. What had seemed an enlightened arrangement years before had grown more complicated. He chastised her for sometimes overriding his instructions to his staff, for her "prima donna" attitude, for meddling and nagging and acting like a spoiled child. He reminded her that she was not just his wife; she was also his employee. This meant that on the one hand, she was his equal; on the other, he was the boss. What had been her helpful prompts or pronouncements in the past had become for George her nagging bid for attention or for credit where less credit was due. Edie had once been the puppeteer, but nowadays she felt more like a puppet. She resented George's criticism, his self-righteousness, and his callousness regarding her hurt feelings. She sometimes felt unwelcome in her own home.

Raised on the turf of his parents' marital battlefield, Philip loved them both and hated to take sides. In 1984 he married Mary Sullivan, an artist he had been dating since they were both art students at Cornell. Now with high hopes for his own young marriage, he wondered if he could help his parents start afresh. Taking charge of his parents in a way he had never felt the confidence to do before, he spoke of his faith in the pre-Canna talks required before marrying Mary, a Catholic, and he shared the rules for problem-solving and fighting they had learned in couples therapy. He urged his parents to seek counseling. Edie, Philip sensed, was willing. But his father, to his mind, "had no capacity for self-correction in the most personal relationships."[12]

Apparently, neither George nor Edie was ready to take advice from their son, and even less from their daughter-in-law. Philip and Mary spent their first two years of marriage in Berlin, making themselves at home in the Bundesplatz studio while they both worked, Philip at his sculpture and Mary at painting. There they befriended a puppetmaker, Ingrid Pitzer, and commissioned her to make marionettes of George and Edie, as if, at least metaphorically, to gain some measure of control over their behavior. Pitzer worked from full-length color portrait photographs by Achim Pahle and created a kind of caricature of the couple. Delighted with the results, Philip and Mary presented his parents with their puppet personae comically and helplessly dangling from their strings, a performance George and Edie received with subdued gratitude, neither being especially receptive to the humor, nor to the inevitability, of the younger generation taking control of their lives.

33

Santa Barbara

AS ATTACHED as George and Edie had become to Berlin and their many friends there, the winters were cold and dark, and the scene was changing. Artist friends and fellow DAAD residents such as Peter Sedgely and his wife, Inge, had moved back to England, Peter and Veronica Nestler had moved to Cologne, where Peter was the city's director of cultural affairs, and Achim Pahle indicated a restlessness that made George wonder if he might be moving on. He had no interest in trying to replace him.

In 1981 George was commissioned by the HypoVereinsbank to make a piece for the atrium of its Munich headquarters, a triangular, sharply vertical tower for which he conceived an ambitious ladder of rocking triangles. "I expect this rococo-constructivist fantasy to be my Berlin swan song," he told Stuart.[1] He was tired of the complications of working with the fabricators in Germany and Holland and decided that all future construction would take place in the United States. Even when the commission came from Europe, East Chatham would

from then on be his sole base of operations. "It's important to keep the core of that staff stabilized and productive," he told Edie.[2] He also wanted to distance himself from the growing trend among sculptors of turning over their work to commercial fabricators (though he himself was among them) and reassert the do-it-yourself approach, the artist-run atelier, that he perceived to be increasingly rare.

Over the years, Santa Barbara had been both an escape to a perfect climate and a strong foundation of personal support. The Doles were like family, and although Bill Dole had died suddenly in 1983 at the age of sixty-five, his wife, Kate, was still in residence, and so were their daughters, Hilary and Debby. Alfred Moir had left Tulane to join the fledgling art history faculty of the University of California Santa Barbara in 1962; Bea Farwell, thanks to George's introduction to Alfred Moir, was also on the art history faculty; and Irma Cavat, a friend since the 1950s, when they all met at the American Academy in Rome, taught painting. George had been a visiting lecturer and Stuart had earned his bachelor's degree in film studies from UCSB in 1975. The University Art Gallery had initiated the exhibition *Constructivist Tendencies* in 1970 and the Constructivism book had originated with the University of California press ten years earlier. George's work was represented in many private California collections, as the climate was ideal for his outdoor pieces. The art collectors Carl and Judy Schlossberg gave him a show at their spacious home and garden in Sherman Oaks, Los Angeles, in 1982, which led to several more showings, and in San Francisco, John Berggruen was thrilled to represent Rickey in his downtown gallery without having to negotiate with another dealer in New York. Santa Barbara beckoned.

In the winter of 1985, Irma Cavat offered the Rickeys a small extension of her house in the exclusive gated community of Hope Ranch, while they looked for a place to rent. A converted stable, Irma's house overlooked an avocado orchard and offered all the tranquility they could wish for, at the same time being close to the conveniences of the small city. Edie and Irma had what Irma called "a very deep shopping

relationship,"[3] much as Edie had with Daphne Buddensieg in Berlin, and they would spend hours scouring the secondhand stores and flea markets. For George, Irma was a fellow artist he admired and a friend of many associations. It was not long before Irma invited them to make the wing of her house into their winter pied-à-terre. George offered to pay rent, but Irma enjoyed their company and instead encouraged them to improve the property at their own expense as a kind of "life rent."

With help from a local contractor, Tom Bortolazzo, they divided the space to create a living room and bedroom and built a deck. Edie devised a mini-kitchen in a four-foot-square closet with a minimum of appliances—electric frying pan, electric slow cooker, electric rotisserie, and toaster oven—and thus equipped was ready to entertain eight or ten for dinner. "She was like a juggler," said Irma. "I just stood there in wonder."[4] Edie loved working with the fresh local ingredients, including the windfall of avocados and oranges in their own backyard, and Irma gave Edie a free hand in gardening and decorating. Edie scattered colorful pillows and rugs around and set up her mini-office with her typewriter, fax machine, and telephone and picked up her voluminous correspondence with characteristic fervor.

George set up a simple studio in the garage underneath the apartment and filled it with his tools and the deck with his latest sculptures. Tom Bortolazzo referred him to his brother Ken as a potential assistant. Ken was a metal sculptor who had admired Rickey's work since he was in high school. He had welding experience and flexible hours, other than that he fished for lobster two or three days a week, which also meant that he could supply them with lobster and channel shrimp straight off the boat. With these California pleasures all around them and many close friends for company, Santa Barbara was to become a habit. Edie called it their "Nest in the West."

On the surface, all was well. Ken found George to be a gentle and genial boss. But off-stage, he often overheard George's voice change to anger at Edie and on other days her anger at him.

※　　※　　※

As BEFORE when they wintered in Berlin, George would periodically return to East Chatham to check on projects in the workshop. But leaving Edie on her own was becoming increasingly worrisome. George was ever on the alert for signs of her furtive drinking, a recurring trend. He would discover a bottle of vodka tucked into her bag, or a coffee cup by the phone smelling strongly of brandy, at eight or nine in the morning. In April 1986, her addiction reached a new level of alarm. While George was in East Chatham, Edie was stopped on the road in Santa Barbara for speeding, given an alcohol breathalyzer test, which showed her well over the legal limit, and wound up spending the night in jail for driving under the influence.

"It's clear that the clandestine drinking is back and will continue," George confided in Stuart after Edie's DUI charge, "and with it deception and lying."[5] By that time he was willing to support her need for a clinical stay in a treatment center, such as Betty Ford in California.

He also recalibrated Edie's involvement in the business in East Chatham. "I want to keep her out of the lower studio, the production, the sales, the shipping, the dealing with dealers," he told Stuart. "Birgit and Dennis handle all this very well. For Edie to have a foot in it makes it more difficult and, sometimes, embarrassing." He was also wary of her spending too much time in the kitchen alone. "She is a very talented and successful cook, but the kitchen has been an escape into solitude and the opportunity to drink unobserved."[6]

In the late 1980s, with several big commissions and projects in the works in Europe, among them the façade of a new theater in Rotterdam and public sculptures for Cologne, Zurich, and the headquarters of Mercedes Daimler Benz in Stuttgart—the Rickeys decided to keep the studio at Bundesplatz at least through 1989. Jörn Merkert, by then the director of the new Berlinische Galerie, was building a collection of modern artists, including Naum Gabo and George Rickey, for whom Berlin represented an important period. With the enthusiastic

cooperation of Gabo's daughter, Nina, Merkert had already secured a room full of Gabo's work from his Berlin period. Ultimately, he envisioned a gallery designated for a permanent installation of Rickey's work too. To inaugurate the project, he proposed a major exhibition of Rickey's sculpture showing his development during the Berlin years, hoping to add many of these works to the museum's permanent collection. For a start, Jörn commissioned a sculpture to be installed outside the Berlinische Galerie building at Gropius-Bau, for which in 1985 Rickey created *Four Lines in a T Fifteen Feet.*

Jörn also planned a corresponding book about George Rickey's Berlin years, calling on a full cast of important art-world colleagues to contribute to the text. The project gave Edie a new sense of purpose. She would create a detailed chronology of their Berlin years, and gather a multitude of photographs to illustrate them.

EDIE WAS also busy working on a creation of her own. Since 1981, when her beautifully restored "Yellow House" on Route 5 burned to the ground (a suspected arson, no one was hurt), she had been lavishing attention on the design and rebuilding of the house from the ground up with the architect Werner Feibes, a colleague of George's from their RPI days, and a close family friend and neighbor of the Rickeys in Schenectady. The new house had an open plan of three floors, descending the slope like giant steps, and a walkway leading to a little gazebo to enjoy the panoramic view of the Lebanon Valley. Edie transformed the garage building, which had survived the fire, into her "Maisonette." On the ground floor, there was enough natural light to grow plants year-round. Adding a touch of theater, she commissioned Irma Cavat's daughter, Karina Katchadorian, to create a trompe l'oeil mural of classical ruins around the interior walls, and the Santa Barbara ceramicist Marge Dunlap added a portal with heads of nymphs and fanciful woodland creatures blending with tropical plants, along with an indoor fountain. A Katchadorian mural of woods

and songbirds surrounded a spiral staircase leading to a study and storage space for Edie's by then extensive "wearable art" collection and her sizeable library of fashion reference books—a secluded hideaway to which she could escape to read.

Nothing could have been more distant from her husband's cool, minimal aesthetic, and she loved it all the more for that. Edie also loved the idea of seeing her collections and creative ideas published in a national magazine. She invited Hilary Dole, who had become a freelance journalist, to write the story. In September 1988, Hilary and her mother Kate flew east at Edie's expense, along with photographer Richard Ross. Edie received them in her full-length peapod outfit, hand painted on raw silk by Karina to go with the peapod earrings made by her favorite Madison Avenue jeweler, Boris LeBeau. Ross photographed her from above, reclining in a wicker chaise longue. The story never found its way into print, but Edie at least had the satisfaction of a permanent record of her creation, a little hedge against dying without being properly recognized. On the other hand, Richard Ross observed, looking around at George's sculptures everywhere the eye could see, "every sculpture is a portrait of Edie: tall and angular, pointed and birdlike, surprising and graceful and shimmeringly exquisite."[7]

Edie lived for travel. She and George had lately developed an annual tradition of taking a sightseeing trip with Peter and Veronica Nestler to southern Europe or to Central and South America. But Edie had also begun to travel without George. In October 1988, she took off for India with a tour group from the Los Angeles County Museum with her friends Marge Dunlap and Debby Dole. After a brief stop in Singapore, they arrived at the hotel in Delhi, elaborately welcomed with flower wreaths around their necks and cocktails with flower petals floating on top. In the middle of this reception, Edie broke away to view a piece of Indian embroidery, tripped on a stone step, and sailed to the ground, landing hard on her right side.

Immediately surrounded by the group, instructed not to move, with handbags propping up her head, she hoped it was just a bone bruise.

Once transported by way of a bumpy ambulance ride to the Batra Hospital and Medical Research Center and X-rayed, she learned that she had a break in her femur just below the hip joint. The orthopedic surgeon told her she would be operated on in the morning and could leave India with the group on schedule. She was enchanted by the nurses, "ravishingly beautiful, quite petite, in blue uniforms with white caps," but after one night in the hospital, Edie decided she would rather have surgery closer to home. Her only question was "How do I get there from here?"[8]

Debby Dole took on the challenge of getting Edie back to America in one piece. Pieter Sanders, in Holland, on the board of KLM, promptly organized their flight out of Delhi. On a stretcher across four airplane seats, heavily sedated with morphine, with Debby Dole in the seat in front of her, Edie flew from Delhi to Amsterdam, where she spent two nights in a hospital, and finally from Amsterdam to JFK on Sunday, October 16. Edie called her historic journey "Around the world on a stretcher in six days."[9] She was operated on at the Berkshire Medical Center in Pittsfield, Massachusetts and a week later, her foot-long thigh wound stapled together, sent home to East Chatham. George had established a special zone of the house for her recovery, with a hospital bed in the dining room, a walker, a VCR, two telephones and a typewriter, and all the publications she could dream of. Through the sliding window she could give orders to George in the kitchen.

From her hospital bed, Edie began to recuperate and catch up with her backlog. But there was an interruption in her already faltering power over operations in East Chatham, and she would never fully regain control.

* * *

A YEAR later, when her orthopedic surgeon deemed her bones suffi-
ciently mended, Edie was willing to submit to treatment of another
kind. In the fall of 1989, at George's urging, she checked into the Betty
Ford Center, in Rancho Mirage, California. A rigorous program of
self-analysis was the essence of its rehab method. Telling one's story
to a group of strangers was integral to the process, and Edie had never
been shy about that. Before, she had played it to vent and to entertain;
Betty Ford called for deeper reflection. George suggested that she tell
her story not in the first person, but in the third, to observe herself
from a distance, as if, he might have meant, from his point of view.

Family members were considered essential to recovery, and
George attended some therapy sessions, which in some ways rankled
him. Later, given a questionnaire about how the program might be
improved, he had plenty to say. If the family meetings were anything
to go on, the communication skills of the counselors, in his opinion,
were "appallingly deficient." Ever a stickler for detail and correctness
when it came to language, he bemoaned the "sloppy dependence on
'Okay'" and the "curious dropping of final g's"[10] and he spun circles
around their use of the word *feelings*, the full force of his 1920s Oxford
education colliding with 1990s Southern California.

Despite these quibbles, George felt positive about the program on
the whole. After a monthlong stay at Betty Ford, Edie emerged a new
woman—"happier, healthier, more responsive, more outgoing, more
confident, more self-possessed," he told Dr. Barbara English, of the
Ford Center, "like a second blooming."[11] He had reason to hope that
Edie's forty years of alcoholism might finally come to an end, and that
"our remaining few together can be tranquil and productive."[12] They
would also soon be welcoming their first grandchild into the world:
Philip and Mary's son Owen was born September 7, 1990.

Indeed, miracles could happen. The night of November 9, 1989,
George and Edie were in Berlin when the news swept through the city
that the wall had been broken and it was coming down. Following a
wave of protests in East Berlin, together with the rise of Gorbachev's

glasnost, there was no way Communist Russia could continue to claim success over its dominion in the West. The Cold War was officially over, and overnight the Berlin wall was an anomaly from another era. "I never thought the wall would come down," remarked George in hindsight, "but it did, and I was there."[13]

SOON AFTER the wall came down, a Berlin patron, the real estate developer Klaus Groenke, gave Rickey his biggest indoor sculpture commission yet. Groenke envisioned a Rickey centerpiece for his new Trigon building—an eight-story triangular office building in the heart of the reunited city. Groenke and his wife, Gisela, had been avid collectors of Rickey's work over the years, and had promised to fund the George Rickey room at the Berlinische Galerie. Although Rickey was daunted by the prospect, he did not like to say no. He conceived a hanging tower of multifaceted parts he called *Faceted Column* and began working on a prototype in Santa Barbara. But when Groenke sent him a scale model of the Trigon building to work with, George wondered whether his sculpture design was strong enough to hold its own in the cavernous space. He doubled the size of the units and halved their numbers from sixteen to eight. In East Chatham, the staff created the hangers and the chassis, sensing George's anxiety about the commission from the start. The triangular building had strong horizontal lines indoors, heightened by the striking contrast of light and dark materials. And in its immense courtyard, air-conditioned and tightly sealed, how would the sculpture move? In 1993, with the building complete, his *Faceted Column* was ready to install, but Rickey told Groenke he was prepared to withdraw the sculpture if it did not work.

A crew of handlers, among them Dennis Connors from East Chatham and Achim Pahle in Berlin, hoisted the sculpture in pieces to the top of the building's atrium, while George looked on with a furrowed brow. Edie had a bad cough but she was there, with the black

patch over her left eye and, as always, dressed to kill. At the opening ceremony Rickey received the highest award from the Federal Republic of Germany—the Verdienstkreuz,1 klasse: Order of Merit, First Class. By that time he had been awarded nine honorary degrees and numerous medals and honors, including membership in the American Academy of Arts and Letters, but the Verdienstkreuz was to him perhaps the pinnacle of achievement, and particularly symbolic of his success abroad.

The honor from his adopted city of Berlin was followed by a shocking discovery from the city of his childhood, with the kind of bad news that all creators of public sculpture learn to dread. On his way home from a Berlin installation, Dennis Connors stopped in Glasgow to view the two sculptures George had given to the city following his exhibition on 1982 and which they had learned had only recently been installed in Festival Park. One was *Three Right Angles Horizontal*, to be positioned over a pond. Unfortunately, within just a few days, some schoolchildren could not resist the temptation to climb on the sculpture, and amid concerns over public safety, it was promptly removed from the site by order of the park officials. The other, *Four L's Excentric* (the "Papal Cross"), had also been removed from its pedestal in Festival Park. Investigating, Connors, along with George Wyllie, learned that rather than being safely stored away, the sculptures were left dismembered and unprotected in a fenced yard. Worst of all, the sculptor himself had never been notified.

Summoning his Scottish connections, Rickey sought advice on how to rescue his work from oblivion at a distance. Barbara Grigor had died, but her husband, Murray Grigor, took up the cause in her place. Cousin Willie Macdonald was already acting as an intermediary, overseeing the installation. As the situation developed, Clare Henry, a Glasgow journalist who had recently married Phillip Bruno, was promptly on the case with the press, lambasting the city authorities for their neglect. "Glasgow should be ashamed of itself," she wrote in the *Glasgow Herald*,[14] and Murray Grigor created a scathing

documentary film of the unfolding events. Mortified into action, the authorities searched for an alternate location for the "Papal Cross," and Rickey agreed to provide a replacement, at the city's expense, as it was beyond repair. Afterward, he told Grigor that "it will be a great relief to me if this saga comes to a happy end."[15] Sadly, he would not live to see the situation resolved.[16]

34

Full Circle

"FUCK THE work, girls," Edie commanded as she strode into the workshop office one spring day, "talk to me!"[1] Enormously tall and dramatic, with her low, smoky voice and a black patch over one eye, Edie made a big first impression on Anne Undeland, a young actress working the Berkshires summer circuit, who joined the Rickey staff in 1992. George and Edie had been in Berlin for the first few weeks of Anne's employment, and she remembered the nervous anticipation in the office as the date of their homecoming approached. Edie in the flesh more than lived up to her much touted larger-than-life personality in both figure and speech. She had stories to tell, gossip to share, and colorful phrases that made light of the day to day and boasted her deep familiarity with the work at hand.

Edie could be full of charm, but her presence often left "a little after burn,"[2] as Mark Pollock aptly put it. Undeland had been hired specifically to assist Edie with cataloging. She soon learned to be wary of Edie's moods. When Anne misplaced a file one day, Edie "ripped me up one side and down the other for incompetence," she grimly

recalled.[3] It was but slight comfort to understand in retrospect that Edie was drunk.

In those days, Edie's personal assistants did not typically stick around for long. Rickeyville, as Edie liked to call it, had begun to take on a somewhat bizarre atmosphere that only the deeply indoctrinated could interpret, and even they would sometimes find it difficult to understand. The parameters of the job were never clearly defined, the boundaries between the help and the family were often blurry, and the day could be full of surprises. One hapless young woman fresh on the job was asked to come into Edie's bathroom while she stood stark naked on the scales and ordered her to read the numbers aloud.

Out-of-town visitors saw the old George and Edie tag team at work, but those closer to the scene felt more than the normal rumbling beneath the surface and instability in the air, which George, in his eighties, strived to keep in balance. Edie was drinking again; the success of her treatment at the Betty Ford Center, followed by AA meetings, lasted hardly more than a year. Philip attributed his mother's relapse to her involvement in preparing the Berlinische Galerie book about George's Berlin years with Jörn Merkert, a project that in 1990 brought her back from the relative sanctuary of Santa Barbara to the busy Rickey workshop in East Chatham. In a huddle with Jörn over dates and details, in the stress over deadlines and the excitement of giving her value to an important project, the old vices crept up on her again. Though she had joined the prescribed AA program in Santa Barbara and George had understood that a "cure" would require his continued support, somehow the program had fallen through the cracks once Edie was home in East Chatham.

George did what he could to steer Edie away from disrupting the workshop staff and to focus on the social and domestic aspects of her role; at the same time, however, increasingly he depended on her memory, especially as he began to feel the effects of losing his own. It was becoming apparent how seamlessly they were woven together. One day, noticing George scratch his head over a forgotten date, Birgit

suggested they ask Edie. "She'll remember," said Birgit. Calling on Edie, Birgit heard George say, "I don't need you, I need your memory,"[4] as if, as Stuart perceived, "it was like a prosthetic limb."[5]

In an earlier era, George had trusted Edie with decoration, her passion. With her first project—the decoration of his apartment in New York before they were married—he was surprised and delighted when she led him, blindfolded, up the stairs to view the transformation. But George was no longer interested in being surprised by Edie; instead, he dreaded it. In East Chatham the definition of domestic space had become something of a contest of wills, a tit for a tat. Each took to making changes in the house while the other was away. When George was out of town, Edie redecorated their bedroom with her prize Biedermeier furniture and heavy swag curtains, like a grand apartment on Park Avenue. Arriving home to this surprising reinterpretation of their marital suite, George felt out of place in his work shirt and muddy boots. Who was it for?

Then, when Edie was in Santa Barbara over the winter of 1994, George undertook a restoration of the back entryway, which led to an expansion of the kitchen. Norman and Philip weighed in on the plans, while David Mieschonz and a local stonemason, Jay Moore, advised as contractors, and Edie was invited to express her preferences from afar. But when she returned home to the result, she felt disoriented. Her kitchen—*her* workshop—was no longer her exclusive domain. The changes they made had put her to one side. But in her compromised position as a relapsed alcoholic, Edie was in less of a position to argue.

Edie's health was in a precipitous fall on several fronts. Her bone density was dangerously low, leading to easy fractures. Her lungs were weak, making her prone to pneumonia. She had returned to drinking furtively, spiking her morning orange juice with vodka, hiding bottles in her handbag and stuffing them into file cabinets. In September 1994, in East Chatham, she tripped on the steps on the way to the dentist and developed chronic back pain. She also developed a bronchial

infection. On pain medication, she was semi-ambulatory and spent much of her time in bed, a cane by her side to tap on the floor to summon anyone from downstairs when she needed something. The family urged her to reenter addiction treatment, and she agreed.

In December she made a short stop at her favorite spa, the Greenhouse in Dallas, on her way to Santa Barbara. Her plan was to spend the month of January at the Betty Ford Center. Norman de Vall, who had retired from the board of supervisors for Mendocino County, was free to help.

On New Year's Eve, Norman picked her up at LAX and delivered her to Irma Cavat's at Hope Ranch, and planned to see her safely into the program. They had dinner that night with the Doles. "Happy New Year," Norman faxed George, Stuart, and Philip the next day, with a full report on Edie's condition.[6] She was frail and very thin, sleeping poorly, smoking and coughing incessantly. She was on a prescribed antidepressant and she confessed that she was also taking a shot of vodka every day, and likely more.

On her way to an appointment with her doctor at the Cottage Hospital, Edie fell against the kitchen door. Dr. Meitus, who was familiar with her chronic obstructive lung disease, alcoholism, and osteoporosis, diagnosed her with a severe bronchial infection approaching pneumonia and a fractured pelvis. He recommended a milder, over-the-counter antidepressant and that alcohol be removed from the house. Norman postponed her stay at Betty Ford, as it was clear she was not ready, physically or mentally, for the demands of the program. In her condition, it was deemed a better fit for Edie to go to the Chemical Dependency Program at the Cottage Hospital, where her physical condition could also be closely monitored and treated. Less rigorous than Betty Ford, visitors and phone calls were encouraged at the Cottage, smoking was allowed in the courtyard, and the facility was not locked. Edie took advantage of her relative freedom to venture out for shopping trips, the main purpose being, as she later confessed to Benigna Chilla, to have a couple of drinks at a bar. She would later

return to the hospital swinging a boutique bag of new clothes she would never wear.

Meanwhile, plans about her care after the usual twenty-eight-day program of rehab at the Cottage were hotly debated among family and friends. The fax machine was in constant use for daily bicoastal bulletins, between Norman in Santa Barbara and George in East Chatham; local opinions were offered from the wings by Irma Cavat, Kate Dole, and Alfred Moir; and Philip, in Saint Paul, and Stuart, in San Francisco, added their thoughts. George wanted her home, but not in the house. Although he wanted to keep her near, he was determined to insulate himself from her emotional instability and erratic behavior. To that end, he was busy preparing special quarters for her recovery—a sort of homemade rehab in the newly renovated basement apartment of the Sherman house, with wheelchair access, a hospital bed, and plenty of staff around to assist.

"I am here 24 hours a day and readily adaptable," he promised Norman.[7] Their doctor at the Pittsfield Medical Center was twenty minutes away. But would she be happy there, especially in the dead of winter, or happier returning to Irma's at Hope Ranch for a month or so in transition? On the other hand, could Irma really cope, even with regular visits from a registered nurse?

The question hung in the balance when on February 14, Valentine's Day, Edie was released from the Cottage Hospital and Norman took her back to Hope Ranch. At first she appeared to be more stable, but she was still weak and depressed. In the past, Edie could call on her reserves of energy and humor to spin a positive picture of her trials, as George had commended her years before—"how you can still find a way to laugh when you are most unhappy."[8] She had lost touch with her indomitable spirit.

Full of remorse for her addictive behavior, she penned an emotional fax to her children and grandchildren. "I've thrown you away with both hands," she ardently confessed on Valentine's Day.[9] She admitted to feeling that she was not safe, to herself or to anyone else.

It was apparent to Norman that her will to live was waning. A few nights later she slid off the bed, causing further back pain, and the following night she took twenty sleeping pills. After a brief return to the Cottage Hospital psychiatric unit, while Norman and George hurriedly coordinated plans for her release, on February 21 she flew home from Santa Barbara first class on United Airlines, with Norman by her side.

The Sherman house apartment was ready for her. George assigned a bright young member of the workshop staff, Krissy Samms, to check in on her during the day, and Ella Lamond, an old familiar friend, was the night nurse. But George did not trust Edie with a telephone, whether to keep her from calling friends and begging them to bring her alcohol or to keep her from thinking about her other addiction—working—or both. He was challenging her to live quietly and contemplatively; he was caring for her and at the same time protecting his operation from her unpredictable and often histrionic behavior. Edie felt strange and isolated, even in those familiar surroundings, and perhaps all the more so to know that the workshop, only a few hundred yards away, was alive with activity of which she was no longer a vital part. She had left the sunshine of Southern California. It was the dead of winter in Columbia County. In the basement of Sherman house, she felt buried alive.

Edie's next stop was Martin House, a nursing home in Hudson, New York, a once thriving industrial town, then an all-but-forgotten stop on the Amtrak line from New York to Canada. Martin House was a grand old Victorian mansion with a homey, historic appeal. Although the staff there were concerned about her history of alcoholism, they admitted her in early March, with a large room of her own. The night of her entry, she trashed the room, tore the blinds from the windows, shouted, and pounded on the floor; she vomited her breakfast the next morning. George, who was occupied with transferring his sister Elizabeth to a nursing home that same day, arrived on the scene to see her by ambulance to the Columbia Greene Medical Center in

Hudson. She was depressed and severely disoriented. "I don't know who I am," she kept saying.

The doctor explained that her low sodium level—hyponatremia—had interfered with the proper functioning of her brain, and prescribed a strictly limited fluid intake. Returning to Martin House, Edie and the staff struggled with her multiple medical conditions. In April, George, Stuart, and Philip visited her. They consulted with her doctors and determined that she was not getting the care she needed at Martin House. In early April, she was moved to the psychiatric unit at the Berkshire Medical Center in Pittsfield. From that point on, Edie's well-being went into free fall. She would never come home again.

Another fall from her bed, which led to another fracture and another surgery, laid Edie up through the spring. A cocktail of a dozen or so medications to deal with her depression, her low sodium, her pain, and her addiction, ever shifting and adjusting, exacerbated one problem even as it treated another, and she was shuttled from the hospital to the addiction center and back again. Edie, deprived of alcohol and cigarettes and estranged from her work and her home, was dissolving inside. Her physical frailty—chronic back pain, surgery wounds that refused to heal, and the psychotropic drugs that battled inside her system—further reduced her will to live. On June 24, 1995, she breathed her last. She died of pneumonia, arrhythmia, and chronic obstructive pulmonary disease a few weeks shy of her seventy-first birthday.[10] Elizabeth Rickey had died two months earlier, at ninety-one.

Mystified by her early death, some would say that Edie died of a broken heart. All would agree that without her devoted assistance over the years George would not have been nearly as successful an artist. She was the keeper of the flame and the fire at its center. Her administrative and social gifts aside, Edie was more than that, a subtler thing that was harder to define. She was the randomness he craved as a counterpoint to his order. She was the whirlwind that blew through his life every day and kept everything in motion. She was the

backbone of his enterprise that kept it on its steady course. She was also the lighthearted spirit to George's intellectual side that brought humor and irreverence to his exalted artistic drive. "I'm the comic relief," she would say.[11]

A memorial service was planned in the garden in East Chatham, and, in the Rickey tradition, a Walkabout. Friends came from New York, the West Coast, and Europe to honor her. Set for three o'clock, they waited in the drizzling rain for guests to arrive from a late train to Hudson. They sat on folding chairs on the sloping lawn under a sea of umbrellas, surrounded by George's waving spears. An Episcopal priest dressed in black read from the Book of Common Prayer. There was no music. As for George, Cooie Harper observed, he "did not seem grief-stricken at losing his wife . . . the past, even last week, is too much to remember and the future may never arrive."[12] At the service, George spoke of Edie's many talents and pleasures, and he also regrettably acknowledged her failure, for lack of time and resources, "to live up to her imagination, and to her wish and her will. Each day was too short, the motor could not recharge. The doctors could no longer keep up with her pace. Edie passed on. If you see a flash and hear a rumble, maybe she's just begun Scene 2, up there."[13]

In the metal hangar down the road, her colorful collections of wearable art and jewelry were displayed for all to admire. They buried her ashes up the hill a few hundred yards from the house, in what was to become a little family cemetery.

SOON AFTER Edie died, George embarked on a radical redesign of the landscape around the house, as if to banish her memory from his daily environment, but also with ideas he had harbored since the early 1970s and had put aside.[14] The little patio surrounded by a lilac hedge outside the sliding glass doors of the living room—Edie's summer dining room—had lost its purpose. To Philip's horror, his father had the lilacs dug up and replanted at a remove from the house. In place

of the patio, George envisioned a kind of amphitheater in which his sculptures would perform. He commissioned Jay Moore, a talented stonemason, to carve concentric tiers into the slope of the lawn and bolster them with artful bands of local stone and built-in benches.

The interior of the house acquired a different mood. In rooms that Edie once filled with activity, there was now an eerie stillness. The rattle of her typewriter was silenced. Her desk was left in a stagnant confusion of papers and files. Her bustling kitchen went quiet. George abandoned the master bedroom with a view to the distant hills and slept instead in a little room at the back of the house facing the woods.

He put her Yellow House on the market, complete with her uniquely decorated "Maisonette." He took her portrait by Max Beckmann off the wall of the living room and offered it as a gift to the St. Louis Art Museum in her memory. The little Calder mobile that sealed their marriage had been given away to the Neuberger Museum in Purchase, New York, along with the couple's extensive collection of Constructivist art. The rich layering of pictures and objects had been stripped down, and what was left had lost its immediacy, its connection to the story of the couple's life in art. "The house was sort of echo-y and unloved," remembered Nina Gabo, who visited George after Edie's death.[15] Edie had left a void George was never expecting he would have to fill. Seventeen years his junior, she was supposed to have seen him through his old age. "He didn't realize how seriously he would miss her," said Birgit Meischonz.[16]

Some saw a reemergence of the pre-Edie George in a positive light. Bea Farwell, who had known George since 1940, appreciated how "the frugality of the orange crate and the rumpled shirt resurfaced, and the work claimed him as it always did."[17] In this unexpected quietude, George insisted that he enjoyed his own company, but it brought about a yearning as well—to condense his studio space, cut back the staff, sell off property, reduce his inventory of sculpture, and simplify his life in every possible way. He looked back with longing for the rustic 1960s, when he and Edie first made the old farmhouse in

the woods their home. At the same time, continuous building projects kept his mind focused and a reason to keep people busy around him. He gutted and remodeled the basement of the house, imagining an art gallery or a little concert venue, a project both his staff and family looked upon with skepticism. He carved tiny cabins and washrooms out of larger spaces, as if preparing to ship off to sea. David Mieschonz compared George's building obsessions to his deep-seated seafaring instincts. The buildings were like a yacht that he endlessly fussed over in his spare time. Meanwhile, Billy and Ella Lamond hovered like family. Ella cooked lunch every day, and Billy slept in the house, in case George fell down in the night or left the stove on.

Without Edie, it was not easy to decide where to go for the winter, or whether he should go anywhere. But as the late fall of 1995 closed in, he wrote to Kate Dole, who encouraged him to come back to Santa Barbara, "It would be foolish to keep a staff here to shovel snow for my one pair of feet."[18] George had given Ken Bortolazzo the use of his studio and tools in California, just as he had done with Achim Pahle in Berlin, but when George returned to Santa Barbara, it was unclear whose space it really was, as the agreement with Irma had always been an unofficial life tenancy. Without Edie, he no longer felt welcome. Kate Dole came to the rescue, offering him their garage as a studio. As for lodging, for the time being he would take up residence in a modest room at the Sandman Motel on outer State Street. Debby Dole picked him up every morning, took him out to breakfast, and delivered him to his studio, where he worked peacefully all day on his little sculptures, and then, after supper, took him back to the Sandman for the night. She found him inspiring. "He never wasted a moment," Debby remembered. "If he wasn't working on a piece of art, he always had pen and paper. He wrote constantly." Hilary Dole remembered how he worked to the minute they called him in for dinner: "Often we'd find him practically in the dark, so absorbed by what he was working on, he was unaware of the falling light." Over dinner, George would tell them stories of his childhood in Scotland and of wartime

in Denver. Often, Hilary recalled, "he would end the story by saying, 'and so you see, it all turned out very well.'"[19] A year later, Kate offered George the little guest cottage at their house on Los Olivos as his winter quarters. "You set us all such a good example of what a diligent work ethic can do," Kate wrote to him.[20] Devoted as they had been to Edie's care in her last months, the Doles were equally prepared to look after George as a widower.

As GEORGE'S ninetieth birthday approached, Max Davidson organized an exhibition at his new gallery space in the Fuller Building, on 57th Street. During a recent summer, when Max and Mary rented Edie's Yellow House in East Chatham, they discovered a trove of George's early work in the goat shed at the bottom of the lawn. Max was fascinated to see the emergence of Rickey's kinetic sculpture from the 1950s and early 1960s, which he had not shown publicly for decades. The ninetieth-birthday exhibition would bring some of these early works to light again, with his allusions to the natural world in *Tree, Sedge,* and *Wave,* and the beginnings of his blade pieces in *Summer Sketch.* Wrote Davidson in the catalogue, "[T]he creative diversity of these early sculptures is astonishing,"[21] and he was grateful that George was ready to bring them to light again. Although George was willing, he showed little interest in his past work. "He was only interested in the next thing," recalled Davidson.[22]

Another project that would honor Rickey's life and art was in the works that year: an hourlong documentary by his young cousin Kevin Macdonald. Kevin and his brother Andrew were both pursuing careers in film, following in the footsteps of their maternal grandfather, the legendary director Emeric Pressburger. Kevin was getting his start as a documentary filmmaker; Andrew had put Edinburgh on the map as an edgy contemporary scene with his productions of *Shallow Grave* and *Trainspotting.* George Rickey, their first cousin twice removed, had been an inspiring model for the young Macdonald brothers.

Their father, Willie, had spent two seasons in the Rickey workshop, and they would never forget the Rickeys' generosity and encouragement in their student years. When Kevin left Glenalmond for Oxford, an anonymous donor sent him money to spend on cultural pursuits. Andrew received the same. They later learned that the anonymous donor was Edie.

Seth Schneidman's documentary about Rickey had never made it to distribution, but it had a great deal of valuable footage, now more than twenty years old. George proposed to Kevin that he make use of Seth's work and with some filmmaking of his own create a full-length documentary. Kevin regarded his cousin's sculptures as "very cinematic, space-age objects,"[23] and was excited at the prospect. They would call it *The Moving World of George Rickey.*

The project set George to thinking about his past, a subject that indeed preoccupied him more and more. In order to capture his childhood memories vividly on film, he traveled to Scotland with Philip in 1997. They began their tour in Glasgow, visited the family house in Helensburgh overlooking the Clyde, and traveled on to Glenalmond to tour the campus and locate his name in gold letters on the walls of the cloister for his place on the 1924–25 rugby team. George could point to his dorm-room window at Goodacres, and cheerfully recalled how he started every morning with a dunk in the ice-cold "Wallows." They visited his *Two Lines Up Excentric VI*, from 1977, on the lawn of the Scottish National Gallery of Modern Art in Edinburgh. For his film, Kevin would also salvage much of Schneidman's irreplaceable footage, such as scenes of domestic life at the Bundesplatz studio in Berlin and of the installation of his retrospective at the Guggenheim in 1979.

Back in East Chatham that winter, George was able to show Kevin his latest work. Beginning in 1994, he had been experimenting with circles, inspired by an annular eclipse that year on May 10. This is the kind of solar eclipse in which the moon moves in front of the sun but is too far away to cover it completely, leaving a ring of fire around the edge. George was riveted by the spectacle, and involved everyone in

his excitement about the event and his ideas for a sculpture that would somehow create an image of this planetary phenomenon. For the first time in decades, Rickey would give his new sculpture a title that referenced nature, and perhaps for the first time ever, the concept would begin—not end—with its title, *Annular Eclipse*. Like all of his other sculpture, it was not as simple as it looked. Outside the studio window in the snow, a single stainless-steel circle, eight feet in diameter, attached to a post, moved three hundred sixty-five degrees in a single plane. It was just the beginning.

35

Saint Paul

EVEN IN his ninth decade, George Rickey never wavered from his habit of returning to work every evening after supper. For decades he would head out the back door to the upper studio, where he constructed small kinetic sculptures by hand and conjured up ideas for larger sculptures. Lately he had returned to color, applying a mixed palette of acrylic paint to small tabletop works of stainless steel, each one balanced on a straight pin glued to a square stone base. His eyesight was not what it used to be, and years of using his hands in the intricate work and repetitive movements of building sculptures had left a numbness in his fingers brought on by a pinched nerve in his left wrist, and though he had been operated on for carpel tunnel syndrome, convalescence was slow, and cutting and bending metal was arduous and painful. For most of his life he had been virtually ambidextrous: He divided up the tasks between his two hands, working with tools in his left—his "mechanical hand" for cutting and welding—and writing and painting with his right, which he now favored.

A former workshop assistant, Mark Tavares, returned to spend a few hours a day with George, helping him to cut and bend the shapes to his liking. George considered the making of these small, painted sculptures "a good solution to advancing age,"[1] and he made them by the score.

In the late fall of 1997, as the days grew colder and darkness fell earlier, George felt the urgency of the work still before him. At the same time, he planned his yearly escape. Wherever he might spend the winter, it would be a relief to be away from East Chatham, where he felt constantly robbed of his precious remaining time by administrative problems that seemed to grow by themselves, and out of nowhere. While projects continued in the workshop, George was no longer sure who was doing what exactly, and whether anyone was doing it right. The workshop seemed lately to have developed a life of its own. Increasingly, he wondered if his assistants were making technical and management decisions without consulting him. Most vexing was that he could not always recall his own instructions to his staff. He could no longer trust his memory of the discussions they had either had or not had, even five minutes before, what had been said or not said, who had said yes or no, and to what question.

His brain, which for all his life had been a nimble instrument that had come to his aid at a moment's notice, carrying within it a vast storage of encyclopedic knowledge—formulas and equations, the Latin roots of English words, passages from Milton, Keats, and Shelley, entire speeches, sonnets from Shakespeare, the names and dates of all the kings and queens of England and Scotland—was now unreliable. The information was there, but how to access it? "There's nothing wrong with my memory bank, only with retrieval," he would say, smiling.[2] He was long in the habit of scratching his head when he was working something out in his mind. Lately, in frustration, he would bang the side of his head with the heel of his hand, as if to kick-start the machine inside.

When the Muse came knocking, he would hold his head tightly

with both hands, as if to trap the inspiration inside. Sometimes the Muse came to him in daylight, as he was shaving or washing dishes or filing a metal part; sometimes she arrived early in the morning as he lay in bed in a state between wakefulness and slumber. The important thing was to resist the temptation to go back to sleep, and instead to reach for the pen and paper on the bedside table and make a note, that the idea not die "before my pen has gleaned my teeming brain,"[3] as Keats, he recalled, had put it so well. It might be a new idea; often it was a solution to an idea already in the works. Whichever it was, he lamented, "The Muse is willing but shy," and "It is clear that if one doesn't answer her knock promptly she goes away, doubtless pouting and reluctant to return."[4]

The inveterate note taker, George counted on his favorite blue felt-tipped pens and yellow notepads at key locations around the house, but now when he reached for them, they were not always there. And that was only one of his many complaints. As members of the staff came and went through the house freely, there was too much activity to keep track of. Paranoia settled around him. Someone, it seemed, had tuned the radio to strange stations he never listened to. The coffee had been raided again. The bottle of cognac, his personal nightcap, was down an inch, even though he had drawn a skull and crossbones on the bottle and marked it, in block letters, POISON.

As the staff became aware of George's short-term memory loss and its effect on his mood, they scrambled to cope. He tended to point a finger, even if there was no foundation for his suspicion, whether it was at a longtime staff member or at someone new to the scene, and to take action in unexpected ways. In the past, "he trusted everyone who worked for him," remembered Birgit Mieschonz,[5] but as he aged, that trust began to erode, and with it his ability to delegate.

In the workshop, he was especially vexed by the structural problems of the large circles then under way. The concept had begun in 1994 with a small, wall-mounted circle on a knife-edge bearing. Ultimately, he envisioned an outdoor sculpture—a pair of circles—scaled

up to eight or even sixteen feet in diameter. Instead of the excentric, gyratory movement he had lately favored, the circles would be taking turns at leading and following in a continuous planar dialogue of movement, and momentarily, often gently, coming together as one. He was particularly interested in the crescent forms the pair of circles would alternately make with its movements, and the symbolism built into the root of the word, the Latin *cresco*, to grow.

He soon discovered the challenge of joining the stainless steel in a perfect circle without distortion. He also discovered that reinforcing the circles with a steel tube inside the triangular section caused stress on the structure when it moved. While he turned to Roland Hummel and Dennis Connors for their help with ideas and solutions, he no longer trusted them. "Neither you nor Roland asked the essential question about the stresses," he wrote in a note to Dennis,[6] as he worried about what else they may have overlooked. The closer a staff member was to him, the more George distrusted that person's judgment, resented his autonomy, and feared his ability to control his destiny. With no foundation, he suspected that Dennis, with all the special skills he had learned working for him, might continue to make his sculptures after he died. "He turned against me," Dennis recalled. "He wanted to ease me out."[7]

George did, however, entrust Dennis and Roland Hummel with the installation of *Two Rectangles Vertical Gyratory Up V*, at the Gibbs Sculpture collection in Auckland, in 1998, as he did not feel up to the journey, but not before sending Dennis a warning that his time in the Rickey workshop might soon be up. Shortly afterward, he negotiated a severance package and let Dennis go.

THAT WELL-OILED machine—the George Rickey workshop—had lately become a place of tension and uncertainty for all concerned. George would deliver little handwritten notes to workshop staff with his orders and complaints of the day. The staff braced themselves

when he entered the lower studio for his daily rounds. Newcomers and veteran members of the Rickey staff alike felt the constant risk of reprimand, or worse: the abrupt loss of their job. As Birgit began to realize that George was losing his memory, she struggled to adjust her modus operandi. At first, her natural response was to point out his error and remind him of what he had said before, but this instinct had to be recalibrated. George had changed. From now on, she resolved, we live in the present, because that is where George lives. "It's only now that matters," she recalled thinking. "If he says he wasn't there, even if he was, we go along with it. From now on, we never remind him of anything. We never say, don't you remember, George, what you said?"[8]

He seemed to thrive in a state of continuous motion, with several balls in the air that kept his mind active in ways that his sculpture no longer fully did. Plans for his escape to a simpler life took various forms. One was the idea of reducing his workshop to a studio on wheels that could be driven and parked anywhere he pleased, then picked up and moved again. But this fantasy was just one side of the seesaw, or one end of the pendulum, depending on the winds of the day. On the other side, at the other end, he urgently sought order to the vast archive of his life and work. Caught between preparing his grave and grasping his last lease on life, dual instincts battled inside him day and night. "Sic transit gloria mundi," do not to try to keep the ghost alive, he frequently muttered in notes to himself.

He also felt the need for a new kind of staff member, someone he described as an "amanuensis," the closest he could come to defining the role that Edie had played in the best of times and which he now felt a great need to replace—someone he could count on to be at his side and who could respond intelligently to his thoughts. Lane Faison, retired art history professor at Williams College, recommended Joan Dix Blair, a former student then in her fifties.

George liked her gentle and well-spoken manner, and that when asked a question, she answered in the conditional tense. Aware that

George was suffering from memory loss, Joan arrived in the same flowered linen suit for her first few days of work to make sure he would remember who she was. Her job, as she saw it, was essentially to keep George focused, organized, and comfortable. From the workshop's point of view, Joan was helpful in seeing him safely across the road and then keeping him from lingering overly long. She established afternoon teatime, and in that peaceful interlude he asked her to read poetry aloud from the golden treasury of his youth. At a certain hour, she handed him off to Mark Tavares, in the upper studio, to work on his little painted sculptures. When she left for the day, she would make sure that George's notepads and felt-tipped pens were stationed where he expected to find them, and his calendar and schedule for the next day laid out before him. On the rare occasion, she prepared him to attend a luncheon at the Century Association, his private men's club in New York City, or a meeting at the American Academy of Arts and Letters, which awarded him the gold medal for sculpture in 1995, the year Edie died. Joan packed his shoulder bag with his papers and pads and made sure his American Academy pin was in the lapel of his favorite jacket. She also made sure that Billy Lamond was ready to drive him down to the city for the day.

Over the years, various employees, among them Edie, David Lee, Lucinda Barnes, and Gail Day, had undertaken archival projects, as had George himself. In 1997, George found his first professional archivist. Maria Lizzi, fresh out of SUNY Albany with an undergraduate degree in art history and master's in library science, was interested in the opportunity to apply her skills with a living artist. All of twenty-five, Lizzi had a passion for research and the skeptical nature of a true historian. She was attracted to the solitary nature of the job, of "working with people at a safe distance, so I can box up their stories and put them away when they become overwhelming."9 She also had the academic credentials to make a favorable first impression on George. During her interview, she could answer correctly his question about the meaning and origins of the phrase "beyond the pale." Once

hired, however, it was not immediately clear to Lizzi where to begin. There were several filing systems to get acquainted with, and then the problem of how to merge them into a coherent and retrievable whole.

Lizzi noticed that George was only interested in the distant past, and that anything after his marriage to Edie seemed to be blocked from his memory. Perhaps it was too painful to think about their years together, both the good years that he missed and the unhappy years he regretted. Perhaps, on the other hand, with Edie gone, the pre-Edie days came into sharper focus. For whatever reason, he had Lizzi chasing down the facts and dates of people who had crossed his path long ago: when, where, and why. He was drafting his memoirs, dredging up primal, sensual impressions of his childhood in Scotland and student days at Oxford to the last vivid detail. On these subjects his mind was bright. In others, it meandered and lost its way. Pen and paper were his compass and his anchor.

Once acquainted with the barrage of little notes George produced throughout the day and their often negative effects on the staff, Lizzi gave herself a new routine. Every morning she would stop first at the house before George was up and about and collect his handwritten notes to his staff, airing his worries, his complaints, and his latest ideas, which he left scattered around the various rooms. She would take them down to her office in the workshop and consider whether or not they should be delivered, if they actually specified something to be done or were simply the irrational ravings of a moment that would pass. To spare recipients an unnecessary rant, she often summarized the content to them verbally. Most of the time she regarded these notes as archival evidence of the artist's aging mind and preoccupations and simply filed them away.

WITH HIS mind then constantly on estate planning and the distribution of his inventory of sculptures, George had three main concerns: the financial security of his heirs, the tax consequences of their

inheritance, and the preservation of his artistic legacy. As early as 1989, he had discussed the future of his estate with his closest confidants. For an informational meeting in the corner office of his tax lawyer, Ralph Lerner, he gathered Nan Rosenthal, Ed Fry—a curator and old family friend—and his sons, Stuart and Philip. Less officially and more immediately, George had also called on his nephew Norman de Vall's advice in sorting out the estate finances, consolidating his real estate, and reducing his staff.

Of his two sons, George had spent more time conferring with Stuart about estate business, believing him more likely to be interested in taking it on than would his younger brother. With six years between them, Stuart and Philip belonged, in a way, to different eras and they took after each of their parents in different ways. Stuart was quiet, deliberate, and thoughtful. He chose his words with precision and used his facts with care, like his father, though he was also quick-witted, like Edie. Like George, he sought lightness and movement that offset his highly structured intellect, beginning with an interest in music in his teens, then film in his twenties, and, some time later, the tango. Like both his parents, Stuart was restless, adventurous, and reluctant to settle down. Philip, like Edie, was a hands-on learner, a voluble talker, and given to rambling and sometimes emotional tangents.

Philip, however, had more literally followed in his father's footsteps by becoming a sculptor, although he consciously aimed to distance himself from George's example, with a hardness and permanence to his work in stone that was the antithesis of his father's kinetic sculptures. In an effort to distinguish himself during his college years, he exchanged the name Rickey for his mother's maiden name, Leighton, when signing a work. When he married Mary, she reasoned, "Whether you change your name or not you're still the son of George Rickey," and he took her point. In 1993, Philip and George had shared father-and-son exhibitions at the Inkfish Gallery, in Denver, and earlier, in 1990, *A Family Affair*, including paintings by Mary, at the

Arpel Gallery, in Santa Barbara. George, comparing Philip to himself, honored his son's more traditional approach by calling him "the real sculptor."[10]

Stuart, by then living in San Francisco with his partner, Virginia King, made occasional visits to East Chatham, whereas Philip, married to Mary and with two small children in Saint Paul, came more often. In the 1990s, as Philip sought a renewed closeness with his father and to the scene in East Chatham, Stuart sought some distance.

In the late 1990s, George was alarmed at the size of his inventory of unsold sculptures and pondered the options of sales or gifts, while retaining a portion as archival material as a record of his career. He designated the metal hangar as a storage for his sculpture archives for some five hundred small pieces as well as prototypes or "hard to sell" pieces still in his inventory. He considered the feasibility of setting up a George Rickey Foundation for scholars and visitors. But that would require substantial funding and, once he was gone, East Chatham seemed a remote location to attract interested traffic. Around that time, an offer came from the amiable Charles Loving, director of the Snite Museum at Notre Dame University, to take on his entire archives of works of art, papers, and correspondence spanning his lifetime and to create a George Rickey sculpture center. Though a Catholic institution was alien to his nonreligious outlook, and his "decidedly anti-Catholic streak," as detected by Maria Lizzi,[11] South Bend was his birthplace, and the city had made a favorable impression on him with his four-part retrospective exhibition in 1985. The Snite Museum gave him another show, in 1997, on the occasion of his ninetieth birthday. In a further bid for his archives, in 2000 Notre Dame offered him an honorary doctor of fine arts, his tenth honorary degree. At that point, the deal was struck.

Another satisfying sense of completion for Rickey came in May that year when one of his last major sculptures was installed, on Park Avenue in New York City between 61st and 62nd Streets, by invitation of the NYC Park Avenue Mall Sculpture Committee. This was the

fully completed pair of circles he called *Annular Eclipse V*, one of several in a series he had begun in 1994. It had taken many years of trial and error and, above all, determination. Rickey had finally achieved the results he was looking for. Following the technical struggles he and his team had faced in his own workshop, he turned to his veteran assistant Steve Day, who had established a workshop of his own in Old Chatham. With the lessons of trial and error in his favor, and with the additional advantage of not being constantly under George's critical gaze, Day was able to construct the circles to his specifications. "Circles," said Day, "are a whole other metalworking process and require creative adaptations of metalworking machines."[12]

The largest version of the sculpture—sixteen feet in diameter at a height of twenty-five feet—was erected in a field to the west of the Rickey house where it focused the view of the distant hills. From then on, it was a performance George enjoyed every day. A smaller pair, eight feet in diameter, traveled down to New York City for the installation on Park Avenue.

Kevin Macdonald, by then an Oscar-winning documentary film director, flew in from London to make a short film of the installation as it unfolded on a bright and breezy day in late May. The film shows George, aged ninety-three, seated in a folding chair on the median strip, a cane resting between his knees, while assistants unload the piece from a moving van and lift it into place, and Birgit, sharing his excitement, hovering by his side. "I never expected to be embraced by the skyscrapers," George says, as he watches his pair of circles secured into place on Park Avenue. From long experience, he had learned never to take the success of a sculpture installation in a new environment for granted. "It's doing its stuff!" he exclaims with a smile,[13] when the circles begin their performance and passersby on the sidewalk or leaning out of car windows gaze up at the surprising spectacle. It would remain there for the next six months.

✳ ✳ ✳

DESPITE THESE astonishing achievements for a man of his age, Philip and Mary grew concerned not only about George's ability to make important decisions about his future but also about his ability to manage his staff, and they to manage him. Handling sales, Birgit had grown increasingly weary of George's frequent changes of heart. She would promise a sculpture to a collector only to have to withdraw it when George changed his mind, for no apparent reason. He would make an appointment with a client from Europe, and then at the last minute refuse to receive him. He agreed to meet Meryl Streep, who planned to drive over from Connecticut to view his work, but on the appointed day he said he was too tired to see her. For Birgit, rescuing the situation from disaster time after time was a fraught and exhausting exercise.

Equally exhausting was the way George would sit down in her office at the end of the day for a lengthy session stretching well into the dinner hour, until he had unloaded everything on his mind, most of which she had heard many times before. Birgit finally told Philip that her work had become impossible. By that time, Billy Lamond was not only spending the night in the house with George, but also helping to bathe and dress him, and Ella came in every day to cook his meals and keep the house clean. Billy told Philip one day in 2001 that they could not look after his father any more. He needed more care than they could give him, and in a safer place. This was the cue for Philip, now armed with power of attorney, to initiate his father's move from East Chatham to an assisted living facility near his home in Saint Paul for the last few months of his life.

In late June 2001, Birgit said goodbye to George. As her eyes brimmed with tears, he assured her that he would see her soon. She knew he would never come back to East Chatham, and nor would she visit him in Saint Paul, afraid that she might give him the false hope that she had come to rescue him and bring him home again.

In the Rosewood Estate assisted living facility, Philip had secured two adjacent small apartments for his father so that he could live in

one and make the other into a little sculpture studio. Mark Tavares came out to set it up with the tools he might need. At first agreeing to his move to Saint Paul, and enjoying the idea especially of seeing his grandchildren, Owen and Nora, on a regular basis, George soon felt anxious. Comfortable as Rosewood was, he hated his loss of control and his waning sense of purpose. During his first few weeks there, he packed his bags every day to go home again. He would call Birgit and other friends and beg them to come and get him. He would go out to the reception room and lie down on the floor in front of the front desk. "I've been kidnapped by my son," he would say. Accustomed to such adjustment pains among new residents, the staff dealt with his protests with calm and equanimity. Eventually he accepted his fate— of the three fates he would cite from Roman mythology, the one that cuts—and adapted to his circumstances.

He went for dinner at Philip and Mary's once or twice a week. Stuart visited periodically from California. He saw George's memory drift in and out, from coherent to incoherent, "like a pattern on a worn carpet."[14] A few friends came from the east. "He recognized me," remembered Max Davidson, and he was touched to see his old friend's "moments of clarity amidst ensuing fog."[15] Ever ready with his charcoal, George made a portrait of Max on the spot. Billy and Ella Lamond visited from East Chatham and Peter Nestler flew out to see him for the last time while on a visit to New York. Philip also hired a companion for George, a young photographer named Ina Valin. Ina would come over every day, keep him supplied with art materials, take him for walks, sit with him at meals, and talk. "They hit it off," remembered Philip, not only because Ina was interesting company, but also "he liked someone at his beck and call."[16] Stuart put it differently: "He loved having a beautiful young woman to talk to, and he loved being a teacher. There was always a little Pygmalion in George."[17]

Ina kept a daily journal about what they did, what they talked about, what he ate and drank, and how much. She noted that George never made use of his adjacent sculpture studio, but he did make

drawings in charcoal, pencil, or pastel every day. Just as he had done at Lowry Field, in Denver, during the war, he kept his observational skills sharpened by making portraits of his fellow residents at Rosewood. He also made countless drawings of flowers. After a while, the walls of his apartment were papered with his drawings.

In February 2002, George began to complain of lower back pain. He had been diagnosed with prostate cancer in 1991, but regular Lupron hormone therapy shots had kept it contained. When a decade later his cancer metastasized, he felt the disease as it worked its way through his system. Even so, he was not fully resigned to staying still. In March he wrote to Norman de Vall, "I hope that at some point, our paths may cross, by your travel, or mine. I work here now, with portraits, flowers, pastels, and inventions."[18] In May he laid down his pencils and pastels, without the strength to draw anymore. In July hospice care arrived at Rosewood to see him comfortably through his last days. He died on July 17, 2002, at ninety-five, with Stuart and Philip by his side. A small gathering in Saint Paul commemorated his last few months and honored the people who had cared for him there.

On October 24 of that year, friends came from far and wide for a memorial celebration of his life at the Guggenheim Museum. Five close friends—Nan Rosenthal, Werner Feibes, Bea Farwell, Peter Nestler, and Max Davidson—spoke of different chapters in his long journey, which had spanned a century. As Stuart and Philip wrote in a memorial booklet, the occasion was "an opportunity to remember the George we knew and recognized, but also introduced us to a George who was—for each of us in different ways—less familiar, and therefore surprising."[19] In closing, Stuart chose a verse from Alfred, Lord Tennyson.

> *Sunset and evening star,*
> *And one clear call for me!*
> *And may there be no moaning of the bar,*
> *When I put out to sea.*

Two days later, the family hosted a gathering and a Walkabout in East Chatham to mark his burial. George had made himself an urn for his ashes—a stainless-steel square box—and asked that it be laid next to Edie's in the woods above the house. His sons filled his favorite shoulder bag with the tools he might need in the afterlife: pad, pencils and pen, pliers, screwdriver, file, hammer, a coil of stainless-steel wire, and some metal scraps, stuffed the urn inside it too, and buried it under the trees.

ACKNOWLEDGMENTS

MANY PEOPLE have helped to bring this book into the world. Most of all, I have George Rickey himself to thank for preserving his life in a voluminous archive, and for vividly sketching his early years in an unpublished memoir. His correspondence with friends and family, especially with his wife Edie, his mother, Grace, and his lifelong friend Ulfert Wilke, has also provided exceptionally rich, candid, and detailed material of his day-to-day life from childhood to old age for his future biographer.

Maria Lizzi, whom Rickey hired as his archivist in 1997 and is the archivist to this day, has been an incomparable ally, patiently and meticulously serving up the relevant files at every stage of my research, as well as assisting with detective work in many areas beyond the reach of the Rickey archives. Conversations with Maria over my numerous visits to East Chatham added greatly to the shape, texture, historical context, and psychological insight of my writing. Maria's contribution to the first stage of editing the manuscript was also invaluable.

In addition to the Rickey archives held by the George Rickey Foundation, I have been assisted by many archivists and curators of other collections relating to the sculptor's life and work. I would like to thank Elaine Mundill, of Trinity College, Glenalmond; Jo

Sherington, of the Clydebank Library; Laura Mac Calman, of the West Dunbartonshire Council; Jane Marrison, of the Lomond School; Tom Melham of Holywell Manor, Oxford; Douglas Brown, of the Groton School; Lorna Hepburn, of Hill House; and archivists at the American Academy in Rome, the John Simon Guggenheim Foundation, the Winchester Thurston School, the Ellsworth Kelly studio, Kalamazoo College, the New Orleans Museum of Art, Tulane University, the Archives of American Art, Muhlenberg College, the University of Notre Dame, Balliol College, Oxford, the Santa Barbara Museum of Art, and the Berlinische Galerie, Berlin.

I was fortunate that the George Rickey Oral History Project was well under way when I began my research—a collection of interviews with Rickey's friends and associates conducted both near and far by Anne Undeland, Khushi Pasquale, Hilary Dole, and Nora Rickey. I was grateful to pick up the remaining interviews and in several cases add to interviews already done with Fletcher Benton, Rod and Daguerre Blackburn, Ken Bortolazzo, Karol Broniatowski, Phillip Bruno and Clare Henry, Daphne Buddensieg, Benigna Chilla, Dennis Connors, Giulia Cox, Michael Cullen, John Cunningham, Maxwell and Mary Davidson, Steve and Gail Day, Norman de Vall, Charles de Larbe, Debby Dole, Hilary Dole, Patricia Fansler, Steve Flanders, Werner Feibes, Pat Gelbart, Lucinda Gideon, Murray Grigor, Sam Harper, Victoria Harvey, Volker and Helga Henckle, Penny Hutchinson, Robert Janz, Charles Jencks, Doug King, Virginia King, Billy and Ella Lamond, David Lee, Linn and James Lee, Anne Lilly, Maria Lizzi, Lee Luria, Andrew Macdonald, Donald and Louise Macdonald, Jörn Merkert, Birgit and David Mieschonz, Janna Mietusch, Jay Moore, Alexandra Munroe, Rupert Murdoch, Peter Nestler, Achim Pahle, Khushi Pasquale, Mark Pollock, Philip Rickey, Stuart Rickey, Carl and Judy Schlossberg, Frederick Schwartz, Gabrielle Selz, Peter Selz, Jack Shear, George Sherwood, Mark Tavares, Anne Undeland, Rose Viggiano, Stephan Von Wiese, Maurice Weddington, and Nina and Graham Williams.

I am also especially grateful to Hilary Dole for providing access

to her interviews with George and Edie Rickey and with Alfred Moir that predated the Oral History Project. I would also like to thank Jed Perl and Michael Brenson for their thoughts on their research on Alexander Calder and David Smith, respectively, and to Reiko Tomii for generously discussing her groundbreaking scholarship on George Rickey relating to her PhD dissertation for the University of Texas, Austin, *George Rickey: Between Two Continents.*

This book would not have come about without the dedication of Philip Rickey. His initiation of the project and his active and unwavering support throughout are especially appreciated. Many hours on the phone and in person with Philip, including a memorable trip to Berlin, added greatly to my insights into George the man, the artist, and the father, and into Edie, his chief collaborator and matriarch. Philip also provided invaluable fact-checking at the final stages of the manuscript.

I would like to thank my agent, Ike Williams, for shepherding the biography from its inception safely into print. I am grateful to David Godine for signing the book for his eponymous publishing house and, following David's retirement, to president Will Thorndike, publisher David Allender, editors Joshua Bodwell and Celia Johnson, and designers Brooke Koven and Hilary Vlastelica for seeing the book through to publication at the level of quality we have come to expect from David Godine. I would also like to thank Richard Benefield, executive director of the George Rickey Foundation, for his attentive interest in the project.

My numerous visits to East Chatham were aided by the warm hospitality of Birgit Mieschonz, Mark Pollock, Anne Undeland, and Maria Lizzi of the Rickey workshop. All were equally welcoming to my dog, Ink. (I could not have done it without him.) I was fortunate to have good friends as neighbors in Columbia County: Tim Husband and Nicholas Haylett entertained me over delightful meals and outings too numerous to count. My son, Elliot Ouchterlony, who has appreciated Rickey's sculpture from an early age, buoyed my progress with his interest and support over the years, including, on a visit to East Chatham, his mastery of the Rickey Mobikit.

NOTES

Unless otherwise noted, all material cited below is from the George Rickey Archives, George Rickey Foundation, East Chatham, New York (to be transferred to the University of Notre Dame).

Rickey was a copious notetaker and preserved many of these documents in his archives, here cited as "notes to himself" and "study notes."

For a bibliography, technical glossary, and illustrated chronology of George Rickey's life, visit the George Rickey Foundation website: www.georgerickey.org.

CHAPTER 1 / **Eclipse**

1. Philip Rickey, conversation with the author, December 7, 2017.
2. Rupert Murdoch, interviewed by the author, July 11, 2017.
3. Tom Armstrong, et al., 200 *Years of American Sculpture* (Boston and New York: David R. Godine, in association with the Whitney Museum of American Art, 1976), 302.
4. Ken Johnson, "George Rickey," obituary, *New York Times*, July 21, 2002.
5. George Rickey, draft of untitled lecture, Amerika Haus, Berlin, 1979.
6. Ibid. 8.
7. Hayden Herrera, "George Rickey," in *George Rickey in South Bend* (South Bend: Art Center of South Bend/Indiana University/St. Mary's College/Snite Museum of Art Notre Dame University, 1985), 11.
8. George Rickey, manuscript, "Statement of Plans," application for Guggenheim Fellowship, 1960.

9. George Rickey, draft of lecture, "How Henry Hope Came to Indiana University," January 25, 1991.
10. George Rickey, "In the Fullness of Time," in *George Rickey zum 80 Geburstag: Skulpturen-Eine Werkubersicht* (Berlin: Galerie Pels-Leusden, 1987), 16.

CHAPTER 2 / **A Scottish Childhood**

1. George Rickey, memoir manuscript, "I remember…or do I?" 1990, 1.
2. Ibid.
3. Years later, George Rickey contributed to the restoration of the Athol Congregational Church tower in memory of his grandfather.
4. George Rickey, "I remember…", 3.
5. George Rickey, interviewed by Paul Cummings, June 11, 1968, Archives of American Art, Smithsonian Institution.
6. Ibid.
7. George Rickey, "I remember…", 2.
8. George Rickey, memoir manuscript, "What Has Come in My Time," n.d., 2.
9. George Rickey, "I remember…", 3.
10. George Rickey, untitled memoir manuscript, n.d., 45.
11. Ibid., 26.
12. Ibid., 2.
13. Ibid., 7.
14. Ibid., 25.
15. George Rickey, memoir manuscript, "Sailing", n.d., 8.

CHAPTER 3 / **Glenalmond**

1. George Rickey, untitled memoir manuscript, n.d., 16.
2. Ibid., 55.
3. Correspondence, George Rickey to Kate Rickey, February 12, 1922.
4. George Rickey, memoir manuscript, 48.
5. Ibid., 49.
6. Ibid., 51.
7. Ibid., 26.
8. Ibid., 53.
9. Correspondence, George Rickey to Grace Landon Rickey, June 1923.
10. Correspondence, George Rickey to Walter Rickey, September 1925.
11. George Rickey, notes to himself, n.d.
12. Correspondence, George Rickey to Walter Rickey, n.d.
13. Correspondence, George Lyward to Walter Rickey, June 9, 1925.
14. Correspondence, George Rickey to Walter Rickey, April 1925.
15. Correspondence, George Lyward to Walter Rickey, June 9, 1925.

CHAPTER 4 / **Oxford**

1. George Rickey, note to himself, "GR Memo," September 29, 1999.
2. George Rickey, Mediterranean-trip diary, August 1, 1925.
3. Correspondence, George Rickey to Henry Snow, March 7, 1994.
4. George Rickey, untitled memoir manuscript, n.d., 69.
5. Herbert Henry Asquith, "Political Notes," the *Times*, July 23, 1908.
6. Correspondence, George Lyward to George Rickey, October 7, 1926.
7. Ibid., July 6, 1927.
8. Ibid., March 2, 1928.
9. Correspondence, George Rickey to Jeremy Harvey, October 1, 1987.
10. David Boyd Haycock, *A Crisis of Brilliance: The Slade and Six Young British Artists* (London: Old St. Publishing, 2010), 14.
11. George Rickey, memoir manuscript, 70.
12. Ibid., 72.
13. Ibid., 73.
14. Ibid., 74.

CHAPTER 5 / **Paris**

1. George Rickey, interviewed by Paul Cummings, June 11, 1968, Archives of American Art, Smithsonian Institution.
2. Correspondence, George Rickey to Walter Rickey, November 1929.
3. George Rickey, interviewed by Paul Cummings.
4. Correspondence, George Rickey to Grace Landon Rickey, October 29, 1929.
5. Ibid., February 16, 1930
6. George Rickey "Kinetic Art," in *Art and Artist* (Berkeley and Los Angeles: University of California Press, 1956), 151.
7. George Rickey, "Biographical Note," in *George Rickey* (Berlin: Amerika Haus, 1979), 27.
8. Correspondence, Leonard Snow to George Rickey, October 6, 1929.
9. Correspondence, George Rickey to Grace Landon Rickey, February 16, 1930.
10. Correspondence, Eve Vogt to George Rickey, n.d., 1930.
11. Correspondence, Roger Merriman to Endicott Peabody, February 24, 1930, Groton School Archives, Groton School, Groton, Massachusetts.
12. Correspondence, George Rickey to Endicott Peabody, February 5, 1930.
13. Correspondence, Eve Vogt to George Rickey, 1930.

CHAPTER 6 / **Groton**

1. Correspondence, George Lyward to George Rickey, November 3, 1930.
2. George Rickey, "The Metier," in *Contemporary Sculpture Arts Yearbook 8*, James R. Mellow, ed. (New York: Arts Digest, 1965), 164.

3. Correspondence, George Rickey to Grace Landon Rickey, September 16, 1930.

4. Frank D. Ashburn, *Fifty Years On: Groton School, 1884–1934* (New York: Privately printed, 1934), 81.

5. Correspondence, George Rickey to Grace Landon Rickey, September 16, 1930.

6. Frank D. Ashburn, *Peabody of Groton: A Portrait* (Cambridge, MA: Riverside Press, 1967), 329.

7. Correspondence, George Lyward to George Rickey, November 3, 1930.

8. Correspondence, George Rickey to Grace Landon Rickey, May 1, 1931.

9. Correspondence, "Mary" to George Rickey, n.d.

10. Correspondence, "Janet" to George Rickey, n.d.

11. Correspondence, George Rickey to Grace Landon Rickey, July 16, 1931.

12. Ibid., September 16, 1931.

13. Correspondence, George Rickey to Walter Rickey, August 7, 1931.

14. Correspondence, George Rickey to Grace Landon Rickey, October 31, 1931.

15. Correspondence, Helen Resor to Walter Rickey, May 23, 1935.

16. George Rickey, "Thanksgiving Address," *Groton School Quarterly* (Winter 1931), 428.

17. Correspondence, George Rickey to Grace Landon Rickey, November 29, 1931.

18. Correspondence, Frank Keppel to George Rickey, September 23, 1932.

19. Correspondence, George Rickey to Grace Landon Rickey, October 2, 1932.

20. Ibid.

21. Ibid. December 1932.

22. George Rickey, interviewed by Paul Cummings, June 11, 1968, Archives of American Art, Smithsonian Institution.

23. Clipping from press scrapbook, "Pen and Ink Work," in the *World*, January 6, 1933.

24. Clipping from press scrapbook, "George Rickey, an instructor . . ." in the *Herald Tribune*, January 1, 1933.

25. Correspondence, George Rickey to Endicott Peabody, January 4, 1933.

26. George Rickey, interviewed by Paul Cummings.

27. Ashburn, *Peabody of Groton*, 281.

28. Ibid. 346.

CHAPTER 7 / **Susan**

1. Telegram, George Rickey to Walter Rickey, March 27, 1933.

2. Transcription of telegram, Walter Rickey to George Rickey, n.d.

3. Correspondence, Susan Luhrs to George Rickey, n.d.

4. Correspondence, George Rickey to Walter and Grace Landon Rickey, March 29, 1933.

5. Ibid.

6. Correspondence, George Rickey to Grace Landon Rickey, April 14, 1933.

7. Correspondence, George Rickey to Walter Rickey, May 3, 1933.

8. Louis Auchincloss, *A Voice from Old New York* (Boston: Houghton Mifflin Harcourt, 2010), 92.

9. Correspondence, George Rickey to Walter Rickey, June 23, 1933.

10. Correspondence, Eve Vogt to George Rickey, n.d.

11. Correspondence, Susan Luhrs to Rickey family, n.d.

12. Correspondence, George Rickey to Endicott Peabody, March 9, 1934.

13. Correspondence, Susan Luhrs to Rickey family, March 9, 1934.

14. Correspondence, George Rickey to Endicott Peabody, September 7, 1933.

15. Correspondence, Reinald Hoops to George Rickey, November 30, 1930.

16. Correspondence, George Rickey to Grace Landon Rickey, n.d.

17. Nan Rosenthal, *George Rickey* (New York: Harry N. Abrams, Inc. 1977), 48.

18. Correspondence, George Rickey to Endicott Peabody, March 9, 1934.

19. Correspondence, Susan Luhrs to Grace Landon Rickey, March 9, 1934.

20. Correspondence, George Rickey to Susan Luhrs, October 16, 1938.

21. Correspondence, George Rickey to Grace Landon Rickey, n.d., 1934.

22. See, for example, *Wave II*, 1956.

CHAPTER 8 / **New York**

1. "Group Exhibition at Uptown Gallery," *New York Times*, April 21, 1935.

2. Correspondence, George Rickey to Walter Rickey, May 4, 1935.

3. Telegram, Susan Luhrs to Emily Rickey Phelps, May 16, 1935.

4. Correspondence, George Rickey to Jane Rickey, June 19, 1935.

5. Ibid.

6. Correspondence, George Rickey to Endicott Peabody, March 9, 1934.

CHAPTER 9 / **Olivet**

1. Thomas Kennedy, "A Last Conversation with Robie Macauley," in *AGNI Fiction Web Issue Four,* accessed on October 13, 2019, http://www.webdelsol.com/AGNI/ag-o8tk.htm.

2. George Rickey, typed journal, "Olivet Notebook," September 14, 1937.

3. Ibid., September 27, 1937.

4. Ibid., September 20, 1937.

5. Ibid., January 12, 1938.

6. George Rickey, "William Dole," in *William Dole, 1917–1983* (New York: Staempfli Galleries, 1984), unpaginated.

7. George Rickey, interviewed by Joseph Trovato, July 17, 1965, Archives of American Art, Smithsonian Institution.

8. George Rickey, "Olivet Notebook," April 7, 1938.

9. Correspondence, Reginald Marsh to George Rickey, February 10, 1938.

10. Correspondence, Susan Luhrs to George Rickey, n.d.

11. Ibid.
12. Ibid.
13. Correspondence, George Rickey to Susan Luhrs, October 16, 1938.

CHAPTER 10 / **Midwest**

1. John Held, Jr., unpublished report, "My Life and Times at Harvard," Artist-in-Residence report to the Carnegie Corporation, c. 1939.
2. Reed Hynds, "Getting Art Down to Work," in *St. Louis Post-Dispatch*, February 22, 1939.
3. Ibid.
4. Ibid.
5. George Rickey, unpublished bound report to the Carnegie Corporation, "The Artist-in-Residence," 1942, 12.
6. Ibid., 10.
7. Dee Ann Rexroat, "Artist-Collector Ulfert Wilke Remembered," in the *Cedar Rapids Gazette*, May 6, 1988.
8. Correspondence, Ulfert Wilke to George Rickey, March 31, 1939.
9. Correspondence, Philip Evergood to Rob Warden, August 27, 1966, Kalamazoo College Archives, Kalamazoo College, Kalamazoo, MI.
10. Correspondence, George Rickey to Charles Dollard, May 28, 1940.
11. Correspondence, Philip Evergood to Rob Warden, August 27, 1966.
12. Carl Sandburg, "The Sins of Kalamazoo," in *Smoke and Steel* (New York: Harcourt, Brace, and Company, 1922), 49.
13. Correspondence, Philip Evergood to Rob Warden, August 27, 1966.
14. George Rickey, unpublished manuscript, "Techniques of Contemporary American Painters," n.d.

CHAPTER 11 / **Mexico**

1. Elizabeth Fagg, "Across Rio Grande," *New York Times*, August 17, 1941.
2. Correspondence, George Rickey to Grace Landon Rickey, August 16, 1939.
3. Correspondence, George Rickey to Frank Keppel, August 8, 1939.
4. Correspondence, George Rickey to Grace Landon Rickey, n.d.
5. Correspondence, Susan Luhrs to George Rickey, n.d.
6. Correspondence, Sarah Middendorf to Grace Landon Rickey, July 6, 1939.
7. Correspondence, George Rickey to Grace Landon Rickey, July 18, 1939.
8. Correspondence, Emily Rickey Phelps to George Rickey, November 3, 1939.
9. Correspondence, Grace Landon Rickey to George Rickey, August 12, 1939.
10. Correspondence, George Rickey to Eric Clarke, May 28, 1940.
11. George Rickey, unpublished report, "Interim Report to Carnegie," March 1941, 3.
12. Beatrice Farwell, text of speech, "George Rickey," booklet of the memorial

service for George Rickey, Solomon R. Guggenheim Museum, New York City, October 24, 2002.

13. George Rickey, "Interim Report to Carnegie," 3.
14. George Rickey, bound report, "The Artist-In-Residence," 1942, 3.
15. Ibid., 38.
16. Correspondence, Frank Keppel to George Rickey, March 10, 1941.
17. Correspondence, George Rickey to Frank Keppel, March 18, 1941.
18. Correspondence, Ulfert Wilke to George Rickey, May 18, 1941.
19. Correspondence, Charles Dollard to George Rickey, March 31, 1941.

CHAPTER 12 / **Muhlenberg**

1. George Rickey, "Reflections on Muhlenberg, 1941–1942; 1945–1948," in *George Rickey at Muhlenberg* (Allentown, PA: Muhlenberg College, 1993), unpaginated.
2. Levering Tyson, unpublished report, "The Present Faculty: Art," report to the Carnegie Corporation on funding of the Muhlenberg College Art Department, 1946.
3. Correspondence, George Rickey to Frank Keppel, March 18, 1941.
4. Correspondence, Ulfert Wilke to George Rickey, November 5, 1941.
5. Correspondence, George Rickey to Josef Albers, February 19, 1942.
6. Correspondence, Ulfert Wilke to George Rickey, December 11, 1941.
7. Ibid., n.d.
8. Ibid., April 17, 1942.
9. Correspondence, George Rickey to Grace Landon Rickey, n.d.
10. Ibid.
11. Ibid., August 2, 1942.
12. Ibid.

CHAPTER 13 / **Denver**

1. Correspondence, George Rickey to Grace Landon Rickey, September 10, 1942.
2. Ibid., n.d.
3. Ibid.
4. Ibid., n.d.
5. George Rickey, notes to himself, "Recollections of Denver," 1996.
6. Ibid.
7. Correspondence, George Rickey to Grace Landon Rickey, n.d.
8. Correspondence, Elizabeth "Pussy" Paepcke to George Rickey, October 5, 1945.
9. Press clippings scrapbook, Helen Arndt, "Mary Reed Library . . . George Rickey's Second Exhibition Is on View," in unknown newspaper, n.d.
10. Correspondence, George Rickey to Grace Landon Rickey, August 16, 1943.

11. George Rickey, "Reflections on Muhlenberg, 1941-1942; 1945-1948" in *George Rickey at Muhlenberg* (Allentown, PA: Muhlenberg College, 1993) unpaginated.
12. Correspondence, George Rickey to Grace Landon Rickey, n.d.

CHAPTER 14 / **Edie**

1. Correspondence, Ulfert Wilke to George Rickey, November 9, 1944.
2. George Rickey, interviewed by Paul Cummings, June 11, 1968, Archives of American Art, Smithsonian Institution.
3. Annie Cohen-Solal, *Sartre: A Life* (New York: Pantheon Books, 1988), 238.
4. Mitchell Abidor, *"Les Temps Modernes*: End of an Epoch," in *New York Review of Books Daily*, accessed on October 14, 2020, https://www.nybooks.com/daily/2019/05/17/les-temps-modernes-end-of-an-epoch/.
5. George Rickey, "The Mobile Civilization," in *Les Temps Modernes*, (August–September, 1946), 445.
6. Eleanor "Cooie" and Paul Harper, interviewed by Anne Undeland for the George Rickey Oral History Project, July 17, 2013.
7. Edie and George Rickey, interviewed by Hilary Dole Klein, April 1986.
8. Ibid.

CHAPTER 15 / **Engagement**

1. George Rickey, unpublished report to the Carnegie Corporation on its grant to Muhlenberg College of December 20, 1940, January 1947, 3.
2. Ibid.
3. Edie and George Rickey, interviewed by Hilary Dole Klein, April 1986.
4. Correspondence, George Rickey to Edie Rickey, June 27, 1946.
5. Eleanor "Cooie" and Paul Harper, interviewed by Anne Undeland for the George Rickey Oral History Project, July 17, 2013.
6. Correspondence, George Rickey to Edie Rickey, June 27, 1946.
7. Correspondence, Edie Rickey to George Rickey, December 3, 1946.
8. Edie and George Rickey, interviewed by Hilary Dole Klein.
9. Ibid.
10. Correspondence, Edie Rickey to George Rickey, December 3, 1946.
11. Grace Landon Rickey to George Rickey, November 11, 1946.
12. Ibid.
13. Correspondence, George Rickey to Edie Rickey, n.d.
14. Correspondence, Edie Rickey to George Rickey, December 11, 1946.
15. Correspondence, George Rickey to Edie Rickey, March 7, 1947.
16. Correspondence, Edie Rickey to George Rickey, March 12, 1947.
17. Correspondence, George Rickey to Edie Rickey, March 14, 1947.
18. Correspondence, Edie Rickey to George Rickey, April 23, 1947.

CHAPTER 16 / **Chicago**

1. Edie and George Rickey, interviewed by Hilary Dole Klein, April 1986.
2. Correspondence, George Rickey to Edie Rickey, July 30, 1948.
3. Edie and George Rickey, interviewed by Hilary Dole Klein.
4. Jean-Paul Sartre, "Calder's Mobiles," in *Alexander Calder* (New York: Buchholz Gallery/Curt Valentin, 1947), unpaginated.
5. Ibid.
6. Correspondence, George Rickey to Edie Rickey, n.d.
7. Ibid., March 8, 1948.
8. Ibid.
9. Edie Rickey, manuscript, "Remembering Max Beckmann," c. 1993.
10. Correspondence, Edie Rickey to George Rickey, n.d.
11. Correspondence, George Rickey to Edie Rickey, July 30, 1948.
12. Ibid.
13. Correspondence, Edie Rickey to George Rickey, n.d.
14. Ibid., January 7, 1947.
15. Ibid., n.d.
16. Correspondence, George Rickey to Edie Rickey, fall 1949.
17. Eleanor "Cooie" and Paul Harper, interviewed by Anne Undeland for the George Rickey Oral History Project, July 17, 2013.
18. George Rickey, interviewed by Paul Cummings, June 11, 1968, Archives of American Art, Smithsonian Institute.
19. George Rickey, study notes, Institute of Design, Chicago, 1948.
20. George Rickey, notes taken in product design foundation course, Institute of Design, Chicago, 1948.
21. Peter Selz, unpublished manuscript, "George Rickey: A Personal Prologue," 2014, unpaginated.
22. Peter Selz, *Directions in Kinetic Sculpture* (Berkeley: University Art Museum/ UC Berkeley, 1966), 1.
23. Naum Gabo, "The Realistic Manifesto," in *Art in Theory, 1900–2000*, Charles Harrison and Paul Wood, ed. (Oxford: Blackwell, 2003), 299.
24. Edie Rickey, "Remembering Max Beckmann."
25. Linette Roth, *Max Beckmann at the City Art Museum: The Paintings* (New York: DelMonico Books/Prestel, 2015), 211.

CHAPTER 17 / **Europe**

1. Correspondence, George Rickey to Eric Clarke, n.d.
2. Correspondence, George Rickey to Grace Landon Rickey, April 25, 1949.
3. Correspondence, Edie Rickey to James and Wilma Leighton, May 12, 1949.
4. Correspondence, George Rickey to Grace Landon Rickey, May 19, 1949.
5. Ibid., June 16, 1949.

6. Correspondence, Edie Rickey to James and Wilma Leighton, June 25, 1949.
7. Ibid., July 13, 1949.
8. Correspondence, George Rickey to Grace Landon Rickey, August 1949.
9. Correspondence, Edie Rickey to James Leighton, n.d.
10. Correspondence, George Rickey to Grace Landon Rickey, August 11, 1949.
11. Ibid., August 1949.

CHAPTER 18 / **Bloomington**

1. Correspondence, George Rickey to Edie Rickey, September 29, 1949.
2. Ibid., October 3, 1949.
3. Correspondence, George Rickey to Henry Hope, April 12, 1949.
4. George Rickey, draft of lecture, "How Henry Hope Came to Indiana University," January 25, 1991.
5. Ibid.
6. Correspondence, George Rickey to Edie Rickey, October 3, 1949.
7. Ibid., September 1, 1950.
8. Correspondence, Alexander Calder to George Rickey, May 25, 1951.
9. Correspondence, George Rickey to Nancy Blackie, July 24, 1996.

CHAPTER 19 / **New Orleans**

1. Correspondence, George Rickey to Dolores Vanetti, n.d.
2. Kate Hope, unpublished elementary school essay on a visit from the Rickeys, 1953.
3. Correspondence, Edie Rickey to Dolores Vanetti, July 27, 1953.
4. Ibid.
5. Ibid.
6. Ibid.
7. Correspondence, George Rickey to Ulfert Wilke, 1955.
8. Correspondence, George Rickey to Dolores Vanetti, n.d.
9. George Rickey, draft of lecture, "How Henry Hope Came to Indiana University," January 25, 1991.
10. John Gruen, "The Sculpture of George Rickey: Silent Movement, Performing in a World of Its Own," in *ArtNews*, 79/4, April 1980, 94.
11. Reiko Tomii, *Between Two Continents: George Rickey, Kinetic Art and Constructivism, 1949–1968*, PhD diss. (University of Texas, 1988), 78.
12. Correspondence, Crombie Taylor to Dean Hubbard, February 1, 1954.
13. Correspondence, Charles Dollard to Dean Hubbard, April 22, 1954.
14. Correspondence, Dean Waggoner to Dean Hubbard, April 28, 1954.
15. Correspondence, George Rickey to Dean Hubbard, May 19, 1954.
16. Ibid., August 24, 1954.
17. George Rickey, interviewed by Paul Cummings, June 11, 1968, Archives of American Art, Smithsonian Institution.

18. George Rickey to Ulfert Wilke, May 18, 1955.

19. Alfred Moir, interviewed by Hilary Dole Klein, July 2002.

20. Correspondence, George Rickey to Ulfert Wilke, October 31, 1955.

21. John and Dorothy Clemmer, interviewed by Anne Undeland for the George Rickey Oral History Project, February 18, 2014.

22. Alfred Moir, interviewed by Hilary Dole Klein.

CHAPTER 20 / **East Chatham**

1. Correspondence, George Rickey to Ulfert Wilke, n.d.

2. George Rickey, "The Metier," in *Contemporary Sculpture Arts Yearbook* 8, James R. Mellow, ed. (New York: Arts Digest, 1965) 166.

3. George Rickey, interviewed by Frederick S. Wight in *George Rickey: Retrospective Exhibition, 1951–71* (Los Angeles: UCLA Arts Council, 1971), 17.

4. Correspondence, George Rickey to Ulfert Wilke, October 9, 1956.

5. Correspondence, George Rickey to Grace Landon Rickey, April 14, 1933.

6. Correspondence, George Rickey to Emily Rickey Phelps, December 4, 1956.

7. Ibid., March 4, 1957.

8. Ibid., February 12, 1957.

9. Ibid.

10. Correspondence, George Rickey to Dean Hubbard, March 5, 1957.

11. Correspondence, George Rickey to Emily Rickey Phelps, February 25, 1957.

12. Correspondence, George Rickey to Dean Hubbard, August 31, 1957.

13. George Rickey, interviewed by Paul Cummings, June 11, 1968, Archives of American Art, Smithsonian Institution.

14. Correspondence, George Rickey to Edie Rickey, September 13, 1957.

15. Correspondence, George Rickey to Ulfert Wilke, June 9, 1958.

16. Correspondence, Edie Rickey to George Rickey, November 17, 1958.

17. Stuart Rickey, interviewed by the author for the George Rickey Oral History Project, March 6, 2017.

18. Elementary school teacher report regarding Stuart Rickey, New Lebanon Central School District, New York, fall 1958.

19. Correspondence, George Rickey to Edie Rickey, n.d.

20. Correspondence, Edie Rickey to George Rickey, November 6, 1958.

21. Correspondence, George Rickey to Ulfert Wilke, March 4, 1959.

22. Correspondence, George Rickey to Antoinette Kraushaar, April 13, 1959.

CHAPTER 21 / **Guggenheim**

1. Correspondence, George Rickey to Antoinette Kraushaar, December 2, 1958.

2. George Rickey, draft of lecture,"How Henry Hope Came to Indiana University," January 25, 1991.

3. Correspondence, Antoinette Kraushaar to George Rickey, December 6, 1958.

4. George Rickey, interviewed by Selden Rodman, in *Conversations with Artists* (New York: The Devin-Adair Co., 1957), 143, 146.

5. Prescott N. Dunbar, *The New Orleans Museum of Art: The First Seventy-Five Years* (Baton Rouge and London: Louisiana State University Press, 1990), 164.

6. Correspondence, George Rickey to Antoinette Kraushaar, May 5, 1959.

7. Correspondence, George Rickey to William Dole, March 6, 1959.

8. Correspondence, George Rickey to Ulfert Wilke, February 10, 1960.

9. George Rickey, manuscript, "Statement of Plans," application for a Guggenheim Fellowship, 1959.

10. Philip Evergood, confidential report on candidate for fellowship, John Simon Guggenheim Foundation, 1959.

11. Correspondence, George Rickey to Dean Hubbard, June 14, 1960.

12. Correspondence, George Rickey to Perry Rathbone, May 25, 1960.

13. Correspondence, George Rickey to William Dole, October 25, 1960.

14. William Macdonald, interviewed by Nora Rickey for the George Rickey Oral History Project, November 2, 2016.

15. Correspondence, George Rickey to Perry Rathbone, May 25, 1960.

16. Correspondence, George Rickey to Henry Allen Moe, January 30, 1961.

17. Correspondence, George Rickey to Dean Hubbard, January 24, 1961.

CHAPTER 22 / **Bewogen Beweging**

1. Correspondence, George Rickey to Ulfert Wilke, March 4, 1959.

2. George Rickey, "The Kinetic International," in *Arts Magazine*, September 1961, 16.

3. Correspondence, George Rickey to Edie Rickey, April 6, 1961.

4. Ibid., n.d.

5. George Rickey, "The Kinetic International," 16.

6. Correspondence, George Rickey to Edie Rickey, April 10, 1961.

7. Ibid., May 7, 1961.

8. Ibid., n.d.

9. Ibid., April 15, 1961.

10. Ibid., April 18, 1961.

11. Correspondence, Edie Rickey to George Rickey, April 19, 1961.

12. Correspondence, Edie Rickey to Dean Hubbard, April 26, 1961.

13. Stuart Rickey, conversation with the author, July 27, 2018.

14. A total of forty-two in 1961 and forty-eight in 1962.

15. Correspondence, Edie Rickey to George Rickey, April 18, 1961.

16. Correspondence, George Rickey to Edie Rickey, May 30, 1961.

17. Correspondence, George Rickey to William Woods, March 26, 1962.

18. Correspondence, George Rickey, draft of letter to Bobby Alford, n.d.

19. Correspondence, George Rickey to William Woods, March 26, 1962.

CHAPTER 23 / **Heirs to Constructivism**

1. Correspondence, George Rickey to Edie Rickey, n.d.
2. Correspondence, George Rickey to Rudolf Springer, March 12, 1962.
3. Correspondence, George Rickey to Joseph Hirshhorn, n.d.
4. Correspondence, George Rickey to Ulfert Wilke, September 25, 1962.
5. Ibid.
6. Correspondence, George Rickey to Rudolf Springer, May 18, 1962.
7. Correspondence, George Rickey to Edie Rickey, October 6, 1962.
8. Correspondence, George Staempfli to George Rickey, April 10, 1962.
9. Correspondence, George Rickey to Edie Rickey, October 6, 1962.
10. Correspondence, George Rickey to James Mellow, May 10, 1962.
11. George Rickey, "Calder in London," in *Arts Magazine*, September 1962, 24–27.
12. Ibid.
13. Ibid.
14. Alex J. Taylor, "The Calder Problem: Mobiles, Modern Taste, and Mass Culture," in *Oxford Art Journal* 37.1, 2014, 43.
15. Ibid.
16. Jed Perl, *Calder: The Conquest of Space, the Later Years: 1940–1976* (New York: Alfred A. Knopf, 2020), 401.
17. George Rickey, "Introduction," in *Constructivist Tendencies* (Santa Barbara: University of California, 1970), 8.
18. George Rickey, *Constructivism: Origins and Evolution* (New York: George Braziller, 1967), vii.
19. Correspondence, George Rickey to Naum Gabo, January 4, 1963.
20. Correspondence, Josef Albers to George Rickey, May 28, 1963.
21. The book was on the whole well received by critics, such as Harold Rosenberg of the *New Yorker*, though he objected to the ambiguity of some of Rickey's definitions.
22. Correspondence, George Rickey to Edie Rickey, May 24, 1963.
23. Correspondence, Edie Rickey to George Rickey, n.d.
24. Correspondence, George Rickey to Edie Rickey, May 24, 1963.
25. George Rickey, manuscript draft for Antoinette Kraushaar, "Tools," December 9, 1958.
26. George Rickey, interviewed by Frederick S. Wight, in *George Rickey: Retrospective Exhibition, 1951-71* (Los Angeles: UCLA Arts Council, 1971), 32.
27. Stuart Rickey, interviewed by the author, March 6, 2017.
28. Correspondence, George Rickey to Ulfert Wilke, March 14, 1963.
29. Norman de Vall, interviewed by the author, February 25, 2017.
30. Correspondence, Edie Rickey to George Rickey, May 29, 1963.
31. Ibid., July 3, 1963.

CHAPTER 24 / **Documenta**

1. Neville Wallis, "Lakeside Sculptures," in the *Spectator*, June 7, 1963.
2. Press release, Institute of Contemporary Art, Boston, February 1964.
3. Press-clippings scrapbook, Walter Spencer, "Today's Artist Is Businessman," unknown newspaper, n.d.
4. Werner Feibes, interviewed by Anne Undeland for the George Rickey Oral History Project, October 24, 2013.
5. Correspondence, George Rickey to George Staempfli, December 9, 1963.
6. Werner Haftmann quoted on "D1 1955 (Doc menta I, 1955)," *Documenta* 12, accessed October 14, 2020, https://www.documenta12.de/en/about-documenta/d1-d11/d1.html.
7. Ibid.
8. Valerie Hillings, et al., *Zero: Countdown to Tomorrow, 1950s–60s* (New York: Solomon R. Guggenheim Museum, 2014), 34.
9. Heinz Mack, interviewed by Khushi Pasquale for the George Rickey Oral History Project, October 28, 2013.
10. Correspondence, George Rickey to Edie Rickey, n.d.
11. Ibid., June 19, 1964.
12. Ibid., June 23, 1964.
13. George Rickey, interviewed by Paul Cummings, June 11, 1968, Archives of American Art, Smithsonian Institution.
14. Otto Piene, interviewed by Anne Undeland for the George Rickey Oral History Project, June 15, 2013.
15. Correspondence, George Rickey to Ulfert Wilke, August 9, 1964.
16. George Rickey, interview by Frederick S. Wight, in *George Rickey: Retrospective Exhibition, 1951-71* (Los Angeles: UCLA Arts Council, 1971), 25.
17. George Rickey, "Morphology of Movement," in *Art Journal*, Summer 1963, 229.
18. Reiko Tomii, *Between Two Continents: George Rickey, Kinetic Art and Constructivism, 1949-1968*, PhD diss. (University of Texas, 1988), 150.
19. George Rickey, "The Metier," in Contemporary Sculpture Arts Yearbook 8, James R. Mellow, ed. (New York: Arts Digest, 1965) 164.
20. Correspondence, George Rickey to Ulfert Wilke, February 2, 1963.
21. Ibid., May 27, 1965.
22. Correspondence, Susan Barrow to George Rickey, February 22, 1965.

CHAPTER 25 / **The Workshop**

1. Correspondence, George Rickey to George Staempfli, November 11, 1964.
2. Peter Selz, "Preface," in *Directions in Kinetic Sculpture* (Berkeley: University Art Museum, 1966), 7.

3. Ibid.

4. Ibid., 10.

5. William Seitz also consulted George Rickey and his personal archive in his research regarding *The Responsive Eye* exhibition at MoMA.

6. Rudolf Arnheim, interviewed in the film *The Responsive Eye*, directed by Brian de Palma, MoMA, 1966.

7. George Rickey, "Introduction," in *Directions in Kinetic Sculpture*, 15.

8. Ibid., 13.

9. Ibid., 14.

10. George Rickey, "Seven Decades Later," in *George Rickey in South Bend* (South Bend: Art Center of South Bend/Indiana University/St. Mary's College/Snite Museum of Art Notre Dame University, 1985), 9.

11. Press-clippings scrapbook, "The Present Exhibition of George Rickey . . .," *Washington Post*, October 9, 1966.

12. Rickey produced a few sculptures in very small editions on demand. He also responded to fund-raising requests with, for example, *Single Line*, 1964, to help fund *Documenta III*, with a total of one hundred, and *Weathervane*, to help fund the publication of his monograph with Harry Abrams, with a total of seventy-three.

13. John Cunningham, interviewed by the author for the George Rickey Oral History Project, January 31, 2019.

14. Steve Day, interviewed by Anne Undeland for the George Rickey Oral History Project, July 24, 2014.

15. Nan Rosenthal, *George Rickey* (New York: Harry N. Abrams, Inc, 1977), 69.

16. Steve Day, interviewed by Anne Undeland.

17. Ibid.

18. George Rickey, interviewed by Frederick S. Wight, in *George Rickey: Retrospective Exhibition, 1951-71* (Los Angeles: UCLA Arts Council, 1971), 32.

19. John Cunningham, interviewed by the author.

20. Steve Day, interviewed by Anne Undeland.

21. John Cunningham, interviewed by the author.

22. Douglas King, interviewed by the author for the George Rickey Oral History Project, January 30, 2017. Rickey may have been referencing Moholy-Nagy's film *Black, White, and Gray*, which he mentions in his essay "Morphology of Movement," 1963.

CHAPTER 26 / **Berlin**

1. David Clay Large, *Berlin* (New York: Basic Books, 2000), 452.

2. Ibid., 456.

3. Ibid., 479.

4. Jörn Merkert, conversation with the author, May 4, 2019.

5. Peter Nestler, conversation with the author, November 20, 2017.

6. Correspondence, Huburtus Scheibe to George Rickey, October 31, 1966.

7. George Rickey, "Ich bin ein Berliner," in *George Rickey in Berlin* (Berlin: Berlinische Galerie, 1992), 316.

8. Ibid., 317.

9. Correspondence, George Rickey to George Staempfli, February 5, 1968.

10. Correspondence, George Rickey to Ulfert Wilke, August 26, 1968.

11. Peter Nestler, interviewed by Khushi Pasquale for the George Rickey Oral History Project, July 13, 2014.

11. Peter Nestler, conversation with the author.

12. Correspondence, Edie Rickey to Dolores Vanetti, n.d.

13. Regina Geccelli, interviewed by Khushi Pasquale for the George Rickey Oral History Project, April 17, 2014.

14. Peter Nestler, conversation with the author.

15. Edie Rickey, unpublished manuscript, "Two Portraits and Several Drawings by David Hockney," n.d.

16. Correspondence, Edie Rickey to Phillip Bruno, March 4, 1968.

17. Michael Cullen, interviewed by the author, May 7, 2019.

18. Correspondence, Edie Rickey to Phillip Bruno, March 4, 1968.

19. Ibid.

20. Ibid.

21. Ibid.

22. Wieland Schmied, "George Rickey—Homo Ludens as Homo Faber," in *George Rickey in Berlin* (Berlin: Berlinische Galerie, 1992), 52.

23. Correspondence, George Rickey to Ulfert Wilke, October 19, 1968.

24. George Rickey, interviewed by Paul Cummings, June 11, 1968, Archives of American Art, Smithsonian Institution.

25. Norman de Vall, interviewed by the author, February 25, 2017.

26. Correspondence, Edie Rickey to George Rickey, September 21, 1968.

27. Correspondence, George Rickey to Edie Rickey, August 18, 1969.

28. Correspondence, George Rickey to Ulfert Wilke, June 27, 1969.

CHAPTER 27 / **Bundesplatz**

1. Correspondence, George Rickey to Edie Rickey, June 10, 1968.

2. Correspondence, George Rickey to Louis Bernstein, October 1, 1969.

3. Correspondence, George Rickey to Edie Rickey, October 3, 1969.

4. Correspondence, George Rickey to Pieter Sanders, December 30, 1969.

5. Correspondence, George Rickey to Edie Rickey, October 3, 1969.

6. Correspondence, Edie Rickey to George Rickey, October 2, 1969.

7. George Rickey, "Ich bin ein Berliner," in *George Rickey in Berlin* (Berlin: Berlinische Galerie, 1992), 317.

8. Achim Pahle, interviewed by the author for the George Rickey Oral History Project, November 21, 2017.

9. Volker Henckel, interviewed by Khushi Pasquale for the George Rickey Oral

History Project, June 26, 2013.

10. Correspondence, George Rickey to Ulfert Rickey, November 11, 1971.

11. Correspondence, Edie Rickey to George Rickey, January 15, 1972.

12. Correspondence, George Rickey to Edie Rickey, January 14, 1972.

13. Correspondence, Edie Rickey to George Rickey, January 28, 1972.

14. In the late 1960s, George paid Edie $12,000 a year, or $92,000 in 2019 dollars.

15. Correspondence, Edie Rickey to George Rickey, January 28, 1972.

16. Ibid.

17. Correspondence, Edie Rickey to George Rickey, March 26, 1972.

18. Edith Rickey, "Conclusion," in *George Rickey in Berlin* (Berlin: Berlinische Galerie, 1992), 129.

19. Correspondence, George Rickey to Ulfert Wilke, April 18, 1973.

20. Correspondence, Edie Rickey to Nan Rosenthal, January 10, 1975.

CHAPTER 28 / **The Walled City**

1. Christo, interviewed by Anne Undeland for the George Rickey Oral History Project, December 3, 2015. Michael Cullen credits himself with giving Christo the idea of wrapping the Reischtag, and he was key to its success through his extensive knowledge of the building and acquaintance with the authorities in Berlin.

2. George Rickey "Ich bin ein Berliner," *George Rickey in Berlin*, (Berlin: Berlinische Galerie, 1992), 323.

3. Kenneth Snelson, interviewed by Anne Undeland for the George Rickey Oral History Project, November 4, 2015.

4. Nancy Kienholz, interviewed by Khushi Pasquale for the George Rickey Oral History Project, April 30, 2014.

5. Correspondence, George Rickey to Ulfert Wilke, October 23, 1978.

6. Ed Kienholz, "Letter to George," in *George Rickey in Berlin* (Berlin: Berlinische Galerie, 1992), 30.

7. Ed Kienholz, "Intro," in *The Art Show* (Berlin: Berliner Künstlerprogramm/ DAAD, 1977), unpaginated.

8. Michael Cullen, interviewed by the author, May 7, 2019.

9. George Rickey, unpublished manuscript, "A Day with Clement Greenberg," n.d.

10. Correspondence, Edie Rickey to Martin Grossman, 1973.

11. Rose Viggiano, interviewed by the author for the George Rickey Oral History Project, July 2, 2017.

12. George Rickey, notes to himself, c. 1990.

13. Correspondence, George Rickey to Volker Henckel, February 22, 1974.

14. Correspondence, Edie Rickey to Martin Grossman, n.d.

15. George Rickey, "Kinetic Sculpture" in *Art and Artist* (Berkeley and Los Angeles: University of California Press, 1956), 161.

16. George Rickey, notes to himself, February 22 and 23, 1974.

17. Ibid.

CHAPTER 29 / **Open Rectangles**

1. Jörn Merkert, interviewed by Khushi Pasquale for the George Rickey Oral History Project, September 25, 2014.
2. Correspondence, George Rickey to Ulfert Wilke, September 1, 1976.
3. George Rickey, *George Rickey: Technology* (Chatham, NY: privately printed, 1976; reprinted 1992), 19.
4. *The Moving World of George Rickey*, directed by Kevin Macdonald, Figment Films/BBC Scotland, 1997.
5. Correspondence, George Rickey to Ulfert Wilke, August 2, 1974.
6. Susan Sontag, "Notes on 'Camp,'" in *Partisan Review*, 31(4), Fall 1964: 525.
7. Jörn Merkert, "From the Spirit of Invention or The Rigor of Geometry as a Living Form: On the Art of George Rickey," in *George Rickey in Berlin* (Berlin: Berlinische Galerie), 18.
8. Peter Nestler, conversation with the author, November 20, 2017.
9. Achim Pahle, interviewed by the author, November 21, 2017.
10. Correspondence, George Rickey to Ulfert Wilke, September 15, 1973.

CHAPTER 30 / **Retrospective**

1. Correspondence, George Rickey to Paul Anbinder, December 3, 1969.
2. Tom Armstrong, et al., *200 Years of American Sculpture*, (Boston and New York: David R. Godine, in association with the Whitney Museum of American Art, 1976), 302.
3. Correspondence, George Staempfli to George Rickey, February 5, 1970.
4. Correspondence, George Rickey to George Staempfli, February 24, 1970.
5. Ibid., July 16, 1975.
6. Philip Rickey, interviewed by the author, April 9, 2017.
7. Stuart Rickey, interviewed by Hilary Dole Klein for the George Rickey Oral History Project, August 19, 2014.
8. Birgit Mieschonz, interviewed by the author for the George Rickey Oral History Project, July 8 and 9, 2016.
9. Ibid.
10. Correspondence, Thomas Messer to George Rickey, August 3, 1977.
11. Correspondence, George Rickey to Thomas Messer, August 3, 1978.
12. Correspondence, Edie Rickey to Irma Cavat, September 10, 1979.
13. John Russell, "Art: 86 Mobiles by George Rickey," in the *New York Times*, September 7, 1979.
14. Kay Larson, "Time Waddles On," in the *Village Voice*, September 4, 1979.
15. Alexandra Munroe, interviewed by the author for the George Rickey Oral History Project, December 13, 2019.

16. George Rickey, "Less Is Less," in *Art Journal*, Fall 1981, 249.
17. Birgit Mieschonz, interviewed by the author.
18. For further assessment of Rickey's position in the art world, see Reiko Tomii, *Between Two Continents: George Rickey, Kinetic Art and Constructivism, 1949-1968*, PhD diss. (University of Texas, 1988). It is also worth noting that a younger generation of artists was emerging in the 1970s, directly inspired by Rickey in their expansion of his kinetic thesis into new forms. George Sherwood and Tim Prentice were among those young artists who visited Rickey in East Chatham and learned directly from his example.

CHAPTER 31 / **Hand Hollow**

1. Maxwell Davidson, interviewed by the author for the George Rickey Oral History Project, June 16, 2016.
2. Ibid. September 16, 2016
3. Ibid.
4. Hilary Dole Klein, interviewed by the author, March 9, 2019.
5. Dennis Connors, interviewed by the author for the George Rickey Oral History Project, August 1, 2016.
6. Ibid.
7. Ibid.
8. *The Moving World of George Rickey*, directed by Kevin Macdonald.
9. Correspondence, Edie Rickey to Dolores Vanetti, January 22, 1982.
10. Dennis Connors, interviewed by the author, August 1, 2016.
11. David Lee, interviewed by the author, August 28, 2018.
12. Dennis Connors, interviewed by the author, August 1, 2016.
13. Robert Janz, interviewed by Anne Undeland for the George Rickey Oral History Project, November 5, 2015.
14. Giulia Cox, interviewed by the author for the George Rickey Oral History Project, January 31, 2017.
15. William Harper, interviewed by Anne Undeland for the George Rickey Oral History Project, April 6, 2016.
16. Ibid.
17. Stuart Rickey, conversation with the author, December 9, 2019.
18. Correspondence, George Rickey to Ulfert Wilke, September 1, 1976.
19. Giulia Cox, interviewed by the author.
20. Philip Rickey, interviewed by the author, April 9, 2017.
21. Alexandra Munroe, interviewed by the author, December 13, 2019.
22. Giulia Cox, interviewed by the author.
23. Correspondence, George Rickey to Edie Rickey, August 13, 1980.

CHAPTER 32 / **Returns**

1. Correspondence, George Rickey to Peter Murray, September 19, 1980.

2. Correspondence, Peter Murray to George Rickey, January 12, 1981.

3. Charles Jencks, interviewed by the author, October 20, 2016.

4. Correspondence, George Rickey to Peter Murray, September 19, 1980.

5. Kevin Macdonald, interviewed by Nora Rickey for the George Rickey Oral History Project, 2016.

6. Linn and James Lee, interviewed by Nora Rickey for the George Rickey Oral History Project, 2016.

7. *The Why?s Man: George Wyllie in Pursuit of the Question Mark*, Barbara and Murray Grigor (producers), BBC Channel 4, 1990.

8. Correspondence, George Rickey to Jeremy Harvey, July 14, 1987.

9. Louis Auchincloss, "Foreword," in *George Rickey* (New York: Maxwell Davidson Gallery and Virginia Zabriskie Gallery, 1986), unpaginated.

10. George Rickey, "Introduction," in *George Rickey in South Bend* (South Bend: Art Center of South Bend/Indiana University/St. Mary's College/Snite Museum of Art Notre Dame University, 1985), 9.

11. Birgit Mieschonz, interviewed by the author, July 8 and 9, 2016.

12. Philip Rickey, interviewed by the author, April 9, 2017.

CHAPTER 33 / **Santa Barbara**

1. Correspondence, George Rickey to Stuart Rickey, January 18, 1981.

2. Correspondence, George Rickey to Edie Rickey, n.d.

3. Irma Cavat, interviewed by Hilary Dole Klein for the George Rickey Oral History Project, June 17, 2013.

4. Ibid.

5. Correspondence, George Rickey to Stuart Rickey, April 27, 1986.

6. Ibid.

7. Hilary Dole Klein, unpublished manuscript, "East Chatham 1988," n.d.

8. Correspondence, Edie Rickey to Pieter and Ida Sanders, December 14, 1988.

9. Ibid.

10. Correspondence, George Rickey to Barbara English, November 28, 1989.

11. Ibid. January 4, 1990.

12. George Rickey, notes to himself, n.d.

13. Ibid. n.d.

14. Clare Henry, "Ungracious Neglect," *Glasgow Herald*, June 22, 1995.

15. Correspondence, George Rickey to Murray Grigor, December 11, 1995.

16. An audit in 2018 revealed that *Three Right Angles Horizontal* (erroneously titled *Three Overlapping Right Angles* by the Glasgow Press) was safely in Glasgow City Council's possession. With advice from Philip Rickey, the piece was restored and in December 2020 it was installed in the boating pond of Queen's Park, Glasgow, thirty-two years after Rickey made it his gift to the city. The fate of the "Papal Cross" remains in the balance at this writing.

CHAPTER 34 / **Full Circle**

1. Anne Undeland, interviewed by the author for the George Rickey Oral History Project, April 6, 2017.
2. Mark Pollock, conversation with the author, July 29, 2016.
3. Anne Undeland, interviewed by the author.
4. Birgit Mieschonz, interviewed by the author, July 8 and 9, 2016.
5. Stuart Rickey, conversation with the author, June 17, 2020.
6. Correspondence, Norman de Vall to George Rickey, January 1, 1995.
7. Correspondence, George Rickey to Norman de Vall, February 8, 1995.
8. Correspondence, George Rickey to Edie Rickey, July 30, 1951.
9. Correspondence, Edie Rickey to Stuart, Philip, Mary, Nora, and Owen Rickey (her sons, daughter-in-law, and grandchildren), February 14, 1995.
10. George made a drawing of Edie on her death bed. He also invited Ellsworth Kelly to do the same. Kelly had been evading Edie's pleas to make a portrait of her for years. George offered him his last chance, and he consented.
11. Birgit Mieschonz, interviewed by the author, July 8 and 9, 2016.
12. Eleanor "Cooie" Harper, unpublished essay, courtesy of Sam Harper.
13. George Rickey, manuscript, "Eulogy for Edie Rickey," July 29, 1996.
14. Correspondence, George Rickey to Ulfert Wilke, March 10, 1971.
15. Graham and Nina Williams, interviewed by Khushi Pasquale for the George Rickey Oral History Project, October 30, 2013.
16. Birgit Mieschonz, interviewed by the author.
17. Beatrice Farwell, "George Rickey," booklet of the memorial service for George Rickey, (New York: Solomon R. Guggenheim Museum, October 24, 2002).
18. Correspondence, George Rickey to Kate Dole, November 24, 1995.
19. Hilary Dole Klein, "George Rickey: In Memoriam," in the *Santa Barbara Independent*, August 8, 2002.
20. Correspondence, Kate Dole to George Rickey, n.d.
21. Maxwell Davidson, "George Rickey: Important Early Sculptures, 1951–1965, in Recognition of His Ninetieth Year" (New York: Maxwell Davidson Gallery, 1997), unpaginated.
22. Maxwell Davidson, interviewed by the author, June 16, 2016.
23. Kevin Macdonald, interviewed by Nora Rickey for the George Rickey Oral History Project, London, 2016.

CHAPTER 35 / **Saint Paul**

1. *The Moving World of George Rickey*, directed by Kevin Macdonald, Figment Films Ltd. in association with BBC Scotland, 1998.
2. This quote and paraphrases in this chapter are taken from Rickey's notes to

himself and to his staff, which proliferated daily from his pen.

3. George Rickey, *George Rickey* (New York: Maxwell Davidson Gallery and Virginia Zabriskie Gallery, 1986), unpaginated.

4. George Rickey, "In the Fullness of Time," in *George Rickey zum 80 Geburstag: Skulpturen-Eine Werkubersicht* (Berlin: Galerie Pels-Leusden, 1987), 16.

5. Birgit Mieschonz, interviewed by the author, July 8 and 9, 2016.

6. Correspondence, George Rickey to Dennis Connors, September 19, 1997.

7. Dennis Connors, interviewed by the author, August 1, 2016.

8. Birgit Mieschonz, interviewed by the author.

9. Maria Lizzi, conversation with the author, November 5, 2019.

10. Philip Rickey conversation with the author, May 6 and 14, 2020.

11. Maria Lizzi, conversation with the author, March 16, 2020.

12. Steve Day, conversation with the author, March 17, 2020.

13. *George Rickey's Annular Eclipse V, 2000, Against NYC Skyline*, directed by Kevin Macdonald, Figment Films, 2000.

14. Stuart Rickey, conversation with the author, June 17, 2020.

15. Maxwell Davidson, interviewed by the author, June 16, 2016.

16. Philip Rickey, conversation with the author, May 6 and 14, 2020.

17. Stuart Rickey, conversation with the author, June 17, 2020.

18. Correspondence, George Rickey to Norman de Vall, March 21, 2002.

19. Stuart and Philip Rickey, text of speech, "George Rickey," booklet of the memorial service for George Rickey (New York: Solomon R. Guggenheim Museum, October 24, 2002).

ILLUSTRATIONS

Walter Rickey, studio portrait, circa 1913. Copyright © George Rickey Foundation, Inc.

Clarendon, the Rickey home in Helensburgh, Scotland, 1921–1935, Rickey family photo album. Copyright © George Rickey Foundation, Inc.

Rickey family on a sailing trip in Scotland, circa 1920., Rickey family photo album. Copyright © George Rickey Foundation, Inc.

George and George Lyward, Trinity College, Glenalmond, Scotland, circa 1925. Copyright © George Rickey Foundation, Inc.

George and Susan Luhrs on the tarmac with the *Scylla*, Croydon, England, 1934. Copyright © George Rickey Foundation, Inc.

George working on the Olivet College mural, Olivet, Michigan, 1938. Copyright © George Rickey Foundation, Inc.

Philip Evergood working on his painting *Bride*, 1948. Photograph by Alfred Puhn. Courtesy of Philip Evergood Papers, 1890–1971, Archives of American Art, Smithsonian Institution.

George and Edie at their wedding reception, New York, 1947. Photograph by James Leighton. Copyright © George Rickey Foundation, Inc.

Max Beckmann, German, 1884–1950; *Portrait of Edie Rickey*, 1949, oil on canvas, 23¾ x 157/8 inches, City Art Museum, Gift of George Rickey, in

memory of Edie, 38:1996; © Artists Rights Society, New York, NY/VG Bild-Kunst, Bonn, Germany.

George Rickey, *The Annunciation*, 1948, oil on canvas. Photograph by David Lee. Copyright © George Rickey Foundation, Inc.

George Rickey, *Phoenix*, Junior Art Gallery, Louisville, Kentucky, 1950. Copyright © George Rickey Foundation, Inc.

David Smith and Jean Freas, Bloomington, Indiana, 1954. Photograph by George Rickey. Copyright © George Rickey Foundation, Inc.

George Rickey (American, 1907–2002), *Seesaw and Carousel*, 1956, stainless steel, brass, paint, 34½ in. H x 120½ in. L x 120 in. D, The Baltimore Museum of Art: Frederic W. Cone Fund, BMA 1956.109. Photograph by Mitro Hood. George Rickey Estate, LLC / licensed by Artist Rights Society, New York.

George Rickey, *No Cybernetic Exit (or) An Overview of Compensatory Reserves of Bituminous Coal*, 1954, brass, painted brass, steel, 9½ x 21½ x 8¾ inches, Indianapolis Museum of Art at Newfields, Gift of Cornelia V. Christenson, 77.63 Copyright © 2021 Estate of George Rickey/Licensed by VAGA at Artists Rights Society, New York.

The house on Hand Hollow Road, East Chatham, New York, 1956. Photograph by George Rickey. Copyright © George Rickey Foundation, Inc.

Edie and Stuart Rickey, East Chatham, New York, circa 1958. Photograph by George Rickey. Copyright © George Rickey Foundation, Inc.

George and Naum Gabo, 1963. Copyright © George Rickey Foundation, Inc.

Edie at her desk, East Chatham, New York, 1964. Photograph by Carl Howard. Copyright © George Rickey Foundation, Inc.

Edie modeling George Rickey's *Space Churn* hairpiece, sterling silver and enamel, 1956. Copyright © George Rickey Foundation, Inc.

George at work on *Crucifera IV*, 1964. Photograph by Carl Howard. Copyright © George Rickey Foundation, Inc.

George Rickey, *Three Red Lines*, 1966, stainless steel and paint with hydraulic devices, mounting, screws and braces. Gift of the artist through

the Joseph H. Hirshhorn Foundation, 1972. Photograph by Lee Stalsworth. George Rickey Estate, LLC / licensed by Artist Rights Society, New York.

George Rickey, *Four Squares in a Square*, Neue Nationalgalerie, Berlin, 1969. Photograph by Reinhard Friedrich. George Rickey Estate, LLC / licensed by Artist Rights Society, New York.

Don Mochon, *At the Rickeys'*, watercolor, undated. Copyright © George Rickey Foundation, Inc.

Edie Rickey in the kitchen, Bundesplatz 17, Berlin, 1981. Photograph by Achim Pahle. Copyright © George Rickey Foundation, Inc.

Ed Kienholz casting Edie for *The Art Show*, Berlin, 1974. Photograph by Nancy Reddin Kienholz, Estate of Nancy Reddin Kienholz. Courtesy of L.A. Louver, Venice, CA.

Rickey family, 1973. Photograph by Arnold Newman. Courtesy of Getty Images.

Dennis Connors with George in the upper studio, East Chatham, New York, 1976. Photograph by Carl Howard. Copyright © George Rickey Foundation, Inc.

Philip Rickey, Ellsworth Kelly, and George, East Chatham, New York, 1976. Photograph by Stuart Rickey. Copyright © George Rickey Foundation, Inc.

George Rickey's *Annular Eclipse Sixteen Feet I*, East Chatham, New York, 1999. Photograph by Serge Lemoine.

INDEX

ABOUT THE AUTHOR

Belinda Rathbone is a biographer, historian, and fine arts journalist based in Cambridge, Massachusetts. She is the author of the critically acclaimed *Walker Evans: A Biography*. Rathbone's books from Godine include *The Boston Raphael: A Mysterious Painting, an Embattled Museum in an Era of Change & A Daughter's Search for the Truth* and her memoir, *The Guynd: Love & Other Repairs in Rural Scotland*.

A NOTE ABOUT THE TYPE

George Rickey: A Life in Balance has been set in Electra, the second typeface released from Linotype by designer W.A. Dwiggins. Electra is a modern face designed in 1935 expressly for book pages. Dwiggins, a student of Frederic Goudy and an excellent calligrapher, was also an admired puppeteer who wrote plays and performed shows as Dr. Puterschein.

Book Design by Brooke Koven